ESSENTIAL
CINEMA

ESSENTIAL CINEMA

An Introduction to Film Analysis

JON LEWIS
OREGON STATE UNIVERSITY

WADSWORTH
CENGAGE Learning·

Australia • Brazil • Japan • Korea • Mexico • Singapore • Spain • United Kingdom • United States

**Essential Cinema: An Introduction
to Film Analysis**
Jon Lewis

Publisher: Michael Rosenberg

Senior Development Editor: Leslie Taggart

Development Editor: Cynthia Ward

Assistant Editor: Erin Bosco

Editorial Assistant: Rebecca Donahue

Media Editor: Jessica Badiner

Senior Content Project Manager: Michael
Lepera

Senior Market Development Manager: Kara
Kindstrom

Senior Marketing Communication Manager:
Linda Yip

Marketing Coordinator: Brittany Blais

Executive Brand Manager: Ben Rivera

Senior Art Director: Marissa Falco

Senior Rights Acquisition Specialist: Mandy
Groszko

Manufacturing Planner: Doug Bertke

Production Service/Compositor: Lachina
Publishing Services

Text Designer: Ke Design

Cover Designer: Roycroft Design

Cover Image: The Kobal Collection at Art
Resource, NY

For product information and technology assistance, contact us at
Cengage Learning Customer & Sales Support, 1-800-354-9706

For permission to use material from this text or product,
submit all requests online at **cengage.com/permissions.**
Further permissions questions can be emailed to
permissionrequest@cengage.com.

Library of Congress Control Number: 2012950823

ISBN-13: 978-1-4390-8368-0

ISBN-10: 1-4390-8368-1

Wadsworth
20 Channel Center Street
Boston, MA 02210
USA

Cengage Learning is a leading provider of customized learning solutions with
office locations around the globe, including Singapore, the United Kingdom,
Australia, Mexico, Brazil, and Japan. Locate your local office at:
international.cengage.com/region

Cengage Learning products are represented in Canada by Nelson Education, Ltd.

For your course and learning solutions, visit **www.cengage.com.**

Purchase any of our products at your local college store or at our preferred
online store **www.cengagebrain.com.**

Instructors: Please visit **login.cengage.com** and log in to access instructor-
specific resources.

Printed in the United States of America
1 2 3 4 5 6 7 16 15 14 13 12

For my mother, Muriel Lewis.

BRIEF CONTENTS

CONTENTS

5 EDITING 118

6 SOUND 148

7 COMMERCIAL AND INDUSTRIAL CONTEXTS 182

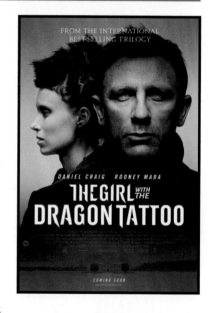

8 DOCUMENTARY, ANIMATED, AND EXPERIMENTAL FILMS 206

9 FILM HISTORY 244

10 WRITING ABOUT FILM 282

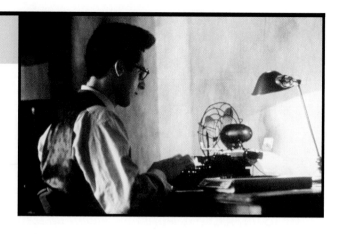

Moviegoing has been a cultural practice—a cultural habit and international pasttime—for over a century. As a medium it transcends social, political, economic, national, and racial boundaries; it speaks a language that is at once universal and undeniably persuasive and compelling. It has, in a word, become essential to our experience as modern citizens of a global culture.

Essential Cinema endeavors to unpack this medium's formal structure and introduce its social and historical contexts. The goal here is twofold: to provide a framework from which students can better understand and appreciate film form, style, and structure; and to introduce important films, filmmakers, and filmmaking traditions covering a range of historical periods, genres, and national cinemas. Through a unique combination of pedagogical features and a focus on essential topics, this book helps students develop the skills and vocabulary of film analysis.

TOPIC COVERAGE: FORM AND CONTEXTS

- The first six chapters of the book introduce students to the medium's essential or constituent formal and stylistic elements: narrative, mise-en-scène, camera work, editing, and sound.

- Embracing the notion that cinema is a commercial and industrial enterprise as well as an artistic and creative endeavor, the book then moves to an examination of the practical aspects of movie development, production, postproduction, distribution (including promotion and advertising), and exhibition. In addition to understanding how the elements of film form and style contribute to meaning, students learn to read films as products produced by movie studios and corporations that profit off a popular mass culture.

- After an introduction to the art and business of live-action narrative cinema, we turn to alternative forms and styles of filmmaking in chapter 8, which focuses on documentary, animation, and experimental films. Key here is that the same basic tools we use to analyze more mainstream or commercial or traditional narrative films can be applied to these non-traditional forms and styles as well.

- Chapter 9 explores the notion that films are products of a particular time and place. The focus is on important eras in Hollywood filmmaking; the distinction between American studio and independent movies; and the relationship between history, culture, and film form in four key European film movements (German Expressionism, Soviet Formalism, Italian Neorealism, and the French New Wave) and in the postwar cinemas of Japan, Hong Kong, and India.

- Chapter 10, on writing about film, can be used at any point in the course. From taking notes through documenting sources, it guides students through common writing assignments and eliminates the need for separate writing texts and documentation guides.

FEATURES

- *Essential Cinema* has a higher picture-to-text ratio than other texts, which translates into a more visual mode of instruction. The 675 pictures (most are frame captures)—all of which are discussed in the main text—help students to see principles at work and develop their skills in close analysis. For the eBook version of *Essential Cinema*, many of the film stills will be clickable—and students will see the film sequence/clip.

- MAKING MOVIES boxes give students insights into how filmmakers think about the elements of form and style discussed in Chapters 2–6 and 8. These exclusive interviews with leading contemporary filmmakers are excerpted in the boxes and available on video in the eBook through CourseMate.

- Screening questions at the end of chapters help students apply chapter concepts to any film that they watch. (These questions appear under the heading ANALYZE.) Students can photocopy these pages or print them from the CourseMate website. The questions are useful for generating notes and ideas for papers as well as for class discussion.

- FOCUS boxes at the end of each chapter bring the chapter concepts together and show students how to apply them.

- Each chapter has a running glossary to help students master the vocabulary of film. There is also an illustrated glossary at the end of the text.

ADDITIONAL RESOURCES

CourseMate for *Essential Cinema*. *Essential Cinema* includes a CourseMate with eBook, which helps students make the grade with exciting multimedia elements. Click play in the interactive eBook and watch stills from the print book come to life as embedded film clips. The eBook also includes highlighting and note taking capabilities, and is accessed from the Course-Mate. The CourseMate also includes "Making Movies Practitioner Interviews." In this video feature unique to this book, film professionals discuss the elements of film form and style. Additionally, the CourseMate helps students succeed with scene analysis tools, chapter quizzes, flashcards, and tutorial videos with author Jon Lewis explaining key concepts.

CENGAGE
brain
.com

Go to **cengagebrain.com** to access these resources, and look for this icon to find resources related to your text.

Instructor Website. This protected companion website provides exclusively instructor materials, including PowerPoint® presentations for each chapter that can be used to guide class lectures.

ACKNOWLEDGMENTS

It is a pleasure to acknowledge and thank those film professors who have reviewed the project and contributed to its development through both critique and encouragement:

Jill Adams, Jefferson Community and Technical College;

Karley Adney, University of Wisconsin–Marathon County;

Jacob Agatucci, Central Oregon Community College;

John Alberti, Northern Kentucky University;

Rebecca Alvin, Cape Cod Community College;

Nathan Andersen, Eckerd College;

George Angell, Hilldale College;

Mike Applin, Louisiana State University;

Jennifer Barker, East Tennessee State University;

Bob Baron, Mesa Community College;

Antonio Barrenechea, University of Mary Washington;

Richard Bartone, William Paterson University;

Brian Baumgart, North Hennepin Community College;

Mary Beadle, John Carroll University;

Miriam Bennett, Cuyahoga Community College;

Dennis Bingham, Indiana University–Purdue University Indianapolis;

Robin Blaetz, Mount Holyoke College;

Richard Blake, Boston College;

Skip Blumberg, Hofstra University;

Jay Boyar, University of Central Florida;

Mitch Brian, University of Missouri;

Michael Briggs, East Tennessee State University;

Heather Brooke, Eastern Michigan University;

Joel Brouwer, Montcalm Community College;

John Bruns, College of Charleston;

Steve Buss, California State University–Sacramento;

George Butte, Colorado College;

David Caldwell, Indiana University–Purdue University Indianapolis;

Sandy Camargo, University of Illinois;

Ed Cameron, University of Texas–Pan American;

Allison Carey, Marshall University;

Tim Case, University of South Dakota;

Peter Caster, University of South Carolina Upstate;

Stephen Charbonneau, Florida Atlantic University–Boca Raton;

Harry Cheney, Chapman University;

Matthew Cheney, Plymouth State College;

William Christy, Rochester Institute of Technology;

Erin Clair, Arkansas Tech University;

Jennifer Clark, Fordham University;

Beth Clary, Irvine Valley College;

Jim Cocola, Worcester Polytechnical Institute;

James Collins, University of Notre Dame;

Jim Compton, Muscatine Community College;

Carolina Conte, Jacksonville University;

John Cooper, Eastern Michigan University;

Susan Cornett, St. Petersburg College;

Tracy Cox-Stanton, Savannah College of Art and Design;

Kenneth Crab, Marymount Manhattan College;

Dan Cross, Southwestern Illinois College;

Samir Dayal, Bentley College;

Bob Deaver, Rochester Institute of Technology;

Camille DeBose, DePaul University;

Linda DeLibero, John Hopkins University;

James Denny, Cleveland State University;

Suzanne Diamond, Youngstown State University;

Helen Ditouras, Schoolcraft College;

Rodney Donahue, Texas Tech University;

Carlen Donovan, Idaho State University;

Andrew Douglas, Cabrini College;

Ashton Dyrk, University of Toledo;

Jon Egging, San Jacinto College;

John Ernst, Heartland Community College;

James Everett, Mississippi College;

Corey Ewan, College of Eastern Utah;

Jenna Feldman, Columbia College Chicago;

Adrianne Finlay, Upper Iowa University;

Tay Fizdale, Transylvania University;

Sean Flannery, Immaculata University;

Hugh Foley, Rogers State University;

Ben Fry, University of Arkansas at Little Rock;

Katherine Fusco, Vanderbilt University;

Paul Gaustad, Georgia Perimeter College;

Raimondo Genna, University of South Dakota;

Angela Giron, Arizona State University;

Barry Goldfarb, Monroe Community College;

Neil Goldstein, Montgomery County Community College;

Nate Gordon, Kishwaukee College;

Paul Hackman, University of Illinois at Urbana–Champaign;

Michael Haddock, Florida State College at Jacksonville;

Mickey Hall, Volunteer State Community College;

Stefan Hall, The Defiance College;

J. Stephen Hank, University of New Orleans;

Matthew Hanson, Eastern Michigan University;

Robert Harris, Fitchburg State University;

Mark Harris, Schoolcraft College;

David Haugen, Ohio University;

William Hays, Delta State University;

Dan Hazlett, Stanly Community College;

Kerry Hegarty, Miami University;

Jeff Heinle, South Dakota State University;

Sean Heuston, The Citadel;

Chris Hite, Allan Hancock College;

Nick Hoffman, Santa Rosa Junior College;

Christina Hopkins, Columbus State Community College;

Tom Isbell, University of Minnesota–Duluth;

Colleen Jankovic, University of Pittsburgh;

Norman Jones, Ohio State University;

Simon Joyce, College of William & Mary;

Jonathan Kahana, New York University;

Carol Keesee, The University of North Carolina–Greensboro;

Douglas King, Gannon University;

Tammy Kinsey, University of Toledo;

David Kreutzer, Cape Fear Community College;

Audrey Kupferberg, the University at Albany;

Abby Lackey, Jackson State Community College;

David Laderman, College of San Mateo;

Matthew Lany, Florida Community College at Jacksonville–South;

Ronald Leone, Stonehill College;

Leon Lewis, Appalachian State University;

Karen Loop, Columbia College Chicago;

Nina Martin, Connecticut College;

Hugh McCarney, Western Connecticut State University;

Shellie Michael, Volunteer State Community College;

April Miller, University of Northern Colorado;

Rick Moody, Utah Valley University;

James Morrison, Claremont McKenna College;

Jonathan Morrow, Mt. Hood Community College;

Mary Ann Murdoch, Polk State College;

Robin Murray, Eastern Illinois University;

Charlie Myers, Saddleback College;

Harold Nelson, Minot State University;

Martin Norden, University of Massachusetts–Amherst;

Hanna Norton, Arkansas Tech University;

Christina Nova, University of North Carolina at Greensboro;

Ian Olney, York College of Pennsylvania;

Bradford Owen, California State University–San Bernardino;

Marjorie Paoletti, Anne Arundel Community College;

Stacey Peebles, Centre College;

Wendy Perkins, Prince George Community College;

Gary Peterson, College of the Canyons;

Dave Posther, Kalamazoo Valley Community College;

Paul Reinsch, Loyola Marymount University;

Rashna Richards, Rhodes College;

Nicole Richter, Wright State University–Main Campus;

Andrea Robertson, Phoenix College;

Christian Rogers, Bowling Green State University;

Elaine Roth, Indiana University–South Bend;

Jared Saltzman, Bergen Community College;

Zoran Samardzija, Columbia College Chicago;

Jen Schneider, Colorado School of Mines;

Matthew Sewell, Minnesota State University–Mankato;

Allen Share, University of Louisville;

Timothy Shary, University of Oklahoma;

Diane Shoos, Michigan Technological University;

Paul Skalski, Cleveland State University;

Mike Solomonson, Northland Pioneer College;

Walter Squire, Marshall University;

Ken Stofferahn, University of Wisconsin–River Falls;

Judy Suh, Duquesne University;

Mark Svede, The Ohio State University;

Molly Swiger, Baldwin-Wallace College;

Nick Tanis, New York University, Tisch School of the Arts;

Joe Tarantowski, Baldwin-Wallace College;

Susan Tavernetti, De Anza College;

Edwin Thompson, University of Massachusetts–Dartmouth;

Michael Vaughan, Oakland University;

William Vincent, Michigan State University;

John Vourlis, Cleveland State University;

Dex Westrum, University of Wisconsin–Parkside;

Timothy White, Missouri State University;

Carolyn Whitson, Metropolitan State University;

Mary Wilk, Des Moines Area Community College–Urban Campus;

Rebecca Willoughby, Susquehanna University;

Shari Zeck, Illinois State University.

I would like to acknowledge the hard work put in on my behalf by the editorial team at Cengage: senior development editor Leslie Taggart, assistant editor Erin Bosco, editorial assistant Rebecca Donahue, media editor Jessica Badiner, senior content project manager Michael Lepera, senior market development manager Kara Kindstrom, marketing coordinator Brittany Blais, executive brand manager Ben Rivera, senior art director Marissa Falco, senior rights acquisition specialist Mandy Groszko, manufacturing planner Doug Bertke, and senior art director Linda May. Special thanks go to the book's publisher, Michael Rosenberg. From our first conversations planning and developing the book through the final hectic days of production, he has been supportive and receptive, providing for me a balance between the practical and the creative aspects of the project. And last but by no means least, a big, big thanks to "my" development editor Cynthia Ward, whose relentless work managing this book (and at times managing me) is everywhere evident in the pages that follow.

At Lachina Publishing Services, which provided the compositing and production of the book, I would like to single out the contributions made by project manager Megan Dykes, editor Amanda Wolfe, and compositor Eric Zeiter. The book looks as good as it does thanks in good part to them.

The video interviews were a joy to plan and produce. The video producer/director Bruce Schwartz worked tirelessly on the project often against tight deadlines. I'd like to also acknowledge the expert work by cameramen Don Feller, Bob Wall, and Peter Bonilla; video editor Stephen Goetsch; and music composer Rocky Davis. A special thanks to James Schamus for his help setting up the first interviews and to production designer Mark Friedberg, cinematographer Ed Lachman, music editor Ken Wannberg, screenwriter Jeb Stuart, film editor Carol Littleton, and documentary filmmaker Kirby Dick for their generous participation in the project.

Special thanks to Bob Wall for his expert technical work on the video clips and voice-overs.

Finally, big love, etc., to Q and the boys (Martha, Guy, and Adam).

ESSENTIAL CINEMA

The Cameraman (Edward Sedgwick, Jr., 1928)

What do we talk about when we talk about movies? As with all first impressions, the conversation begins with likes and dislikes, subjective responses that reflect our experience, knowledge, and temperament. What we say and how strongly we say it—we often talk about movies in terms of love and hate—rather raise the stakes. If you love a certain film and recommend it to a friend, how do you feel when they like it, too? How bad do you feel when they hate it?

Many of the subjective reactions we have to a movie are the consequence of careful creative design, the result of choices about story structure, visual design, camerawork, editing, and sound made to prompt us to react in certain ways, to get us thinking about things from a particular point of view, to make us see and hear things in a specific order and manner. Film analysis enables us to recognize how the filmmakers have worked their magic on us, how all the constituent elements of the film have combined to create that magic. Rather than rob us of the pleasures of watching films, this approach affords us the even greater pleasure of deep engagement. This first chapter begins with the question of why we are drawn to the movies and then introduces and models a scholarly approach to the cinema.

As we ponder our attraction to motion pictures, it is worth thinking about the basic human desires and drives that cinema seems to satisfy, about what made cinema possible, even inevitable. Such a project takes us back as much as 30,000 years to the earliest pictorial expressions carved into and painted on cave walls at Chauvet and Lascaux, images viewed communally by our predecessors by torchlight, anticipating the phenomenon of going to the movies (fig. **1.1**).

What motivated the cave painters was perhaps not so different from what motivated early filmmakers: the fundamental human desire to express oneself, to preserve for posterity images drawn from everyday life, to render tangible and real a particular and peculiar take on the world. And the undeniable presence of an aesthetic, their attention to design and detail, suggests that these artists cared what their audience thought about what they produced. The artist's urge to create an experience for an audience, and the audience's ability to be engaged by that creation, are still at work in the contemporary medium of film.

1-1a The Moving Image

Although the experience of viewing an image illuminated in the darkness extends back into prehistory, the projection of images for public entertainment is a somewhat more recent phenomenon, dating to the eighteenth century and the "magic lantern." This device employed a lens, a shutter, and a persistent light source that projected

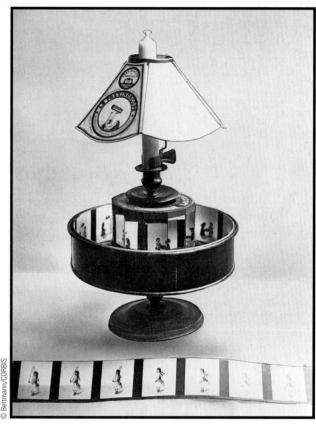

1.2 Emile Reynaud's Praxinoscope moving image viewer (ca. 1887).

etched images from glass slides onto a white wall in the dark. Audiences were fascinated by the power of the lantern operator (usually a magician) to conjure ghostlike images out of the shadows. Over time inventors improved on the quality of the light source, and by the early to mid-nineteenth century the magic lantern was used in conjunction with motion toys. Motion toys like the Thaumatrope (a round card with multiple images held on a string), the Phenakistoscope (a platelike slotted disc spun to simulate moving images), the Zoetrope (a bowl-like apparatus with slots for viewers to peer through), and the Praxinoscope (fig. **1.2**) gave audiences their first glance at multiple, continuous, moving images, their first glance at what would someday be transformed into a new mass medium.

1.1 In his 2010 documentary *Cave of Forgotten Dreams*, Werner Herzog explored the caves at Chauvet, France, where in the mid-1990s archaeologists discovered paintings dating back more than 30,000 years.

1-1b Modern Moviegoing

Over time, the moviegoing experience has become more seamless. There is no flicker to ignore anymore; 35mm exhibition provides beautiful, gigantic moving images; and the advent of digital formats for production and exhibition have eliminated many of the the medium's technical glitches. At the movies today we bear witness not only to the stories told in a given film but to the astounding technology that has made that work of art and entertainment possible.

But even with the advent of advanced technologies, movies continue to appeal to our most primitive desires and anxieties: love, happiness, fear, despair. Moviegoing can be simply diverting, or it can be provocative and unsettling. Sometimes it's both. The film reviewer Pauline Kael once quipped that she "lost it at the movies," a wry joke about losing her innocence there in the dark. But it is fair to ponder the opposite effect, that more often than not we *find* things at the movies ... about ourselves and about our world, things we have otherwise never considered, never thought about deeply.

We study movies because our reactions to them are so powerful, because their role in modern life is so significant, because understanding them informs the way we experience the world. Moviegoing is a unique communal experience, a form of organized leisure that formalizes the expression of shared emotions (laughter, for example, at a screening of the Coen brothers' *The Big Lebowski* [fig. **1.4**]). This book introduces an objective study of such a familiar subjective and communal experience, offering a critical vocabulary for discussing, analyzing, and reflecting upon the movies in our lives.

© Bettmann/CORBIS

1.3 A screening of a Keystone short in 1913. Silent film exhibition featured noticeable flickering light due to its relatively slow speed through the gate of the projector.

The content of these early moving images was rudimentary and largely irrelevant: hand-drawn horses galloping, two children playing leapfrog. The star attraction was the technology itself; the audience was asked merely to bear witness to the phenomenon of seeing pictures move. That phenomenon hinged upon a fundamental trick or lie, what film historians and theorists call persistence of vision or positive afterimages, and what many physicists understand as the phi phenomenon or apparent motion. **Persistence of vision** refers to the tendency for one image to persist or linger on our retina as the next image enters our perception, which explains why we do not perceive the black frames that separate the still images as motion picture film passes through the projector. Apparent motion, or the **phi phenomenon**, describes an optical illusion that allows us to perceive constant movement instead of a sequence of images. Together these phenomena create the impression or perception of a single continuous moving image despite the reality of a series of individual **frames**.

Another trick, or misperception, involves **critical flicker fusion**, a phenomenon in which the light of a film projector flashes so rapidly with each new frame that we do not see it pulse but instead see a continuous beam of light. Motion toys and silent movies (which were shot and projected at the relatively slow speed of 16 frames per second) did display a distinct flicker (fig. **1.3**), hence the slang term for silent movies, "flickers," and the occasionally used synonym for movies today, "flicks." Sound films do not display such a flicker because they are shot and projected at the significantly faster 24 frames per second (fps).

persistence of vision The tendency for one image to persist or linger on our retina as the next image enters our perception, contributing to the illusion of motion pictures.

phi phenomenon The optical illusion that accounts for the impression of movement when one image follows another at the proper speed.

frame The smallest compositional unit of a reel of film: a single photographic image; also, the boundaries of the image.

critical flicker fusion A phenomenon in which the light of a film projector flashes so rapidly with each new frame that we do not see it pulse but instead see a continuous beam of light.

1.4 Cinema as communal experience and organized leisure. Two thousand filmgoers endure the rain to share the experience of watching Joel and Ethan Coen's *The Big Lebowski* (1998), a film most of them have already seen. The unlikely setting for this outdoor show was London's eighteenth-century Somerset House courtyard.

1-2 MOVIES AS ENTERTAINMENT AND ART

By the time we reach our teens, we may have seen hundreds, even thousands of films in movie theaters, on television, laptops, tablets, iPods, and even cell phones. We are, as George Orwell predicted we would be, surrounded by screens in public and private spaces. This ubiquity of the moving image seems hardly a cause for alarm, as it was in Orwell's *1984*. Such access has made moviegoing simpler, easier, even cheaper, as more films are now available in more formats and in more venues than ever before.

The medium's continued popularity is a testament to its entertainment value. And this entertainment value has fueled the notion that going to the movies is primarily a means of escape. Escapism is certainly built into certain forms or genres of movies, and it is a design feature of the movie theater, the site of the so-called first run of the vast majority of motion pictures. Movie theaters have fashioned a built environment that is comfortable,

dark, quiet, and temperature-controlled. When we enter this space, we are asked only to sit back and relax. Yet while such an environment seems to set the stage for escapism, the passive consumption of movie fantasies, it also narrows our focus onto one object: the movie we are watching. In our hyper-stimulated world, the movie theater is a rare secular site designed to eliminate distraction and allow for serious reflection.

As critical filmgoers, we can begin to discover the art in entertaining films as well as an entertainment value in films that are challenging. We can bring a sophisticated analysis to movies that define themselves as escapist fun. And for films that are challenging or unusual, there is a pleasure to be had in figuring out a complexly structured plot, and in appreciating and understanding the filmmakers' unusual choices in design, form, and style.

1.5 Buster Keaton as a projectionist dreaming about an exciting life like those lived on screen. *Sherlock Jr.* (Keaton, 1924).

1.6 In the film within the film, Sherlock Jr. wins the heart of the object of his desire.

1-2a Appreciating and Understanding Entertainment

To see how we might move past our first impressions and introduce a critical analysis, we begin with a popular film comedy from the silent era: Buster Keaton's *Sherlock Jr.* The film is entertaining; it's funny, and Keaton's stunts are original and exciting. Our initial reaction to the film as it unspools is likely one of appreciation—of Keaton's skill as a performer, of the cleverness of the gags—and that reaction is characterized by laughter, an involuntary response that signals the film's success as entertainment.

Sherlock Jr. is particularly useful for us here at the start of this study because it cleverly displays—in fact, it incorporates into its closing sequence—two key processes that characterize our reception of films: **identification** (something in the film reminds us of our own experience) and **idealization** (we think: if only our lives were quite like this!). As we begin to read the film critically—much as we would closely read a novel or poem, for example—we recognize these two processes not only in the context of this film but with regard to our general filmgoing as well.

The film tells the story of a shy and bumbling film projectionist who is falsely accused of stealing a watch, an accusation that promises to nix a budding romantic relationship. Forlorn, he returns to work and as the film he projects unspools, he falls asleep and dreams (fig. **1.5**). In his dream he jumps into the movie screen and takes control of the story underway there. On screen he is the crack detective Sherlock Jr. He is everything he is

not in real life: confident, remarkably agile, an adept deductive thinker. And most important (to this point in the film), unlike the projectionist, Sherlock Jr. "gets the girl" (fig. **1.6**).

For the hapless projectionist, movies are the site of dreams and aspirations. At this particularly low point in his personal life, he imagines what it might be like to be the hero of a movie instead of the man paid to project it. For the critical filmgoer it is important not to miss the parallels between the projectionist's imagined participation in the fiction on screen and our own experience at the movies.

When the projectionist wakes from his dream, we return to the "real world." The dream—structured as a film within the film—has ended with his triumph over adversity. Waking up in the projection booth is at first a bit of a disappointment; he is no longer the hero in a miraculous rescue. But this disappointment is short-lived; his girlfriend has arrived, and she reveals that while he's slept she has solved the case of the stolen watch. Her discovery clears the way for romance.

But the film does not end there. In what silent comedians called a "kick-in-the-pants ending," the film's brief coda reflects explicitly on the processes of identification

identification A mode of engagement with film content; something in the film reminds us of our own experience, and we tend to identify with the relevant character and his or her situation.

idealization A mode of engagement with film content; something in the film resonates with our dreams and aspirations: if only our lives were quite like this!

▶ **1.7–1.17** Life imitating art. The hapless projectionist learns a thing or two about romance at the movies.

and idealization. Still groggy and still unsure of himself, the projectionist is alone with his girlfriend in the projection booth, and all suspicion has abated. He wonders what to do. Then he looks to the screen for help. And there he finds some useful instruction. The film ends with a series of alternating **shots** of the projection booth and the film playing on screen (figs. **1.7–1.17**). (A shot is an image produced from a single "take" on the

shot A continuously exposed, uninterrupted, or unedited piece of film of any length; a basic unit of film structure with discernible start and end points.

film set.) By contrasting the "real" world of the projectionist with the contrived world of Sherlock Jr., Keaton both satirizes the movie melodramas that were popular with 1920s American audiences and also underscores how important they had become in the collective imagination. The ending produces not only a laugh but also an invitation to wake up to how we have identified with and idealized life as it is depicted in the movies.

A film released three-quarters of a century later, *The Matrix*, poses a similar set of challenges as it asks us as critical filmgoers to see past its screen fantasy to find a more complex, more global, more philosophical work. *The Matrix* is an entertaining film in the way, or more

1.18 Even the most implausible of films can get us thinking about the world in which we live now and the world in which we may live someday. *The Matrix* (Andy and Larry/Lana Wachowski, 1999).

accurately, at a scale that only blockbusters can be. It is big, fast, and loud—a Hollywood spectacle *par excellence*. It is designed to transport us, excite us, and even thrill us. But it is also a deceptively complex work: a unique amalgam of stop- and slow-motion photography (fig. **1.18**), a clever adaptation of cyberpunk science-fiction literature, and an evocation of Asian action film and comic-book graphics and visuals. It may be good escapist fun, but it engages complex ideas in complex ways. Careful and close reading prompts an analysis that reflects upon our growing dependence on and fascination with immersive technologies—technologies that may well affect our humanity in profound ways.

Examining what we sometimes call a film's deeper meanings in no way detracts from the euphoric

sensation of watching the film, of being pinned to our seats by the imagery and sound. Indeed, thinking about these meanings helps us situate the film and the sensation it produces in terms of our own lives and intellectual experience.

1-2b Appreciating and Understanding Complex Films

Some films are more difficult to "get into" than others. They are deliberately designed to challenge our belief systems and our expectations about movies, life, and the world at large. When watching such films, we need to be a bit more patient. The pleasure is less immediate and the processes of identification and idealization are less easily engaged. These films require critical analysis for engagement, even entertainment, which makes them well suited to the task ahead in this book.

The modern Japanese film *Vengeance Is Mine* is for many viewers an example of difficult entertainment. The film tells the fact-based story of Akira Nishiguchi (he is called Iwao Enokizu in the film), who went on a killing spree in the early 1960s. Shohei Imamura's film gives us plenty of access to the killer, but it makes little effort to help us understand him. The performance of Ken Ogata, the actor who portrays Iwao, magnifies the character's intent to keep others—including the viewer—at a distance.

Vengeance Is Mine opens with the killer in a police car. As the plot works backward from his capture, we expect to find an explanation for Iwao's actions in the film's flashbacks (fig. **1.19**). But Imamura resists such an easy sociology. The killer's life is eventful but paradoxically empty.

The film's title also frustrates our attempts to understand what has motivated the crime. It offers a familiar New Testament allusion (to Romans 12:19) and more specifically suggests that the killings are meant as retribution. But Iwao hardly leaves the task of vengeance to the Lord, as the Biblical quotation requires, and nothing in the story supports the notion that he is

1.19 The banality of evil. Shohei Imamura's *Vengeance Is Mine* (*Fukushû suru wa ware ni ari*, 1979) endeavors to challenge our expectations about crime dramas and the nature of crime itself. The film frustrates our attempts to understand why Iwao (shown here daydreaming during a police interrogation) committed murder.

killing because he has read or misread the Biblical passage or that he is seeking vengeance. Indeed he feels no discernible euphoria in dispatching his victims.

Vengeance Is Mine is hard work, but the payoff is considerable. Most crime films are satisfying because they reduce evil to narrative formulas. When Imamura's film forces us out of this comfort zone, so to speak, we have to look for another reason why we're witnessing this story, another reason why the evil we see in the film exists. As we analyze the film, we come to reconsider the nature of evil in modern society and arrive at the chilling notion that sometimes people do bad things and even they don't know why.

In his popular 1968 feature *2001: A Space Odyssey*, Stanley Kubrick takes up a familiar sci-fi story: in deep space a computer malfunctions and the crew is put in grave danger. But despite this familiar hook, he seems up to something else in the film, something more.

As we look at the film's narrative structure and pacing, for example, we find the first of many challenges posed by the filmmaker. Kubrick takes us *slowly* into the narrative. The film begins not in deep space but with a long section titled "The Dawn of Man" in which a series of connected scenes track the evolution of human ancestors, shown first walking on all fours, then upright; first truly primitive, then capable of transforming found objects into tools and weapons (fig. **1.20**).

As with many such complex and challenging films, we need to be patient. We need to find pleasure in the director's resistance to formula and his thwarting of audience expectation. Certainly Kubrick is using these early scenes to comment upon human nature, but it is fair to wonder even late in the film what the "Dawn of Man" opening has to do with the rest of the story. Filmgoers for over a generation have pondered these questions, which is evidence of the pleasure that can be had through the hard work of making sense of this difficult film.

One of the pleasures of critical analysis is experienced when we finally feel like we are in on the joke, so to speak, when we begin to "get" what the filmmakers seem

1.20 "The Dawn of Man" in Stanley Kubrick's *2001: A Space Odyssey* (1968) asks us to ponder the nature of humankind.

1.21 The film's climax portrays the nature of modern humanity in a struggle against the machines we've made. But what does this have to do with the film's opening gambit, "The Dawn of Man"?

to be doing with all the painstaking detail in the design of the sets and, with regard to *2001*, in the re-creations of objects and machines floating in space. We are shown a space toilet, for example, complete with warnings about its use in a weightless environment. The camera stays on the instructions long enough to give us time to read them so that we can imagine ourselves in the world of the film, having to use that bathroom, thinking about the travails of space travel in a way we likely never had before.

In the film's climactic confrontation, which hinges on the struggle between human beings and the technology they have made (fig. **1.21**), Kubrick refuses to play the scene straight. To defy our expectations, the tone is that of an absurd comedy. The goal here is not really science fiction but instead a familiarity that fuels identification. Anyone who has struggled with a piece of technology or with some mindless operative on the other end of a phone line has a sense of how the astronaut Dave feels when he asks the supercomputer HAL

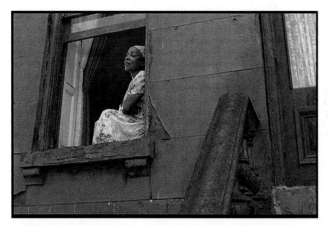

1.22 The neighborhood matriarch, "Mother Sister," looks out on another hot sunny day. Note how details like the peeling paint on the windowsill and the broken concrete on the step suggest not only a setting but a certain social-class milieu. *Do the Right Thing* (Spike Lee, 1989).

1.23 The working poor: the oft-abused Korean store-owners in *Do the Right Thing*.

1.24 The nonworking poor. ML, Sweet Dick Willie, and Coconut Sid hold their daily vigil across the street from the Korean convenience store they so despise.

1.25 Radio Raheem captured in low-angle close-up, his size and his African features exaggerated as he looms above the camera.

to open the pod-bay doors, and HAL rather blankly and calmly remarks that he'd prefer not to.

Some films, like Spike Lee's *Do the Right Thing*, deliberately refuse to deliver escapist entertainment and instead challenge audiences to engage with complex questions of morality and social justice. Lee's film is set in the Bedford-Stuyvesant neighborhood of Brooklyn, New York, in the late 1980s during a heat wave (fig. **1.22**). The milieu is atypical for a commercial American film; most of the setting's inhabitants are people of color, and there are few images of wealth or privilege in sight. The setting is not used as a means of comparison (to life as it is lived in "better" parts of town); we never leave the neighborhood. Here, again, identification plays a part. For an hour or two we are asked to experience imaginatively and intellectually the everyday

dramas that emerge from the incipient racism, white paternalism, and abject poverty that impact life there.

The two successful businesses we see in the film— the mini-mart and Sal's Pizzeria—are owned by neighborhood outsiders, Korean Americans and Italian Americans, respectively. Their success seems at odds with and perhaps at the expense of the African American denizens of the neighborhood. In play then are matters of class and race that complexly come into contest. While no one in the film is wealthy, a separate set of distinctions among the working class, the working poor, and the out-of-work are first drawn and then complicated by exaggerated racial stereotypes: the hard-working Korean store-owners (fig. **1.23**), the patronizing Italian-American restaurateur, and the shiftless African Americans who sit in lawn chairs drinking all day or hold menial jobs they half-heartedly perform (fig. **1.24**). The film so obviously

panders to cultural stereotypes that it asks us to examine them.

It is important when accounting for the social implications of a film to focus on its formal elements and its formal system. For example, it is well worth noting that to highlight racial differences, Lee uses exaggerated close-ups, often featuring characters looming over and talking directly into the camera (fig. **1.25**). Like the film, this stylistic choice is unsubtle but effective.

The film explores gender issues in the African-American community, and again Lee exploits familiar stereotypes: the benevolent but weary neighborhood matriarch Mother Sister, the young unwed mother Tina, the shiftless delivery boy and absentee father Mookie

(played by the director himself), the politicized but mostly uninformed Buggin' Out, and the boom-box-toting, ever-angry Radio Raheem.

Cultural studies scholars use the term "identity politics" to discuss the relationship between the artist and the artist's message about race, class, and gender. This is very much at issue here. The producer-writer-director of *Do the Right Thing* is Spike Lee, an African American who grew up in Brooklyn. It is relevant then that the film is not the work of an outsider looking in but that of an insider looking closely at social problems and issues in his own community. Lee's well-suitedness for such a social critique is essential to appreciating the film's authentic commentary and larger cultural significance.

1-3 HOW TO "READ" A FILM

The goal of this book is to help you develop the vocabulary and tools for critical thinking and to facilitate the critical analysis of any film that you see, whether it aims to be a work of entertainment, a work of art, or both. As a first step in that process, let's consider the bigger picture. What does it mean to analyze films? What makes the scholarly practice of film criticism different from the subjective process of reviewing movies for a thumbs-up or a thumbs-down assessment? How do we move beyond the basics of whether or not we like a film?

We begin with close observation, of the sort suggested by the questions that are provided at the end of each chapter. We might focus our attention on the distinct formal elements of a film (the subjects of chapters 2 through 5) and how those elements interact. We might also think about the film in the context of other similar

films and/or in its larger historical, cultural, and industrial contexts (chapters 7 and 9). As we put these ideas together, we construct an interpretation of the film's meaning(s) and significance.

1-3a Form and Style

In its most basic sense, **form** is the visual and aural shape of a film. Form embraces all aspects of a film's construction that can be isolated and discussed: the elements of narrative, mise-en-scène (the "look of the scene"), camerawork, sound, and editing. Film **style** refers to the particular or characteristic use of these elements. Film style may be associated with a time and place (e.g., **classical Hollywood**), with a type of film (e.g., a western), with a director's body of work (Hitchcock-ian; Fellini-esque), or it may be unique to an individual film. We might characterize a film's style as realistic (fig. **1.26**) or we might recognize it as highly stylized (fig. **1.27**).

To illustrate what it means to examine form and style in a film, let's take a close look at a key scene from the **French New Wave** director François Truffaut's first feature film, *The 400 Blows*. In this scene, the film's adolescent hero, Antoine, has been detained at a police station after stealing (and attempting to return) a typewriter from his father's office.

In terms of story structure, we are at the film's turning point. Antoine has been at odds with his parents and teachers, and his attempts to escape punishment have gotten him into deeper and deeper trouble. Now he faces truly serious consequences. So far the film has alternated between episodes of freewheeling youthful hijinks,

form The visual and aural shape of a film. Form embraces all aspects of a film's construction that can be isolated and discussed: the elements of narrative, mise-en-scène (the "look of the scene"), camerawork, sound, and editing.

style The particular or characteristic use of formal elements.

classical Hollywood The so-called "studio era," roughly from the advent of sound through World War II. Distinguished by an approach to filmmaking that strove for an "invisible style" that allowed viewers to become absorbed by the world of the film.

French New Wave A group of post–World War II French directors including François Truffaut, Jean-Luc Godard, Jacques Rivette, Claude Chabrol, Eric Rohmer, Alain Resnais, and Agnes Varda, all of whom strove to create a more spontaneous and personal style of filmmaking. Many of these directors began as film critics for the magazine *Cahiers du Cinéma*.

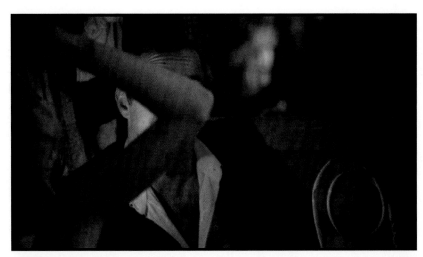

1.26 Natural light, real locales and interiors, and improvisational acting are aspects of the realistic style of John Cassavetes's *The Killing of a Chinese Bookie* (1976). So, too, is the inclusion of shots that "break the rules" of Hollywood filmmaking, such as this one, where the woman's arm obscures our view of the film's principal character in mid-sentence. This "mistake" gives the impression that the story is captured "on the fly."

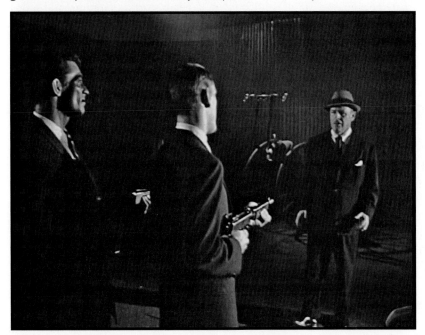

1.27 In Joseph Lewis's gangster drama *The Big Combo* (1955), the highly stylized lighting, sets, costuming, dialogue, and line delivery place us in the hard-boiled urban jungle. This style, known as **film noir** and associated with crime films from the 1940s and 1950s, creates a distinct milieu (a time and place) that evokes feelings of suspense, decadence, and dread.

this point (his anti-authoritarian nature? his parents' neglect? his oppressive school?), whether he deserves to be here (does the punishment fit the crime?), and what will happen to him next.

Antoine is taken down a tight corridor into a holding area, where he is placed into a cell with an adult. Time passes. The camera scans the room, taking in the scene: the dingy windowless space, the police officers killing time playing chess and reading the paper (fig **1.28**), the adult prisoner asleep (fig. **1.29**), and finally Antoine, asleep as well, oddly at peace with his unfortunate circumstances (fig. **1.30**). This is not a melodramatic jailhouse scene but rather one that seems true to the reality of confinement: it is dull and impersonal.

Another moving camera shot follows (fig. **1.31**). It chronicles the arrival of three female prisoners (presumably prostitutes), followed by one police officer's decision to move Antoine to a much smaller cell of his own. All of this is done without a single line of expository dialogue (dialogue meant to advance the story or reveal something important about the characters). Indeed the dialogue in the scene is often drowned out by sound effects (footsteps, the jailers' keys jingling, the jail cell doors opening and shutting), another aspect of the film's realist style. In addition to these effects, we eventually hear some childlike music (a simple scale that suggests a child playing the piano) on the soundtrack. This background music, or underscoring, adds a lighter, almost comic mood to the scene.

The next moving camera shot pauses twice to offer two beautifully framed shots from Antoine's point of view, looking out through the fence-like cell door

truancy, and moviegoing and episodes where Antoine is under scrutiny, disapproval, and control. While the police station scene is part of that larger pattern, it signals the beginning of a new phase in Antoine's life, one of greater confinement and harsher penalties. Watching this scene, we might begin to wonder what has brought Antoine to

film noir A French term for a style originating with American crime films of the 1940s and 1950s, characterized by deep shadows, night scenes, shady characters, and plots involving elaborate schemes and betrayals.

(figs. **1.32** and **1.33**). The camera shot through bars becomes a visual **motif**, or repeated element, from this point on and we are prompted to think about its significance in the larger scheme of the movie (which deals with other such confined spaces like the tiny apartment and the school where Antoine feels similarly imprisoned).

The camera returns to Antoine as the subject of our gaze (fig. **1.34**). His placement within the frame (the boundaries of the image) is significant. He has been backed into the corner, both literally and figuratively, and he is trapped.

Through a close study of this scene, then, we can see how it operates to create a moving portrait of Antoine as he is branded a criminal and herded into the penal system. When developing an interpretation of this scene, we might think about how these elements contribute to the film's themes, to the insights on human experience that the film offers. Some of the themes that critics have seen in this film include the unjust treatment of juvenile offenders, the roots of adolescent rebellion, the stifling of creativity and freedom by rule-bound institutions, and the importance of truth in both human relationships and film techniques.

1-3b Text and Context

Information culled from research about a film's historical or critical context can deepen our analysis. Continuing to use *The 400 Blows* as our sample text, let's explore what such a contextual reading might involve. First, the film is semi-autobiographical; it is largely composed of the director's reflections on his own fraught relationship with his family and institutional authority at public school, at

▶ **1.28–1.30** A single moving camera shot surveys the scene in *The 400 Blows* (*Les quatre cents coups*, François Truffaut, 1959).

▶ **1.31** "I saw a police station in a movie once, and it was a lot cleaner." One of the female prisoners makes a wisecrack that highlights Truffaut's departure from film artifice.

motif Repeated images, lines of dialogue, or musical themes that are significant to a film's meaning.

14 ANALYZING MOVIES

▶ **1.32 and 1.33** Bars upon bars. We see through Antoine's eyes and feel his confinement.

▶ **1.34** As we closely examine this image, we begin to appreciate Antoine's deepening alienation and hopelessness.

church, and in prison. It also depicts Truffaut's instinctive, early love of cinema; much as in the film, the movie theater became the site of Truffaut's escape as a youngster and foregrounded his career as an adult. When we consider this biographical information, we can understand the narrative's loose structure; we can put in context how such a narrative style resembles

the fragmentary nature of the author's childhood memories. And we can more fully appreciate the events in the story because they are likely true and speak directly of the author's experience.

Another context would be Truffaut's *œuvre*—his collected work as a director. Especially relevant here are the four other Truffaut films that depict the **protagonist** introduced in *The 400 Blows*, Antoine, at different stages of his life: the short subject *Antoine and Colette* (1962) and the features *Stolen Kisses* (1968), *Bed and Board* (1970), and *Love on the Run* (1979). Each film is autobiographical and we can observe subtle changes in the tone and content meant to match the maturity of the protagonist (Antoine and, by extension, Truffaut).

We might also consider the film in the context of the French New Wave, a group of post–World War II French directors that includes Truffaut, Jean-Luc Godard, Jacques Rivette, Claude Chabrol, Eric Rohmer, Alain Resnais, and Agnes Varda. Many of these directors began as film critics for the magazine *Cahiers du Cinéma* and made the transition from writing about to making movies to practice what they preached, to usher in a new, more modern French cinema.

Much as *The 400 Blows* chronicles the painful transition from childhood to adulthood, the New Wave movement in general concerned itself with a painful transition from pre-war fascism and wartime collaboration, from a rural, Catholic, and conservative nation into a more modern, urbanized, youth-oriented society untainted by the war and more in tune with the popular consumer culture of swinging London and the United States. Such a transition required a new, more immediate and realistic visual style, one that abandoned the moribund storytelling of

protagonist The film's hero.

the established French cinema. *The 400 Blows* is arguably the first important New Wave feature. It is a film that exemplifies this dual effort to better chronicle the realities of post-war France and to revitalize a national cinema that had become dull and passé.

The film foreshadows the social and political upheaval in France that came to a head a full decade after the film's release. It does so by revealing a generation gap already in evidence between Antoine's war-era parents and the post-war youth Truffaut's hero comes to represent. The film ably critiques adult authority in general and the institutions (family, school) and agencies (police) charged with maintaining the older generation's control.

The industrial context is meaningful too: *The 400 Blows* was produced on a tight budget. It is quite likely that some of the filmmaker's choices were economic as well as aesthetic, which is to say that Truffaut's use of a realist style may well have also been a budgetary matter. All of these contexts can be elaborated upon, and any one of them might provide an avenue for thinking critically and writing about the film.

CHAPTER SUMMARY

Movies are a product of careful creative design, the result of choices about story structure, visual design, camerawork, editing, and sound. A film analysis that takes a close look at these constituent elements enables us to understand and appreciate movies.

1-1 THE MAGIC OF MOVIES

Learning Outcome: *Identify the basic human desires and drives that cinema seems to satisfy and understand how various mental processes produce the illusion of motion pictures.*

- The basic human desires and drives that cinema seems to satisfy can be traced back as much as 30,000 years to the earliest pictorial expressions on cave walls at Chauvet and Lascaux, images viewed communally by our predecessors by torchlight.

- The projection of images for public entertainment dates to the eighteenth century and the "magic lantern." Combining magic lantern and motion toy technologies in the nineteenth century gave audiences their first glance at multiple, continuous, moving images.

- Various mental processes—such as persistence of vision, the phi phenomenon, and critical flicker fusion—create the illusion of motion pictures. The movie theater is that rare public site built and used for an egalitarian, communal ritual during which we express nakedly emotions we elsewhere repress.

1-2 MOVIES AS ENTERTAINMENT AND ART

Learning Outcome: *Recognize the art in entertaining films and the entertainment value in films that are complex or challenging.*

- As we begin to look at films analytically, we discover the art in entertaining films and an entertainment value in films that are difficult or challenging.

- Two key processes characterize our reception of films: identification (something in the film reminds us of our own experience) and idealization (we think: if only our lives were quite like this!).

- Examining films on a deeper level in no way detracts from the euphoric sensation of watching the film, of being pinned to our seats by the imagery and sound. Indeed, thinking about these meanings helps us situate the film and the sensation it produces in terms of our own lives and intellectual experience.

- Some films are more difficult to "get into" than others. These films require critical analysis for engagement, even entertainment.

1-3 HOW TO "READ" A FILM

Learning Outcome: *Understand what it means to analyze films and recognize what makes the scholarly practice of film criticism different from more subjective and impressionistic reactions to and readings of movies.*

- Close reading, or textual analysis, involves a focus on the distinct formal elements of a film and the interaction of those elements.

- Form is the visual and aural shape of a film. Form embraces all aspects of a film's construction that can be isolated and discussed: the elements of narrative, mise-en-scène (the "look of the scene"), camerawork, sound, and editing.

- Film style refers to the particular or characteristic use of the elements of form and can include consideration of a time and place (e.g., classical Hollywood), a type of film (e.g., a western), or a director's larger body of work (Hitchcock-ian or Fellini-esque). Style may also, instead, be unique to an individual film.

- Information culled from research about a film's historical or industrial contexts can deepen our analysis.

Orson Welles's 1941 film *Citizen Kane* is known for its deep focus photography, its multiple narrators, and its defiance of the strictures of classical Hollywood. In the shot below, from a turning point in the story, Kane is addressing a crowd at a political rally in his bid for governor. His political opponent and personal enemy, Jim Gettys, looks on. Gettys's presence at the rally likely means he's sizing up the opposition, or he's got something up his sleeve. Both, it turns out, fit the bill here. As we will discover in a subsequent scene, Gettys has proof of Kane's infidelity that will effectively kill Kane's chances at the polls. The formal elements of the image hint at a change in the power relations between the two men.

The full range of this shot is in focus so that we can see Gettys, Kane, Kane's associates, and the audience clearly. We are meant to take in the relationships among these three groups.

Kane has appeared larger than life throughout much of the film. Now, suddenly he is small and insignificant.

The space that Gettys occupies fills almost half of the frame. He stands high above the rally. His size and position suggest that he is in control of the situation.

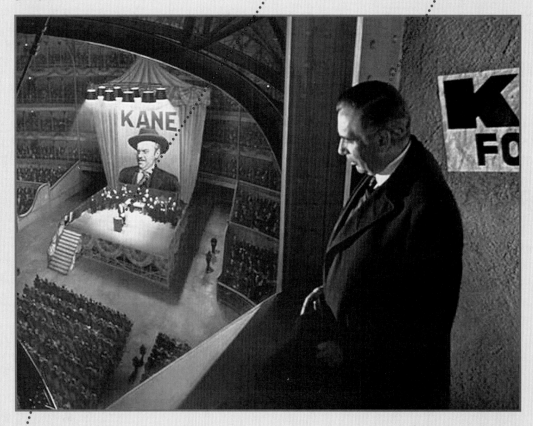

The "people" look like tiny pawns in this scene.

Kane's speech (which can be heard in this scene) attacks Gettys and his political machine as corrupt forces that have betrayed the trust of hardworking people. He promises to give power to the people. This image, however, undercuts his words. It suggests the futility of the kind of populism espoused by Kane and popular at the time the movie was made.

ANALYZE MOVIES

Use these questions to begin practicing the skills of film analysis, focusing especially on aspects of content and context. If you are not assigned a particular film, choose a scene from a film you are especially familiar with and fond of (much as I have chosen the jailhouse scene in *The 400 Blows*). Watch it again a few times. Then answer the following questions.

- What is your initial, subjective reaction to this scene and why?
- Do the processes of identification and idealization apply to your reading of this scene?
- Is the film in which you find this scene by design a work of entertainment or art? If it is a work of entertainment, what aspects of film art can you find? If it is more an art film, what makes it entertaining?
- See if you can isolate the various aspects of form in the scene. What can you identify in the narrative, mise-en-scène, camerawork, sound, and editing?
- Do some research into the biography and filmography of the film's director. How might his or her biography and filmography inform your reading of the film?

2 NARRATIVE

The Fugitive (Andrew Davis, 1993), screenplay by Jeb Stuart and Jeff Twohy

AND GENRE

We begin our examination of the elements of cinema with a study of narrative, the art of constructing a story from a sequence of fictional or nonfictional events. The vast majority of films, even nonfiction films, endeavor to tell a story. And our reaction to and reading of these movies routinely begins at the level of narrative, focusing on the content of the story and the mode of its telling.

The telling of stories—aloud, in writing, on screen—is at the heart of human culture. Stories have long been a means of translating shared anxieties, hopes, and mysteries into a medium that can be communally experienced. Narrative cinema offers stories not as something we hear, or something we read, but as something we witness.

Most of the fiction films we see start with a story idea that is then developed into a screenplay, which in turn is interpreted and given form by the director, actors, designers, editors, and other members of the film's creative team. In other words, the practical development of a movie from idea through production and postproduction routinely begins with a story someone wants or even needs to tell. And the challenge for the filmmakers is to figure out a way to tell that story in an artful, entertaining, and/or compelling way.

In this chapter, we will take a close look at how narratives are constructed—the different ways that events are sequenced and connected, how narrative time operates at various levels, and how characters function and are developed through dialogue as well as action. We will also examine the concept of **film genre**, a way of categorizing films according to narrative patterns and/or emotional effects. Focusing on two popular, enduring genres (westerns and horror movies), we will see how these familiar types of stories can tap into current social trends as well as universal themes.

MAKING MOVIES

JEB STUART ON SCREENWRITING

Jeb Stuart is a screenwriter who specializes in writing action films. His script credits include *Die Hard* (John McTiernan, 1988), *Another 48 Hours* (Walter Hill, 1990), *The Fugitive* (Andrew Davis, 1993), and *Blood Done Sign My Name* (Stuart, 2010). In 1994 Stuart was nominated for a Writers Guild of America award (with David Twohy) for Best Screenplay Based on Material Previously Produced or Published for *The Fugitive*.

Q1: Could you describe what a screenwriter does?

A: A screenwriter is responsible for creating a blueprint for what a movie is going to be. This blueprint has to be easy to read because the filmmakers have to know what the movie is about, who is going to be in it, how much it's going to cost, is the movie worth making?

Q2: How important is the three-act structure?

A: It's a very well-accepted tradition that a screenplay has three acts. In a three-act structure, the first thirty pages is the first act—the set-up. The next sixty pages is the second act where everything is developed, the conflict is built. Then there are the last thirty pages, which become the third act, and that's the denouement, that's where everything that's unraveled comes together in the end. You can find it in just about every movie and just about every screenplay.

Q3: John Sayles famously advises screenwriters to "write it and forget it"—suggesting that screenplays are seldom followed very closely in the development and then production of a film.

A: Filmmaking is a collaborative process. You may set sail with the boat but then other people get on board the boat. . .and sometimes the writer gets forced off the boat. So, even then, you go away thinking, well, there wouldn't be a boat without me. But if you're fortunate enough to stay with that boat until it docks, you still may not recognize the movie you were involved with every day. The actors and the director may change lines of dialogue. . .the cinematographer may decide to shoot it at night-time instead of in the day. . .the editor may decide to pick up the pace in the second act. . .one of the things I was told when I first took up screenwriting was: "If you don't like collaboration, then go write poetry."

Q4: Movie dialogue is of course meant to be read—delivered dramatically by actors. How does this change what's on the page?

A: Collaboration can be a tremendously empowering and creative thing. I'll never forget the very first time I sat in on a read-through of one of my scripts. It had before that been my baby and suddenly we had professional actors who were excited about the project and had thought a lot about their characters. . .when they were reading, the words just exploded off the page. Only then did I realize how powerful what I wrote could be.

CENGAGE brain.com **LINK TO THE FULL INTERVIEW** http://cengagebrain.com

A typical narrative film follows a character or characters through a chain of events that has a beginning, middle, and end. Film theorists who focus on narrative structure make a useful distinction between the full set of events that we piece together as viewers (the story) and the events that are presented in the film (the **plot**). The plot, then, is a particular selection and arrangement of events from the full story. The challenge for the screenwriter and for the filmmakers is not only to invent a compelling and coherent story but also to decide how to structure that story for audiences. In this section, we will consider some of the strategies that filmmakers employ and develop a vocabulary for talking about narrative structure.

Though we won't focus on nonnarrative films until chapter 8 (in the experimental film section), it is worth noting here that not all films are organized around story and plot. Nonnarrative films are instead structured around, for example, visual or aural motifs, abstract forms, and patterns. The images and sounds in these films tend to be more metaphorical or allusive. Many of these films are fundamentally disorderly, "organizing" images and sounds to match the illogic of dreams or altered states of consciousness.

2-1a Plot and Story Order

The narrative of Billy Wilder's 1950 Hollywood melodrama *Sunset Boulevard* illustrates the distinction between **plot order**, the sequence of events adopted in the telling of the tale, and **story order**, the chronological sequence of narrative events. The film begins with the aftermath of a murder as we see an unidentified man floating face down in a swimming pool (fig. **2.1**). One hundred minutes later, immediately preceding the film's final scene, we find ourselves at the same swimming pool looking at the same dead body (fig. **2.2**). The film story is about a down-on-his-luck screenwriter and his relationship with a former silent screen star. The story has an arc, a trajectory from their first encounter to his eventual seduction to his death face down in the pool. But unlike the linear story order, the plot order is evocatively circular. The impact of the cautionary tale the film tells is held not, or not only, in its basic story line but also in its telling. The circular shape to the plot (end, beginning, middle, and end) renders the hero's fate inevitable. The rest of the film is an explanation;

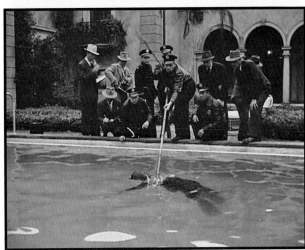

2.1 and 2.2 Two sequential story events in Billy Wilder's *Sunset Boulevard* (1950) are shown in the beginning and ending of the plot. The rest of the film serves mostly to explain how he and we got here and why.

it shows us *how* yet another Hollywood dreamer has been corrupted by the Hollywood dream.

This same basic plot structure—end, beginning, middle, end—is used to a different effect in the French melodrama *Leaving* (Catherine Corsini, 2009). The film opens with a middle-aged couple in bed; she is

plot Story events presented on screen.

plot order The sequence of events adopted in the telling of a story.

story order The chronological sequence of narrative events.

awake, he is asleep, snoring. She gets up and exits the room. And then we hear a gunshot; though we don't see the grisly act itself, we gather she has killed herself. A simple title follows, setting the story some months earlier. The title keys a **flashback**, a scene or in this case a sequence of scenes that recapitulate the past (in the world of the film's story).

This flashback structure is common in film storytelling, and as film-goers we instinctively recognize its function. We assume as we watch *Leaving* that the flashback will explain what has driven this woman to this act. When, some 80 minutes later, we find ourselves in that same bedroom on that same morning, we know better why she is upset; her affair has ended and she has reluctantly returned to her husband, the man sleeping beside her. But as we see this scene for the second time, we discover that she does not shoot herself but instead she shoots him. Despite a plot order that begins with the ending, we are still surprised when we see the ending a second time.

Flash-forward, a shot or scene or sequence of scenes that projects future events in the world of the film's story, is not nearly as common as flashback. There are basic, logical reasons for this. The storyteller knows the past, but how can he or she know the future? And while flashbacks can suggest such commonplace activities as reflection and remembrance, flash-forwards suggest paranormal prescience. Most often flash-forwards are less a mode of storytelling than a momentary interruption in the logical flow of the narrative, as in *Easy Rider* (Dennis Hopper, 1969) when we get a glimpse at the bloody climax (a shot of the apparent aftermath of a motorcycle accident) before it happens "live" on screen.

A plot that scrambles or withholds story events can engage us in trying to piece together the story order and make sense of its logic. Marc Webb's *500 Days of Summer* (2009) plays provocatively with sequencing, telling its story with vignettes taken from seemingly random days in a 500-day romance. The plot order may seem arbitrary (it begins with day 488 and moves back and

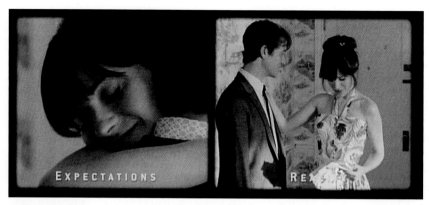

2.3 When Tom and Summer reconnect after breaking up, we are shown two versions of events: one reflecting his expectation that they will get back together and the other reflecting the reality that she just wants to be friends. *500 Days of Summer* (Marc Webb, 2009).

forth from there), and it certainly does not match the story order (which starts with day 1 and ends with day 500). The point the film makes is that the breakup was not a simple matter of cause and effect, or the fallout from some single significant argument, but was instead the consequence of a number of little things. When the romance just sort of fizzles out, we (along with the male protagonist, Tom) are left with the task of figuring out why. This task involves finding clues by revisiting memories of better days (fig. **2.3**).

Story order and plot order can be—and often are—the same, since chronological order is a traditional way to structure a screenplay. When story order and plot order differ, it is useful to think about why the filmmakers chose to plot the events as they did and how that structure relates to meaning.

2-1b Stories in Three Acts

Lecturers at screenwriting seminars inevitably tout the three-act structure as a way to build a narrative arc. And most screenwriting software follows suit. The three-act structure plays out as follows: In act 1 expectations are raised. In act 2 expectations are confounded. And in the final act expectations are resolved (requited, dismissed, found to be silly), ideally in a mildly surprising fashion. Though we may resist thinking about creative work as the product of such a simple formula, it is interesting to see how many films fit this pattern and how well this pattern facilitates the telling of a story.

The three-act structure is evident in the frothy contemporary romantic comedy *My Best Friend's Wedding*. Act 1 establishes the relationships among the principal characters and elaborates their expectations

flashback A scene that interrupts the chronological flow of story events by referring to an earlier time.

flash-forward A scene that interrupts the chronological flow of story events by skipping ahead to a later time.

for the future. It is composed primarily of **exposition**, the presentation of narrative information that provides context for the story and plot, including character development and the establishment of setting and/or location. Through the story's exposition, we discover that food critic Julianne and her best friend Michael, a sports reporter, have made a deal: if neither has found a suitable mate by the time they both reach 28, they will marry each other. The plan may have been a lark at first, but for Julianne at 28 it offers the promise of marriage to a man she actually likes. Her only other significant relationship with a man at this time is with George; he is likeable but, inconvenient for her, gay. The big date is about to arrive, and Julianne is anxious to cash in the wager, but Michael upsets her plan. He calls to say he's fallen in love with Kim, a woman he's met in Chicago. He has proposed and she has accepted. Act 1 ends and act 2 is cued succinctly by Julianne: "I've got exactly four days to break up a wedding, steal the bride's fella, and I haven't a clue how to do it" (fig. **2.4**).

With the advent of act 2 "complications ensue": Julianne's various attempts to embarrass the bride-to-be fail, in large part because Kim is sweet, smart, and tough (fig. **2.5**). Making matters worse, Michael really is in love with Kim. Steven Spielberg has famously said that the key to all love stories is "the obstacle," what prevents the couple from simply getting on with their lives together. Here the film plays with this formulaic element: Kim is the obstacle for Julianne and Michael, or so the film seems to suggest at the start of act 2. But as act 2 plays out, we discover that it is Julianne who is the obstacle to the true love match of Kim and Michael, a mild surprise that composes much of act 3. Indeed, act 3 is cued by a climactic showdown in a ballpark women's bathroom (fig. **2.5**) as Kim finally abandons "being nice" and decides to fight for her man. As in many three-act films, the climax marks a turning point in the narrative.

The final act is composed of the wedding itself—a celebration of the right couple getting hitched—and it is the film's mild surprise that the standard romantic

2.4 "I've got exactly four days to break up a wedding, steal the bride's fella, and I haven't a clue how to do it." Her expectations confounded, Julianne is poised to set the events of act 2 in motion. *My Best Friend's Wedding* (P. J. Hogan, 1997).

2.5 A complication Julianne hadn't considered punctuates act 2: she discovers that Kim is tougher than she looks.

comedy narrative is upset and in the end Michael rejects Julianne for Kim (fig. **2.6**). (The standard romantic comedy formula would have Michael finally reject Kim, who would be revealed to be dependable but no fun, for Julianne, who is a pain in the neck but lots of fun.) In the film's final moments, Michael's apparent happiness with Kim actually makes Julianne happy, which surprises Julianne as much as it surprises us.

Writers often discuss the importance of characters changing in this final stage or act of the drama. Though *My Best Friend's Wedding* seems slight and sweet, its third act carries a significant message: Julianne does not get what she (thinks she) wants, but in the end she's a better person for it. She learns a thing or two about love even though, for the moment, she hasn't found it for

exposition The presentation of narrative information that provides context for the story and plot, including character development and the establishment of setting and/or location.

2.6 We are mildly surprised when act 3 ends with Michael and Kim's happy wedding.

herself. The film's life lesson is that even thwarted desire has its rewards, a lesson contained in the mild surprise of the third act.

Closure—the final resolution of the various narrative threads and the various questions or problems posed by the story's conflicts—can be neat or untidy; closure can be the consequence of a logical progression of events or the result of some magical, fateful occurrence. In David Lean's 1945 melodrama *Brief Encounter*, for example, the *narrative fix*—a term used to describe the conflicts set in motion in the story—concerns the relationship between a doctor (Alec) and a housewife (Laura), both married to other people. They meet by chance at a railway station café, talk, meet again, and fall in love. Both still care for their spouses, but the prospect of being together is difficult to resist. This desire leads to a rendezvous at Alec's friend's apartment where an affair seems sure to begin. But just as they are about to give in to their desire, the friend arrives unexpectedly and the opportunity is lost.

Closure is complicated here: Alec and Laura are, after all, proper married people, and what they have planned to do is deeply problematic. Two things we know for sure: they're in love, and they can't be trusted to resist temptation on their own. So fate intervenes, twice. Out of the blue, Alec tells Laura that he has been offered a post in South Africa and has decided to leave England, in part to keep from acting on his desire to be with her. This seeming "hand of fate" imposing

closure on the film is called a ***deus ex machina*** (roughly "God from the machine"), the introduction of a contrived event to solve the problems set in motion in the story.

All that is left for them, then, is one last moment together in the railway café. But they are denied that as well, as a second fateful occurrence interrupts their final brief encounter; one of the woman's chatty friends arrives and sits down at their table. The friend blathers on even as the doctor says good-bye, lightly touches Laura's shoulder, and exits to catch his train. To the friend's bewilderment, Laura follows him out onto the platform (fig. **2.7**). As Alec's train whizzes by, for a moment we are led to believe that Laura might hurl herself onto the tracks. But she doesn't. She returns home to an uncertain reunion with her husband. The film may well end affirming the sanctity of marriage—"You've been a long way away," the husband remarks in the last scene, as if he knows what's she's been up to, "Thank you for coming back to me"— but it also makes clear that "true love" will never be realized. Moreover, though the final scene ends with Laura embracing her husband, whatever she still feels for Alec is unresolved. Closure need not tie up every loose end in the story; life simply goes on.

2.7 Alec and Laura are forlorn; their chance at an affair is now forever lost. Narrative closure in *Brief Encounter* (David Lean, 1945) is untidy; they return to their spouses but we fear—we know—that true love and happiness have eluded them both forever.

closure The resolution of narrative questions and/or problems.

deus ex machina The introduction of a contrived event to solve the problems set in motion in the story.

2-1c The Hero's Journey

The three-act formula roughly matches the hero narrative proposed by the religion and mythology scholar Joseph Campbell. This paradigm, which has roots in Greek mythology, involves a lone male hero who must endure or fight to achieve his goal. His story has three stages: (1) the hero ventures forth, (2) he faces a trial of sorts (a series of obstacles he must overcome, a series of fights he must win), and (3) in the end he returns home smarter (though not necessarily better off materially) than he was when the story began.

Clint Eastwood's western *Unforgiven* (1992) illustrates the hero's journey (figs. **2.8–2.10**). The film begins as William Munny, a retired gunfighter, is unsuccessfully and unsatisfyingly working his small farm. His wife dies, leaving him to take care of their children, another job he's unsuited for.

The first stage of Munny's journey begins when the town prostitutes offer him the job of avenging an attack on one of their co-workers; he straps on his guns and ventures forth. In stage 2, the trial or combat, he faces a series of challenges, climaxing with a gunfight against the vicious and corrupt town sheriff, the inaptly named Little Bill.

After dispatching Bill, and in doing so establishing justice for everyone in the town of Big Whiskey, Wyoming, Munny hangs up his guns and returns to the domestic life he abandoned at the start of the film. He is now wiser for having lived through the trial. A final title card tells us of his move to San Francisco with his children and that he is happy now earning a living in the dry goods business.

2.8 The retired gunfighter William Munny covered in mud after tending to the hogs, most of which, we learn, "have the fever." *Unforgiven* (Clint Eastwood, 1992).

2.9 Tired and beat-up (note the gashes under both eyes), Munny endures the trial stage of the narrative.

▶ **2.10** Having vanquished Little Bill and rid Little Whiskey of its villains, Munny returns to the farm as the sun finally sets on his career as a gunfighter.

The hero's search is often for an answer to a single pressing question: Who am I? Sophocles's *Oedipus the King* is the classic example of this quest narrative, cast as a tragedy: the play's "hero" searches for his true identity only to discover that he has killed his father and married his mother. Though the specific content may not apply, we can see a variation of this "Who am I?" formula at play in a number of Hollywood films, including the *Star Wars* series (George Lucas, 1977–1983). With the universe in the balance, the serialized conflict between

2.11 Bonnie spies Clyde stealing her mother's car. Rather than call the police, she quickly gets dressed and joins him. *Bonnie and Clyde* (Arthur Penn, 1967).

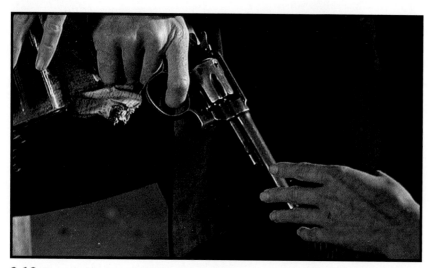

2.12 Bonnie admires Clyde's gun. The gesture links the A and B narratives.

the Empire and the rebels and the rivalry between Luke Skywalker and Darth Vader chronicled in episodes 4 through 6 is finally resolved only when Luke answers the question, "Who am I?" and comes to grips with his true identity, that he is Vader's son.

Lucas was well aware of Campbell's work when he introduced the *Star Wars* series in 1977. The film is set in a galaxy far, far away, but the story is at once accessible and familiar. We are meant to recognize these basic formulas as an entrée into the otherwise unfamiliar,

A and B stories (also, kernel and satellite stories) A narrative formula that prioritizes one of the narratives while simultaneously tracking a second narrative.

fantasy world of the film. Indeed Lucas's goal here is to use this simple narrative framework to universalize the drama in this timeworn story.

2-1d A and B Stories

Many film narratives employ a dual structure: what screenwriters call **A and B stories**, or **kernel and satellite stories**. This formula prioritizes one of the narratives, the A (principal or kernel) story, but simultaneously tracks a second narrative, the B (secondary or satellite) story. The implicit promise inherent to this structure is that the A and B narratives will somehow intersect or at least their resolutions will complement each other.

Arthur Penn's 1967 film *Bonnie and Clyde* offers a good example of this storytelling structure. The film opens with Bonnie alone and undressed in her bedroom. She is tired of her life as a waitress in her dusty little town and she is ready for adventure, ready for someone to come along and take her away from this life. Opportunity knocks in the person of the escaped convict Clyde Barrow, whom she spies out her window as he is stealing her mother's car (fig. **2.11**). Rather than turn him in, Bonnie joins Clyde in the stolen car and the two embark on a crime spree.

Two narratives are set in motion in this opening scene: (A) the crime-spree story and (B) the story attending the fraught sexual relationship between the two outlaws. As they ponder running off together in her mother's car (the A story), Bonnie admires Clyde's pistol and goads him flirtatiously, "Bet you wouldn't have the gumption to use it" (the B story). The double entendre is thick here; we know that she's not only talking about shooting a gun (fig. **2.12**). Clyde is remarkably clueless: He shows her he's adept with the pistol (in the A story), but after they rob a local store and stop for their first real tryst, we discover why Clyde was so slow to follow Bonnie's prompt regarding sex (in the B story). Clyde is not, as he puts it, "much of a lover boy." The rest of the film tracks both narratives. The crime spree is followed in some detail,

2.13 Bonnie discovers that Clyde "ain't much of a lover boy."

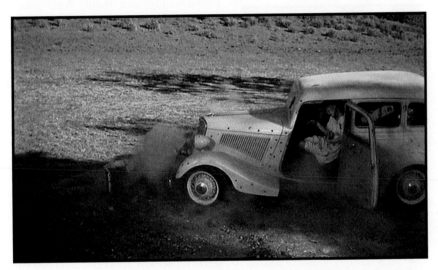

2.14 The bloody climax of *Bonnie and Clyde*. In the end, the A story takes precedence, and the joy the outlaws find in the B story is short lived.

and it is, in that they get away with the robberies, a story of a series of triumphs. The B story for most of the film offers significantly less evidence of success as it chronicles Clyde's continued troubles in bed (fig. **2.13**).

At the two-thirds mark of the plot, after a series of capers, Bonnie and Clyde stop to reflect on their handiwork. Bonnie begins thinking about the future, about going straight, about retiring after one last score. We have seen enough crime films to recognize the meaning of this moment in the A story: such reflection seems a sure sign they're about to get caught. It is at this very moment in the A narrative that Clyde finally succeeds in the B narrative.

We find the lovers post-tryst. "Do you feel like you're supposed to feel?" he asks. "You did perfect," she replies. "I guess I did," he beams. As things play out, this moment of bliss in the B story proves fleeting as the A

story takes precedence again and the legendary outlaws are gunned down by the FBI (fig. **2.14**).

2-1e Parallel Stories

Some films have multiple narratives and, unlike the A and B narrative formula, deliberately do not prioritize the stories. Instead the point of this structure is to highlight parallel action, to track several stories simultaneously and then show how these seemingly unrelated stories somehow connect. A good example of such a film is Steven Soderbergh's *Traffic* (2000), which follows three distinct narratives: the story of two Mexican detectives negotiating the treacherous world of gang-controlled drug running; the story of two American detectives who arrest a drug kingpin (who is set up by his cohorts) and then watch as the kingpin's wife takes over the business; and the story of an ambitious, politically conservative judge committed to the party line on fighting the so-called drug war until his daughter falls into drug addiction and teaches him that the war on drugs may well be unwinnable (figs. **2.15–2.17**).

By the end of the film we discover that these three stories overlap: the corruption of law and order in Mexico and the drug cartels there and elsewhere in Latin America are the source for the drugs peddled by the organization headed by the American-based drug trafficker (and then his wife) and used by the daughter of the judge. What Soderbergh shows by tracking these three narratives simultaneously is what the judge finally understands at the end of the film: the war on drugs is a complicated, global phenomenon involving peasant farmers, organized gangsters, cops, and finally teenage girls—very different players in simultaneous narratives that depend on each other in complex ways.

The striking experiment *Timecode* (2000) uses a different system to track multiple narratives. The director Mike Figgis shows four simultaneous stories unraveling in four separate "windows" on screen (fig. **2.18**). The effect is at once visually arresting and a testament to our ability as contemporary filmgoers to pay attention

2.15–2.17 The parallel narratives in Steven Soderbergh's *Traffic* (2000). Soderbergh helps us distinguish the narratives by color-coding them: The story set in Mexico is shot in an orange-brown tint. The story of American police in pursuit of the American-based drug lord is cast in yellows and greens. The judge and his daughter's story is captured in blues.

to more than one set of images and more than one story at once.

2-1f Narrative Time

As discussed the introduction to this section, there is a distinction between *story* (the full set of events that we piece together as viewers) and *plot* (the on-screen events). That distinction is especially useful when we analyze how the story is told, which moments from the story the filmmakers have selected for inclusion in the film, in what order they occur as the film unfolds, and finally how much time it takes for the filmmakers to reveal these moments on screen.

The term **story duration** refers to the elapsed time from the first to the final events of the narrative. While it is possible for story and plot to cover the same time span, typically **plot duration** involves a shorter span of time than story duration. The plot of *Young Adult* (Jason Reitman, 2011), for example, covers a short period in Mavis Gary's life at age 37, while the story extends further back in time to Mavis's high school years. A third distinction, **screen duration**, refers to the running time of the film. During the 93 minutes from the opening sequence to the credits, we see selected moments from the weeks covered by the plot.

The distinction between story duration and plot duration is made clear by what the filmmakers choose to tell in full and what they choose to summarize or ignore. For example, the past that characters bring with them into a film, what screenwriters call **backstory**, is part of the story duration but may not take up much time in the plot. In *The Maltese Falcon* (John Huston, 1941), the detective Sam Spade's shady past is mentioned but never shown. Though little time in the plot is spent on the topic, it is nonetheless important to a full understanding of the story; it provides Spade's

2.18 Four related narratives play out in four distinct "windows" within the frame. *Timecode* (Mike Figgis, 2000).

▶ **2.19 and 2.20** An innocent toast and its not so innocent aftermath. The abrupt transition signals that all is not well in Todd Phillips's *The Hangover* (2009).

complex motivation for solving the case of his murdered partner.

Filmmakers are constantly battling against the constraints of the typical 90- to 120-minute running time of a feature film and employ strategies of compression, in which scenes are stripped to their essentials and/or summarized by familiar "codes." A related maxim of screenwriting is "arrive late; leave early." Note how often in films we enter a scene (a conversation, a scuffle, a sexual act) after it has begun and how often we exit the scene before said action has completely played out. As filmgoers, we fill in the beginning and end.

Strategic use of **ellipses** (the on-screen omission of story events, as described above) allows films to cover vast amounts of story time—a life from birth to death in *The Curious Case of Benjamin Button* (David Fincher, 2008), for example. Days, weeks, months, even years can be dispatched with a single cut from a character looking young to looking old (or the reverse, as in *Benjamin Button*).

Ellipses can also represent a gap in a character's memory or knowledge, as in *The Hangover*. Early in the story, four young men stand on the roof of a hotel and raise a toast (fig. **2.19**). The subsequent scene is of the morning after, as the characters realize in dramatic fashion the promise of the film's title (fig. **2.20**). Finding out

story duration The time span encompassing all of the story events.

plot duration The time span encompassing only those story events that are selected for the plot.

screen duration The running time of the film.

backstory The past that characters bring with them into a film.

ellipses The omission of significant chunks of story time in the on-screen plot.

what happened between the two scenes drives the narrative; this missing piece of story time holds the answer to a missing friend's whereabouts.

When filmmakers want to quickly cue the audience to the passage of time, they may use **intertitles** such as "later that day" and "five years later." Intertitles are examples of **nondiegetic** material (figs. **2.21–2.23**). The term is used by film scholars to denote material derived from outside the story world; the Greek word *diegesis* refers to the fictional world in which narrative events occur. (These terms will be revisited in more detail in chapter 6 on sound.)

Timecode, which we looked at as an experiment in parallel narratives (fig. **2.18**), also offers a rare example of a film that unfolds in real time; the plot duration corresponds to the screen duration. All four stories were shot simultaneously; four cameras in four locations began rolling and stopped at exactly the same time, without cuts. The 1952 western *High Noon* is the classic example of a film that takes place in real time, as the film tracks the inexorable lead-up to a climactic gunfight (fig. **2.24**).

More often plot time and screen time are matched only in specific scenes to heighten suspense or to set up a sudden jolt of violence. In the opening sequence of

intertitle A piece of text inserted into the film to cue the audience to the passage of time. Intertitles might also provide dialogue (in silent films), prologue, or epilogue copy.

nondiegetic A term used to denote material within a film that comes from outside the world of the story.

One Year Later

2.21–2.23 At the end of the comedy *Chasing Amy* (1997), writer-director Kevin Smith uses an intertitle to quickly signal the shift from the main characters' breakup to a brief and bittersweet reunion a year later.

Alfonso Cuaròn's *Children of Men*, for example, we follow the main character Theo through the routine of an ordinary morning. He buys a cup of coffee, stops to add a little booze to the drink, and then, just as he is about to continue, a bomb detonates nearby (figs. **2.25–2.27**). What makes this scene work is the "day-in-a-life" feel created as events unfold in real time. We watch the scene much as we would watch the same actions play out in our everyday lives.

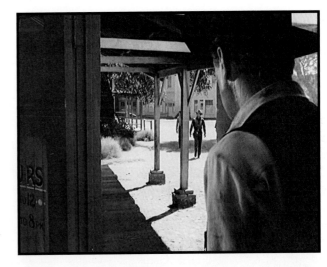

2.24 Plot time and screen time are synchronized as we wait with our hero, Will Kane (foreground), for the inevitable gunfight in *High Noon* (Fred Zinnemann, 1952).

▶ **2.25–2.27** The opening sequence from Alfonso Cuaròn's *Children of Men* (2006) unfolds in real time so that the sudden detonation of a bomb delivers a jolt to the audience.

2-2 CHARACTERS

Characters are a key to our emotional and intellectual investment in the story. Because of our identification with and idealization of movie characters, we follow story events with keen interest. As we endeavor to more complexly analyze the narrative function of these movie characters, we need to begin to recognize in the stories we see on screen fundamental character types and begin to appreciate and understand how dialogue and narration are used to reveal character traits, motivations, and points of view. Also of import here is the effect movie stars have on how we appreciate and understand the movie characters they portray.

2-2a Character Motivation

Characters are fundamentally the sum total of external, physical, observable details—appearance, gestures, dialogue, and actions. It is from our observation of such superficial and partial information that we begin to figure out who they are and why they do what they do in the film's story. The key to a deeper understanding of film characters is to apprehend their motivation, the proximate cause or explanation for their behavior. This focus on motivation importantly repeats a process already undertaken by the actors cast to play these characters, as they too try to situate the character (via his or her quirks, behavior, and participation in the story at hand) with regard to fundamental desires and dreams.

In *Let the Right One In*, character motivation is essential to our appreciation and understanding of the film. All of the characters want something, and when we figure out what that is, we understand who these people are and where they are headed in the world of the film.

We are first introduced to Oskar, a preadolescent boy, as he playacts at threatening someone with a real knife. Who is this strange child, we ask ourselves, and what is he planning? We then meet Håkan, an older man who has moved into Oskar's apartment building. We see him coolly murder a man, then drain and collect his blood (fig. **2.28**). And we wonder, why is he doing this? Finally, there is Eli, the androgynous teenager in what appears to be Håkan's care (fig. **2.29**). We get only a glimpse of her at first. But even at first glance, she is at once fascinating and unusual.

The motivations for these characters become clear as the film unspools. Oskar is brutally bullied at school and dreams of (but initially is too afraid to seek) revenge (fig. **2.30**). Håkan, we discover, kills at Eli's behest. Though he is an old man, there are hints at his deep affection for Eli that seem not exactly parental. Eli is a vampire. Her basic motivation is simple—she needs blood to live. And she needs Håkan to get it for her, if only to keep her from desperate acts of violence on the streets. Her

2.28 Håkan kills a man and then drains his blood. But why? *Let the Right One In* (*Låt der rätte komma in*, Tomas Alfredson, 2008).

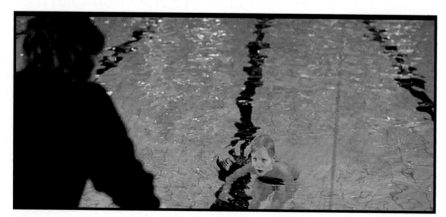

2.29 Eli has simple motivations: she needs blood and shelter from the daylight to survive.

2.30 Oskar is tormented at school. His relationship with Eli gives him power against the bullies.

2.31 The final scene shows Oskar tapping k-i-s-s in Morse code on a box containing and concealing Eli as he escapes with her. Here he embarks on the road Håkan has previously traveled.

The plot chronicles Håkan's exit from Eli's life and his replacement by Oskar. We know why Oskar leaves with Eli: she's his ticket out of town and away from awful parents and classmates. But we wonder all the way through the film's final scene whether Eli really cares for Oskar or simply needs him, much as she once needed Håkan (fig. **2.31**). How we read Eli's motivation very much governs how we read the film; it is either an odd little love story or the tale of a monster and her pitiable and willing victim.

Our expectations regarding character motivation are made especially clear when they are deliberately subverted, as in Jean-Luc Godard's 1960 film *Breathless*. Patricia, the American student abroad who falls into a romantic entanglement with a French gangster, seems to act only on impulse. When she calls the police and turns in her lover Michel, we have no idea why. In the end as Michel lies dying in the street, Patricia first appears dismayed (fig. **2.32**), then almost immediately afterward she holds her head in her hand and looks down at the ground as if she doesn't quite understand what has happened and why (fig. **2.33**), even though it was *her* phone call that helped the police trap him. Her final gesture is a look back at the camera (fig. **2.34**) that seems to suggest

"attraction" to Oskar is more complex; at first she recognizes his loneliness and isolation—she too is lonely and isolated—but such a recognition may be less a matter of friendship or love than an aspect of her predatory nature.

2.32–2.34 After her lover dies in the street, Patricia looks dismayed and then somewhat confused, then a bit bored. When she looks directly at the camera, it denies us any indication as to her motivation. *Breathless* (*À bout de souffle*, Jean-Luc Godard, 1960).

2.35 Chief Brody, the outsider, is new to Amity Island and afraid of the water. He is the least likely of the three men to kill the shark. *Jaws* (Steven Spielberg, 1975).

2.36 Hooper, the nature-loving scientist.

2.37 Quint, the iconoclast seaman, has a singular desire to kill the shark. His character has parallels to Captain Ahab in the novel *Moby Dick*, including a shared fate.

2-2b Character Types

As we will see in the section on genre later in this chapter, film narratives often adhere to established formulas. If we are watching a western, for example, we recognize the hero instinctively, just as we recognize his adversary. Their different motivations (e.g., to save the town, to rob a bank) and attitudes (e.g., to protect and serve, to satisfy a desire for more money, sex, or power at any cost) give the narrative shape and coherence. If a film is about good versus evil, it helps if characters clearly embody these characteristics.

Character types need not be so sharply opposed in order to generate dramatic tension. In Steven Spielberg's *Jaws*, three men are put aboard the same boat with the same assignment: find and kill the shark before it ruins the summer season in Amity, a resort town. Drama ensues as the three men clash in conflicts made inevitable by their fundamental character differences (figs. **2.35–2.37**). That these characters fit certain familiar types does not cheapen the story; indeed, wondering how these men work together holds our interest and sustains the suspense of the film.

Recognizable character types have been an essential aspect of film narrative since the advent of cinema. Absent the clues to character that spoken dialogue can offer, "stock characters" made the prospect of following silent movies easier. For example, audiences attending a screening of D. W. Griffith's silent melodrama *Way Down East* in its initial release in 1920 no doubt recognized the drama's three leads as familiar types: the country innocent Anna Moore who ventures to the city (fig. **2.38**), the womanizing city slicker Lennox Sanderson who leaves her pregnant (fig. **2.39**), and the good-hearted farmer's son David Bartlett who saves

that she is looking to us, the filmgoers, for a clue. It's if she does not know how or what to feel. Therefore we do not read the scene *with* her, but rather consider the narrative events despite her, in the absence of the cause-and-effect structure implied when we view action as a consequence of character motivation.

2.38 Anna, the girl from the country. *Way Down East* (D. W. Griffith, 1920).

2.40 David, the good-hearted country-boy hero.

▶ **2.39** Lennox Sanderson, the womanizer.

2.41 Griffith satirizes progressive women by portraying Anna's suffragette aunt as a silly eccentric.

the day (fig. **2.40**). The film is populated by secondary characters who also fit into types: the nutty professor, the vile busybody, and the silly suffragette.

Each of these character types in *Way Down East* contributes to the film's larger implications as a social commentary. First, there is the treatise on the Christian virtue of forgiveness, a key theme of many silent film melodramas. Anna is seduced and despoiled by Lennox, but the reasons for her predicament impress none of the older, righteously old-school characters. We first meet a local preacher who refuses to baptize Anna's child, then the boardinghouse proprietor who tosses her out on the street because she had a baby but no husband, and finally David's father who quotes scripture as he too fails to act with compassion and kicks her out into a raging storm. David, the farmer's son, goes against his father's wishes, assails Lennox, and proclaims his love

for Anna. In the end it is hard to miss the Christian parable in play: it is the son's love and understanding that sways the rest of the characters.

The use of character types to fill in the lesser roles in the drama allows Griffith to comment upon the perils of modernity, another familiar theme. Anna's suffragette aunt may have a big heart, but she is depicted as an eccentric (she wears men's clothing, for example)—no doubt Griffith's comment on what he saw as the comical notion of women seeking the same rights as men (fig. **2.41**).

2-2c Dialogue and Narration

With the advent of "talkies," filmmakers gained another tool for revealing characters' personalities, motivations, and perspectives on the action in the film.

Dialogue—what the characters say within the world of the story—and narration—commentary from outside the story (and therefore nondiegetic)—offer these kinds of insights. Both are written into the script and delivered by actors, whose "reading" of the lines affects their meaning. We will explore dialogue and narration in greater depth in chapter 6 on sound, but here we will focus on their connection to character.

The example that follows is from the script for *Fargo* (1996), written and directed by Joel and Ethan Coen. The script excerpt includes some notes on setting and action, but it consists primarily of dialogue. The details of what the bar looks like, what songs are playing, and how the men appear and say their lines are left for the director, designers, and actors to realize. It is an adage of screenwriting that there is no inner life in a script, but note how well the Coen brothers communicate through dialogue and gesture what's going on in the characters' heads without ever resorting to internal monologue.

Fargo tells the story of a car salesman named Jerry who plots and then stages the kidnapping of his wife in order to extort ransom money from his wealthy father-in-law, money he needs to cover up his embezzlement of dealership funds. The scene in question stages his first meeting with Carl and Gaear, the men Jerry will hire to kidnap his wife.

```
-----------------------------------------
INT. CHAIN RESTAURANT - NIGHT

The bar is downscale even for this town.
Country music plays on the jukebox.

Two men are seated in a booth at the
back. One is short, slight, youngish.
The other man is somewhat older, and
dour. The table in front of them is
littered with empty long-neck beer
bottles. The ashtray is full.

Jerry approaches.

                JERRY
        I'm, uh, Jerry Lundegaard -

                CARL
        You're Jerry Lundegaard?

                JERRY
        Yah, Shep Proudfoot said -
```

```
                CARL
        Shep said you'd be here at 7:30.
        What gives, man?

                JERRY
        Shep said 8:30.

                CARL
        We been sitting here an hour.
        I've peed three times already.

                JERRY
        I'm sure sorry. I - Shep told me 8:30.
        It was a mix-up, I guess.

                CARL
        Ya got the car?

                JERRY
        Yah, you bet. It's in the lot there.
        Brand-new burnt umber Ciera.

                CARL
        Yeah, okay. Well, siddown then.
        I'm Carl Showalter and this is my
        associate Gaear Grimsrud.

                JERRY
        Yah, how ya doin'. So, uh, we all
        set on this thing, then?

                CARL
        Sure, Jerry, we're all set. Why
        wouldn't we be?

                JERRY
        Yah, no, I'm sure you are. Shep
        vouched for you and all. I got
        every confidence in you fellas.

They stare at him. An awkward beat.

                JERRY
        . . . So I guess that's it, then.
        Here's the keys -

                CARL
        No, that's not it, Jerry.

                JERRY
        Huh?

                CARL
        The new vehicle, plus forty
        thousand dollars.
```

JERRY
Yah, but the deal was, the car
first, see, then the forty
thousand, like as if it was the
ransom. I thought Shep told you -

CARL
Shep didn't tell us much, Jerry.

JERRY
Well, okay, it's -

CARL
Except that you were gonna be
here at 7:30.

JERRY
Yah, well, that was a mix-up, then.

CARL
Yeah, you already said that.

JERRY
Yah. But it's not a whole pay-
in-advance deal. I give you a
brand-new vehicle in advance and -

CARL
I'm not gonna debate you, Jerry.

JERRY
Okay.

CARL
I'm not gonna sit here and debate.
I will say this though: what Shep
told us didn't make a whole lot of sense.

JERRY
Oh, no, it's real sound. It's
all worked out.

CARL
You want your own wife kidnapped?

JERRY
Yah.

Carl stares. Jerry looks blankly back.

CARL
... You - my point is, you pay
the ransom - what eighty thousand
bucks? - I mean, you give us

half the ransom, forty thousand,
you keep half. It's like robbing
Peter to play Paul, it doesn't
make any -

JERRY
Okay, it's - see, it's not me
payin' the ransom. The thing is,
my wife, she's wealthy - her dad,
he's real well off. Now, I'm in
a bit of trouble -

CARL
What kind of trouble are you in, Jerry?

JERRY
Well, that's, that's, I'm not gonna go
inta, inta - see, I just need
money. Now, her dad's real wealthy -

CARL
So why don't you just ask him
for the money?

FARGO, Joel Coen and Ethan Coen. Published by
Faber & Faber (London), 1996.

The scene is fairly simple: three people in a room
with something (money) they all want or need. They
don't trust each other: Carl is oddly peeved about Jerry's
late arrival and then overreacts to Jerry's simple query:
"... we all set on this thing, then?" Gaear's silence is
offered in counterpoint to Jerry and Carl's chatter; he
is frightening in part because he doesn't speak. His lack
of bluster implies impending action, that he might act
without bothering to say anything first.

At a key moment in the scene Carl is bewildered
and asks Jerry, "You want your own wife kidnapped?"
"Yah," Jerry replies simply. The matter-of-fact dialogue is
offered on the one hand to establish the intellectual level
of the characters and on the other to allow us to focus
on a telling exchange of gestures elaborated in the simple
stage direction: "Carl stares. Jerry looks blankly back."
Throughout Jerry is revealed to be a bumbling weakling;
indeed his repeated apologies (for being late, for being
misunderstood, for needing the money) do little to instill
confidence in his adopted role as criminal mastermind.
He may have "every confidence in" Carl and Gaear, but
they (and we) have little reason to have confidence in him.

When Carl states the obvious, that Jerry's plan
"doesn't make any sense," Jerry replies by stammering
about his rich father-in-law, then remarking: "I'm in a
bit of trouble." When Carl asks, "What kind of trouble
are you in?" he speaks for us; that is, he states what we

are wondering as well. Jerry continues to stammer: "I'm not gonna go inta," then repeating "Now, her dad's real wealthy." Again Carl asks the question that is likely on our minds, "So why don't you just ask him for the money?" We are hooked into watching more to find out about the problem between Jerry and his father-in-law, a problem that has put Jerry in a plot with the likes of Carl and Gaear. It is a simple scene with decidedly simple dialogue. But it sets the parameters of a narrative that is anything but simple.

There is little physical action in the scene. Jerry enters the restaurant, finds Carl and Gaear, sits, and then has a brief and unsatisfying conversation with them. But a lot happens. The key to this scene as written is a dramatic predicament elaborated in fairly banal dialogue, dialogue that suggests conflicts (between Jerry and his father-in-law, between Jerry and his wife, between Jerry and two criminals who think he's an idiot) and reveals personalities that will be the key to our appreciation and understanding of the film. We know a lot more when we leave this restaurant than when we entered it, and, more important, we want to know more.

Fargo unfolds without voice-over narration; the insights we gain into the characters come from listening to and observing them, as is the case with most films. Some films have a **narrator**, a person who sets up the story and comments on the action. As in literature, if that person is a participant in the story (signaled by "I"), then his or her commentary is known as **first-person narration**. **Third-person narrators** are unseen observers and not characters in the story. We will look at different types of narration in the "Voice Track" section of chapter 6 on sound.

A related issue has to do with the larger question of point of view in film and whether a film (not just the narration) can be told in the first person. Some film theorists argue that all cinema is told in the third person; they view the camera as a narrator and contend that the camera is never actually or literally "I." Most film professors opt for a more fluid notion of cinematic narration—that it is possible for all or part of a story to be limited to the experiences and awareness of one person.

narrator A person who sets up the story and comments on the action.

first-person narration Commentary on the film's action by a character who speaks as "I."

third-person narration Commentary on the film's action by someone who is not a character in the story and who refers to all of the characters as *he, she,* or *they.*

2-2d Movie Stars and Screen Characters

Unlike the characters in literary works, screen characters are "embodied"; that is, we do not imagine what they look like from a description, but rather they come to us in visible, tangible form. We don't watch scripts, after all, we watch movies. In the next chapter, we will examine how actors are dressed and styled to look like the characters they play and how they create their characters through performance; here we consider how a star's persona merges with the character.

The script for the 1959 film *Some Like It Hot* includes the character of Sugar Kane, a lonely band singer with lousy luck at love. Watching Marilyn Monroe play Sugar Kane at once simplifies matters (she gives the role a physical form and she gives the character a recognizable voice) and complicates them (fig. **2.42**). Sugar (as written) and Monroe (as an iconic Hollywood movie star) combine to create the character in the narrative, and it is difficult for the filmgoer to separate the two. So, as Sugar sings "I'm Through with Love" near the end of the film, it speaks to both Sugar's heartbreak and Monroe's, who as a public figure was famously unlucky at

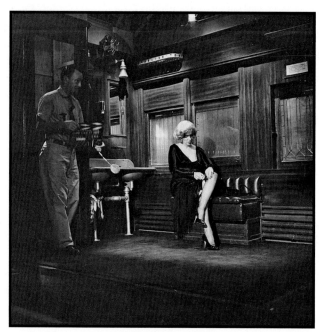

2.42 Marilyn Monroe on the set of *Some Like It Hot* (Billy Wilder, 1959). Seeing her captured here in a moment of reverie, we can see how singing a song like "I'm Through with Love" might speak not only for Sugar Kane, the character she plays in the film, but for Monroe (the movie star, the woman) as well.

2.43 Jason Statham as Frank Martin in *The Transporter 2* (Louis LeTerrier, 2005). It's hard to imagine anyone else playing the part.

love. As filmgoers we can't help but see the movie star in the character and the character in the movie star. Indeed, in many ways the movie exploits the complication.

The indelible and enduring nature of Monroe's stardom is at the heart of the 2011 film *My Week with Marilyn* (Simon Curtis). Indeed the film's narrative is built upon the familiarity of Monroe as a celebrity whose public and private life remains a fascination to many moviegoers. The film features Michelle Williams in a platinum-blonde wig and skin-tight dresses, speaking in that little-girl-lost whisper that became Monroe's trademark. The character "Marilyn" in the film, then, is a re-presentation of the Marilyn we have come to "know" through her films—*Gentlemen Prefer Blondes* (Howard Hawks, 1953), *The Seven Year Itch* (Billy Wilder, 1955), *Some Like It Hot* (Billy Wilder, 1959), *The Misfits* (John Huston, 1961)—through ruminations on her life on and off screen (e.g., Norman Mailer's 1973 biography *Marilyn* and Joyce Carol Oates's historical novel *Blonde*, first published in 2000), and the tell-all celebrity gossip that accompanied her stardom and has endured, astonishingly, ever since. Just as it was difficult to separate the real Marilyn from the woman up there on screen in *Some Like It Hot*, in *My Week with Marilyn* it is difficult to distinguish Williams's characterization of Monroe from the real thing. The story told in the film depends on Williams's evocation of the familiar look and style of Monroe, the movie star. We thus read the narrative already knowing the character, constructed as it is from the mythology of Marilyn Monroe as a troubled, needy young woman consumed by Hollywood stardom. What the film then adds is nuance to that legend, depicting the actress off screen as manipulative and ambitious, driven by insecurities so complex they baffled and frustrated everyone in her life.

Movie stars are often associated with a signature role: Sylvester Stallone as Rocky, for example, or

Harrison Ford as Indiana Jones. For reasons that extend beyond the character as written, the movie star makes the role his or hers. Imagine, for example, *The Transporter* films with someone else besides Jason Statham in the lead role. His character, Frank Martin, as written is somewhat flat; he spends most of the films seated at the wheel of his gorgeous Audi, driving. Statham gives Frank an identity, one tied into the way the actor carries himself as a movie star (and former athlete and fashion model), his rugged good looks, even the way he wears his suit (fig. **2.43**).

Film theorists talk about a movie star's "discrete identity," the public persona—drawn from gossip, self-promotion, and other movie roles—that inevitably leaks into the portrayal of the fictional characters they portray. In the 1930s and 1940s in Hollywood, movie stars were often typecast or pigeonholed; they played the same basic character in every one of their films. So, for example, the actor Errol Flynn played the rebel Robin Hood (fig. **2.44**) and the boxer Gentlemen Jim Corbett—two historical characters separated by centuries—much the same way. Both characters as played by Flynn are risk takers, swashbucklers, lovers, and fighters with an indomitable spirit. Both characters have only a passing relation to the real historical figures they are based upon but are very much tied into Flynn's discrete identity as a romantic leading man with a reputation off screen as a lovable rogue.

2.44 Errol Flynn in *The Adventures of Robin Hood* (Michael Curtis and William Keighley, 1938).

Genre is a French term used widely in English-language literary and film criticism. It is an organizing principle that refers to a kind or type of work. In film studies, genre criticism begins with the task of categorizing a group of films that share certain narrative elements, visual style, and/or emotional effects. A film is perceived to be a western, a romantic comedy, a gangster, or a horror film because it appears to be the same kind or type of film as others in that genre.

The critical task of grouping like works of art into genres dates to Aristotle's *Poetics*, written in 350 B.C. Aristotle's primary focus in his discussion of genre was on narrative-based art forms like stage plays and lyric poetry. He organized these traditions into two rather comprehensive categories: comedy and tragedy. These two genres, according to Aristotle, were defined and distinguished from each other on two counts: (1) with regard to constitutive elements (narrative structure, certain key themes and motifs), and (2) with regard to their presumed effect on the audience. Our reactions to tragedy and comedy are distinct and different; we recognize whether we've seen a tragedy or comedy based in part on the structure and content of its story and plot and also with regard to what and how the story makes us feel.

Well over 2,000 years later, the same basic distinguishing characteristics are in play when we critically discuss motion pictures: We recognize genre films—that is, films that can be organized into genres—by their

2.45 Four cowboys meet on a dusty street with a sign for a saloon in the background. We recognize from these constituent elements that the film is a western. *Tombstone* (George P. Cosmatos, 1993).

▶ **2.46** Genre defined by its effect: the scary climax of the 1978 horror film *Halloween* (John Carpenter).

formulaic narrative elements and/or by their effects on us. We collectively recognize a **western**, for example, based on its narrative elements: the characters (cowboys, American Indians, gunslingers, and outlaws), the setting (the wide-open spaces, the saloon), and certain narrative events (the inevitable gunplay) (fig. **2.45**). We are more apt to recognize a **horror film** from the effect the narrative has on us, and how the events and characters create the desired sense of suspense and dread (fig. **2.46**). After all, the term *horror* is derived from words meaning "to shudder" and "to stand on end."

2-3a Form and Formula: The Western

Westerns are composed of familiar images, sounds, and stories. They may well be attractive and popular because

western A film genre that is recognized and understood based on its narrative elements: the characters (cowboys, American Indians, gunslingers, and outlaws), the setting (the wide-open spaces, the saloon), and certain narrative events (the inevitable gunplay).

horror A film genre that is recognized and understood based on the effect the narrative has on us, and how the events and characters create the desired sense of suspense and dread.

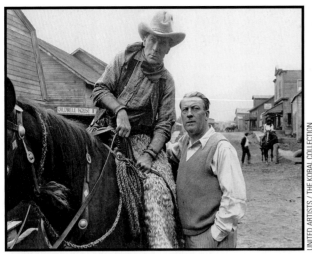

2.47 Early western movie star William S. Hart with the director King Baggot on the set of *Tumbleweeds* (1925).

2.48 John Wayne, the quintessential American cowboy, in John Ford's 1939 western *Stagecoach*.

they are so familiar; we find comfort or pleasure or both in recognition and repetition, and we like to have our expectations satisfied. In an otherwise chaotic world, we find comfort in the ordered universe of genre fiction.

Because genres hinge on conventions and expectations, recognition is a key. We know we're in a western, for example, even though few of us have ever met a real cowboy and even though very few filmgoers were alive during the time period covered by the genre (roughly 1840–1920; from the embrace of the notion of Manifest Destiny through the resolution of the Mexican Revolution and so-called Indian Wars). What we recognize then is not a place or story we have experienced first-hand, but instead a familiar set of images and a tradition of storytelling.

To appreciate and understand the western, we must first recognize the constituent elements specific to the genre. First and foremost we have the cowboy: a man with a gun and a horse (fig. **2.47**). He is defined less by what he does (for a living, for example) than what he is (a cowboy) and what he represents (freedom from material possessions, freedom from domesticity, freedom from institutional authority). For filmgoers overseas, the cowboy became the American *par excellence*; but for the American moviegoer, the cowboy is very much a figure in a popular mythology, an idealization of masculine behavior in a world that exists only in the movies (fig. **2.48**).

Women also fit into stereotypical or archetypical roles in the western and as such tend to be peripheral to the action. Unlike stories in other heroic genres, in westerns women are seldom the object of the hero's quest. Instead they exist as distractions, as sexual outlets, and as "civilizers" who promise or threaten to transform the cowboy into a modern married man. The very convention of marriage that offers a significant rite of passage in modern American life marks the death of the cowboy; "settling down" is something he doesn't or can't do without hanging up his guns and changing his ways.

The setting or space of the western is immediately recognizable on screen: the wide-open prairies with mountains looming in the distance, the tumbleweeds, the big sky (fig. **2.49**). The cowboy is often depicted against such a majestic natural backdrop—a lone individual in an untamed land. Scattered in the wilderness we find lonely homesteads and slowly developing towns—tentative attempts to civilize the virgin land. As a consequence, exteriors tend to dominate the genre, so much so that interiors (the saloon, the hearth) gain unique

2.49 The space of the western. *The Searchers* (John Ford, 1956).

importance. We recognize the space of the western not because we have been there but because we have seen these spaces in other movie westerns.

The vast majority of westerns fit into a handful of basic narrative formulas. The hero is most likely an outsider or at least he is different from those he ends up protecting. He is adept at gunplay; he is a survivor in a ruthless and rugged place. The villains are nearly as adept, and the struggle between the hero and villain at once involves the western society (the townsfolk, the homesteaders) and takes shape without their direct involvement. The western narrative often comes down to a struggle between personifications of good and evil. The hero and his nemesis are more than just two men with guns facing off to settle some personal dispute. Instead, by the time they face off on a dusty street or in a dimly lit saloon, their confrontation comes to embody larger notions of justice, vengeance, and the necessary victory of good over evil (fig. **2.50**).

Indeed, the themes that westerns typically explore can be expressed in terms of competing values or concepts: progress (or modernity) versus nostalgia, sex versus love, the male bond versus the male ideal of isolation. Violence has a specific function in the western as a means of establishing social control that is simple and effective but nonetheless short-lived. Civilization and modernity will, we know, win out in the west; as such the genre is essentially nostalgic . . . a longing for simpler times.

2-3b Form and Effect: The Horror Film

Horror films hinge upon a predictable reaction to visual, aural, and narrative elements; we know we're watching a horror film because we recognize its effect on us. Because it so hinges upon effect, the genre raises two fundamental questions: First, how can anyone be frightened by a movie? After all, the world on screen does not exist. Second, why would anyone go to a horror film knowing in advance that he or she will be horrified, and that the film will likely prompt an unpleasant reaction such as disgust, nausea, repugnance, or fear?

The answer to the first question may be a simple matter of what scholars call a "willing suspension of disbelief"; we know we are witnesses to the staging of

2.50 The inevitable, climactic gunfight in a dimly lit saloon: Shane (foreground) faces off against Wilson (background) to settle things once for and all. *Shane* (George Stevens, 1952).

a work of fiction, but we rather easily accept this world on its own terms, with its own rules, characters, and plotlines.

The answer to the second question regards the curious attraction of things that promise to frighten us, from roller coasters to haunted houses. It also regards the public ritual of going to the movies; horror films are built on suspense and shock, both of which depend on audience expectation and succeed once they prompt audience reaction. Sharing this expectation and reaction with other filmgoers heightens the genre's inevitable effect.

The stories told in horror movies target a virtual catalogue of human weaknesses and fears (figs. **2.51–2.58**)—fears of the unknown, of human frailty

2.51 The fear of losing control, the fear of going crazy, the fear of demonic possession: *The Exorcist* (William Friedkin, 1973).

2.53 The fear of the dark, the fear of getting lost: *The Blair Witch Project* (Daniel Myrick and Eduardo Sanchez, 1999).

▶ **2.52** The fear of others: *Nosferatu* (F. W. Murnau, 1922).

2.54 The fear of disease and death: *Let the Right One In* (*Låt der rätte komma in,* Tomas Alfredson, 2008).

2.55 The fear of social transgression, of growing up too fast, of risky sex: *Halloween* (John Carpenter, 1978).

(dismemberment, demonic possessions), of others (people unlike us, people or monsters with unsavory origins from strange places with strange habits), or of disease and death (zombies existing in a permanent disease state, vampires existing somehow between conventional notions of life and death). Horror need not involve the supernatural. Common phobias are often at the heart of the matter: fear of heights, of enclosed spaces, of strangers, of losing control (e.g., demonic possession), of getting lost in the woods. Also in play is the larger matter of crime and punishment: sex outside of marriage and its punishment in teen horror films, science messing with God's work of creation in the many *Frankenstein* films, and fears of our own nature or psychology (that we may be capable of some hideous act, that a monster resides inside us waiting to be awakened or released) as in the classic horror story *Dr. Jekyll and Mr. Hyde*, which has been made and remade on screen several times. Finally, horror often hinges upon a belief in bad luck or fate, the fundamental notion that pretty much anything could happen to anyone at any time.

2.56 The fear of science. *Bride of Frankenstein* (James Whale, 1935).

2.57 The fear of our own worst instincts: Is there something inside of us that can be awakened and exploited? *The Cabinet of Dr. Caligari* (Robert Wiene, 1919).

A close look at twenty-first-century horror films such as *Saw* and *Hostel* suggests that we're a lot harder to scare than we used to be; filmmakers now go to gruesome extremes to deliver thrills. It is fair to wonder what is entertaining about these films. Also popular today are horror parodies—the *Scream* films for example, or the *Scary Movie* franchise, that poke fun at the genre's conventions. Because these parodies can elicit fear and laughter at the same time, they prompt us to ask if we have somehow equated being horrified with being amused, and to consider what this might say about the modern condition.

2-3c The Social Function of Genre

A number of film historians, critics, and theorists contend that the primary function of genre is to offer a familiar narrative frame for a contemporary social commentary. As such, genre films function much as myths do: they translate lived experience into stories that help us understand ourselves—our aspirations, our longing, our struggle with the essential conflicts and paradoxes of contemporary life.

To see how this works, let's look at the two genres discussed in detail previously: westerns and horror films. Though westerns are set in a specific historical place and time in the distant past, at stake are fairly universal themes: good versus evil, family versus work, civilization versus wilderness. Genre critics contend that the conflict between cowboys and American Indians we see in these films tells us less about nineteenth-century Manifest Destiny and the real Indian Wars than about race in contemporary America. This is certainly clear in John Ford's 1956 film *The Searchers*, released just two years after the landmark Supreme Court case *Brown v. Board of Education* that mandated the racial integration of American schools. The film's most adept cowboy is Ethan Edwards, a racist. He

2.58 The fear of bad luck: "There is no coincidence," a gypsy fortune teller informs Lawrence Talbot, "only fate" *The Wolfman* (Joe Johnston, 2010).

undertakes the search for his teenage niece Debbie, who has been kidnapped by the Comanche war chief Scar. Ethan's motivation, initially at least, is not to execute her rescue but to put her out of her misery, to kill her and in doing so save her from the shame of miscegenation. Along the way we get several glimpses at Ethan's unreasoned hatred of Native Americans in general.

The film ends as Ethan finally finds Debbie after killing Scar's band of renegades. At the moment when we (and she) fear the worst, he has a brief but nonetheless highly sentimentalized change of heart. The image of Ethan lifting Debbie over his head and then letting her drop lovingly into his arms, punctuated by

the single line of dialogue "Let's go home, Debbie," reveals the disconnect between his previous statements about race and his necessary actions as a western hero (fig. **2.59**). *The Searchers* is ostensibly about a cowboy and a band of renegade American Indians, but its narrative attention to race had a much more modern referent. In the liberal fantasy evinced by this genre narrative, Ethan discovers the folly of racism.

Screenwriters and directors also turned to genre films in the mid-twentieth century as a way to comment on the Hollywood blacklist, which they were forbidden to address directly. These films offered a metaphorical, as opposed to literal, attack on the industrywide ban (from roughly 1947 through 1959) on the employment of over 300 writers, directors, producers, and actors suspected of having communist political sympathies. In *High Noon*, for example, the hero Will Kane refuses to turn his back on the town he has sworn to protect, even though the folks he protects may not be worth the trouble (fig. **2.60**). At one point a character remarks to Kane, "This is no time for a civics lesson," but that's precisely what the film offers. The cowboy hero is true to genre form: he believes that a man is only as good as his word. But much as this philosophy fits the genre formula, it was a profoundly resonant position to take in 1952, given the various efforts afoot to get Hollywood talent to inform on one another.

A less subtle genre reframing of the blacklist can be found in Nicholas Ray's 1954 western *Johnny Guitar*. The film begins with a lynch mob, a not unusual story element for a western, but Ray uses this motif several times in the film to reveal the essential injustices—invasion of privacy, guilt by innuendo, loss of life or livelihood—that occur whenever a mob smells blood. The film climaxes with the interrogation of a young outlaw named Turkey, who is beaten

2.59 *The Searchers* (John Ford, 1956) is clearly about race and racism but not necessarily, or not only, about cowboys and Indians.

2.60 By the end of *High Noon* (Fred Zinnemann, 1952), the strong and silent cowboy is exhausted by the burden of being a hero in such a cowardly and treacherous town. The film is set in the Wild West, but the town is clearly meant to represent Hollywood during the blacklist.

2.61 Turkey is interrogated in *Johnny Guitar* (Nicholas Ray, 1954). He betrays Vienna to save himself. The mob hangs him anyway . . . no doubt an allegory for what was happening to those hauled in front of the committees charged with enforcing Hollywood's blacklist.

into falsely implicating the film's heroine, a businesswoman named Vienna, in a bank robbery (fig. **2.61**). While the coercive tactics used in service of the blacklist stopped short of physical violence, the parallels are clear.

The various fears that lay at the heart of horror film narratives—fear of the dark, fear of strangers, fear of death and disease, and so on—may also allude to social issues. For example, *Nosferatu* depicts the vampire as an unwanted immigrant whose arrival poses a sexual and biological threat to Germany: he has designs on the very flower of German womanhood, and he has brought with him a contagion that ravages the population (fig. **2.52**). In 1922, when the film was released, there were political and social movements in Germany, including the nascent Nazi Party, demonizing foreigners, immigrants, and Jews. More modern examples of horror films touching on social issues are the teen horror films beginning in the 1970s with *Carrie* and *Halloween* that exploit basic fears (of the unknown, of monstrous evil and psychopathology) to focus our attention on more general adolescent worries about bullying and unprotected sex.

Carrie tells the story of a lonely high school girl who is tortured by her classmates and by her fanatically religious mother. Carrie's role as an outcast is made worse by the fact that there's something clearly "different" about her. It is of course fair to ask, what high school student doesn't at some point feel "different?" But Carrie is really different from her classmates: she's telekinetic. She can, when angry, make objects move, even fly through the air.

2.62 Carrie (screen right), the girl everybody loves to pick on, gets her revenge on her teachers and fellow students (screen left) in the film adaptation of Stephen King's horror story about bullying and sexuality among small town teenagers. *Carrie* (Brian DePalma, 1976).

and her body clenched in psychic rage, she lays waste to the entire school (fig. **2.62**). A wish-fulfillment allegory for every person who has ever been bullied or humiliated and a cautionary tale for the popular set, *Carrie* deftly appealed to the anxieties and fears of adolescents about interpersonal relationships and the hormonal nightmare of adolescent sexuality.

In *Halloween* we again focus on the downside of teen sexuality, here policed by an irrational, super- or sub-human violence (fig. **2.55**). The film poses a simple narrative: if you have sex, you die. The link that *Halloween* established between teen sex and irrational violence became the hallmark of a

The torments that she suffers from her bullying classmates finally trigger within Carrie a power that no one, not even she, foresees at the beginning of the movie. In the film's climactic scene, Carrie's anger and humiliation at a final, horrifying insult—a bucket of pig's blood dumped on her head during a school dance—propels her over the edge. Eyes popping out

new subgenre, the slasher film. Not only do these films adhere to genre convention by successfully scaring audiences, they also deliver a very contemporary, cautionary message about the perils of teen sexuality (STDs, AIDS, unwanted pregnancies), suggesting a cosmic payback for the sexual revolution of the late sixties and early seventies.

CHAPTER SUMMARY

When we analyze a film's narrative, we look at the ways that events are sequenced and connected, how narrative time operates at various levels, and how characters function and are developed through dialogue as well as action.

2-1 NARRATIVE STRUCTURE

Learning Outcome: *Recognize and analyze the narrative structure of a film.*

- Narrative structure encompasses both the full set of events that we piece together as viewers (the story) and the events that are presented in the film (the plot). In other words, the plot is a particular selection and arrangement of events from the story.

- There is a distinction between plot order, the sequence of events adopted in the telling of the tale, and story order, which refers to the chronological sequence of narrative events.

- The three-act structure is a common mode for building a narrative arc or shape. In act 1 expectations are raised. In the second act expectations are confounded. And in the third act expectations are resolved (requited, dismissed, found to be silly), ideally in a mildly surprising fashion.

- The three-act formula roughly matches the hero narrative. This paradigm, which has roots in Greek mythology, involves three stages: the hero ventures forth, he faces a trial, and in the end he returns home having learned something from his journey.

- Many film narratives employ a dual structure: what screenwriters call A and B, or kernel and satellite, stories. This formula prioritizes one of the narratives but simultaneously tracks a second story.

- Story duration refers to the elapse of time from the first to the final events relevant to the tale being told. Plot duration is composed of selected stretches of story duration—a highlight reel of sorts. A third distinction, screen duration, regards the passage of time involved in the screening of the film.

2-2 CHARACTERS

Learning Outcome: *Understand and appreciate the narrative function of movie characters and movie stars.*

- Our understanding of film characters is mostly based on external, physical, observable details: appearance, gestures, dialogue, actions. Actors endeavor to help us understand the inner lives of characters through their expression of these details.

- Recognizable character types have been an essential aspect of film narrative since the advent of cinema. If we are watching a western, for example, we recognize the hero instinctively, just as we recognize his adversary.

- Dialogue, what the characters say within the world of the story, and narration, commentary from outside the story, often guide our reading of and feelings about characters and their roles in the larger narrative.

- Unlike the characters in literary works, screen characters are embodied; that is, we do not imagine what they look like from a description, but rather they come to us in visible, tangible form. Movie stars complicate this phenomenon as we consider their public persona and their roles in previous films whenever we see them on screen.

2-3 GENRE

Learning Outcome: *Distinguish and discuss the concept of genre with regard to the structure and effect of film narrative.*

- Genre is an organizing principle that refers to a kind or type of work. In film studies, *genre* refers to a group of films that share certain narrative elements, visual style, and/or emotional effects.

- Genre offers a familiar narrative frame for a contemporary social commentary. Many genre films function much as myths do: they translate lived experience into stories that help us understand ourselves—our aspirations, our longings, our struggles with the essential conflicts and paradoxes of contemporary life.

Reading a movie script reminds us that the mode of telling that story on screen—the images and sounds—can only be approximated or suggested by the written word. With that caveat, we will look at an excerpt from the screenplay for Billy Wilder's 1944 crime film *Double Indemnity*. It is the climactic scene of the movie where the insurance man Walter confronts the treacherous *femme fatale* Phyllis. They have conspired to kill her husband for an insurance payoff, but after that deed was performed, Phyllis has played Walter for a sucker, a fairly typical 1940s crime film plotline.

Earlier in the film, Walter compared acting out a murder to riding on a trolley . . . that when two people conspire to commit such a crime they need to stay on the trolley and stick by one another (and one another's stories) to the bitter end. Both characters have gotten off the trolley at this point. Note how the hard-boiled dialogue maintains the noir, crime-film milieu and yet also manages to pack an emotional punch.

The simple action of turning his back to her heightens the suspense—we've seen her hide a pistol under the seat cushion of her chair.

We know that Phyllis has shot Walter without ever seeing her fire the gun. We see events unfold first by seeing Walter's face and then from a shot of Phyllis holding the gun from Walter's point of view. The suspense builds as we wonder if she will fire again.

Tough guy banter: an element of the crime genre. He is angry and taunting her.

Another pregnant pause that builds suspense.

Despite a bullet in the gut, more tough guy banter.

She is not acting the cold-hearted *femme fatale* now. We, like Walter, want to know why.

Phyllis just stares at him. He goes quietly over to the window and shuts it and draws the curtain. Phyllis speaks to his back:

> PHYLLIS
> (her voice low and urgent)
>
> Walter!

Walter turns, something changes in his face. There is the report of a gun. He stands motionless for a moment, then very slowly starts towards her. CAMERA IS OVER HIS SHOULDER AT Phyllis as she stands with the gun in her hand. Walter stops after he has taken a few steps.

> WALTER
> What's the matter? Why don't you shoot
> again? Maybe if I came a little closer?

Walter takes a few more steps towards her and stops again.

> WALTER (cont'd.)
> How's that? Do you think you can do it
> now?

Phyllis is silent. She doesn't shoot. Her expression is tortured. Walter goes on until he is close to her. Quietly he takes the gun out of her unresisting hand.

WALTER (cont'd.)

Why didn't you shoot, baby?

Phyllis puts her arms around him in complete surrender.

WALTER (cont'd.)

Don't tell me it's because you've been in love with me.

PHYLLIS

No. I never loved you, Walter. Not you or anybody else. I'm rotten to the heart. I used you, just as you said. That's all you ever meant to me—until a minute ago. I didn't think anything like that could ever happen to me.

WALTER

I'm sorry baby. I'm not buying.

PHYLLIS

I'm not asking you to buy. Just hold me close.

Walter draws her close to him. She reaches up to his face and kisses him on the lips. As she comes out of the kiss there is realization in her eyes that this is the final moment.

WALTER

Goodbye baby.

Out of the shot the gun explodes once, twice …

DOUBLE INDEMNITY: THE COMPLETE SCREENPLAY, Billy Wilder and Raymond Chandler. University of California Press, 2000.

A key gesture that signals her character's third act change of heart.

Given Phyllis's prior deceptions, we too wonder if she is pretending.

Is she telling the truth? Her admission of guilt makes the change of heart convincing to us, if not to Walter.

The kiss does not lead to reconciliation, as it would in a romance. It is important that she learns that she hasn't gotten away with murder.

Predictably, closure is attained when the criminals are punished (they both die). The mild surprise of the third act is that Walter is the one who kills Phyllis.

ANALYZE NARRATIVE AND GENRE

Use these questions to analyze how the basic elements of narrative and genre contribute to the form and meaning of a film.

- Film narratives often refer directly or indirectly to a contemporary issue. Does the film you are analyzing refer to a larger political, social, or economic reality?

2-1 NARRATIVE STRUCTURE	• Does the plot order match the story order? If not, list the differences and discuss how these changes from story to plot order contribute to the narrative. • Briefly summarize the arc or shape of the narrative. Can you organize the events into a three-act structure? Can you identify a so-called narrative fix, or central conflicts that create the drama in the story? Is closure accomplished? • Does the story adhere to the hero narrative proposed by Joseph Campbell? • Does the film have discernable A and B (or kernel and satellite) stories, or does it have parallel narratives? If so, how do these stories relate to one other? • What parts of the story have been left out of the plot? How do the omissions contribute to the telling of the film's story?
2-2 CHARACTERS	• How would you describe each character's motivations? How does his or her motivation contribute to his or her development as a character? How does his or her motivation contribute to the telling of the film's story? Are any character's motivations unclear or surprising and, if so, how does this questioning of character motivation contribute to the telling of the film's story? • Do any of the film's characters fall into discernable types (e.g., the all-American hero, the nutty professor)? If so, how are these types used in the telling of the film's story? • Focus on a scene involving a dialogue between two or more characters. What does the dialogue tell you about the characters? • Are any of the characters played by a movie star? If so, how does the movie star's discrete identity—his or her biography and previous film roles—affect your reading of the film character and the film as a whole?
2-3 GENRE	• Select a genre film to analyze. What elements of story, plot, character, setting and/or emotional effect are associated with that genre? • How are conventions and expectations fulfilled by the movie? Are any genre conventions tweaked or thwarted, offered in variation, or contradicted? • Is the genre narrative used to offer a social commentary?

3 MISE-EN-SCÈNE

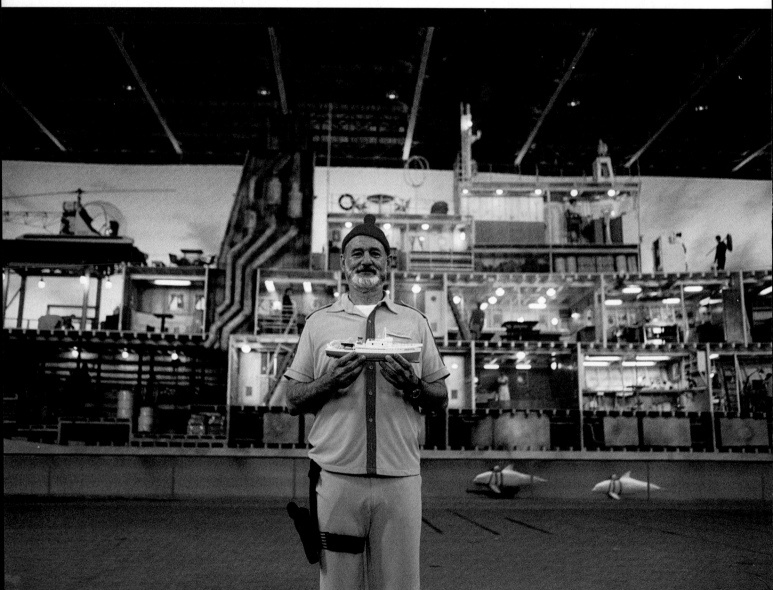

The Life Aquatic with Steve Zissou (Wes Anderson, 2004), production design by Mark Friedberg

Most movie projects begin with a story. The screenplay fleshes out that story and offers a blueprint from which the filmmakers will work. The challenge for the production design team is to create what is placed before the camera—the film's **mise-en-scène**. Roughly translated as "putting into the scene," for most scholars mise-en-scène refers to the set, lighting, costumes, makeup, hair, and the position of the actors. Some film theorists use the term more broadly to include camera work as well, which is the subject of our next chapter.

Mise-en-scène is the responsibility of the production designers and set builders and dressers, hair and makeup departments, the cinematographer (who supervises the lighting of the film), and the director (who leads the entire production). We will take a close look at the kinds of decisions that they make so that you can analyze how mise-en-scène contributes to the visual style and story content of a film.

mise-en-scène Roughly translated from the French, "putting into the scene." Mise-en-scène is composed of the set and props, the look of the characters (costumes, makeup, and hair), dramatic staging (the blocking of characters as they move about the set), and the lighting (including the position, intensity, and balance of the lights).

MAKING MOVIES

MARK FRIEDBERG ON PRODUCTION DESIGN

Mark Friedberg is a Hollywood production designer who has worked with many of contemporary cinema's most interesting directors. His design credits include *The Ice Storm* (Ang Lee, 1997), *Far From Heaven* (Todd Haynes, 2002), *The Life Aquatic with Steve Zissou* (Wes Anderson, 2004), *Broken Flowers* (Jim Jarmusch, 2005), and *Across the Universe* (Julie Taymor, 2007). Friedberg won a 2011 Emmy for outstanding art direction on *Mildred Pierce* (Todd Haynes).

Q1: What exactly does a production designer do?

A: The production designer is responsible for imagining, finding, and/or creating the world in which the characters live. This work is broken down into many components and handled by different departments that report directly to the production designer: the art department, the construction and paint departments, the set decoration department, the property department, the locations department, and the special effects department. Today many production designers work closely with the visual effects department so that their work lives within the overall design of the film.

Q2: Would you talk a bit about the process (from sketch to realization) of your work?

A: The production designer is often the first hire after the line producer and it's in that embryonic time in the production that the first conceptual discussions of the look of the film occur. This discussion grows upon the arrival of the cinematographer as the camera work is added to the conversation.

Later the costume designer, the lighting designer, and then the gaffer weigh in. The first order of business is to determine the movie's visual language. Is the film to be stylized or realistic? What will the images we make look like? Will they be colorful, stark, textured, modern, rustic? As technology advances, sketching has become more and more reliant on Photoshop where we are able to render three-dimensional digital models and preview angles and lighting and set dressing options.

Q3: While stage plays ask the audience to imagine what a theater set suggests—we see a couch and table and we imagine a living room, for example—movie sets for the most part re-create the fictional world in more realistic detail. Are there fundamental differences between designing sets for the stage and for the screen?

A: Theater can tend to be a more poetic presentation of the world. In theater, the stage designer makes the frame. The shape of the story world and its intersection with the audience are defined in the set design. Where the world of the

story stops and the world of the audience begins is finite. In the theater your perspective stays the same because the relationship of your seat to the stage is fixed. The theatrical viewpoint is your own but in a film you can see from various characters' points of view. Another major difference is scale. You can contrast a huge bird's-eye view with a macro close-up. A small detail can be shot in close-up and when projected be seen 80 feet long; it can possess monumental importance.

Q4: Has your experience as a designer enabled you to develop a signature style? Or is production design all about physically realizing a director's imagined world?

A: The production designer's responsibility is to make worlds. We do that by best fitting our decisions into the visual language developed with the director and cinematographer. Having said that, no two designers would render the same set for the same film.

CENGAGE brain.com **LINK TO THE FULL INTERVIEW** http://cengagebrain.com

While stage plays ask the audience to imagine what a theater set suggests—we see a couch and table and we imagine a living room, we see a mock-up of a building in the background and we recognize a street scene—**movie sets** for the most part re-create locations in more realistic detail and ask that we imagine instead what it might be like to be in this apparently real living room or street. The set might be constructed on a production **soundstage**, where everything can be controlled for optimal film and sound recording, or it might be located on a real site outside of the production studio (resulting in **location shooting**). The set takes shape as a collaboration among the art department, the construction and paint departments, the set decoration department, the property department, the locations department, and in modern moviemaking the special effects department.

The set plays a significant role in how we read a scene, offering useful information regarding time, place, social class, and even the mental state of the characters. In addition, the set affects how the actors behave because it defines the space within which they operate. The set also affects where the camera and sound recording equipment can be placed, a practical detail that can have an enormous impact on the framing of the shot, as we will see in the following chapter.

3-1a From the Drawing Board to the Screen: Set Design

Sets are sketched out by hand, previsualized on specialized computer programs, or modeled (built in miniature) well in advance of production. As the sets evolve on the "drawing board," the director and designers work out the visual language of the film, making decisions, for example, about the color palette, the choice of patterns and materials, the scale of rooms and furnishings, and the space for cameras and lighting. Once the sketches and models are approved, a myriad of artists and builders undertake the set's construction.

A particularly evocative use of soundstage set design can be found in the 1931 film *Grand Hotel*. The MGM studio set was built to replicate an opulent Berlin hotel frequented by Europe's upper classes in the last days before the fall of the Weimar Republic and the transition into Nazi Germany. The original design sketches suggest a circular space that creates the illusion of greater size (and enables panoramic moving camera shots). Details

3.1 A preliminary sketch for the lobby set in *Grand Hotel* (Edmund Goulding, 1931).

3.2 A second sketch highlights the scale and scope of the proposed set.

include a tiled floor, glass doors, Art Deco furnishings, and the arced reception desk at which much of the early action in the film takes place (figs. **3.1** and **3.2**).

movie set Most often refers to a set constructed on a studio lot or soundstage. Also used more generally to refer to any location, real or constructed, where filming takes place.

soundstage Looking much like an airplane hangar, a soundstage is a windowless, soundproofed shooting environment.

location shooting The filming of a scene in a found location rather than in a constructed set.

In a production still taken during the filming of one of the early scenes in *Grand Hotel*, we can begin to see how the sketches are translated into the final look of the picture (fig. **3.3**). The space occupied by the characters, which in the shot from the film appears to be the full three-dimensional space of the Grand Hotel lobby, is on the actual set relatively small. **Metonymy** is the rule here, which is to say that filmmakers use a part (the narrowly viewed constructed space of the set) to suggest the whole (the larger space in which the story takes place). We see two men walking towards a shop in the hotel lobby (fig. **3.4**), but we are meant to imagine a larger space as a bellhop in the foreground seems headed for a part of the lobby not seen in the frame. Many of the set's details—the tiled floor, glass doors, Art Deco furnishings, and the arced reception desk— serve as well to suggest the whole of the hotel lobby.

The hotel in the film is meant to exist in a real city, Berlin, and while most of the action takes place inside, the vast glass doors of the set allow for shots showing some characters peering into the hotel space (fig. **3.5**) while other characters move freely between the interior of the hotel and exterior space of the city. Because this is an indoor set in Los Angeles and not a real hotel on a city street in Berlin, the exterior of the hotel is implied or suggested; there is in reality no street but instead just more soundstage on the other side of the glass doors. No doubt the glass enhances the illusion of real exterior city space. And it also supports a larger class-distinct drama in play in the film: that there are those wealthy enough to occupy the space inside of the hotel and others who, on the other side of the glass, must watch from a distance.

3-1b Sets on Location

Real locations—both exterior and interior—can lend a degree of realism to a film. Like *Grand Hotel*, the 1998 thriller *Run Lola Run* is set in Berlin, but the *Lola* filmmakers opted to shoot on the city's streets rather than on a soundstage (fig. **3.6**). The location shots quickly establish the locale and also the trajectory of the drama: Lola must run from one end of Berlin to the other in order to rescue her wayward boyfriend, who has lost money that belongs to some pretty rough characters. The film poses three distinct outcomes all set on the same recognizable streets, each one dependent on a fateful move or moment in time wasted or saved during Lola's run.

metonymy A type of metaphor in which a thing is represented through one of its attributes. Most often this rhetorical form uses a part to signify the whole, e.g., "the crown" to signify royalty.

3.3 A bird's-eye view of the lobby set in *Grand Hotel*. Note how little of the space on the MGM soundstage is used in the shot and how much is occupied by the production crew and equipment.

3.4 In film production, a small portion of a set can imply a larger, full-scale space, as in this shot from *Grand Hotel*.

3.5 Outside looking in. The suggestion of street space on the studio set allows for an important message about social class in *Grand Hotel*.

3.6 *Run Lola Run* (Tom Tykwer, 1998) rather depends on its exterior setting: the recognizable Berlin streets that stage Lola's race against time to save her boyfriend. The location scouts clearly factored in how this specific street corner might look in the shot described in the script; the train that speeds by screen right offers a neat match for Lola's run around the curved street below.

3.7 and 3.8 Lola approaches the Deutsche Transfer Bank and then, in what seems like the inside of that building, she attempts to steal 100,000 DM. The exterior and interior sets are real all right, but neither is a bank.

One popular formula for using locations is to establish place with real exteriors and then cut to interiors on the studio soundstage or in a different real location. When we see a real exterior and then cut to an interior, the implication is clear; we have moved inside the building we have just seen. Whether or not the interior we see is really inside that specific building is not, for the filmgoer at least, important or relevant because continuity between the two sets has been established by the logical link between the two shots.

When Lola dashes into a bank in a desperate attempt to get help from her estranged father, we first see her approach a real building with a real sign that reads "Deutsche Transfer" on a real city street (fig. **3.7**). When we cut to Lola inside, we assume she has entered the building we have just seen (fig. **3.8**). In actuality, the bank exterior is that of a government building on Berlin's historic Bebelplatz and the interior is in city government offices on the Kurfursterdamm. We believe that the interior and exterior are the same place because of the logic of the sequence and because the sets are convincingly dressed.

The overall feeling of authenticity in *Run Lola Run* may well be enhanced by the location work and real sets, but, ironically, as a native Berliner would no doubt know, Lola's run does not make much geographical sense. The locations used do not track any logical route but rather were chosen for aesthetic reasons. As filmgoers we buy into the fiction of a linear run from point A to point B because the location work, sets, and editing (the subject of chapter 5) convince us that the space of the narrative is real.

3-1c Sets and Milieu

Sets establish milieu, the place and time of the film. Whether the milieu is a specific historical setting, in the

3.9 Attention to historical detail is crucial in so-called period pieces like *The Age of Innocence* (Martin Scorsese, 1993). Note that the painting in the background resembles the costuming and staging of the characters posed in the foreground, a clever visual move that furthers the notion of authenticity.

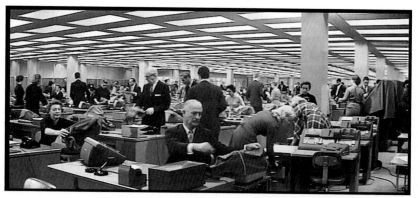

3.10 The corporate workplace circa 1960 in *The Apartment* (Billy Wilder, 1960). No wonder C. C. Baxter, the film's central character, is willing to do almost anything to get his own office.

present day and in a recognizable space, or in some fantastic, invented locale, as filmgoers our first (and surest) key to the environment, geography, and basic rules in play (e.g., realism, science fiction, or fantasy) come from our understanding of the film's sets.

Sets play a particularly important role in films that endeavor to reproduce and re-create a specific historical setting, so-called **period pieces**. In such films, set design must convince filmgoers that the constructed space accurately reproduces a specific time and place. Though *realism* may be a misleading term to use here, since the space itself is fabricated, the effect should on some significant level appear realistic. For example, in Martin Scorsese's adaptation of Edith Wharton's 1920 novel *The Age of Innocence*, the production

period piece A film set in the past, often characterized by lavish set design and costuming.

designer and art director establish the film's world of high society in late-nineteenth-century New York in an early scene of an annual ball in the Beauford family home (fig. **3.9**). This exquisitely furnished mansion with its lavish fine art collection telegraphs the wealth of its owners and communicates their refined taste and attention to appearances, values that become important to the central conflict of the story. The Beauford home's interior was not a wholly built set but a real place, the National Arts Club dressed to look like the family home it once was. Dressed and thus reconsidered, the National Arts Club lends an aura of realism to the setting, but it also challenged the filmmakers to move through a space that could not be structurally reconfigured (torn down and rebuilt to suit camera work and lighting).

Sets can establish an authentic milieu while offering a more vivid version of the real thing. In Billy Wilder's 1960 melodrama *The Apartment*, the film's unlikely hero, C. C. Baxter, is a middle manager for an insurance company. He works along with other such white-collar workers in a huge common room, a movie set with row after row of identical workstations (fig. 3.10). While the set may have struck 1960s audiences as a true representation of an office space, the tight arrangement of the desks, low overhead lights, and chaotic placement of the actors was deliberately designed to be unsettling. We can appreciate Baxter's desire to move out of this space and into his own office—a desire so strong that he makes a corrupt bargain with his boss in order to get it.

While some sets aim to re-create real worlds from the past or present, many other films use sets to establish imaginary places. The filmmakers establish a "creative geography" in which various sets and design details suggest a complete if not in the strictest sense of the term "real" space. The fantastic dining hall, classrooms, and dormitories created for the Harry Potter series match descriptions known to the avid fans of J. K. Rowling, for whom accuracy to the original is essential (figs. **3.11–3.13**).

3.11–3.13 Three sets from the film adaptation of *Harry Potter and the Sorcerer's Stone* (Chris Columbus, 2001), the first in the Harry Potter series.

fabricated to fill the space occupied by the fixed background color. When the images are put together we have the semblance of a film set, one in which no actor (indeed no human being) has ever set foot.

For one of the most resonant images in Peter Jackson's remake of *King Kong*, the actress Naomi Watts was filmed in front of a green screen. Background images of New York City and the CGI version of the giant ape King Kong were added after the fact (figs. **3.14** and **3.15**).

Even simple logistical problems on constructed sets can be facilitated by green screen work. In a sequence in *Star Trek*, we see Spock leave one deck, enter an elevator, and then exit onto the bridge of the Enterprise. As we watch the sequence in the completed film, it appears to feature three distinct sets, but it's really just one. As Spock enters the elevator, he is shot in front of a green screen (fig. **3.16**). We then cut to the interior of the elevator, which is not an operating lift; it's just a mock-up at one end of the same bridge set. To simulate movement in the elevator and to imply Spock's transition from one interior location to another, there is a slow camera move of about 180 degrees. When the door to the elevator swings open, we see Spock exit onto the bridge, a physical space the actor has, in reality, never left.

3-1d Sets and Special Effects

In contemporary filmmaking, especially in science fiction, futurist, and fantasy films, sets are often enhanced, at times wholly created, by compositing or matting and/or **CGI** (computer-generated imagery). In such cases, set design (technically, set extension) becomes an aspect of postproduction special effects and computer re-creation.

Compositing allows the filmmaker to fabricate a set from distinct images. An actor performs in front of a backdrop of a single color (usually blue or green, hence the alternate terms for compositing: blue screen and green screen). Separate images are then shot or

3-1e Stylized Sets

For a handful of films, realism is beside the point as sets serve to call attention to artifice and highlight the stylized as opposed to realistic aspects of the film. In the 1919 **expressionist** film *The Cabinet of Dr. Caligari*,

> **CGI** (computer-generated imagery) Images that are not photographically produced but are created on a computer.
>
> **expressionism** A cinematic style with roots in painting that emerged in Germany between the two world wars. Expressionism is visually characterized by chiaroscuro lighting and highly stylized sets. The best-known expressionist filmmakers are Fritz Lang, F. W. Murnau, and G. W. Pabst.

▶ **3.14 and 3.15** For a key scene in Peter Jackson's remake of *King Kong* (2005), Naomi Watts was filmed in front of a green screen and held in a mock-up of the giant ape's hand (covered in green canvas). The composite final version of this shot includes a skyline shot replacing the green screen background and the ape's hand in CGI.

3.16 Zachary Quinto, playing Spock in *Star Trek* (J. J. Abrams, 2009) is filmed on the bridge set (top image) in front of a green screen. The green screen portion of the image is replaced by an image of the elevator interior, creating the illusion that the character is in a different place on the ship.

3.17 The expressionist, painted sets reveal the tortured mental state of the "narrator" in *The Cabinet of Dr. Caligari* (*Das Cabinet des Dr. Caligari*, Robert Wiene, 1919).

3.18 The fantasy sets for Oz suggest a place that exists only in Dorothy's imagination. *The Wizard of Oz* (Victor Fleming, 1939).

for example, the hand-painted sets (fig. **3.17**) are not meant to realistically reproduce the streets of Holstenwall, where the film is set, or the apartments in which the characters live. Instead the sets hint at the narrative frame of the story, that what we see is in essence the dreamscape of the film's addled narrator, a patient at a psychiatric hospital. In *The Cabinet of Dr. Caligari*, the dreamscape setting is meant to evoke and express a nightmare mental state from which no escape is possible.

Some films—like *The Wizard of Oz*—use both fantastic and realistic sets. The highly stylized and colorful sets that characterize the dream world of Oz (fig. **3.18**) are contrasted with the drab, homespun Kansas, which seems by comparison colorless (fig. **3.19**). The film's final message, that "there's no place like home," may seem to be at odds with the appeal of the sets, but

3.19 Compared with Oz, Kansas, a real place albeit reproduced on the studio lot, is drab and colorless. But there is more than one way to look at the film's payoff line, "There's no place like home."

3.20 The underground factory in Fritz Lang's futurist parable *Metropolis* (1927).

3.21 The Reality Wrecking Yard in Francis Coppola's *One from the Heart* (1982). Hank stands amidst the ruins of Vegas's fabricated neon culture.

that may well be the point: that Dorothy needs to get her head out of the clouds and learn to appreciate the comfort of the familiar.

In Fritz Lang's *Metropolis*, the highly stylized, expressionist sets of the futurist city correspond to a larger creative argument about the exploitation of workers in the capitalist system. The atomization of the future factory worker is dramatized by the sheer scale of the built environment (fig. **3.20**). Note the size of the various support structures and the factory machines in the background. At the center of the image stands the film's reluctant hero, dressed in white, tiny and alone, daunted and helpless.

In a nod to the conventions and illusions that characterize movie romance, the set of Francis Coppola's *One from the Heart* calls attention to its own artifice. When, for example, the film's hero Hank is bereft after being dumped by his girlfriend Frannie, we find him moping around the aptly named Reality Wrecking Yard (fig. **3.21**). He is, at this point in the film, an emotional wreck. The mountains in the distance are an obviously painted backdrop, and the wrecking yard itself is by design unconvincing as an exterior image (e.g., the artfully arranged junk, the abundance of empty space in what should be a crowded junkyard). Unlike in most movies, this set is deliberately designed to look like a set.

3-1f Props

Once the carpenters, electricians, and painters complete their work, the set dressers step in. Their job is to put the final touches on the constructed set—to add objects (lamps, paintings, photographs, kitchenware, audio equipment) that match the design sketches. Objects added by the set dressers—the artfully arranged "junk" in the Reality Wrecking Yard in *One from the Heart*, for example—are called **props**, short for *properties*.

Early on in the history of cinema, filmmakers recognized the value of props. Slapstick and knockabout performers in silent film comedies, for example, often interacted imaginatively with inanimate objects: for example, Charlie Chaplin's elegant dance with a broom in *The Bank* (1915), or his use of a gas streetlight to subdue a neighborhood bully in *Easy Street* (fig. **3.22**).

In *Sherlock Jr.*, Buster Keaton structures an extended gag around a single prop, an exploding pool ball. First, as a sort of magician's "reveal" (in which

> **prop** Short for *property*, an object placed in the set. Props may play a significant part in the action.

3.22 The streetlight gag in Charlie Chaplin's 1917 comedy shot *Easy Street*.

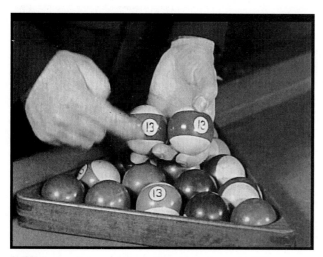

3.23 A simple prop, a complex gag: the exploding 13-ball in Buster Keaton's *Sherlock Jr.* (1924).

3.24 Keaton's sleight-of-hand at the pool table in *Sherlock Jr.*

3.25 A second "reveal" . . . Sherlock Jr. is ready to lob the villain's weapon back at him.

the trick is set up), one of Sherlock Jr.'s adversaries substitutes the exploding ball for a real ball (fig. **3.23**). A game ensues and to the frustration of the villains, the detective pockets ball after ball, somehow never touching the 13-ball. Finally, on the last shot of the sequence, he pockets the 13-ball, but the explosion we have been waiting for fails to happen (fig **3.24**). Not until later in the film do we discover how this trick was performed. In an extended chase scene during which Sherlock Jr. rescues his girlfriend, the detective pulls the exploding ball out of his pocket (where we gather he has concealed it all along) and tosses it at his pursuers, sending them careening off the road (figs. **3.25** and **3.26**).

Props can hold plot-turning significance. In *sex, lies, and videotape*, Ann finds an earring under her bed. She holds it up so she (and we) can have a closer look

3.26 The comic payoff: the 13-ball foils the villains' pursuit of Sherlock Jr., enabling his escape with the girl he adores.

▶ **3.27** The plot of *sex, lies, and videotape* (Steven Soderbergh, 1989) hinges on a single (and small) prop, an earring found under a bed.

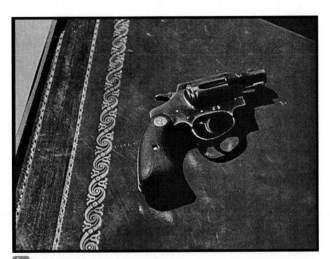

▶ **3.28** The film's opening shot: a gun. *The Big Heat* (Fritz Lang, 1953).

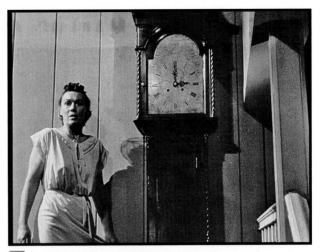

▶ **3.29** A strategically placed prop lets us know that it's the middle of the night.

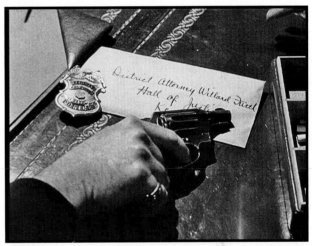

▶ **3.30** A gun, a badge, and a letter.

and all at once we recognize the earring ... it is her sister's (fig. **3.27**). Together we surmise the rest—that Ann's sister is having an affair with Ann's husband.

Everyday objects like clocks and watches are often used as props to establish time in the plot; in an action film or thriller they cue us that time is of the essence. Periodic looks at Snake Plissken's watch in *Escape from New York* (John Carpenter, 1982) remind us of the little time he has left to rescue the president. Frequent shots of clocks in the 1952 western *High Noon* (Fred Zinnemann) have a similar effect; like the film's hero we acknowledge that time is passing, that the time before the showdown is closing fast.

The opening scene of the crime film *The Big Heat* illustrates how strategically placed props can tell a story. Through the series of shots that introduce the film's plot, not a single line of dialogue is spoken. All we have to work with is the mise-en-scène, especially four significant props.

First we see a gun on a desk (fig. **3.28**). Apropos the stage and cinema adage, "if you introduce a gun, someone better use it," the gun is picked up by a character who remains off-screen, and then we hear it fired. The character's head falls forward into the frame, and we gather that he has used the gun to shoot himself. We then see a woman responding to the sound of the gunfire. She pauses in front of a clock at the top of the stairs; it is 3 A.M., the dead of night (fig. **3.29**). We then see three props strategically placed together: the gun (still in the man's grasp), a police badge, and a sealed envelope addressed to the district attorney (fig. **3.30**). Absent a single line of dialogue, we know that a policeman has shot himself and has left a suicide note addressed not to the woman at the top of the stairs, whom we assume (correctly) to be his wife, but to the district attorney to whom such a sealed confession suggests crimes or corruption the policeman can no longer keep secret.

Mise-en-scène also includes the look of the actors who are costumed, made-up, and coiffed to resemble the fictional or historical characters they play on screen. Costume, makeup, and hair are important to the overall effect of an actor's performance. They are important as well to the overall design scheme: the color palette, the degree of stylization, the time, and the place of the film.

3-2a From the Drawing Board to the Screen: Costumes, Makeup, and Hair

The team responsible for "human design" begins with the raw material, the actor's physical features. Then, so-called movie magic behind the scenes is used to transform the performer through costume, makeup, and hairstyle. We tend to notice elements of human design most in certain genres: horror, historical or period pictures, and science fiction—films in which actors are made to look somehow different from people we are likely to meet today. In the seminal Hollywood monster film *Frankenstein*, for example, the actor Boris Karloff wore elaborate makeup to play the famous monster. While the notion that such makeup was somehow realistic seems beside the point—the monster after all does not exist—what the Universal Studios makeup artist Jack Pierce achieved proved convincing and endures in our collective consciousness as the look of Frankenstein's monster.

The Hollywood legend is that the director James Whale saw Karloff on the studio lot dressed in a suit and spied something in the actor's facial bone structure. Under the pretense of discussing the lot of British actors in Hollywood (both Karloff and Whale were from England), Whale befriended Karloff and convinced him to test for an unidentified role in a forthcoming picture, which turned out to be the role of the monster in Whale's *Frankenstein*. When we look at the before and after pictures of Karloff, first in a suit circa 1931 (fig. **3.31**) and then in his makeup as the monster (fig. **3.32**), we can see the skill of Pierce and Universal's makeup department, and also we can see that Whale was right—there really is something cadaverous about the actor's facial bone structure.

Makeup, including skin prosthetics, is not just the stuff of monster movies. Indeed, makeup is routinely used to fix a character's age at a certain time in the narrative. For films that span a wide range of historical time, changes in makeup and hair can key the changes. Such changes may be subtle: accentuating wrinkles or dark circles under the eyes, a greying of the hair. Or prosthetics may be used to attend to a greater span of time, as in Arthur Penn's *Little Big Man*. The lead character and narrator of the film, Jack Crabbe, is played as an adult by Dustin Hoffman. The actor was at the time 33 years old. The character he played ranged from his 20s through well over 100 (figs. **3.33** and **3.34**).

An image from the era depicted in a period film can be the starting point for the director and design team. For example, in Sofia Coppola's *Marie Antoinette*, the design team used Elisabeth Vigée-Lebrun's

3.31 Boris Karloff at Universal Studios in 1931.

3.32 Karloff as Frankenstein's monster. *Frankenstein* (James Whale, 1931).

3.33 Dustin Hoffman as a twenty-something Jack Crabbe in Arthur Penn's *Little Big Man*, (1970).

3.34 Same actor. Same character. About 100 years later (in the story told in the film).

3.35 Elisabeth Vigée-Lebrun's 1778 portrait of Marie Antoinette.

1778 portrait (fig. **3.35**) as a source for the costume, makeup, and hair in a playful scene of the young queen enjoying the pleasures of court life (fig. **3.36**). Note the billowy white garment, the feathered headpiece, the white pancake makeup, and the heavy rouge on the cheeks. The set, makeup, hair, and costume design work hand in hand so that the actress Kirsten Dunst looks like the famous image of the legendary monarch;

the design work also implies that the character is a confection of sorts, like the candies and cakes she so loves. While Sofia Coppola's film toys with historical accuracy—much of the music is pop, rock, and hip-hop, and Marie behaves like a contemporary American teenager—the mise-en-scène grounds the story in pre-revolutionary France and creates an evocative portrait of the young queen.

3-2b Communicating Character through Costumes, Makeup, and Hair

Costuming, makeup, and hairstyle are part of a film's visual shorthand; we can apprehend a character's social standing, occupation, even their attitude toward life by how they are made to look by the costume, makeup, and hair departments. The titular character in the Coen brothers' *The Big Lebowski*, a slacker par excellence who goes by the nickname "the Dude," lounges for much of the film in baggy shorts and a filthy T-shirt, unshaven

3.36 Kirsten Dunst as the eighteenth-century French queen in *Marie Antoinette* (Sofia Coppola, 2006).

3.37 Jeffrey Lebowski (left), AKA "the Dude," abiding at the bowling alley, dressed in his signature baggy shorts and rumpled T-shirt. *The Big Lebowski* (Joel Coen, 1998).

3.38 Julian, in one of his several Armani suits, with a client in Paul Schrader's *American Gigolo* (1980).

and unkempt, his hair greasy and long (fig. **3.37**). His slovenly appearance corresponds to a carefree existence in which, as the film's loopy cowpoke narrator tells us, "the Dude abides." What happens, then, is that his

3.39 The ragged petty thief, Nikita, just after her arrest. *Nikita* (Luc Besson, 1990).

3.40 New clothes, makeup, and hair transform Nikita, the street urchin, into a sophisticated superspy.

appearance of being carefree is challenged at every turn of the plot. Thugs toss a marmot into his bathtub and soil his rug. He loses the other Jeffrey Lebowski's ransom money, and his bowling buddy Donnie is gunned down by pseudo-anarchists. Throughout the Dude *looks* like the wrong guy in the wrong sort of movie, which makes his predicaments all the more entertaining.

Conversely, Julian, the preening male prostitute in Paul Schrader's *American Gigolo*, is meticulously dressed in custom-tailored Armani suits, his face always clean-shaven, his hair perfect (fig. **3.38**). When he is falsely accused of a murder and his upper-class clients abandon him, the façade comes undone. We see a less polished version of Julian as he desperately searches for the real killer among the lower-class hustlers with whom he once worked. A former client who provides him with an alibi for the night of the murder saves him from a prison sentence. And more important, he is redeemed because she has "bought" more than just the façade; indeed she has seen through his polished image to the real man inside.

Character transformation—from human to monster (*The Wolfman*), from tramp to millionaire (*The Gold Rush*), or from mousy secretary to the Catwoman (*Batman*

3.41 Robert DeNiro as the boxer Jake LaMotta in his prime. *Raging Bull* (Martin Scorsese, 1980).

3.42 Same actor, same film, different look: Robert DeNiro as Jake LaMotta, nightclub owner and retired boxer

Returns)—can be accomplished when an actor's performance is supported by changes in costume, makeup, and hair. In *Nikita*, Anne Parillaud (in the title role) begins the film dirtied-up in ragged clothes, dull makeup (no lipstick), and unkempt hair (Fig. **3.39**). After her secret training as a spy and assassin, she is the picture of French female sophistication in a tailored black blazer and pearls, her hair cut and combed to perfection, her makeup now highlighting her eyes and lips (Fig. **3.40**). It helps of course that Parillaud, like most movie stars, is beautiful in the first place.

Some actors undergo months of special diets or exercise to reshape their bodies for a role. In *Raging Bull*, Robert DeNiro trained for weeks to play the boxer Jake LaMotta in his fitter, younger days and then gained sixty pounds to portray LaMotta overweight and boozed-up later in life (figs. **3.41** and **3.42**). While prosthetics, hair, and makeup certainly contributed to the character's transformation over time (note, for example, his receding hairline and bulbous nose in the later-day shot), it is the actor who embodies the change and truly makes it credible.

3-3 BLOCKING AND PERFORMANCE

Not only is the look of the actors an aspect of mise-en-scène, but so is their positioning within the set. Where the actors move within the space—which film and theater directors call **blocking**—is carefully worked out before the cameras roll. As we will see, blocking conveys story information and can create a compelling image. Yet acting is more than mise-en-scène, of course; the actor must convincingly embody the character through posture, gesture, facial expression, and voice.

Performance is at the most basic level a key to engaging audiences: if we can believe in the actor's portrayal of a character, we can believe in the fictional world that character inhabits. The actor's performance also needs to fit the visual language of a film; a film that strives for naturalism would require a different acting style from one that is highly stylized. The point here is that actors are more than visual design elements, though on a very basic level they contribute to the larger visual language of the film.

blocking The choreographed positioning of actors and camera(s).

3-3a Blocking and Narrative

The term *blocking* is used to refer to the choreographed positioning of actors and camera(s). Combined with framing (discussed in chapter 4), blocking is a key aspect of composition created by an integration of mise-en-scène and camera work. A key aspect of blocking is rooted in stagecraft and involves the playing out of a scene as actors move to specific "marks" (often taped or drawn on the floor) following scripted cues, preset lines of dialogue or scripted physical actions. Blocking can be static (characters standing or sitting in place for an entire shot) or fluid (characters moving to prescribed marks). For most Hollywood movies, blocking is meant to appear natural, to simulate realistically how people might position themselves as they talk and act in a given setting. But while the goal may be realism, blocking is seldom improvised or inadvertent.

A pivotal scene in the 1937 romantic comedy *The Awful Truth* illustrates how blocking supports the story. Jerry and Lucy are recently divorced. Dan is Lucy's new beau, an Oklahoma oilman who is sweet but dull. Jerry wants to break up Lucy and Dan. Dan's mother, who enters the scene late, also wants to break up her son's relationship with Lucy. A close look at the blocking shows how the physical relationships among the characters shift to support the story arc over the course of the scene.

The scene begins as Jerry arrives at Lucy's apartment. He steps into the room and stops between Dan and Lucy (fig. **3.43**). Dan then walks behind Jerry and moves next to Lucy, putting his arm around her (fig. **3.44**). The blocking subtly reveals Jerry and Dan's struggle for Lucy's affection.

Jerry notices Dan's possessive gesture and to make Dan uncomfortable, he refers to Lucy's habit of keeping important legal documents in her stocking drawer ("every legal paper we had smelled of sachet ... even the marriage certificate"). After Jerry reminisces about a practical joke played by a bellhop during their honeymoon, Lucy pulls out from under Dan's embrace, walks behind both men, and sits down on the arm of a chair. Dan sits on the loveseat and then Jerry sits quite close to him, again taking the space between Dan and Lucy (fig. **3.45**). We recognize from the theatrical blocking as well as the familiar romantic comedy trope that this romantic triangle will have to be sorted out.

Dan's "Ma" enters the scene and walks to her mark. In doing so she strategically increases the space between Dan and Lucy (fig. **3.46**). Ma has arrived after hearing an account of Jerry and Lucy's divorce, gossip that puts Lucy in an unfavorable light. She recounts some gossip about Lucy and her handsome music teacher: "You do

3.43 Jerry's arrival at Lucy's apartment in *The Awful Truth* (Leo McCarey, 1937).

3.44 A simple gesture unsettles the scene.

3.45 The three characters keep changing places, chairs, and positions in the frame.

 3.46 Dan's Ma endeavors to (literally and figuratively) come between her son and his new girlfriend, Lucy.

3.47 The men sit at the bottom and edge of the frame while the two women sort things out for them.

3.48 Here staging reveals the inevitable couples: Jerry and Lucy, Dan and his Ma.

sing divinely, dear, but I never realized until this afternoon that you had a teacher—and a very handsome one I understand." After a cut to a shot revealing Dan's discomfort and Ma's pleasure at unsettling her son's relationship with Lucy, the characters are reset to new marks: the men sit at the bottom and edge of the frame while the two women stand. Now that there are four characters in the scene, the split is more amicable; with a romantic triangle, one person is sure to be left out. With four, it's simpler, just a matter of pairing off (fig. **3.47**).

Though the uncertainty regarding the night Lucy spent with her music teacher did lead to their divorce, Jerry calls Ma's accusations regarding the music teacher "silly." Tongue firmly in cheek, Jerry "defends" Lucy's honor. While Jerry talks, Dan moves to a mark behind his mother. The two couples are now as they should be, as they will be at the end of the film: Jerry and Lucy, Dan and his mother. Significantly, in this last image from the scene, the men stand at the periphery as the two women occupy center stage (fig. **3.48**).

3-3b Blocking and Visual Design

In addition to using blocking to visually communicate the dynamic among characters, filmmakers think about the placement of figures in terms of the design of the image. In Terrence Malick's *Days of Heaven*, for example, the migrant farm workers are spaced across the frame in a way that is balanced and beautiful; they are depicted as a harmonious part of the larger prairie landscape (fig. **3.49**).

In an image set on the following day (fig. **3.50**), we see these same workers harvesting wheat. In both images, individuation and performance are beside the point: the human figures are part of the larger design of the shots; they are aspects of the setting.

A similar use of staged human figures is apparent in the breathtaking Death Valley sequence in Michelangelo Antonioni's *Zabriskie Point*. From a great distance we see young lovers as they decorate the barren landscape (fig. **3.51**). We have no idea who they are or why they are there, but that doesn't really matter. Instead, we see them as organic aspects of a dramatic geographic setting.

Antonioni's emphasis on design over character in *Zabriskie Point* was nothing new. After a particularly disastrous reception at a screening of his groundbreaking melodrama *L'avventura* at the 1960 Cannes Film Festival, Antonioni proclaimed that cinema had grown overly tied to story, that filmmakers needed to return the medium to its constitutive, visual roots. His film

3.49 Migrant workers pause for a benediction blessing the harvest. Theatrical blocking as design: Terrence Malick's *Days of Heaven* (1978).

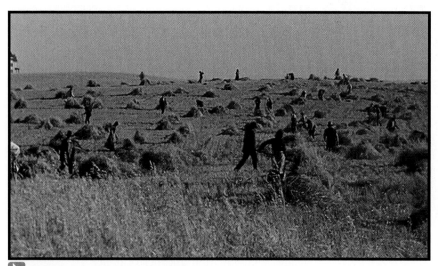

▶ **3.50** Individuation and performance are irrelevant here; the human figures serve as props within the landscape.

3.51 Blocking used to create a compelling image: Young lovers litter the Death Valley landscape in Michelangelo Antonioni's *Zabriskie Point* (1970).

rather intentionally disparaged narrative conventions and highlighted mise-en-scène.

What little story we have to work with in *L'avventura* concerns Claudia's half-hearted search for Anna, a friend who went missing on a pleasure cruise. After Anna's disappearance, Claudia takes up with Anna's former lover, Sandro. The two drift together; and while Claudia has her doubts and regrets, she does little to discourage this new relationship. When Claudia and Sandro stop at a police station to inquire about the official search for Anna, Claudia waits outside and quickly finds herself the object of the gaze of several men (fig. **3.52**).

Antonioni carefully placed the figures within the frame to achieve a certain visual design, but he also used blocking for thematic purposes. When Claudia subsequently walks forward into the foreground of the frame, the men don't move, but their heads all turn to face her. We can see from her facial expression that she is now aware she is being watched (fig. **3.53**). In a subsequent shot, the men move closer to her. As they crowd her, the dramatic staging serves to heighten the seeming threat they pose (fig. **3.54**).

Antonioni never explains who these men are or why they look at Claudia the way they do. They can't possibly know what she's done (with her lost friend's lover) or what she hasn't done (she hasn't looked all that hard for her missing friend). Instead, it is in the relationship of bodies in space that Antonioni finds a visual equivalent for Claudia's shame and guilt. The apparent threat posed by these anonymous men, at the very least that they judge her harshly, is the very sort of uncomfortable moment she has endeavored all film to avoid.

3.52 The pictorial equivalent of guilt and shame. *L'avventura* (Michelangelo Antonioni, 1960).

3.53 A closer look at the same mix of emotions: Claudia realizes that she is being watched (and judged) in *L'avventura*.

3.54 As the men move closer to her, Claudia begins to worry that these strangers may mean her harm.

3-3c Screen Acting Styles

Though it is not technically an aspect of mise-en-scène, acting is at once dependent upon and a formal extension of design (costumes, makeup, and hair; blocking). The following brief introduction to certain key schools of acting suggests the significance of performance to the larger visual language of the film.

Performance styles evolve in tandem with other formal elements of the medium. Silent film acting resembled stage acting, much as many silent films were set and shot like stage plays. In the absence of dialogue, actors tended to signal emotions with exaggerated gestures and facial expressions. Even the subtlest silent screen acting eschewed realism in favor of heightened emotions; the dramatic superseded the realistic as filmmakers and film actors strived for a larger-than-life performance (fig **3.55**).

With the advent of sound cinema, a more naturalistic style of acting emerged to lend a heightened realism to the medium. But even as gestures and facial expressions became subtler, realism is a relative rather than absolute aim for the screen actor. The goal is to be convincing within the larger world depicted in the film, as two spy films released in the 1960s illustrate. In *From Russia with Love* Sean Connery plays James Bond, a spy with expensive tastes in wine, cars, and women, a swashbuckler who plays by his own rules (fig. **3.56**). Connery plays Bond with an easygoing, "anyone for tennis" style; he is at once unflappable and indomitable ... a supremely suave and confident superspy. The success of Connery's performance lay in the actor's keen understanding of the

▶ **3.55** One of the most respected actors of her generation, Lillian Gish conveys sadness as she holds her dying child in her arms in D. W. Griffith's *Way Down East* (1920). Though less exaggerated in style than most silent screen acting, Gish's performance did not aim for subtlety of expression and gesture.

3.56 Sean Connery as 007 James Bond, the irresistible and irrepressible British spy in *From Russia with Love* (Terrence Young, 1963).

sort of free-wheeling, high-concept action film he is in. Richard Burton's performance as the aging British spy Alec Leamas in *The Spy Who Came in from the Cold* released two years later is by comparison muted and melancholy (fig. **3.57**). Connery's Bond is a man of action; Burton's spy is a quiet, crafty operator. Both performances are successful not because the actors realistically reproduce the character of a British spy during the Cold War—after all most of us have no idea what makes such a person tick—but because they are believable, convincing, and interesting within the context of the respective films.

Many screen actors claim that their goal is a kind of truth, a psychological depth that can only be achieved by really understanding the motivations and emotions of the characters they play. Adherents of "the method" school of acting, for example, draw from personal experience rather than techniques of impersonation. In an effort to produce a fuller, more life-like performance, method actors analyze not only the characters they play within the narrative but their own personal connection to the feelings felt by these characters at different points in the story. When James Dean used "the method" to get at the inner torment of the 1950s suburban American teenager, his every

3.57 Richard Burton as the melancholy British spy Alec Leamas in the screen adaptation of Jon Le Carré's *The Spy Who Came in from the Cold* (Martin Ritt, 1965).

3.58 When the method actor James Dean (as the suburban American teenager Jim Stark in Nicholas Ray's 1955 melodrama *Rebel without a Cause*) shouts: "You're tearing me apart!" his facial expression and hand gestures reveal the depth of his frustration.

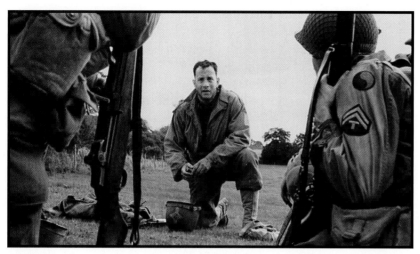

3.59 From the moment we see Tom Hanks as Captain Miller in *Saving Private Ryan* (Steven Spielberg, 1999), we make certain assumptions and have certain expectations about the character he plays.

his portrayal was so powerful many American teenagers took a cue from the character Dean played in the film and displayed a theatrical moodiness to portray their ennui to their parents and teachers.

Finally, screen acting is often rendered secondary to the celebrity status of many of the performers. Audiences have since the advent of the medium found joy in the mere presence of movie stars onscreen. Some stars exude an essential goodness or humanity that audiences identify with and respond to. In Steven Spielberg's *Saving Private Ryan*, for example, from the moment we see Tom Hanks, we know certain things about the character he plays: that he is humble, humane, moral, and resolute (fig. **3.59**). Another star—someone familiar from action films, for example, or someone better known for playing villains—would bring a whole different set of expectations into the mix.

gesture seemed to embody a discomfort in his own skin (fig. **3.58**). His contortions may well seem comical today given the transition to more naturalistic, more self-conscious acting styles, but in his day his performance proved nothing short of a sensation. Indeed,

Once the set has been designed and built and the actors dressed and placed, the scene must be lit. Indeed, lighting is designed much as sets and costumes are, and this design feature is integrated with the other elements to create the mise-en-scène.

Lighting design can highlight or eliminate shadows; it can brightly illuminate a shot, shroud an image in eerie darkness, or simply mark a time of day or night. It can direct our eyes to a certain portion of the frame, shape our impressions of the characters, or create a mood. Illumination fundamentally facilitates our view of the action on screen, and the way this is done is an important aspect of the visual language of the film.

The cinematographer is charged with lighting design in concert with the film's director. The lighting scheme is then executed by the gaffer, grips, and other crew members on the set. Every shot we see in a film has been lit separately and differently. In each case, decisions are made about how many lights (sources) to use, where to place and aim these lights (direction), and how strong the lights should be (intensity or quality) to allow us to see

the scene as the director intends, to engage us visually with regard to story, theme, and mood.

3-4a **Three-Point Lighting**

The fundamental lighting scheme in Hollywood film production is called **three-point lighting**, after the three sources of light on the subject (fig. **3.60**). The **key (main) light** is the primary lighting source, generally placed in front (though often not directly in front) of the principal object of the camera. The key light is the brightest light in the frame; it takes our eyes to a certain figure or object. The **backlights**, also called **rim lights**, can create

> **three-point lighting** A balanced lighting scheme that employs three points of illumination: a bright light that directs our eyes to the subject (**key light**), a balancing (less intense) **fill light** that softens the shadows created by the key light, and a **backlight** behind the subject to add highlights.

Backlight

Fill light

Camera

Key light

3.60 Three-point lighting.

3.61 Balanced three-point lighting makes actress Rita Hayworth glow in Charles Vidor's *Gilda* (1946).

low-key lighting A lighting scheme that emphasizes key light and diminishes or sometimes eliminates fill and backlights. Low-key lighting creates greater contrast between the light and dark areas in the frame.

high-key lighting A lighting scheme that typically uses fill and backlights to lessen the contrast between the light and dark areas in the frame.

a halo effect if they are pointed at a character. But even when used more subtly, backlights can effectively separate visually the object (usually a character) from the background.

Fill lights accomplish what the term implies; using a less intense illumination, these lights fill in the areas not directly lit by the key light. The ratio of key light to fill light creates contrast in the image. Cinematographers refer to **high-key lighting** when the intensity of the key and fill lights are fairly close and there is thus comparatively little contrast between the light and dark areas of the shot; this is how the fill lights are used in three-point lighting. When there is strong contrast between fully illuminated and dark areas of the shot due to a pronounced difference in intensity between the key and fill lights, it is called **low-key lighting**.

When three-point lighting is balanced perfectly, as it is in so much of classical Hollywood cinema, the goal is often glamour instead of realism. In the 1946 film *Gilda* (fig. **3.61**), for example, the actress was lit in a way to convince audiences that Rita Hayworth's character was a *femme fatale*, a woman so beautiful she leads men to ruin. To accomplish the appropriate "look," the cinematographer used a key, or main, light to fully illuminate her face, while fill lights soften the image. The backlights form highlights (the light bouncing off Gilda's bare skin and hair) that produce the aforementioned halo effect, which is ironic here since the character is hardly angelic. The net effect renders the glamorous actress in as flattering a light as possible, which is often referred to by filmmakers as "soft" lighting.

Balanced, high-key lighting was the norm in classical Hollywood because it invited viewers to enter the space of a film easily and seamlessly, to simply *fall into* the world of the film. In more contemporary movies (many of which make frequent use of more high-contrast, low-key lighting for dramatic effect), high-key lighting is often implemented to accentuate the upbeat tone of a scene. For example, in *The Social Network*, we meet the Winklevoss twins—characters who are dismissed by Mark Zuckerberg in the film as upper-class dopes—in high-key, low-contrast light (fig. **3.62**). The lighting is

3.62 High-key, low-contrast lighting introduces the Winklevoss twins as happy-go-lucky jocks in David Fincher's *The Social Network* (2010).

3.63 Mark Zuckerberg, a stormy personality to say the least, is captured in low-key, high-contrast lighting. Here lighting is a design feature that complements the tone and content of the scene.

▶ **3.64** Low-key (high-contrast) lighting in Francis Coppola's *The Godfather* (1972).

one of the cues for the audience to share Zuckerberg's opinion and not to take them very seriously. Their nemesis, the antisocial genius Zuckerberg, is a far more complex (and perplexing) character. When he decides to develop The Facebook on his own, we see him in low-key, high-contrast light, a design element that sets the tone and content of the scene (fig. **3.63**).

3-4b Other Lighting Schemes

Balanced, high-key lighting creates a flattering, accessible, and often upbeat image, the goal of much of classical Hollywood cinema. As we have seen in figure **3.63**, low-key lighting offers an expressive as opposed to ideal lighting scheme.

Low-key (high-contrast) lighting can be used to heighten the sense of tension, as in Francis Coppola's *The Godfather* when the drug kingpin Sollozzo holds the Corleone family consigliere Tom Hagen hostage. A low-key-lit image of Sollozzo's face—which seems to float in a black void—offers an apt visual rendering of a man whose nefarious work in the drug trade has cut him off from legitimate society (fig. **3.64**). When we subsequently see Tom, he is by contrast half-lit, half dark—a telling physical portrait of the family attorney who is at once inside and outside the criminal underworld (fig. **3.65**). Such a bold contrast between light and dark is called **chiaroscuro**, a lighting style used to great effect in many gangster and horror films.

Filmmakers often use **under lighting**, in which a strong source light is positioned below the subject, to create a distorting, unsettling, or horrific effect. For example, in the offbeat suspense film *Blue Velvet*, director David Lynch under lights the gangster Ben, in part to make him look especially creepy but also to reflect Jeffrey's view of the scene. Jeffrey is at this moment

chiaroscuro Dramatic high-contrast lighting that exploits gradations and variations of light and dark in an image.

under lighting A lighting scheme in which the key or source light is placed below the subject.

▶ **3.65** Chiaroscuro, created by light focused from a single source and direction into a dark space, is used frequently in gangster films like *The Godfather*. Though the key light is placed to the side here, as opposed to directly in front (fig. **3.64**), a similarly strong contrast between light and dark areas in the frame is apparent in both images.

3.66 The unsettling effect of under lighting in David Lynch's *Blue Velvet* (1986).

befuddled and afraid; he has been abducted by the terrifying gangster Frank Booth and taken to Ben's apartment, where Ben, at Frank's behest, implausibly breaks into song—Roy Orbison's soaring ballad, "In Dreams." To simulate some sort of strange stage show, Ben turns off the lights in the room and illuminates himself from below (fig. **3.66**). The lighting effect fits the oddball narrative and the unsettling nature of the scene: indeed this theatrical gesture makes little sense to Jeffrey or to us. (This shot also illustrates how the source of lighting can come from a prop within the scene.)

Top lighting, in which the source light is positioned above the subject, tends to be more flattering and more

> **top lighting** A lighting scheme in which the key or source light is placed above the subject.

natural than under lighting. But it too can be used for dramatic effect, as in figure **3.67** from Ridley Scott's *Blade Runner*, where top lighting is used to complete a stylized, postindustrial atmosphere. Note the way the top lights filter into the scene and how illumination from above is used to highlight the smoke billowing up just above the bounty hunter ("blade runner") Holden's head. Notice also how the backlights are used to silhouette Holden, here depicted alone in an office awaiting the arrival of his android adversary, the "replicant" Leon, whom he will subsequently interrogate. The top lights also highlight the chair in which Holden will sit—a seat that will become an important prop in the following scene when he gets too close to the truth about Leon. Scott uses top lighting in this our first view of Holden to keep us at a distance from him—we cannot see him clearly enough to read his face and body language. Top lighting conceals more than it reveals here, creating an atmosphere of suspense. The viewer doesn't know what is lurking in the shadows, which can be unsettling.

A subsequent top-lit shot in the same sequence shows Holden seated across the table from Leon (fig. **3.68**). This lighting scheme does little to "humanize" or distinguish between the two characters: Holden, whom we take to be an authentic human, and Leon, whom we will soon discover, is not. As such it fits the larger themes in play in *Blade Runner*, which is a film about the gray area between real and fake, the distinction between authentic humans and expertly crafted replicants.

3-4c **Tinted Light**

Sometimes filters are used during production to "color" a scene for dramatic effect, as we can see in the example from *Blade Runner*, where grey-filtered light is used to accent the film's dull-metal color scheme and postindustrial look. A common way to accomplish this tinting effect is to place a thin sheet of polycarbonate or polyester, called in the trade a *colored gel*, in front of a

3.67 Top lighting in Ridley Scott's *Blade Runner* (1982).

3.68 Top lighting tends to be impersonal, even clinical, as in this shot from the opening scene of *Blade Runner*.

3.69 Blue filter matches the film's title (and title song) in *Blue Velvet* (David Lynch, 1986).

Lynch's use of the blue gel is literal; it corresponds directly to the song. As such it fits the film's apparent self-reference, the constant reminders that its images and events are artificial and constructed.

An example of a symbolic use of tinted light can be seen in Martin Scorsese's 1973 gangster film *Mean Streets*. As Johnny Boy enters Tony's bar, the scene of his first meeting with criminal company in the film, the scene is bathed in red filter. It is hard to imagine that any bar is lit quite this way, so Scorsese invites us to read the tinted light figuratively, to match our/Johnny Boy's figurative descent into a (criminal) underworld (fig. **3.70**).

In both *Blue Velvet* and *Mean Streets*, color-tinted lights direct us to read the scene in a certain way. As such, the use of color tinting provides a design element and contributes to the narrative.

3-4d Natural and Artificial Light

Though it may seem illogical, filmmakers typically bring in artificial lights even when **natural light** is available. Indoors, light filters into real locations at various intensities through the day, and conventional lamplight is almost always insufficient for the filmmakers to adequately illuminate an indoor set. Even outside in daytime, natural light is not adequate. The position of the sun in the sky changes successively through the day, and clouds and shifting weather conditions also affect the light. It might take hours to film a scene that is supposed to represent only a few minutes of

lighting fixture or window. In *Blue Velvet*, for example, the character Dorothy Valens sings the sixties standard "Blue Velvet" and is captured in a blue light (fig. **3.69**).

natural light The use of natural sunlight (or occasionally moonlight) in exterior or interior scenes.

3.70 Johnny Boy's arrival at a gangster hangout in *Mean Streets* (Martin Scorsese, 1973). The red tint affects the way we read the scene.

3.71 Artificial light creates the effect of sunlight streaming into the side and rear windows of the limousine that takes Sasha Grey to her next appointment in Steven Soderbergh's *The Girlfriend Experience* (2009).

3.72 Natural light as neorealism in Vittorio De Sica's *Bicycle Thieves* (*Ladri di biciclette*, 1948).

neorealism A post–World War II film movement in Italy in which directors adapted the conventions of documentary realism in their fiction films. The best-known neorealist filmmakers are Roberto Rossellini, Luchino Visconti, and Vittorio De Sica.

Dogme 95 A group of mostly Scandinavian filmmakers who signed a manifesto, agreeing to abandon all aspects of Hollywood artifice. They use only hand-held digital video cameras, shoot only in natural light, and add no music.

story time, and to maintain that illusion, the light cannot change. Therefore, sunlight is almost always balanced with strategically placed artificial lights to create the impression of natural light (fig. **3.71**).

When feature filmmakers choose to use unfiltered, unadorned natural light, it is often as much an ideological as an aesthetic decision, as in **neorealist** films like Vittorio De Sica's *Bicycle Thieves* (released in the United States in 1948 as *The Bicycle Thief*). In concert with other 1940s and 1950s Italian directors, De Sica shot in available natural light to more realistically present everyday life in postwar Italy.

The neorealists believed that cinema should tell the truth about the cataclysmic effects of World War II. De Sica endeavored to give audiences a real sense of what Rome (circa 1948) might have looked like on a sunny late afternoon, in this case the fateful sunny late afternoon when the forlorn father (in the foreground in fig. **3.72**) fulfills the promise of the film's title and in desperation steals a bicycle. Unlike the image of Sasha Grey in figure **3.71** in which natural light is simulated to soften the image, the natural light in *Bicycle Thieves* seems hard and harsh—the cold light of day, so to speak—which rather suits the unvarnished and raw reality of the film.

More recently, **Dogme 95** filmmakers like Lars von Trier (*The Idiots*; see fig. **3.73**) and Thomas Vinterberg (*The Celebration*, 1998) have vowed to eschew artificial light to create, per De Sica and the neorealists, an unmediated representation of contemporary reality. For these Dogme 95 filmmakers, their commitment to realist aesthetics (formulated as a set of principles or dogma that goes beyond issues of lighting) is meant to comment upon and provide an alternative to a popular, fantasy-based commercial cinema that seems to them to be dominated by fabrication and falsehood.

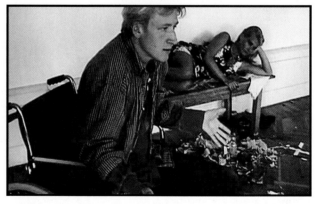

3.73 An interior shot in natural light in Lars von Trier's *The Idiots* (*Idioterne*, 1998). The director adhered to the austere tenets of Dogme 95 in which no artificial "movie" lights are used.

CHAPTER SUMMARY

The design elements of a film—the set design, hair, makeup, costumes (wardrobe), the staging of scenes, and lighting—combine to create its mise-en-scène. Together with camera work, the mise-en-scène is a key aspect of film composition.

3-1 THE SET

Learning Outcome: *Describe the function of set design in the visual language of a film.*

- Sets are a significant part of the design scheme of a film and are typically meant to suggest the larger real space in which a story takes place. The set can be constructed or it can be a real location.

- The set plays a crucial role in transporting the filmgoer to a specific place, whether in the historical past or in the present or in an imagined place, and in providing insights about the characters' situations.

- In science fiction, futuristic, and fantasy films, the film set establishes a "creative geography" in which the story takes place.

- Contemporary filmmakers may use CGI to enhance or wholly create the set.

- For a handful of films, sets are deliberately artificial or stylized in order to serve an expressive purpose, such as evoking a character's mental state, making a creative argument about life in the future, or calling attention to the constructed nature of film.

- A prop can play an important role in a film: it can be the source of a gag, the object of a quest, or a clue for a character and/or the film viewer.

3-2 COSTUMES, MAKEUP, AND HAIR

Learning Outcome: *Analyze costumes, makeup, and hair with regard to character development and visual style.*

- "Human design" (costumes, makeup, and hair) helps transform actors into the fictional or historical characters they play on the screen.

- In some genres (horror, science fiction, and historical dramas) the transformation can be especially dramatic.

- Costuming, makeup, and hairstyle can tell us about a character's social standing, occupation, and attitude toward life.

- Costuming, makeup, and hairstyle can also communicate a character's transformation over time, whether the result of age or a change in job or social status.

3-3 BLOCKING AND PERFORMANCE

Learning Outcome: *Analyze blocking and performance with regard to design and narrative.*

- For most Hollywood movies, the movement of actors is meant to appear natural, but in fact the actors move to specific marks on the floor responding to preset lines of dialogue or scripted physical actions.

- Blocking communicates information about relationships among characters, including which character controls the dramatic situation.

- The blocking of human figures in a scene can be part of the larger design of a shot so that the figures are aspects of the setting, decorating the landscape.

- Though it is not technically an aspect of the mise-en-scène, acting is at once dependent upon and a formal extension of design (costumes, makeup, and hair; blocking).

- Acting styles evolve in tandem with other formal elements of the medium.

3-4 THE LIGHTS

Learning Outcome: *Recognize how lighting schemes contribute to aspects of design and narrative, mood and meaning.*

- Three-pointing lighting is the fundamental lighting scheme in Hollywood film production. The three types of light used are (1) key, or main, lights, (2) fill lights, and (3) back, or rim, lights.

- When we analyze lighting, we focus on source, direction, and intensity (alternatively called "quality"). Low-key and high-key lighting schemes produce different levels of contrast between light and dark areas in the frame. Low-key lighting produces greater contrast, including dramatic chiaroscuro. High-key, low-contrast lighting tends to be more balanced, more flattering, and/or more upbeat.

- Lighting can be tinted to cast colors on the set and characters, and these colors can have significance to the meaning of the story.

- Even when the filmmaker uses natural light to give the film a more natural or realistic look, artificial lights may also be needed. Some directors are committed to realism and avoid the use of artificial lights as part of their filmmaking philosophy.

FOCUS on Mise-en-Scène: *Psycho*

Let's look at how various design elements work together in a single image from an early scene in Alfred Hitchcock's 1960 suspense film *Psycho*. This shot is from an encounter between Norman Bates, the lonely psychopath and proprietor of a motel that has seen better days, and Marion Crane, an unlucky guest who will soon be killed by Norman. The scene is set in the parlor adjoining the motel office where the two meet for a snack; they discuss Norman's hobby, taxidermy. It seems at first an innocuous little conversation between a shy young man and an attractive woman who is clearly out of his league. But there is more to this little conversation than meets the eye, as implied by the mise-en-scène. A close reading of this shot tells us a lot about Norman and foreshadows his next, rather unhappy encounter with Marion in the bathroom of her motel room.

Norman's makeup and hair are unremarkable. The scary thing is that he looks ordinary. If he looked odd, Marion would pack her bags and leave.

Norman's face is half lit and half dark, also a result of low-key lighting and also suggestive of his dual nature.

Norman is pinned in the corner of the set. "We are all in our private traps," he remarks.

While the brass candlestick and chest of drawers do little more than decorate the set, the stuffed bird is an important prop. Marion's last name is Crane (like the bird). And while Norman "eats like a bird," he also shares (with some species of birds) a predatory nature.

The way Norman sits (his hand tucked between his legs), his mannerisms, and hand gestures are elaborate, birdlike, and feminine. He is, in 1950s parlance, a momma's boy, though not necessarily in the way we expect.

Norman wears a sports jacket but no tie. The open collar is at once informal and boyish. It speaks to his arrested development and (for 1960) to the informality of the Bates Motel.

A prominent shadow is the result of low-key, high-contrast lighting that is used frequently in images of Norman in the film. Norman has a dark side; one might say a dual personality. The shadow here hints at that.

ANALYZE MISE-EN-SCÈNE

Use these questions to analyze how the basic elements of mise-en-scène contribute to the visual style and story content of a film. For a close analysis, it is better to pick a single image or scene. Begin by thinking about the overall effect of the mise-en-scène, and then focus on individual design elements.

- What do you learn about the story and characters—without the use of dialogue?
- Does the mise-en-scène attempt to be realistic or is it deliberately artificial?
- What emotional effect does the mise-en-scène have on you?

3-1 THE SET	• Take note of the interior and exterior architecture, furnishings, and props in the scenes. • What larger location for the story is suggested by these elements? • What time period is evoked? • What does the set tell you about the characters' personal lives and interests, working conditions, or social and economic status? • Does the set design represent an imaginary place and, if so, how might this be connected to a larger creative argument? • Is the set deliberately theatrical or artificial, and why? • Are there any key props in the scene, and how are they used? Do they provide clues to the action or have symbolic meaning?
3-2 COSTUMES, MAKEUP, AND HAIR	• If you are familiar with the off-screen look of the actors in this scene, how have they been transformed by wardrobe, makeup, and hair? • What can you tell about a character's social standing, occupation, and attitude toward life from his or her appearance? • Does the character change over the course of the film, and what role does costume, makeup, and hair play in commenting on this transformation?
3-3 BLOCKING AND PERFORMANCE	• Where are the characters sitting or standing in relationship to one another? What does this positioning tell you? • If the characters move around the scene, what meanings do those movements convey? • Does one character visually dominate the scene? • Do any of the human figures function purely as design elements in the scene? If so, what role do they play in the larger meaning of the scene?
3-4 THE LIGHTS	• Does the lighting direct your eyes to a certain figure or object? • Has the filmmaker used under lighting or top lighting to dramatic effect? • Are there sharp contrasts between light and dark areas in the frame? • Is a character shown in hard or in soft light? • Does the scene appear to have been shot in natural light, and is that choice an aspect of the film's meaning?

4 CAMERA WORK

Todd Haynes's *Far from Heaven* (2002), cinematography by Edward Lachman

The first stage in developing the visual language of a film is performed by the production design team. The next major creative step involves camera work. Indeed the camera crew's fundamental role is to capture dynamically the design elements of the mise-en-scène. What is unique to cinema is that the camera positions us as viewers of the mise-en-scène, governing our perspective on a scene. This perspective, importantly, depends a lot on what we see and how the filmmaker has chosen to show it to us.

The cinematographer works with the director to design and execute the film's camera work. In addition to making lighting decisions (see chapter 3), cinematographers make choices about where to place and how to aim the camera, whether and how to move it through the scene, and what kind of lens and film stock to use. Camera work can be so subtle that we seem to be simply, casually, even uncritically watching the action on screen. Or it can be obvious, as the camera tilts off its axis, as it moves through the set to simulate the point of view of a character in the film, or as it shifts from live action to slow motion. But whether we notice the camera work or not, the camera is always *doing* something . . . and there are always reasons why. This is a key principle of film analysis, and one that we will explore in this chapter.

MAKING MOVIES

© Kurt Krieger/Corbis

EDWARD LACHMAN ON CINEMATOGRAPHY

Edward Lachman is a cinematographer who has worked on more than fifty feature films. He is credited as the cinematographer or director of photography on such notable titles as *The Virgin Suicides* (Sofia Coppola, 1999), *Erin Brockovich* (Steven Soderbergh, 2000), *Far from Heaven* (Todd Haynes, 2002), and *A Prairie Home Companion* (Robert Altman, 2006). He won the prize for Best Cinematography for *Far from Heaven* at the Venice Film Festival, a film for which he also received an Oscar nomination.

Q1: **What exactly does a cinematographer do?**

A: We work with the director, the art director, and the wardrobe designer to create the style, the look, the feeling of the film. I've always believed that the image is the language of cinema, not words. I try to find the visual grammar and language.

Q2: **Would you talk a little about the process from design to realization of your work?**

A: When I get a script, I look for cues for how to tell the story. For me, I'm always looking for the point of view of the storyteller. Is it an objective point of view outside the world of the film, or is it a personal viewpoint within the story? It's then about the palette, the colors, and the way the camera sees the world through movement. I also consider the location. Every location gives me ideas about what the lighting could be. I want to find what's unique about a location or space or set and discover how I can approach that with light.

Q3: **How do you feel about the increasing use of digital cameras?**

A: Well, I'm from a different generation. I grew up with film. And my eye is trained with film. Some stories can be told digitally— documentaries, for example. But for the big screen I still get more satisfaction out of film. For me the difference between a chemical (film) image and an electronic (digital) image is that a piece of film responds to light like an etching. The digital chip that the image is photographed on is all one plane. And your lights and darks and colors are all on this one plane. I think that gives the image a feeling that has a certain flatness; it doesn't have the depth that, for me, film does. When you see a painting in a museum, you see the brush-strokes. When you see that image digitally you've lost that texture. When I photograph with film I see that depth.

Q4: **Has your experience as a cinematographer enabled you to create a signature style? Or is your goal to create a unique style to fit each film?**

A: Because my background was painting, I've always been interested in different styles. I always felt that each story could be told in its own language. I know there must be certain things—the way I use and understand color—but I really try to approach each film differently.

When William Heise and W. L. K. Dickson first shot films for the Edison Manufacturing Company and brothers Auguste and Louis Lumière first produced their own films at the end of the nineteenth century, about the only aesthetic decision these early filmmakers could make regarded camera placement. They worked with bulky fixed-lens cameras, and their films were limited to a single shot, with one load of the camera (often less than a minute). A brief look at their contrasting approaches offers a useful introduction into how camera placement functions.

The filmmakers working for Edison followed a fairly simple philosophy: each film was designed as a glimpse at (and for posterity, a recording of) a real, live event. Therefore, camera placement had a purely objective, documentary relationship to the subject at hand. The camera in early Edison films was routinely placed at a right angle to the action, as if it (and we) were in a theater audience seated front-row-center. In the 1896 film *Cockfight*, such a position was literalized; we watch the cocks fight through a wire cage, much as we might have if we were present at the live event (fig. **4.1**). The irony here is that we are not witnessing a live event; indeed, unlike the Lumières brothers, who took their camera to the events they documented, Edison staged this and most of his other early films at his Black Maria studio.

For the 1896 film *The Kiss*, the Edison filmmakers again placed the camera at a 90-degree angle to the action (fig. **4.2**). The filmmakers paid little attention to dramatic staging; the action takes place against a flat black background, which was typical of portrait photographs of the time. This kiss, the first ever on film, was actually taken from a scene in a popular stage play, *The Widow Jones*, but it seemed at the time less like a dramatic moment from a fictional story than a documentary of a certain physical act. Indeed censors viewed the film as the nonfiction capture of an intimate act and so reviled the image that they called for a ban not only of this film but of the entire medium.

The Lumière brothers were also limited to a single load of the camera, a single mono-focus lens, and restrictions on camera movement, but they were from the start more interested than Edison in the dramatic potential of camera work. In their most famous short film, *L'arrivée d'un train* (*Arrival of a Train*, fig. **4.3**), they positioned the camera at an acute angle and at eye level, as if it were a person waiting on the platform. This is no longer an objective camera, placing the viewer on the sidelines, but a subjective one, giving the viewer the sense of being in the scene.

As a result of choices regarding camera placement, these two early cinema pioneers created very different aesthetics and audience dynamics. Audiences for the Edison shorts tended to view the films as recorded live events to which they had been given privileged access. The Lumière brothers cleverly placed the filmgoer in the space of the film, prompting a moment of real drama.

4.1 We watch *Cockfight* (Edison, 1896) much as an attendee at the live event might have at the time, assuming he or she had a really good seat.

4.2 Placed in front of a flat, black background, the actors May Irwin and John Rice are captured in a style consistent with portrait photography. *The Kiss* (Edison, 1896).

4.5 The director Orson Welles captures the actor Orson Welles in a distorting low-angle shot. The superficial ugliness of the image implies the true nature of the unscrupulous and unsavory character (*Touch of Evil*, 1958).

▶ **4.3** Legend has it that early French filmgoers cowered as the train seemed to come straight at them. *Arrival of a Train (L'arrivée d'un train,* Lumière brothers, 1896).

4-1a Angle

When we talk about the angle of a shot, we refer to the placement of the camera in relation to the subject and not the position of the subject of the shot. So, for example, a **low-angle shot** denotes a camera placed below the subject, pointing up. The reverse, a camera placed above the subject pointing down, produces a **high-angle shot.**

Low-angle shots tend to exaggerate size, especially for subjects placed relatively close to the camera. Filmmakers often use low angle to imply authority or to grant a character a semblance of gravitas or menace.

In the Coen brothers' *No Country for Old Men*, the hit man Anton Chigurh is repeatedly shot in low angle, systematically marking him as an intimidating, looming figure (fig. **4.4**).

Low-angle images are often unflattering. Filmmakers occasionally use low angle, then, to depict something essentially unpleasant about a character. In *Touch of Evil*, the director Orson Welles cast himself as the corrupt police captain Hank Quinlan, who finds himself in a struggle with a squeaky-clean and handsome rival (a Mexican-born policeman named Vargas, played by the good-looking leading man Charlton Heston). Quinlan has, as his former lover points out, been "eating too many candy bars" (Welles wore a padded suit), and he has been drinking way too much, burying his sadness over his wife's death in excess. Welles uses low angle to create a grotesque image of a grotesque character, and he uses the physical ugliness exaggerated by the low-angle shot to infer the ugliness inside the tortured, racist policeman (fig **4.5**).

Though low angle tends to be unflattering and thus is often connected with the monstrous or unsavory, it can also be used to confer authority, royalty, even divinity. In Luc Besson's epic *The Messenger: The Story of Joan of Arc*, Saint Joan's destiny—her inevitable leadership and her ascendance to heaven—is first marked in a series of low-angle shots as she rallies her followers (fig. **4.6**). Her voice may crack as she gives instructions to the men—she is after all just a teenager—but the way she is shot against a cloud-dappled sky conveys an otherworldly authority.

▶ **4.4** Anton Chigurh, a man with bad intentions, in Joel and Ethan Coen's *No Country for Old Men* (2007). The low-angle shot conveys an ominous tone.

low-angle shot A shot made by placing the camera below the subject, angled upward.

high-angle shot A shot made by placing the camera above the subject, angled downward.

4.6 A low-angle shot of the heroic Joan of Arc as she prepares to lead her followers in battle. *The Messenger: The Story of Joan of Arc* (Luc Besson, 1999).

4.7 The movie star Rita Hayworth in flattering high angle in Orson Welles's *The Lady from Shanghai* (1947).

▶ **4.8** A high-angle shot in *No Country for Old Men* confers insignificance and vulnerability. It also toys with aspects of scale: the seemingly small man, the big boats.

What made the fighting *men* of fifteenth century France follow a teenage girl into battle? What made them believe in this peasant girl's claims of divine inspiration? The answer to these questions can be found in

the simple but effective camera work that presents the legendary figure as "larger than life."

High-angle shots, on the other hand, tend to be more flattering, and they also tend to humanize in part because they diminish size and scale. If the camera puts on ten pounds, high angle tends to diminish that effect. This is why we often see high angle used to shoot attractive movie stars; it's a flattering visual style for folks used to flattery. In Orson Welles's *The Lady from Shanghai*, the movie star (and the director's soon-to-be ex-wife) Rita Hayworth gets the full-star treatment in a beautifully lit high-angle shot (fig. **4.7**).

High angle is also used to manipulate scale within the shot. While low angle exaggerates the size of figures against the background, a high-angle shot dwarfs them. We can see how this works by looking at a high-angle shot from *No Country for Old Men*, with the same basic content as the low-angle image discussed previously: a character standing in front of a store with a prominent sign. The hired gun, captured in low angle in figure **4.4**, looms large and thus appears menacing, his intentions ominous. The high-angle image in figure **4.8** dwarfs its subject, who seems captured in the crosshairs of an assassin's gaze (simulated by high angle looking down on him). High angle here signals the subject's seeming (in)significance and also his vulnerability.

High angle, which can provide a bird's-eye view of a scene (fig. **4.8**), was a popular technique for shooting song and dance numbers in musicals of the 1930s. This use of high angle, made famous by the choreographer-director Busby Berkeley, presented vertiginous, kaleidoscopic images of perfectly synchronized dance routines (fig. **4.9**).

What is most interesting about the high-angle shots in early musicals like *42nd Street* is how they positioned the audience, reproducing the point of view of someone seated in the balcony peering down at the stage. Such a camera point of view highlighted the qualities of performance and artifice, leaving little doubt that what we are watching is essentially a performance.

While such an emphasis on performance fits movie musicals, dramatic films often depend on the impression

4.9 One of Busby Berkeley's perfectly synchronized production numbers in the 1933 musical *42ⁿᵈ Street* (Lloyd Bacon).

4.10 Charlie (left) and Terry (right) Malloy ponder the past in Elia Kazan's *On the Waterfront* (1954). The director's emphasis on natural, organic performances required an unobtrusive visual style, as in this simple but effective eye-level shot.

that what we are watching is unfolding naturally before our eyes. To create such an impression, filmmakers can employ the **eye-level shot.** Eye-level shots imply a connection between the viewer and the characters on screen, with whom we share a space and into whose eyes we can directly peer. Take for example a pivotal scene in *On the Waterfront,* in which the two brothers, the mobster Charlie the Gent (at left in fig. **4.10**) and the former boxer and disgruntled dockworker Terry Malloy, discuss what might have been had Charlie not forced Terry to throw his most important fight. The speech made by the normally inarticulate Terry—"I coulda been a contender. I coulda been somebody, instead of a bum, which is what I am, let's face it"—is all the more poignant because we can scan Terry's wounded face.

Camera angles can be used to affect our experience of a film in subtle ways. But there are occasions when the angle of a shot is so strange, so crucial to the image

eye-level shot A shot made by placing the camera at eye level with the subject.

canted shot A shot made by tilting the camera at an angle on the subject.

long shot A shot that includes the entire person and background or a shot where the subject appears relatively small. Variations include the **extreme long shot** and the **medium long shot**, a shot of a person from the subject's knees up or a shot where the subject is slightly smaller than a medium shot.

medium shot A shot of a person from the waist up, or a shot where the scale of the subject is of moderate size.

close-up A shot of a person's face, or any shot that offers a detail of the subject. Variations include the **medium close-up** (usually face and chest) and the **extreme close-up.**

itself, that we must not miss its significance. Take for example the unusual camera angles used in a key scene in the teen melodrama *Rebel without a Cause.* Jim has just come home after the disastrous "chickie run" in which a rival teenager has died accidentally driving a car off a cliff. Jim wants advice, but his father and mother are not up to the task. First we see Jim in high angle, looking up at the ceiling (fig. **4.11**).

Then we see what he sees: his mother. And we see how he sees her: upside down (fig. **4.12**). Here the camera angle offers a commentary on the action that is hard to miss or misread: Jim feels like he is living in a world turned upside down (in which wrong is right and right is wrong). As his mother descends the stairs, the camera angle continues to rotate from upside down to right side up. During this camera move, the image is serially **canted,** a term used when the framing of images seems tipped to one side or another (fig. **4.13**).

When analyzing the camera angles of a shot, then, the key is to understand and appreciate how camera position frames its subject and in doing so provides a point of view on the mise-en-scène. In a significant way, where the camera is and the angle at which it focuses on its subject governs the way we understand the story.

4-1b Distance

A second important aspect of camera placement is distance, that is, the distance of the camera from its subject. The designations are as follows: **extreme long shot, long shot, medium long shot, medium shot, medium close-up, close-up,** and **extreme close-up.**

4.11 A lonely teenager looking for answers. *Rebel without a Cause* (Nicholas Ray, 1955).

4.12 An upside-down world in which wrong is right and right is wrong.

4.13 An example of canted framing (also known as a Dutch-angle shot), as the image seems to be tipped to one side. The effect is used to simulate Jim's point of view as he rights himself and watches his mother descend the stairs.

The terminology used to delineate camera distance translates literally: an extreme long shot regards a camera placed a great distance from its subject. An extreme close-up denotes a camera placed extremely close to its subject.

The extreme long shot is often used to introduce a given space or place, which is called in the trade an **establishing shot**. When we get a look at the exterior of a building (often from a distance, thus the extreme long shot) and then see a scene played out in a room, we assume that the room is inside the building, even though in reality it might be on a soundstage on a studio lot.

The extreme long shot is also used to establish geographic setting, especially in movie westerns. Note how the extreme long shot renders the human figures small against the natural background in *The Searchers* (fig. **4.14**). Director John Ford uses the shot to highlight the natural majesty of Monument Valley and to underscore the challenge it presents to the characters trying to "tame" such a vast and rugged land.

A long shot—in which the camera is closer to the subject than in the extreme long shot but still far enough away that the entire human body or other full figures are shown—might also be used to establish location, though that is not its only function. Long shots can be used in musicals to reproduce the dynamic of stage performance; the filmgoer is given a view of the action similar to what he or she would have in a theater (see fig. **4.9**). Long shots are also used in fight sequences, especially in contemporary

establishing shot, also **master shot** A shot that orients the audience for the scene that follows.

▶ **4.14** An extreme long shot in *The Searchers* (John Ford, 1956).

4.15 The hero (screen right) and his nemesis face off in the climactic fight sequence in *Romeo Must Die* (Andrzej Bartkowiak, 2000).

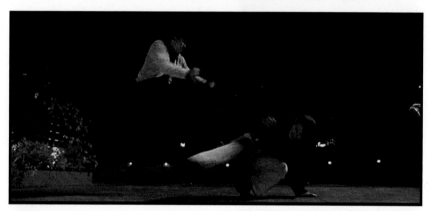

4.16 Attack and parry . . . captured in a long shot.

4.17 A telling blow, again in long shot.

martial arts films in which hand-to-hand combat is choreographed like a dance sequence in a musical. In the climactic fight between the hero, played by Jet Li, and his nemesis in *Romeo Must Die*, the action is best captured in a series of long shots (figs. **4.15–4.17**).

two-shot A shot with two people.

Directors often use long, medium long, or medium shots to frame a **two-shot** (a shot composed of two people in the frame). The difference between these types of shots is how much of the human figures we see. In a long shot we see the characters in full figure. In a medium long shot the characters are often cut off just below the waist (fig. **4.18**) or are shown seated. The difference between the medium long and the medium shot is fairly subtle, especially if the figures in the frame are themselves small (which may depend on the type of lens used; more on that later in this chapter). The key here is that both the medium long and the medium shot are used frequently in filmmaking because they let viewers see what the characters *and* their surroundings look like. Because they lack the grandeur of long shots and the intimacy of close-ups, there is something natural or naturalistic about them.

Medium shots are meant to situate characters in an environment and/or in relation to other characters. As such they can be revealing and dramatic. In *Aguirre: The Wrath of God* (fig. **4.19**), we see in a medium two-shot a conquistador in full armor and a native Indian playing a pan flute. The medium shot offers a glimpse at the conquistador's expression (a combination of disdain and bewilderment) and the musician caught up in his music. The background reveals the physical and cultural space between the two characters; it also suggests that one clearly belongs in the setting, and the other doesn't.

The medium close-up brings us close enough to the character to easily read his or her facial expression. In *Raiders of the Lost Ark*, the opening action sequence is set up by a medium close shot of Indiana Jones looking at a golden idol (fig. **4.20**). We read a combination of worry and anticipation in his face, as if he knows something is going to happen, but he is not sure what. Because the camera has taken us close to Indiana Jones, we are caught up in his emotions.

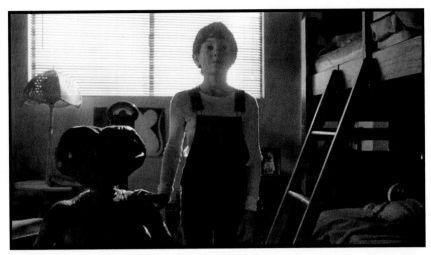

4.18 A boy and his . . . Elliot and E.T. in a medium two-shot in *E.T.: The Extra-Terrestrial* (Steven Spielberg, 1982).

4.19 A conquistador tries to fathom a native Indian in the jungles of South America in a medium shot from Werner Herzog's *Aguirre: The Wrath of God* (*Aguirre, der Zorn Gottes*, 1972).

4.20 Indiana Jones in medium close-up. We are keenly aware of how he feels and what the idol means to him. *Raiders of the Lost Ark* (Steven Spielberg, 1981).

There is a story about the advent of the close-up that is worth telling here, though it may not be true: when the pioneering early cinema stylist D. W. Griffith first captured his characters in close-up, studio management groused, "We paid for the whole actor." Griffith understood what these businessmen did not. In *Way Down East*, for example, as the heroine begins to suspect that her secret marriage may not have been "real," though the baby inside her is, Griffith uses a close-up to show us what she's feeling and thinking, and in doing so he presents the drama as hers (fig. **4.21**). We read the scene and the dramatic situation with her welfare in mind.

On the big screen close-ups can be jarring. They give us an intimacy with a character but tend to stop the action cold. Close-ups and extreme close-ups obliterate background; they pull the characters out of the set and setting (fig. **4.22**). They offer characters alone in their thoughts (or somehow cut off from others). This impression of isolation is why close shots are used so frequently in horror films, because characters in such films often find themselves alone with a monster. For registering emotions conveyed primarily through the eyes, the extreme close-up is a powerful tool (fig. **4.23**).

It is important to understand and appreciate how camera distance affects how we see a shot and by extension how we are likely to read that shot. If the camera is placed far away, we get a more complete view of the geography in play, but we don't get a good look

at the characters who occupy that space. We need to see them better for that—the camera needs to get us closer for that. When a camera is placed close up to its subject, we recognize and appreciate that we have been granted access; we can read the characters' faces, which then key us to what they're thinking or how they're feeling at that precise moment. But despite such access, when the camera is close to its subject, we lose what the long shot gives us: context, geography, the set, as well as the setting.

4-1c Off-Screen Space

We have looked at how camera angle and distance play a role in the framing of the image on screen. The frame—which film theorists describe as the "arbitrary rectangle" formed by the boundaries of the movie screen—positions us as viewers of the mise-en-scène, governing our perspective on a scene. This perspective, importantly, depends a lot on what we see and how the filmmaker has chosen to show it to us. But as is often the case, what we can't see (and maybe want to, maybe need to, to feel better or simply understand a scene more fully) can be important as well.

Alfred Hitchcock was especially adept at using **off-screen space** in his suspense films. In the famous shower scene in *Psycho*, for example, the very limitations of the frame heighten the suspense. In the shower, Hitchcock isolates Marion in the lower right portion of the frame (fig. **4.24**). The remainder—that is, the space surrounding the subject, often called negative space—is empty and undefined.

What exists on the other side of the curtain (the off-screen space) is what concerns us here. But we wait ... the essence of suspense, after all, are things suspended, actions delayed. And then, entering from outside the frame and from outside the bathroom, we see a figure filling the space on the other side of the opaque curtain, knife at the ready (fig. **4.25**). Hitchcock cuts to the killer, and now Marion is in the off-screen space. Here off-screen space implies point of view; we are seeing the killer as Marion does, and we experience the menace along with

off-screen space The space in a scene that the audience cannot see but knows to contain someone or something of importance to the story.

▶ **4.21** A close-up in D. W. Griffith's 1920 melodrama *Way Down East*. Note the beautiful use of blue tinting in the shot, which was the result of dipping the positive print in a dye.

4.22 A close-up of the actress Charlotte Rampling in Liliana Cavani's *The Night Porter* (*Il portiere di notte*, 1974). Note how the close-up (and the evocative use of selective focus, discussed later in this chapter) pulls the character out of her surroundings.

4.23 An extreme close-up draws our attention to the longing in Bonnie's eyes in Arthur Penn's *Bonnie and Clyde* (1967).

4.24 The famous shower scene in *Psycho* (Alfred Hitchcock, 1960). Note how the empty space, screen left, cries out to be filled.

4.25 The killer enters the bathroom prepared to strike. The impact of this image depends on what we know to exist outside this frame: Marion, nude and defenseless in the shower.

4.26 Here the close-up on Marion screaming suggests bodily injury that we imagine or envision but can't see because that portion of her body is off screen.

her. The next shot in this sequence shows Marion in an extreme close-up, screaming in pain and fear (fig **4.26**). This shot's impact comes from what we can see (Marion's face) but also what we can't see (the killer). Our imagination supplies an image of her wounded body, while the fact that we can't see her attacker heightens our anxiety.

When we watch a movie, we by necessity focus on framing on the go. Some images stick in our minds more than others, but it is important to appreciate that the framing of each shot is the result of conscious choices about camera angle, distance, and on-screen/off-screen space.

4-2 CAMERA MOVEMENT

Early cinema is distinguished by moving images captured by a stationary camera. But it was only a matter of time before someone figured out how to make the camera move and still attain focused, watchable images. One of the first moving-camera sequences comprises the entire 3-minute running time of the 1903 film *The Georgetown Loop*. The filmmakers placed a camera on a train car and filmed a particularly dramatic run of tracks in the Colorado Rockies (fig. **4.27**). Among the sights were a handful of no doubt chilly passengers waving at the camera from the observation stand of the caboose and, as the train navigated the various switchback turns, the front cars.

There is no plot or apparent point to the film except the gee-whiz factor produced by moving the camera. At least initially, the moving camera produced a new sensation for a new medium. Eventually it would be used not only for sensational effect but also to allow us as

filmgoers to enter and move around in the space of the film more fully.

4-2a The Tracking Shot, Dolly Shot, and Steadicam

In the century or so since the introduction of the moving camera, filmmakers have developed a number of ways to move the camera though the set, including mounting it on a dolly (a cart) that can then be moved across tracks that the camera crew puts down (fig. **4.28**). The result of this moving-camera technique is called a **tracking shot**. A

> **tracking shot** A shot produced with a camera that moves smoothly alongside, behind, or ahead of the action.

4.27 Camera movement circa 1903. *The Georgetown Loop.*

4.28 The camera crew executes a tracking shot during an action sequence in the fifth installment of the *Fast and Furious* series, *Fast Five* (Justin Lin, 2011). Tracking shots allow for the smooth capture of a shot from the side of, in front of, or behind the action.

4.29 Shooting a Steadicam sequence during the production of Terrence Malick's *Tree of Life* (2011).

▶ **4.30–4.32** A moving-camera shot begins with a handshake outside the Copacabana nightclub and ends three minutes later with Henry and Karen seated at a table up close to the stage. This is just one of several bravura moving-camera sequences in *Goodfellas* (Martin Scorsese, 1990).

slightly modified version of the tracking shot is the dolly shot, a more modern technique in which the dolly moves freely along the floor (absent tracks). Though it is imprecise, the term *tracking shot* is often used to describe any shot that moves smoothly alongside, behind, or ahead of the action, even when a track is not used.

A third technique used to attain fluid camera movement was introduced in 1976: the Steadicam shot. Essentially a stabilizing apparatus worn by a camera operator, Steadicam delivers the image steadiness of a tracking or dolly shot in spaces where a dolly isn't practical, such as on stairs, through crowded rooms, and in the shallow end of the ocean (fig. **4.29**).

Moving-camera shots are used to "open up" cinematic space, to present a dynamic view without resorting to a stationary long shot or a series of cuts. Director Martin Scorsese is known for using moving camera

4.33 The opening image—close-up of a bomb being set—in Orson Welles's *Touch of Evil* (1958). Camera movement takes us from this first image, through the streets of the border town and the border checkpoint, to the explosion of this device in a car traveling from Mexico to the United States.

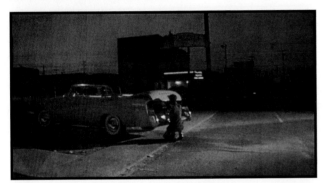

4.34 The plot of the film hinges on the identity of the bomber, but we see him only from behind and from a distance.

4.35 A crane shot shows us a man and a woman entering the car, clearly unaware that a bomb is in the trunk.

4.36 As the car heads towards the border crossing, it passes by a Mexican policeman and his American wife. Both of their lives will be impacted by the explosion that punctuates this opening moving-camera shot.

to expose the setting for a film's story more fluidly. In *Goodfellas*, the gangster Henry takes his new girlfriend Karen to the Copacabana nightclub where, she and we discover, he's a VIP. The moving-camera sequence (executed by the film's Steadicam operator) introduces Karen and the viewer to a wondrous new world—a new world that begins with a handshake (and a big tip) outside the club, continues as we walk in through a service entrance and venture through the kitchen (where everyone knows Henry), and ends at a table set up just for them at the very edge of the stage (figs. **4.30–4.32**). At the end of this moving-camera shot, Karen is suitably impressed (as are we); she discovers, as Scorsese himself described the shot, that all doors are open to Henry. She is seduced by Henry, by the Copacabana, and by a new lifestyle. We are seduced as well, by the exhilarating camera movement that carries us into Henry's world.

One of the most famous moving-camera sequences in film history opens Orson Welles's *Touch of Evil*. This nearly four-minute **long take**—a term used to describe a particularly long duration of screen time between two

cuts—begins with the setting of a bomb in the trunk of a car (fig. **4.33** and **4.34**). Once the bomb is set and placed in the car, Welles executes a dramatic **crane shot** that takes us over a block of buildings to an adjacent street (fig. **4.35**). The crane then drops the camera down to a less dramatic high angle where a tracking shot follows the doomed car as it passes by the film's hero (a Mexican policeman who investigates the crime) and his wife, who will become the target of a Mexican gang and a crooked American policeman (fig. **4.36**).

A street-level camera tracks the car and the policeman and his wife as they all meet up at the border crossing (fig. **4.37**). Like all good opening sequences, this one introduces the principal characters and brings them

long take A single continuous shot of unusually long duration.

crane shot An aerial or overhead shot executed by a camera operator on the platform of a moving crane.

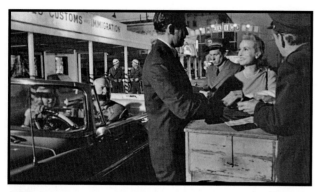

4.37 When the woman in the car says, "I've got this ticking noise . . . in my head," no one pays attention . . . except us.

4.38 We watch for nearly four minutes before Welles cuts to the second shot in *Touch of Evil*.

briefly together. By happenstance their lives have suddenly intersected, a meeting-up that is punctuated as the tracking shot finally ends. We hear the sound and then cut to the image of the car exploding on screen (fig. **4.38**).

The challenge in executing such a long and complicated moving-camera sequence is that the entire shot can be ruined by a single mistake such as a flubbed line of dialogue or a light or wire or crewmember caught in the shot as the camera moves through the set. There is a complicated choreography for the actors and crewmembers, all of whom have to be in synch with the camera.

4-2b Subjective Camera

When following an entrance into a magical new space, as in *Goodfellas*, or a chain of events, as in the example from *Touch of Evil*, the moving camera simulates third-person narrative point of view. Moving camera can also be used to approximate first-person or **subjective point of view**, so that we see the world through a character's eyes as he or she moves through the world of the film.

subjective point-of-view shot A shot that simulates what a character sees.

4.39 The opening shot of *Halloween* (John Carpenter, 1978).

4.40 Throughout the Steadicam sequence, we share the killer's point of view.

4.41 The murderous intent becomes clear.

In the horror film *Halloween*, John Carpenter opens with a moving-camera sequence from the subjective viewpoint of an unknown character. The first thing we see is what the character sees, the Myers' house (fig. **4.39**). The camera approaches the house; the Steadicam shot matches the character's movements. We stop at the window and look in: a young woman and her boyfriend are kissing (fig. **4.40**). The music and lighting signal from the start that something bad is afoot, but it isn't until we enter the house and walk into the kitchen that we know exactly where the sequence is heading. Much as we would see our own hand as we reach into a drawer, we watch as the character's hand enters the frame and grabs a kitchen knife (fig. **4.41**). A second, similar action occurs after we ascend the stairs. We see a mask and then we see a hand reach out and grab it. The character then pauses to put the mask on, and the rest of the sequence is shot through (and thus simulates

4.42 We see what the killer sees and anticipate the violence that follows.

4.43 The subjective camera sequence gives way to a more traditional third-person viewpoint as we see the killer in his Halloween costume.

the act of looking through) the eyeholes of the mask (fig. **4.42**).

We turn a corner and see a young woman, mostly undressed, brushing her hair, seated in front of her mirror. She cries out a name: "Michael." She clearly knows her assailant and we gather he is not welcome in her room. Through the mask we watch as "Michael" attacks the young woman with the knife. Michael stabs at her relentlessly until she slumps over, bloodied and presumably dead.

We then accompany Michael back down the stairs and out the front door. The subjective moving-camera sequence ends only after we exit the house and walk to the street to meet a car that has just pulled up. We finally switch from first- to third-person point of view to see the unmasking of the assailant. The payoff is that the killer, whose point of view we have briefly shared, is just a child (fig. **4.43**).

The use of subjective camera here is complex and effective. The key to the sequence is the revelation at its end—that the killer is a little boy, the victim's brother. This secret can only be kept by taking the little boy out of the frame, by showing the scene through his eyes. Some film critics have argued that the subjective camera implicates the filmgoer in the crime. This seems a bit of a stretch. Much of the rest of the film endeavors to make clear that Michael is a monster, beyond reason or redemption. The notion that *we* are somehow *him,*

despite the analogy created by subjective camera, is not supported by the rest of the film.

4-2c Handheld Camera

Steadicam enables a filmmaker to move a camera through space and deliver fluid, moving images that can roughly simulate human sight. Another way to gain the same basic effect, albeit with noticeable camera jitter, is for the camera operator to take the camera off its tripod, track, or Steadicam and hold it by hand as he or she moves through the set. This technique became possible with the advent of lighter-weight cameras in the 1960s, the very technological development that fueled a revolution in documentary aesthetics with the *cinéma vérité* and direct cinema movements (see chapter 8-1d). Today, high-quality, low-cost digital video cameras enable fiction filmmakers to include **handheld shots** to simulate real, lived experience. Some filmmakers have used portable cameras and handheld techniques to create a more spontaneous or realistic film style, one familiar to viewers of reality television and DIY videos on the Internet.

Among the first to use this technique in fiction film were the French New Wave filmmakers of the 1960s, especially Jean-Luc Godard. The effect was in many cases more ironic than realistic as moving camera sequences matched, or more accurately deliberately mismatched, documentary filmmaking technique with fictive genre content (from crime, melodrama, and comedy, for example). In *Breathless*, a simple conversation between a gangster, Michel, and his American girlfriend Patricia is presented in a three-minute handheld mobile shot along the Avenue des Champs-Élysées. The scene is at once natural and naturalized, realistic and real. But it is also in a fundamental way comically absurd.

The shot begins as Michel locates Patricia on the famous avenue. We see Patricia much as Michel does at this point, from behind, walking away (fig. **4.44**). The camera moves towards her and once she stops and turns around, the camera catches up, and Michel moves into the frame (fig. **4.45**). We discover at this moment that this is not a subjective camera shot, that the source of the image is not Michel. The two characters continue to walk and talk and the camera follows them. Godard is not interested in the ideal way to film their conversation. Instead he follows them from behind, making the viewer feel like a furtive eavesdropper. Though there is little doubt that we are in a fictional film, the way that

handheld shot A shot made with a portable camera that may show signs of not being mounted, such as jitter or off-center framing.

4.44 An American in Paris. *Breathless* (*À bout de souffle*, Jean-Luc Godard, 1960).

4.45 The gangster boyfriend arrives.

4.46 Cars and people pass by; some even stare at the camera. This is filmmaking on the fly and on the sly as passersby inadvertently become part of the sequence.

4.47 The lovers stop, but not for a kiss or an exit line.

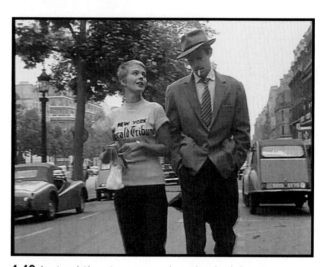

4.48 Instead they turn around, a cheeky joke on film form.

the foot and automobile traffic crosses in front of the camera suggests a documentary style—an impromptu, improvised, realistic style (fig. **4.46**).

In fictional films, moving-camera sequences are often capped by a significant action; the *Touch of Evil* sequence we examined earlier provides a classic example. Godard plays with the assumption that the camera is taking us from one place to another for a reason as Patricia and Michel stop in the middle of the street. He defies that expectation when they don't embrace or kiss or part company (fig. **4.47**). They simply turn around and begin to walk back towards the camera, which now reverses direction (fig. **4.48**). Godard is likely making a little joke on film form by not offering a dramatic pay-off. In *Breathless*, the handheld camera gives the viewer the impression of witnessing something real but mostly insignificant (as most real moments are).

Though the gesture is towards a cinematic realism, in *Breathless* Godard rather cheekily calls attention to how the moving camera might function if the scene in question mattered more. But a larger commentary on film form is in play here, that modern cinema need not be tied to modes of production unique to fictional or documentary filmmaking and, by extension, that the traditional distinctions of fictional genres—gangster, melodrama, and comedy, in this case—need not apply.

A number of contemporary features use shaky handheld footage to suggest another type or style of nonfiction filmmaking: amateur production. We believe that the footage is "real" because it's too badly produced to be fabricated, too amateurish to be "Hollywood." The low-budget horror film, *The Blair Witch Project*, for example, tells the story of some ambitious but inept college film students making an amateur video production. The film that we watch is supposed to be footage that they shot and left behind before they "disappeared." Handheld is used to convince us that the film was shot not by professionals (which it was) and that the footage, frightening as it may be, is real (which it is not). In the film's climactic scene, we watch the action as if we too were looking through the camera's viewfinder (fig. **4.49**). The sloppily framed and poorly focused image is meant to enhance the realism of the handheld shot.

The same basic premise is used in the monster picture *Cloverfield* (Matt Reeves, 2008), as supposed **found footage** produced by a young man initially filming a party catches by accident a supposed real and terrifying event as it unfolds. This sort of pseudorealism—history caught quite by accident—borrows (aesthetically, at least) from the artless amateur handheld footage posted on the web, from lame dog tricks to celebrity sex tapes. *Cloverfield* also alludes to the happenstance capture of significant live events by amateur videographers and photographers, like the disturbing video shot by George Holliday of the Rodney King incident in 1991 and images of the destruction of the World Trade Center in New York City on September 11, 2001.

Used more sparingly and selectively, handheld need not be tied so to cinematic realism. In *The Bourne Supremacy* (2004) and *The Bourne Ultimatum* (2007), Paul Greengrass employs handheld technique in action sequences not so that we read these events as somehow

▶ **4.49** A deliberately amateurish canted handheld shot seen through the camera viewfinder in the stirring climax of *The Blair Witch Project* (Daniel Myrick and Eduardo Sanchez, 1999).

4.50 Handheld simulates the movement of jogging for both the character on-screen and the camera operator behind him. *The Wrestler* (Darren Aronofsky, 2008).

real (they're not, and we know that) but to disorient us. The technique suggests events happening too fast to be captured with a stationary camera.

Handheld can also be used to simulate dizziness, queasiness, or vertigo. In *The Wrestler* we follow the film's battered hero, Randy the Ram Robinson, into the woods for his first post–heart-attack jog. Director Darren Aronofsky employs handheld first to match the side-to-side and up-and-down movement involved in running, as the camera seems to track a few steps behind Randy (fig. **4.50**), then to simulate his loss of equilibrium as he gasps for breath, dizzied by the exertion.

found footage Filmed material that is discovered and used by another filmmaker.

4-2d Pan and Tilt

The camera need not move through space in order to provide the mobile framing characteristic of moving-camera techniques. Far easier and simpler camera movement can be accomplished by panning or tilting. Unlike handheld mobile shots, for pans and tilts the camera is mounted on a tripod. And unlike tracking and dolly shots, the tripod remains fixed in place. A fluid or geared head on the tripod allows for movement 360 degrees laterally (a **pan**) and, practically speaking, vertically, floor to ceiling, ground to sky (a **tilt**). Though the techniques are quite different, it is sometimes difficult to discern a pan from a short tracking shot. Both create a mobile frame and both simulate a presence, either first- or third-person, within the space of the film. The pan (an abbreviation for *panorama*) is often used to simulate an eyeline view as if one's eyes were following an action or searching for something. Like a lateral turn of the head, the pan gives us access to a panoramic as opposed to fixed point of view.

In his 1939 comedy of manners, *The Rules of the Game*, Jean Renoir used mobile framing and shot mostly in natural light to produce a realistic picture of the French aristocracy in the last days before the onset of World War II. The film climaxes with a clever variation on the comedic theme of mistaken identity, only, instead of uniting the unlikely couple, the mistake leads to a senseless murder, one that makes clear the film's larger concerns with the entrenched conflicts between rich and poor, French and foreign-born.

The sequence begins in a garden outside the chateau. The camera pans and then pauses briefly at a greenhouse, where a hooded figure, a woman, waits (fig. **4.51**). The woman is Christine, the Austrian-born wife of a French aristocrat, and she is waiting for any one of several men with whom she has dallied to join her in a clandestine exit from the chateau. The pan simulates an eyeline point of view, but it is not connected to any one character. Instead, like an omniscient third-person narrator, the camera continues to pan (fig. **4.52**) and then stops as it finds two men hiding in the bushes: Marcel (a poacher who has recently taken a job as a servant at the chateau) and Schumacher (the gamekeeper and Marcel's former rival), whom we see holding a gun (fig. **4.53**). When Christine meets her lover, Schumacher mistakes the couple for his own wife (Christine's servant)

pan A lateral camera movement along an imaginary horizontal axis.

tilt An upward camera movement along an imaginary vertical axis.

4.51 The camera pans and stops briefly at the greenhouse in *The Rules of the Game* (*Le règle du jeu*, Jean Renoir, 1939).

4.52 The camera continues to pan as if looking for something.

4.53 The camera finds what it's looking for: two men who furtively await the clandestine meeting in the greenhouse.

and her supposed lover and shoots. The joke, dark as it may be here, is that, despite the pan and its simulation of human sight, one cannot always trust what one sees.

Tilts seem less natural and thus more dramatic than pans if only because the vertical action of scanning from foot to head or head to foot in real life is pretty rude. Indeed, tilts often simulate the act of sizing someone up or assessing someone's attributes, so to speak. In *The Devil's Advocate*, John Milton, the mysterious head of a law firm, tempts Kevin Lomax, a junior associate, with a clandestine after-hours "meeting" with two beautiful women in his penthouse apartment. Lomax turns Milton down, but a simple camera gesture, a tilt obviously aligned with Lomax's subjective point of view, reveals that he is interested (figs. **4.54–4.56**).

The mobile framing produced by the pan and tilt simulates a roving eye. But neither is an exclusively first-person technique. Instead, both serve to naturalize camera point of view, which film theorists have called "the spectator in the text." All of these types of moving-camera and mobile framing techniques simulate a narrator in the space of the film. It is well worth acknowledging here how much we identify with the camera as it looks for or with us.

4.54–4.56 A tilt scanning the bodies of two beautiful women in Taylor Hackford's morality play, *The Devil's Advocate* (1997).

4-3 FOCUS AND DEPTH

While the camera may serve as our eyes on a scene, there are of course differences between what we see by direct observation (with our own eyes) and what a camera captures. These differences concern two key attributes of the shot: focus and depth. While the technical aspects of camera operation are beyond the scope of this chapter, it is nonetheless valuable to appreciate and understand the expressive choices made by cinematographers and movie camera operators to represent, reproduce, and manipulate focus and depth on screen.

4-3a Focal Length

Unlike the human eye, the camera can be adjusted to "see" differently by changing the size of the lens and aperture (the iris, or opening). Lenses are generally categorized according to their focal length, technically speaking, the distance from the optical center of the lens to the

focal point where captured rays of light meet in clear and sharp focus on the film stock or video/digital sensor. The focal length of the lens determines the field of view as they are represented on the flat, two-dimensional screen. With the combination of field of view and distance from the subject, perspective of the shot is thus controlled.

The greater the focal length, the narrower the angle of view becomes (fig. **4.57**). Yet with this greater length comes greater magnification, much like that of a telescope or microscope. We see less of the whole but in more detail.

Wide-angle (short-focal-length) lenses offer, as the name suggests, a wide-angle view of the subjects in the frame. In figure **4.58** from *The Wild Bunch*, a wide-angle

> **wide-angle lens** A lens that allows for a wider angle of view and that can increase the illusion of depth within the shot.

4.57 A line drawing illustrating focal length.

angle of view

focal length

wider angle of view/lower magnification

shorter focal length wide-angle lens

narrower angle of view/ higher magnification

longer focal length telephoto lens

4.58 A wide-angle shot from the opening sequence of *The Wild Bunch* (Sam Peckinpah, 1969).

telephoto lens A lens with greater magnification power that can make objects seem closer to the camera and that can decrease the illusion of depth within the shot.

lens allows the filmmakers to fill the frame with a horizontal group shot of some children torturing a scorpion—a resonant image foreshadowing the savagery to follow. Wide-angle shots can create a greater feeling of depth in the frame, but at a price. For example, in figure **4.59** from *The Age of Innocence*, a wide-angle lens allows us a wider view of the room that Archer enters, but it also distorts the room's dimensions, exaggerating the depth of field. A similar distortion can be seen in figure **4.5**, as Welles combines the use of a wide-angle lens with low-angle camera placement.

The **telephoto (long-focal-length) lens**, with its greater magnification power, can focus clearly on objects a greater distance from the camera. Yet when the camera is placed at a greater distance, space appears to be more compressed, and characters or objects appear closer together than they really are. The telephoto lens brings into sharp focus an object or character in the frame but holding much of anything else in sharp focus at the same time is difficult. A long-focal-length lens is used extensively by Robert Bresson in his character study of a lonely thief in *Pickpocket*. This otherwise anonymous and insignificant man is serially brought into relief as he moves among the crowds in Paris (fig. **4.60**).

Telephoto shots are often used to simulate or represent surveillance, sometimes quite literally showing us what a character in the film sees as he or she peers through a telescope (as in Brian DePalma's *Body Double,* 1984) or a camera with a telephoto lens (as

4.59 We accompany Archer into the first in a succession of anterooms. The wide-angle shot allows us a fuller view of the room but at the same time distorts its dimensions. *The Age of Innocence* (Martin Scorsese, 1993).

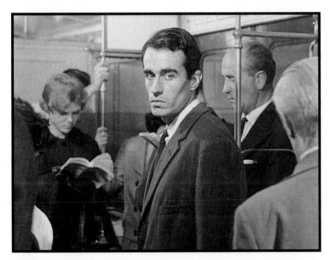

4.60 A long-focal-length lens isolates Michel, a petty thief, to make him appear alone despite the crowd. *Pickpocket* (Robert Bresson, 1959).

4.61 Telephoto shots can be furtive, as in this shot of a girl caught by the camera hiding behind a curtain in *Cries and Whispers* (*Viskningar och rop*, Ingmar Bergman, 1972). Here again only the object of the camera's gaze—the little girl—is held in sharp focus.

in Hitchcock's *Rear Window*, 1954; see figs. **5.62–5.66** in the following chapter). Even when the telephoto is not used so literally, it can nonetheless have a furtive, voyeuristic quality as in figure **4.61**, a stunning telephoto shot in Ingmar Bergman's *Cries and Whispers*, which accompanies an internal monologue about a little girl hiding behind a curtain.

Another type of lens used by filmmakers is the **zoom (variable-focal-length) lens**. Though the camera remains stationary, a variable-focal-length lens simulates movement, either lengthening (a zoom-out) or diminishing (a zoom-in) the *apparent* distance between the camera and its subject.

One of the most famous zooms in American film history accompanies the opening monologue in Francis Coppola's *The Godfather*. The film begins with a close-up on Amerigo Bonasera, an undertaker, as he delivers the film's famous opening line, "I believe in America," then backs away (and opens up) to offer a first glimpse at the Corleone family's seductive and secretive world. The shot lasts for over two minutes and benefits from a computer-timed zoom lens that adjusts incrementally to simulate camera movement (figs. **4.62–4.67**).

As if to provide a counterpoint to the opening zoom-out in *The Godfather*, in his next film, *The Conversation*, Coppola begins with a three-minute zoom-in on Union Square in San Francisco on a sunny afternoon (figs. **4.68–4.72**). The zoom-in simulates a search for something or someone in the frame. In *The Conversation*, a film about illicit surveillance and the routine invasions of privacy enabled by sophisticated video and audio equipment, such a search sets us up for the cat-and-mouse games that compose most of the rest of the film. The opening zoom begins with a long shot that establishes the setting: San Francisco. As the camera zooms in closer, we start to distinguish individuals. First, there is the mime, Coppola's nod to Michelangelo Antonioni's *Blow-Up* (1966), a similarly plotted film that ends with mimes "playing tennis." As the camera continues to give us a closer view, we see a man pass by the mime drinking a cup of coffee. Later we will

> **zoom lens** A lens with a variable focal length that can lengthen (zoom out) or diminish (zoom in) the apparent distance between the camera and its subject.

4.62–4.67 The zoom-out at the start of *The Godfather* (Francis Ford Coppola, 1972).

meet this man: he is Harry Caul, an audio surveillance expert with an obsession about his own privacy. The mime follows Harry through the square, mimicking his walk and his every sip from the coffee cup. Harry does not like the attention; he is a private guy. He finally ditches the mime, and the shot ends as Harry nervously exits the square alone.

4-3b Depth of Field

Another variable under the control of the cinematographer concerns depth of field, which refers to how much

> **deep focus** Describes a shot where both the foreground and background planes are in sharp focus.

of the foreground, middle ground, and background planes are held in focus. The larger the range within the frame between the closest and furthest object held in focus, the larger the depth of field.

Deep focus (large depth of field) involves keeping objects and characters from the foreground through the background in sharp focus. Filmmakers accomplish this look by using short-focal-length or wide-angle lenses, a narrower aperture, faster film (which can produce sharp images in lower light), and well designed and executed mise-en-scène (especially lighting techniques that strategically illuminate different portions of the frame differently).

Deep-focus sequences were introduced in a number of late 1930s Hollywood films. In *Wuthering Heights*, the depth-of-field work was so compelling it won an Oscar for its cinematographer, Gregg Toland (fig. **4.73**). Two years

 4.68–4.72 The three-minute zoom-in that opens *The Conversation* (Francis Ford Coppola, 1974).

later, working with the director Orson Welles on *Citizen Kane*, Toland used deep focus far more extensively. For Welles, shots composed in depth were "democratic," in that they allowed filmgoers to focus on any part of the image they wished and to find in either foreground or background dramatic moments worth watching. For his actors, deep focus meant that everyone in the frame might be the object of the filmgoer's eye even if that person was not speaking or performing a significant action.

A famous example of deep focus can be found in an early scene when we first meet Charles Foster Kane as a young boy playing in the snow in Colorado (fig. **4.74**). Three fields are in sharp focus in the shot. We see Kane's mother and the banker, Thatcher, his new guardian, in the foreground. Kane's father, who is left out of the decision-making process, is alone, in the middle ground. And young Charles blithely carries on in the background, oblivious to the decisions made on his

behalf in the rest of the frame. Though we are looking at a two-dimensional image, Welles successfully stages and films the scene to imply depth. Key to this impression of depth is the diminishing scale of the figures and objects; note, for example, how tiny Kane is compared to his mother and how small the objects next to the window are compared with those on the desk.

In **selective focus**, by contrast, one field or plane within the image is in sharp focus while other fields appear out of focus. In *The Assassination of Jesse James by the Coward Robert Ford*, selective focus is used to highlight larger-than-life figures like Frank and Jesse James. Early in the film, we find Frank James weary of the outlaw life. He suffers fools badly, and, unfortunately

selective focus Describes a shot where part of the image has been deliberately blurred while another is in sharp focus.

▶ **4.73** Deep-focus composition in *Wuthering Heights* (William Wyler, 1939) allows us a clear view of both Heathcliff's dramatic departure and the woman he will leave behind.

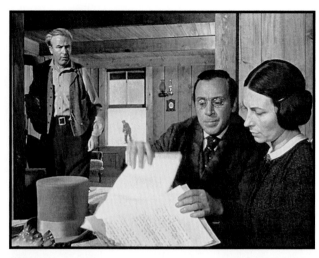

4.74 Deep focus in an early scene in Orson Welles's *Citizen Kane* (1941).

for him, the ragtag "gang" assembled for one last train robbery is composed mostly of fools. Frank is feeling isolated and anxious, a sensation highlighted by selective focus (fig. **4.75**).

Later in the film, Jesse avenges a (probably imagined) betrayal. His victim, the dimwitted Ed Miller, knows he is about to be killed. Ed moves into focus at the very moment Jesse retreats to the deep background, obscured in the dark and rendered small and indistinct (fig. **4.76**). Jesse is descending into madness by this point in the story, and the selective focus here and elsewhere establishes a visual referent for his paranoia and feelings of isolation and depression.

A technique known as **racking (pulling) focus** enables filmmakers

racking focus Describes a shot where the focus shifts among foreground, middle ground, and/or background planes.

4.75 Frank James's isolation is highlighted by selective focus in *The Assassination of Jesse James by the Coward Robert Ford* (Andrew Dominik, 2007).

4.76 Selective focus dramatically captures the moment of truth in the murder of Ed Miller.

4.77 and 4.78 Early on in *The X-Files* (Chris Carter, 2008), a racking-focus shot highlights the different mind-sets of the film's two lead characters, the scientific Scully (in focus in fig. **4.78**) and the intuitive Mulder (in focus in fig. **4.77**).

(foreground, for example) in sharp focus and another (background, for example) out of focus. Racking focus then allows the filmmaker to shift the focus rather quickly and accurately.

Racking, or pulling, focus is an intrusive camera technique; it calls attention to itself and clearly guides our eyes as we read the shot. Filmmakers resort to racking focus when they want to make a comparison (usually between characters), to show incompatibility (e.g., that while one is held in sharp focus the other is not or that the two characters can't be held in focus at the same time because they're so different) or to emphasize spatial relationships (between objects or characters in the foreground and background).

Early on in *The X-Files*, a racking-focus shot is used to highlight the different mind-sets of the film's two lead characters, the scientific Scully and the intuitive Mulder (figs. **4.77** and **4.78**). As this focus technique suggests, we will eventually have to side with only one of these characters and her or his philosophy.

to shift sharp focus from one plane to another without a cut. The filmmaker first shows one plane in the shot

In addition to the filmmaking options we have examined so far, decisions regarding film stocks (or abandoning film for video), camera exposure settings, and camera types (35mm, 16mm, Super-8mm, video, digital video) also significantly affect what we see and how we see it. The basic and fundamental decision to shoot in color or in black-and-white affects the look of the film and how viewers are likely to read the images on-screen. In-camera effects governing speed of motion—for example, slow, fast, and stop-motion—are also in the arsenal of the filmmaker to alter the look of the film. Also relevant here is frame size, the aspect ratios

of width to height in the movie image (1.66:1; 1.85:1; 2.35:1, etc.). Aspect ratios are discussed separately and at length in chapter 7-3b.

4-4a **Film Stock**

Filmmakers can choose from a variety of film stocks. Stocks are differentiated according to the specific chemical properties of the emulsion (the ratio of silver halide to gelatin in the mix on the film). Using a different film stock (with a different emulsion) can allow a filmmaker to produce more or less contrast in the image. When

shooting in color, it may also allow for more vivid or saturated colors. Color can also be manipulated when the film is developed at the lab.

In the crime drama *What Doesn't Kill You*, the film opens and closes with an armored car heist. The stock used for these two sequences highlights cold colors like silver and blue; it seems well chosen to heighten the feeling of a cold winter's day in New England (fig. **4.79**). It seems also well chosen to mark the way the heist plays out; this opening sequence ends in the cold light of day, or so the film stock renders things, as one of the robbers faces off with a police officer in a gunfight that seems sure to end badly for everyone concerned. Most of the rest of the film is shot on different stock, one that highlights warmer tones of brown and orange (fig. **4.80**). This distinction in color scheme achieved by using different types of film stock proves significant when we return to the heist the second time near the end of the film. At first it seems—it no doubt is—the exact footage and film stock we saw at the opening of the film. So we are led to assume that the rest of the film has been just a flashback leading inevitably to this fateful event. But then we discover why we are seeing this scene a second time and why the alternative stock has been used to distinguish it from the rest of the film. The heist is revealed to be a daydream, and in the end it is what the hero decides *not* to do. The scene looks different from the rest of the film because it never happens.

4.79 Film stock highlights cold blues, grays, and silver in the opening scene of *What Doesn't Kill You* (Brian Goodman, 2009).

4.80 Most of the rest of the film is told in warmer tones of brown and orange, the result of using a different film stock.

4-4b Exposure

Exposure refers to the amount of light that passes through the camera lens onto the film. Underexposure produces dark images and **overexposure** produces the opposite: pale, washed-out images. Adjusting exposure to a slight degree can subtly lighten or darken an image to achieve a certain style or look or to highlight figures or objects in the frame. More extreme manipulations of exposure setting can produce dramatic effects, as in Jennifer Lynch's Sunbelt murder mystery *Surveillance*, in which overexposures are used to establish the sun-drenched locale and conceal the identities of the murderers (figs. **4.81–4.83**).

4-4c Digital versus Film

Digital cameras are now frequently used instead of 35mm-film cameras. The digital format is cheaper, faster, and easier to work in. Digital filmmaking was initially used for mock or fake documentaries, ultra-low-budget features, and made-for-cable miniseries. Today

overexposure A technique that creates a washed-out image by bathing the film in excessive light.

 4.81–4.83 Overexposure in Jennifer Lynch's 2008 desert Sunbelt murder mystery *Surveillance* establishes the sun-drenched space and sets up the surreal scenes of murder and mayhem to follow. Overexposure in the murder scene effectively conceals the identity of the killers.

many high-end productions—even high-profile, effects-laden features like *Sin City* (Frank Miller, Robert Rodriguez, and Quentin Tarantino, 2005) and the *Star Wars* (George Lucas, 1999, 2002, and 2005) prequels—are shot in digital format.

This is all to say that digital camera work has come a long way in a short amount of time. The ultra-high-res digital Red One camera, introduced in 2008, for example, records with a resolution roughly equivalent to the industry standard 35mm film. With so much

exhibition turned to digital technology (see chapter 7), it is fair to wonder how long filmmakers will be, strictly speaking, making *films* … how long before the term *film* will refer not to a raw material but less distinctly to a medium no longer based on that raw material. Despite the ease, cost-effectiveness, and comparable resolution of digital "cinema," many cinematographers contend that digital images tend to be more clinical—that they lack depth, grain, and gradations or decay in color values.

That said, for the average filmgoer, it may not be that important to recognize whether a filmmaker has used a 35mm film or digital camera. But occasionally filmmakers create sequences from images that are clearly derived from different sources (evidencing different stocks, exposure settings, cameras, and camera types). The effect, as in the opening sequence of Oliver Stone's *Natural Born Killers*, can be at once visually arresting and intellectually challenging, in effect asking the filmgoer to ponder not only the content but the source of the image as well (figs. **4.84–4.87**).

4-4d Color and Black-and-White

The first color-process films date to the 1930s. But for the subsequent thirty years most movies were photographed on black-and-white film. Early color processes were unrealistic, expensive, and a bit unpredictable. And many of the early color prints faded and degraded horribly. The industry-wide shift to color dates not to the advent of improved color stock and film processing in the 1950s but to the advent of color television in the following decade. The film studios were loath to allow the upstart medium to have anything that seemed like an advantage.

The choice between shooting in color or in black-and-white in modern American films is seldom a matter of budget; in many cases black-and-white stock costs

as much as or more than color film. Instead, it is an aesthetic choice that can have a significant impact upon filmgoers' reactions to a film.

When modern filmmakers choose black-and-white, they do so with a number of goals in mind: to allude to films of earlier eras (*The Artist*, Michel Hazanavicius, 2011 or *Ed Wood*, Tim Burton, 1994), to establish a setting (e.g., a time characterized by black-and-white cinema and TV: *good night, and good luck*, George Clooney, 2005), to establish a monochromatic visual style (e.g., the shimmering slate-grey New York in *Manhattan*, fig. **4.88**), to simulate a bland lifestyle (the urban hipster ennui of *Stranger than Paradise*, Jim Jarmusch, 1984), or to, ironically, imply a cinematic realism (Scorsese's effective use of black-and-white to simulate newspaper sports photography—figs. **4.90** and **4.91**—and home movie footage in *Raging Bull*).

When we talk about color, it is important to note the impact of various film stocks and camera exposures (discussed above). It is also important to recognize how observable uses of color affect film content—how shading, intensification, or saturation (*color tone*) as well as color contrasts affect the style and meaning of a film. Most if not all color films evince a color scheme that can embrace alternatively dramatic contrasts or, at the other extreme, an extremely limited palette emphasizing one tone (which we call a monochromatic color design, apparent in fig. **4.80**). Color can also be an aspect of the larger design of a film. In *Far from Heaven*, for example, the mise-en-scène (sets, locations, props, costumes, and even the characters' hair colors), cinematography (lighting, film stock, exposure, and camera type), and post-production lab work combine to create a sumptuous color scheme (fig. **4.89**).

4-4e Speed of Motion

Camera effects like stop, fast, and slow motion compose what filmmakers call **speed of motion**. These camera effects are created by filming action at faster or slower speeds and then projecting the sequences at standard speed. Changes in speed of motion interrupt the flow of a film and are sometimes used to call our attention to certain physical actions or to attributes of the actor performing these actions, as in the athletic training sequences

speed of motion A camera-based special effect that makes the action on screen move at unrealistic speeds (fast, slow, or briefly paused, or stopped). Speed-of-motion effects are created by filming action at faster or slower speeds and then projecting the images at standard speed.

4.84–4.87 Four exterior images from the title sequence of *Natural Born Killers* (Oliver Stone, 1994): grainy black-and-white with little contrast; sharply focused and high-contrast black-and-white; low-contrast color landscape with red tinting; and vivid color (note how the sign is held in sharp relief to the beautiful blue sky).

4.88 Black-and-white evoking a shimmering, timeless New York in Woody Allen's *Manhattan* (1979).

▶ **4.89** In *Far from Heaven* (Todd Haynes, 2002), the color of the changing autumn leaves and the lush lawns is roughly matched by the women's costumes and hair colors. Note also that the red truck parked on the street in the background roughly matches the color of one of the dresses and some of the leaves at screen right.

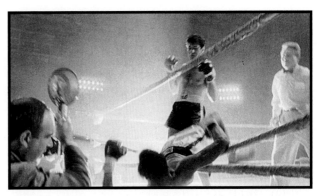

4.90 Scorsese uses overexposure and stop-motion to frame a knockdown much as a sports (still) photographer might. *Raging Bull* (1980).

4.91 Slow motion and a canted camera angle underline a fighter's resignation to exhaustion and defeat.

4.92 When Hutter enters the land of the phantoms en route to the vampire's castle in *Nosferatu* (F. W. Murnau, 1922), the basic rules of physics are abandoned. Fast motion signifies the transition from real to supernatural space.

in *Chariots of Fire* (Hugh Hudson, 1981) and *Personal Best* (Robert Towne, 1982). Slow motion can be used to suggest a dreamlike quality, distinguishing by speed of motion between reality and an imagined time and space.

In *Raging Bull*, Martin Scorsese uses stop and slow motion to highlight the more poetic aspects of the so-called sweet science of boxing and to make clear at the same time the spectacular nature of such a modern gladiatorial sport. At one point Scorsese uses overexposure with stop-motion to reproduce a classic sports snapshot (seemingly captured with exploding flashbulbs) of a knockdown (fig. **4.90**) and then in a separate bout he uses slow motion to underscore a fighter's exhaustion and resignation (fig. **4.91**).

Fast (sped-up) motion is used most often for comic effect to show time passing quickly, or, more seriously, in time-lapse photography. Filmmakers also use fast motion in montage sequences (see chapter 5-1d) to connect or summarize a series of connected or repeated actions, as in Darren Aronofsky's *Requiem for a Dream* (Darren Aronofsky, 2000) when a series of sped-up shots depicting a woman taking her daily diet pills fly across the screen. It can also be used like slow motion to signal a transition from the real to the supernatural world, as in *Nosferatu*, when the sped-up movement of a carriage marks its passenger's entrance into the land of the phantoms (fig. **4.92**).

CHAPTER SUMMARY

Our view of the mise-en-scène is carefully controlled by the camera, which governs our perspective on a scene and allows us to enter and move around in the space of the film.

4-1 CAMERA PLACEMENT

Learning Outcome: *Recognize and analyze the basics of camera placement: angle, distance, and framing.*

- When we talk about the angle of a shot, we refer to the placement of the camera in relation to the subject and not the position of the subject of the shot. The angle can influence a range of perceptions about a subject.

- Camera distance affects how much of the subject we see and controls our ability to read a character's face and understand the larger context.

- Framing positions us as viewers of the mise-en-scène and governs our perspective.

- Our perspective is additionally affected by what we can see (on-screen space) and what we can't (off-screen space).

4-2 CAMERA MOVEMENT

Learning Outcome: *Identify different types of camera movement and discuss their aesthetic and narrative significance.*

- There are three principal types of *fluid* moving camera shots: the tracking shot, the dolly shot, and the Steadicam shot.

- Moving camera can also be used to approximate first-person or subjective point-of-view, so that we see the world through a character's eyes as he or she moves through the world of the film.

- Some filmmakers have used portable cameras and hand-held techniques to create a more spontaneous or realistic film style.

- For pans and tilts the camera is mounted on a tripod. A fluid or geared head on the tripod allows for movement 360 degrees laterally (a pan) and, practically speaking, vertically, floor to ceiling, ground to sky (a tilt).

4-3 FOCUS AND DEPTH

Learning Outcome: *Understand and detail the key aspects of focal length, depth of field, and selective focus.*

- Lenses are generally categorized according to their focal length, with wide-angle as the shorter focal length and telephoto as the longer focal length.

- Though the camera itself remains stationery, a variable focal length lens can be used to simulate movement, either lengthening (a zoom out) or diminishing (a zoom in) the *apparent* distance between the camera and its subject.

- Depth of field refers to how much of the foreground, middle ground, and background planes are in focus. Deep focus (large depth of field) involves keeping objects and characters from the foreground through the background in sharp focus.

- Deep focus (large depth of field) involves keeping objects and characters from the foreground through the background in sharp focus.

4-4 STOCK, EXPOSURE, AND EFFECTS

Learning Outcome: *Recognize how the choice of film stock, speed, and exposure affects the look of the film.*

- Using a different film stock (with a different emulsion) can allow a filmmaker to produce more or less contrast in the image.

- Exposure refers to the amount of light that passes through the camera lens onto the film. Under-exposure produces dark images and over-exposure produces pale, washed-out images.

- The choice between shooting in color or black-and-white is an aesthetic choice that can have a significant impact upon how filmgoers react to and read a film. Shading, intensification, or saturation (what is called *color tone*) as well as color contrasts affect the style and meaning of a film.

- Fast, slow, and stop motion camerawork interrupt the natural flow of a film and are often used to highlight action, a change in location or setting (e.g. from natural to supernatural), or a performer's particular attributes or talents.

Before filming begins on a movie, the director and the design team may adapt portions of the screenplay into storyboards, which are hand-drawn or computer-generated shot-by-shot breakdowns that offer pictorial renderings of scenes. The following storyboard sketches were used for the memorable "raptors in the kitchen" scene in *Jurassic Park* (Steven Spielberg, 1993). Note how the storyboards consider elements of mise-en-scène and camera work that we have been examining. The corresponding shots from the movie are included for comparison.

WIDE HIGH ANGLE DOWN TO TIM AND LEX

The basic set design is sketched out here. What purpose might there be for the long counters and aisles? Note the camera instruction: "wide high angle down to Tim and Lex." Why might the filmmakers choose a high-angle camera position and a wide-angle lens?

HIDE AT END OF AISLE BEHIND COUNTER... THE RAPTOR APPEARS.

"Hide at end of aisle behind counter . . . the raptor appears." How does this blocking add to the tension in the scene?

THE STEAM VANISHES - THE RAPTOR LOOKS.
AND SEES.

"The steam vanishes. The raptor looks. And sees."
A visual effect—steam—is planned. Why show
steam and then the eye? How might the concept of
off-screen space be relevant here?

cont'd. [PAN] kids around corner... Raptor starts to
poke head thru counter

"Pan. Kids around corner . . . Raptor starts to poke
head thru counter. (arrow) Pan ahead with kids."
Moving camera captures this game of cat-and-mouse.

ANALYZE CAMERA WORK

Use these questions to analyze how the basic elements of camera work contribute to a close reading of a scene in a film.

4-1 CAMERA PLACEMENT		• How does the angle of the camera placement affect your view and the meaning of the image? • How does camera distance affect your view and the meaning of the image? • How does the framing of the image affect its meaning? • Does off-screen space add to your understanding of the shot?
4-2 CAMERA MOVEMENT		• How does the camera move through the cinematic space? Does it glide smoothly through the space or is it obviously handheld? How does the crane movement affect your view and the meaning of the shot? • Does the camera pan and/or tilt? If so, how does this technique affect the meaning of the scene? • Is the camera objective or does it seem to represent the point of view of a character? If the latter—if it is subjective—what effect does that have?
4-3 FOCUS AND DEPTH		• What kind of focal length or angle of view does the camera lens appear to offer on the scene? Is it wide-angle, telephoto, or zoom? Does it switch back and forth within the scene? How does this lens affect your view and the meaning of the shot? • Notice which planes (foreground, middle ground, and background) of the image are held in focus. How does the focus influence the mise-en-scène and your reading of the shot?
4-4 STOCK, EXPOSURE, AND EFFECTS		• Is the film in black-and-white or in color? If it is a contemporary film shot in black-and-white, what does that choice suggest? • If in color, are the colors especially vivid or saturated? What impact does this effect have on your reading of the shot? • Does the shot use overexposure and/or slow, fast, or stop-motion to dramatic effect? What is gained (with regard to aesthetics and content) by using this technique?

5 EDITING

The Manchurian Candidate (Jonathan Demme, 2004), editing by Carol Littleton and Craig McKay

Movie editing is at once technical and creative. Fundamentally it involves the cutting and joining of shots (or the use of computer software to accomplish this task electronically) to assemble a scene, then a sequence of scenes, and finally the completed film. The basic task may be rudimentary, but the process of selecting and arranging the shots is not. An editor typically has between nine and fifteen hours of footage from which to create a 90-minute film. (This is an approximation and assumes a typical shooting ratio—the ratio of exposed film stock to footage used in the final cut—for a feature film.) The decisions made in editing have an enormous impact on the film's narrative form and rhythm and on its visual, emotional, and intellectual power.

In this chapter we will look at the meaning and function of motion picture editing. We will examine the editing style developed for classical Hollywood movies, one that draws our attention away from the fact that the cinematic world is constructed from individual and independently produced shots. We will also recognize alternatives to this "invisible" style that call attention to the constructed nature of film.

LEARNING OUTCOMES

After reading this chapter, you should be able to do the following:

5-1 Appreciate and understand the theoretical, historical, and practical foundations of film editing.

5-2 Recognize and analyze continuity editing as a storytelling technique.

5-3 Identify and assess the expressive uses of discontinuous and live broadcast editing styles.

▶ **PLAY VIDEO ICON:** This icon signals that a corresponding video clip is available in the eBook. The eBook can be accessed at cengagebrain.com.

movie editing The cutting and joining of shots to assemble a film; also known as **montage**.

MAKING MOVIES

Photo by William Stetz

CAROL LITTLETON ON EDITING

Carol Littleton is a movie editor who has worked with some of Hollywood's most important and influential directors. Her editing credits include *E.T.: The Extraterrestrial* (Steven Spielberg, 1982), *The Big Chill* (Lawrence Kasdan, 1983), *Wyatt Earp* (Lawrence Kasdan, 1994), and *The Manchurian Candidate* (Jonathan Demme, 2004). In 1983 Littleton was nominated for an Academy Award for her editing work on *E.T.: The Extraterrestrial*, and in 2000, she won an Emmy for the television movie *Tuesdays with Morrie* (Mick Jackson, 1999).

Q1: Could you briefly describe the editor's contribution to the filmmaking process?

A: I generally come in after the first day or so of production, and I work simultaneously with the shooting crew. Once I get the dailies, I work on them and then move on to the next sequence and then the next and the next . . . I look at the performances. I look at the shots I have to work with. I think about the problems I may have—sound problems, a compositional problem. Or something that is particularly salient like a beautiful shot that I did not anticipate when I first read the script. A day or so after the principal photography is over, I sit down with the director and we look at the first assembly of the film. From that point on—contractually it's a ten-week period—we work on the "director's cut." Then the producers come in, and we screen the film, and it's revised again until we have the final cut. We lock that final cut, and then the sound editors come on and do their work until we have the final mix. Then it goes to the laboratory, and then we have the final version of the film.

Q2: How important are transitions from shot to shot?

A: Thinking about transitions is the most important thing a filmmaker can do in advance of shooting a scene. It's amazing how many beautiful scenes I get where no thought has been given to how we can get from one moment to the next . . . and if those transitions haven't been thought about in advance, then I have nothing to work with. Many times the simplest transition can be an abrupt cut from a day scene to a night scene . . . as simple as the transition from light to dark . . . or from having light on the right side of the frame and dark on the left and then cutting to the opposite.

Q3: How important is time in the editing of a film?

A: It's as if the metronome is ticking. At the beginning of a shoot, the script supervisor takes the script and times it. . . . While that may not be the time in the final cut, it gives me a guideline—an amount of time a scene should not exceed. We're trying to tell a story taken from 120 pages in 120 minutes. One of the most important things that film editors do is to compress time. Like the former Columbia studio mogul Harry Cohn said, "It's all about asses in seats." How long you can keep them there. We're very aware of running time, the time of each scene, how quickly a transition is made, how quickly an idea is grasped by an audience, and how quickly you need to move on.

Q4: What are the larger challenges of film editing?

A: In many regards, film editing is solving a puzzle with lots and lots of moving pieces. And you're trying to put them all together . . . to get the best performances . . . to get the best audience response out of a scene.

CENGAGE brain.com **LINK TO THE FULL INTERVIEW** http://cengagebrain.com

5.1–5.3 In this short film from 1900 (*Explosion of a Motor Car*), a car appears to explode, and its contents (and passengers) fly into the air. The filmmaker Cecil Hepworth used the "stop-trick" technique introduced by the French filmmaker Georges Méliès. The cut is executed by turning the camera off, rearranging the props, and then turning the camera back on.

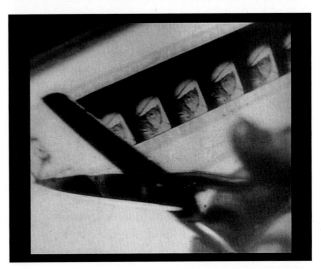

5.4 Yelizaveta Svilova is shown cutting film stock in *The Man with a Movie Camera* (*Chelovek s kino-apparatom*, 1929), a film she edited for Soviet filmmaker Dziga Vertov. The editor in that era not only joined shots but also physically cut them, hence the synonym *cutting* for *editing*.

As we saw in the previous chapter, the first films produced in the late nineteenth century were composed of a single load of the camera—a continuous length of exposed film stock. Editing was introduced just a few years later and quickly became a fundamental element of film form. Some early editing was accomplished "in camera." In such cases the camera was simply shut off, the scene reset, and then the camera was turned back on (figs. **5.1–5.3**). Eventually editing tables were designed where strips of film were cut and then taped or glued together (fig. **5.4**). This explains why the spot where one shot ends and another begins is still known as the **cut**.

Editing allowed for the move from the Lumière brothers' **actualities** and Edison's nonfiction, single-take documentaries—short movies that captured a single event—to narrative films that could bring together multiple plot points depicting a variety of actions in multiple locations or settings. In this section, we will consider how the ability to assemble, link, and juxtapose shots opened up a new world of possibilities for filmmakers.

cut The place where one shot ends and another begins; a direct transition from one shot to the next.

actualities Slice-of-life documentaries produced by the Lumière brothers at the end of the nineteenth century.

5-1a Shot Relationships

As cinematic techniques developed, filmmakers, film critics, and theorists began to debate what might constitute the fundamental unit—the ground zero—of meaning in cinema. Some argued that it was the shot. Evinced most clearly in the expressionist cinema of Germany at the time (the 1920s), this argument was rooted in the notion that each shot on its own bears a singular and specific meaning. Others, many of whom participated in the formalist film movement in the newly established Soviet Union, held that meaning in cinema emerges from the relationship between shots spliced together; in other words, meaning emerges through editing (also known as *montage*).

In Soviet montage theory, the meaning of one shot is always subject to the previous and subsequent shot. Meaning is a matter not of singular content but of context. To demonstrate montage theory, the formalist filmmaker and film teacher Lev Kuleshov presented his students with a sequence of six shots: a bowl of hot soup, a corresponding reaction from the famous actor Ivan Mozzhukhin, a dead woman lying in a coffin, a corresponding reaction from Mozzhukhin, a little girl playing with her teddy bear, and a third reaction from Mozzhukhin. Kuleshov initially told his students that the sequence proved that Mozzhukhin was an adept actor. And the sequence seemed to support such a notion: the actor's face appeared to register hunger,

sorrow, and joy, respectively. But then Kuleshov disclosed that each shot of Mozzhukhin was identical, proving his theory that it is the juxtaposition of images and not the single shot that holds meaning. The shots of Mozzhukhin meant nothing (really, they could mean anything) in and of themselves.

A second Kuleshov demonstration revealed how editing can create a place that only exists on-screen, a creative geography of sorts. It involved a five-shot sequence: a man walks screen right to left, a woman walks screen left to right, they meet, we see a grand building in the distance, and finally we see a couple ascend a flight of stairs outside (fig. **5.5**). None of the five images was shot in the same place (indeed the grand building was the White House!); yet when we watch the sequence, we assume they were.

In the very process of proving his point regarding cinematic space, Kuleshov showed that five random shots cut together can create the entry point to a narrative: a man and a woman meet and ascend stairs en route to a grand building. As we can see from this experiment, cinematic time as well as space is shaped through editing. The editor's job is often to make us forget the film's running time and transport us forward and/or backward in story time through the arrangement of shots. Editing enables the medium's most difficult aesthetic enterprise: to create a believable spatial and temporal world out of pasted-together strips of celluloid projected onto a screen.

5.5 From five separate locations, editing can create a single space that exists only in the world of the film.

5.6 and 5.7 In *Man with a Movie Camera* (*Chelovek s kino-apparatom*, 1929) Dziga Vertov uses a tonal cut to mark the transition from interior to exterior, from a dark foyer to a sunlit square.

5.8 and 5.9 A tonal cut in *The Godfather* (Francis Ford Coppola, 1972) takes us from the cozy confines of the somberly lit den where Michael is in full control to the sunlit Las Vegas strip where his ability to muscle in on Moe Green's casino is brought into question.

5-1b Tonal and Graphic Relationships

Soviet montage theorists were also interested in the formal relationships between juxtaposed shots; for example, they realized that editing could create tonal and graphic patterns in a sequence. Tonal relationships (light-to-dark, dark-to-light) were especially recognizable in the era of black-and-white film, and formalist filmmakers created tonal patterns for aesthetic effect (figs. **5.6** and **5.7**), much like formalist photographers and painters. Early filmmakers also realized that abrupt shifts in tone could call attention to cuts, and they avoided such juxtapositions when their goal was to sustain a cinematic illusion of fluid reality. Tonal relationships continue to be significant in color film (figs. **5.8** and **5.9**).

Graphic relationships involve the arrangement of shapes across shots. Graphic patterns may have symbolic meaning or they can provide a visually striking segue from one scene to another. In a famous example of a **graphic match** (also known as a **cut on form**) from *2001: A*

graphic match, also known as a **cut on form** A way of connecting two or more shots through repeated shapes or patterns.

▶ **5.10 and 5.11** A graphic match in *2001: A Space Odyssey* (Stanley Kubrick, 1968) is a transitional device that signals a temporal shift from the Paleolithic Age to the Space Age. The symbolic meaning of this pairing is open to the audience's interpretation. Note that this is also an example of a tonal cut (i.e., it takes us from light to dark).

5-1c Rhythm and Tempo

Like rhythms in music, film rhythms are experienced as a combination of tempo (speed), beats, and accents. The concept of rhythm applies from the smallest unit—the transition from one image to another—to the overall feeling of the film as a whole.

Tempo is created in editing by working with the length of shots. A shot may be as quick as a single frame or may be over a thousand frames long; it can go from one brief instant when projected to several minutes long. When directors want to slow down the pace of the film, they can use the **long take**, a single continuous shot of unusually long duration. Some directors, like Michelangelo Antonioni (fig. **5.16**) and Theo Angelopoulis (*Landscape in the Mist*, 1988), employ the long take to offer commentary on the modern condition. For these directors the seeming frozen action of the long take emphasizes a sense of ennui (boredom) as the characters are posed, literally stuck in empty landscapes.

Some contemporary directors use the long take to poke fun at the conventionally fast-paced editing of commercial action-based films. Jim Jarmusch, for example, made quite a splash at the Cannes Film Festival in 1984 with his low-budget, low-energy urban comedy *Stranger than Paradise*, a film composed of long takes that go on past all reasonable expectation; even the actors seem to lose interest in the scene before Jarmusch bothers to cut. And Sofia Coppola employed much the same style in her 2010 film *Somewhere*, in which the long takes linger on the main character, a burnt-out Hollywood actor, driving in circles or staring into space.

The long take is routinely featured in westerns not only to match the leisurely pace of premodern America but also to represent dramatically the uncluttered wilderness that the cowboy inhabits. In *The Assassination of Jesse James by the Coward Robert Ford*, a take lasting 1 minute and 40 seconds (inordinately long by contemporary film standards, for which an average shot length is approximately 7 seconds) shows the famous outlaw and his sidekick Charley Ford hesitating at the banks of a frozen river (fig. **5.17**).

Space Odyssey, the cut is from an oblong bone to a similarly shaped spaceship, placed in the same spot within the frame (figs. **5.10** and **5.11**). The cut takes us from thousands of years into the past to what was at the time of the film's release thirty-three years into the future.

Graphic matches can draw attention to the artifice of film for serious or comic effect. A simple gag in Buster Keaton's *Sherlock Jr.* is based on a series of cuts on form (figs. **5.12–5.15**). First he is seated on a mound of dirt in the desert. In the next cut, he is seated on rock (same shape, same basic position in the frame) in the ocean. He stands up on the rock and decides to dive off. In the final shot, the form at the center of the frame is now a snowdrift, and he plunges not into water but into the snow. The gag plays on the spatial and temporal relationships created by the editing scheme: desert to ocean to mountains in the time it takes to stand and jump.

long take A single continuous shot of unusually long duration.

5.12–5.15 A sight gag in Buster Keaton's *Sherlock Jr.* (1924) follows a single continuous movement against a changing landscape.

5.16 The final scene from Michelangelo Antonioni's *L'Avventura* (1960). One of the last in a series of gorgeously composed but nonetheless static long takes.

Charley is reluctant to cross the river for fear the ice might break, a fear made worse when Jesse wanders out onto the ice and then out of the blue asks if Charley has ever considered suicide (fig. **5.18**). The editing scheme slows the film down not only to ponder such a troubling question but also to isolate the characters in the vast emptied-out landscape. The extreme long shot emphasizes this feeling of isolation. A subsequent shot is somewhat shorter (about 40 seconds long) and slightly tighter (a long shot replaces the extreme long shot), again highlighting the powerful scale of the natural elements (fig. **5.19**). The characters are

framed by untouched stands of trees and majestic mountains in the distance. These are men alone in the wilderness, their basic urges and doubts and instinct for survival laid bare in the long take.

The use of editing techniques to speed up the tempo is characteristic of modern, commercial, "thrill-ride" American filmmaking. The editing technique is fairly simple: shots taken from multiple camera positions are spliced together at an accelerated pace. To heighten the frenetic "feel" of the footage, the length of each shot gets shorter as the scene heads toward its climax. The action-edited sequence is meant to be visceral and experiential as opposed to purely realistic. As the Russian formalists argued in the 1920s (based on Ivan Pavlov's research on the reflex system), when editors accelerate the rhythm of a sequence, they can achieve a heightened emotional response.

A good example of fast-paced action editing can be found in the drag-race sequence near the end of George Lucas's *American Graffiti*. In this brief sequence Lucas intercuts camera angles to show the simple action of two cars heading away from a starting line. When one of the cars swerves off the road and crashes, we see the mishap from several new camera positions (figs. **5.20–5.26**).

The scene itself lasts less than 20 seconds, about the same duration as a real drag race, especially one that ends so abruptly with a crash. The speed of the editing simulates the frenzy of the race. That it all happens so fast, and that the event is so fleeting, fits with the fragmented and fragmentary experience of youth depicted in the film: the long periods of seeming aimlessness cruising the strip punctuated by sudden moments of excitement, sensation, or meaning.

▶ **5.17** Jesse James and Charley Ford at the start of a take that lasts 1 minute and 40 seconds in Andrew Dominik's *The Assassination of Jesse James by the Coward Robert Ford* (2007).

▶ **5.18** Jesse James ponders suicide at the end of the same long take.

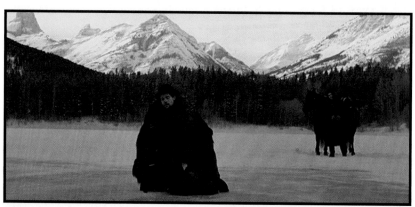

▶ **5.19** A western tableau captured in yet another long take at the river.

5-1d Elliptical Editing and the Montage Sequence

One of the primary functions of editing is to manage transitions from time to time, place to place, action to action, or character to character. As such, editing offers the filmmaker a visual shorthand—filmic equivalents for storytelling phrases like "meanwhile," "elsewhere," "and then," or "in another place at another time." Cutting from daylight to dark, for example, is all we need to see to know that a day has passed. A simple sequence showing the changing of seasons or an insert showing

▶ **5.20–5.26** The climactic drag race scene in *American Graffiti* (George Lucas, 1973) is a primer in action editing.

the pages of a calendar torn off tells us that while the filmmakers have only an hour or two to tell the story on-screen, far more time in the world of the narrative has passed.

Elliptical editing, where cuts move us along in the plot by removing parts of the larger story, is a crucial technique in the management of narrative time. Indeed it allows the filmmaker to elide (omit) events to save time in the telling of the film story. When a character begins her day, for example, elliptical editing might go like this: the woman grabs her keys off a table / cut / we see her in a car driving / cut / we see her exiting an elevator and entering her office complex. We don't need to see her get into or out of her car; in fact the editor

could cut from her reaching for her keys to her entering her office space, and we would understand that time has passed (it has been elided in the telling of the story).

One frequently used elliptical editing technique is the montage. The term *montage* can denote editing in general, but the phrase **montage sequence** refers to a specific film technique in which a series of brief shots

elliptical editing Editing that allows an action to consume less screen time by transitioning between shots that suggest the passage of time.

montage sequence A series of brief shots that summarizes a section of the story.

5.27 The training montage in John Avildsen's *Rocky* (1976) ends with the journeyman boxer atop the stairs at the Philadelphia Museum of Art.

summarize a section of the story. Films attending to long periods of time—bio-pics (biographical films), for example—frequently use montages to show time passing, relationships developing, and characters aging. Films with shorter story durations still include montage sequences to quickly cover plot points that do not need full exposition. The 1976 film *Rocky*, for example, condenses the protagonist's weeks of training into a sequence of 2 minutes and 44 seconds that shows his developing strength and endurance. The montage is accompanied by a song whose lyric—"Getting strong now..."—hammers home the point (fig. **5.27**).

Another common use of elliptical editing is in the presentation of sex scenes. To comply with regimes of censorship, shots of fragmented body parts in brief succession imply the real sex act the filmmakers dare not show in full. Even with more modern films in which nudity and simulated sexual activity are within the acceptable range of imagery for an R rating, shots of body parts that suggest rather than show what is happening in the story remain a well-worn stylistic gesture.

Consider the sexual liaison between the male prostitute Julian and the wealthy politician's wife Michelle in Paul Schrader's R-rated *American Gigolo*. In part because this tryst is supposed to mean something more than the usual pay-as-you-go interlude—indeed, later in the film, Michelle risks everything to protect Julian—a full-figure simulation of foreplay and intercourse is eschewed in favor of a series of artful and tasteful close-ups (figs. **5.28–5.30**). We are meant to extrapolate from these fragments a larger and longer scene of the characters engaging in foreplay followed by intercourse.

The montage has become such a familiar, even cliché, technique that it became the object of satire in *Team America: World Police* (figs. **5.31–5.35**). As the song accompanying Gary's evolution from actor to super-spy explains: "[with] every shot you show improvement / [to] show it all would take too long / That's called a montage / ... even Rocky had a montage."

5.28–5.30 A brief montage of close-ups may fragment film space and time, but it artfully implies the larger narrative of the scene. *American Gigolo* (Paul Schrader, 1980).

5-1e Alternatives to the Cut

As we have seen, the transition from shot to shot in most films is accomplished with a cut. But filmmakers can also focus in and then out or overlap shots, employing techniques that more elegantly or leisurely take us from one place, time, action, or character to another. In a **fade** (figs. 5.36–5.41), the shot slowly darkens and disappears (fade-out) or lightens and appears (fade-in). In a **dissolve**, one shot gradually disappears as another gradually appears (figs. 5.43–5.46). The **iris**, where the image contracts or expands within a small circle (fig. 5.47–5.51), and the **wipe**, where one image appears to be pushed aside by the next (fig. 5.42), are techniques that evoke the earlier eras of filmmaking.

5.31–5.35 "We're going to need a montage": Trey Parker and Matt Stone's tribute to the elliptical editing technique in *Team America: World Police* (2004).

fade A transitional device in which a shot slowly darkens and disappears (fade-out) or lightens and appears (fade-in).

dissolve A transitional device in which one shot disappears as another appears.

iris A transitional device in which the image contracts or expands within a small circle.

wipe A transitional device where one image appears to be pushed aside by the next.

▶ **5.36–5.41** After Lola is shot in *Run Lola Run* (*Lola rennt*, Tom Tykwer, 1998), we find her on her back on the street. As she drifts out of consciousness, we fade out to red. This is a clever variation on the more common fade to black. After a brief dreamed interlude, we fade in to normal flesh tones to signal Lola's return to reality.

5.42 Wipes involve the use of one image moving left to right (left), right to left, top to bottom, or bottom to top to take the place of a previous image. One of the distinguishing stylistic characteristics of George Lucas's *Star Wars* (1977) was his frequent use of wipes, a nod to 1920s serials and low-budget science fiction. Of the optical transition devices listed here, the wipe is the least used and the most intrusive.

5.43–5.46 A dissolve from young Vito Corleone detained at Ellis Island to his grandson fifty years later at his confirmation. The challenge for Francis Coppola in *The Godfather Part II* (1974) was to distinguish temporally and at the same time establish significant thematic parallels between these two narratives. He did so by, at strategic points in the film, having one image (one narrative) elegantly dissolve into the other.

5.47–5.51 An iris-in in F. W. Murnau's *Nosferatu* (1922) takes us from a full view of a town crier to one masked or constricted at the edges of the frame. The iris-in implies an eye closing; the technique is complete as the screen is briefly black. A subsequent iris-out takes us back to the street, albeit from a different camera position and angle.

While Soviet filmmakers were exploring the formal and expressive possibilities of shot juxtapositions (a subject we will return to later in the chapter), Hollywood filmmakers were working out a system to make editing appear seamless. **Continuity editing**, as this editing style became known, supports the illusion that each scene unfolds in a continuous time and space, when in reality it has been assembled from multiple takes and different camera positions. To achieve this effect, the editor must make sure that certain aspects of the shots match up when joined. In this section, we will look at the basic principles of continuity editing and its use as a storytelling technique.

5-2a The 180 Degree Rule

One of the ways that filmmakers give the audience a clear sense of where people and things are in the story space is by adhering to the **180 degree rule**. This basic rule, applied during filming so that the editor has workable footage, maintains that there is an **axis of action** that runs along an imaginary horizontal line in a given sequence. This line bisects an imaginary circle, and the camera must stay within one half of that circle, an area of 180 degrees; it cannot cross the axis of action (fig. **5.52**).

The 180 degree rule is useful for scenes involving conversation, when the filmmakers want to cut back and forth between the characters. A scene from the 1962 political thriller *The Manchurian Candidate* illustrates the rule and why it is effective. The first shot, called the **establishing shot** or the **master shot**, establishes the spatial relationships among the characters and objects in the dramatic scene (fig. **5.53**). Without consciously thinking about it, we absorb the fact that Major Marco is on the left, Eugenie Rose Cheney is on the right, and the train window is behind them. The subsequent shots alternate between the two characters as they converse, following a convention known as **shot/reverse shot** (figs. **5.54** and **5.55**). The axis of action is drawn between the two characters, and the camera stays within the half circle in front of the axis when filming the master shot (here, a two-shot) and the individual shots. Because the camera does not cross the axis of action and, for example, move behind Eugenie, spatial continuity is maintained. Marco does not suddenly appear facing left, for example, at any time during the scene.

When watching a conversation unfold on-screen, whom the editor has chosen to show us is significant. In *The Manchurian Candidate* scene, not only do we turn to each character as he or she speaks, but we also get **reaction shots** that show us how the listener is responding (fig. **5.54**). Together these shots enable us to follow the conversation and read its nuances (what is said and

continuity editing An editing style that minimizes the filmgoer's awareness of shot transitions and in doing so supports a seamless telling of the film's story.

180 degree rule A principle of continuity editing that requires the camera to stay within a 180-degree area defined by the **axis of action**, so that the spatial relationships across a sequence remain consistent.

establishing shot, also **master shot** A shot that orients the audience for the scene that follows.

shot/reverse shot An editing pattern that cuts between two characters in conversation.

reaction shot A shot that shows how one character is responding to what another is saying or doing.

Imaginary line

180° arc

Master shot

5.52 The 180 degree rule.

5.53 An establishing shot of the characters on the train sets the stage for the audience. *The Manchurian Candidate* (John Frankenheimer, 1962).

5.54 We have only a partial view of the scene in this reaction shot, but figure **5.53** has cued us that Eugenie is at screen right. Marco is distressed by Eugenie's apparent interest in him (the close-up allows us to see the perspiration on his upper lip); she keeps repeating her contact information even though he barely knows her.

5.55 The reverse shot: Marco's anguished facial expression finds its counterpoint in Eugenie's smile and the glint in her eyes. Despite his distress, she seems to be trying to pick him up.

5.56 Marco begins to open up.

5.57 The reestablishing shot shows us that Eugenie has moved directly across from Marco; we are thus prepared for a new background behind her in the next shot.

5.58 Eugenie as Marco sees her. She tells him her address yet again. This shot lets us know that he has indeed (finally) processed this information.

how it is received) while also making the scene more watchable. There is no action in the scene, so the editing scheme breaks up the monotony of a single shot set in a confined space.

5-2b The Eyeline Match

The **eyeline match** is an editing formula that first shows someone looking and then what that person is looking at; the next shot shows us who (or what) he or she is looking at. An eyeline match can also follow the gaze of a character to an object or place as well as to a person, in all cases giving us access to his or her point of view.

The eyeline match dates to the very first multishot films, notably found in the 90-second 1901 film *Peeping Tom (Par le trou de serrure)*. *Peeping Tom* uses the eyeline match to play on the theme of voyeurism and the pleasure that cinema audiences derive from peering into the lives of others (figs. **5.59–5.61**). We see a long shot of a man peeping through a keyhole, and then we see what he sees: it appears to be a woman undressing and taking off her makeup in front of a mirror. The payoff comes as the woman he has watched so furtively is eventually revealed to be a man.

In Alfred Hitchcock's *Rear Window*, we see the eyeline match used to great effect. The film tells the story of a magazine photographer holed up in his New York apartment, nursing a broken leg. The photographer gets bored and kills time peering out his window, often with the aid of the telephoto lens on his camera. In the process of spying on his neighbors, he discovers what he believes to be a man covering up the murder of his wife.

The photographer then tries to convince his girlfriend and his nurse of his suspicions. Soon all three are looking out the window and across the courtyard. In one eyeline match from this scene, we see the photographer peering through his camera's telephoto lens (fig. **5.62**), and then we see what he sees—a man cleaning a bathroom wall (fig. **5.63**). This may be an innocent act but not in the context of the murder story the photographer has concocted. We have ample circumstantial evidence here, but we wonder: is he really cleaning his wife's blood off the wall or just doing some housecleaning?

Later, the photographer's girlfriend gets caught snooping in the murderer's apartment. Again we see the photographer look through his camera (fig. **5.64**).

eyeline match An editing pattern that cuts between a character looking and the object of his or her gaze.

▶ **5.59** The voyeur in 1901 film *Peeping Tom* (*Par le trou de serrure*, Ferdinand Zecca).

▶ **5.60 and 5.61** A stencil cutout shaped like a keyhole placed over the camera lens simulates the voyeur's gaze. A surprise is unveiled.

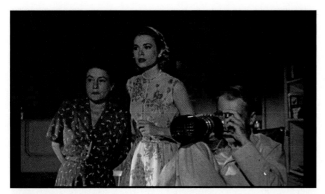

5.62 "We've become a race of peeping Toms." *Rear Window* (Alfred Hitchcock, 1953).

5.63 A man washing a wall, a mundane act that perhaps suggests something more sinister.

▶ **5.65** The eyeline match to what the photographer sees through his lens.

▶ **5.66** Now we're convinced the neighbor has killed his wife. The eyeline match sequence is capped by a surprising return of the gaze across the courtyard.

▶ **5.64** A telephoto lens provides even greater access.

And then we see what he sees—his girlfriend wearing the missing wife's wedding ring (fig. **5.65**). We wonder along with the photographer and his girlfriend: why would the wife leave to visit a relative (the story the neighbor has told the police) without her ring?

Though the wedding ring offers yet more circumstantial evidence, there's still a reasonable doubt . . . at least until the murderer returns the gaze across the courtyard (fig. **5.66**). What makes this last image especially trenchant is that it confirms our suspicions about the neighbor just as it shows the photographer caught in the act of peeping. When the neighbor looks back across the courtyard, he turns the tables on the photographer. He turns the tables on us as well; after all, we have shared with the photographer the furtive act of peeping and gained some pleasure in snooping into the neighbor's apartment. It is a rare moment indeed when a film character looks right back at us.

5.67 Anna succumbs to the cold and is left defenseless on the ice. *Way Down East* (D. W. Griffith, 1920).

5.69 David's frantic search is punctuated by this close-up; he has found her but his eyes signal the danger that awaits them both.

5.68 The falls, which we see at strategic moments throughout the rescue scene.

5.70 The eyeline match to what David sees: Anna out cold on the ice floe headed toward the falls.

5-2c Editing Parallel and Simultaneous Actions

As filmgoers, we are not only able to make the connection between a character and what he or she sees, but, if the continuity editing is skillful, we can also follow two or more simultaneous actions. We do not need to see any two shots or scenes at the same time, as we might in split screen (see fig. **2.18**). The very process of cutting back and forth (**cross-cutting**) cues filmgoers to read the actions as parallel. **Parallel editing** is well suited to cinematic events like rescues and chases, where multiple actions build to a climax.

> **cross-cutting** The process of cutting back and forth between two or more parallel actions; also known as **parallel editing**.

The last-minute rescue sequence was a staple of silent film melodrama. One of the most compelling parallel sequences can be seen in D. W. Griffith's 1920 film *Way Down East*. The sequence runs for 13 minutes and is composed of well over 100 shots editing together two parallel actions: Anna's venture out into the snow and David's search for her. Once Anna is shown floating downriver on an ice flow (fig. **5.67**), Griffith adds a third parallel event, shots of the rushing water as it leads to the falls (fig. **5.68**). What makes the scene—what allows us to get swept up in the rescue—is the skillfulness of the continuity editing.

Griffith pays off these parallel sequences in a way even filmgoers in the 1920s found familiar. First a close-up highlights David's eyes opened wide to signal recognition (fig. **5.69**). We don't have to see Anna in the frame with him to know that he has found her. The

5.71 Popeye Doyle commandeers a car in *The French Connection* (William Friedkin, 1971).

5.73 A third angle on Doyle driving car in pursuit of the train.

5.72 Doyle's car continues to move from screen left to screen right.

5.74 A fourth angle puts the viewer in the back seat of the car. Note how all four very different camera positions and angles follow a consistent screen direction, showing the car move from screen left to right.

eyeline match (to Anna on the ice floe) that follows affirms what the close-up of David implies (fig. **5.70**).

In a parallel edited chase scene in *The French Connection*, we can see how consistent **screen direction**—another key principle of continuity editing—is crucial to our ability as filmgoers to keep track of the fast-paced action. When he spies one of the drug smugglers' henchmen board a train, the eccentric New York City police officer Popeye Doyle commandeers a car and gives chase. The first four shots in the sequence establish the space and pace of the chase. We see in quick succession: the car Doyle has commandeered (fig. **5.71**), Doyle driving that car (fig. **5.72**), the car from a different angle (fig. **5.73**), and Doyle's view looking out through the windshield (fig. **5.74**).

The next shot shows the train he is chasing (fig. **5.75**). We recognize the geographic logic of the pursuit because the filmmakers maintain consistent screen direction; the train is shown moving (like Doyle's car)

consistently from screen left to right. A quick cut to a shot of what one might see looking out the windshield of the train (fig. **5.76**) maintains the frenetic pace, perpetuates the sense of movement (in the same direction: screen left to right), and shows in the near distance a station, a place where the villain might disembark and try to escape on foot. Subsequent shots in the sequence reinforce the sensation that Doyle is moving in pursuit of the train overhead (figs. **5.77–5.79**). Even though the car and the train are not in the same frame, through parallel editing and consistent screen direction, we understand that they have a relationship as pursuer and pursued.

screen direction The directional relationships in a scene determined by the position of characters and objects, by the direction of their movements, and by eyeline matches.

5.75 The train that Doyle pursues.

5.78 The train overhead . . .

5.76 The train approaches a station.

5.79 . . . and the car below.

5.77 Cut to: Doyle in hot pursuit.

5-3 ALTERNATIVE EDITING STYLES

Continuity editing is the dominant mode of assembling a sequence or scene because it maintains the verisimilitude of the fictional world. Yet not all films have verisimilitude as a primary goal; not all filmmakers want audiences to "fall into" the story. Some European filmmakers of the 1920s, for example, were interested in creating a surreal experience or offering significant editorial commentary on the story. They were less interested in making editing invisible than in exploring the expressive possibilities of shot juxtapositions. Later filmmakers deliberately violated the rules of continuity editing to call attention to its artifice or to unsettle the viewer. And others break the rules to simulate the kind of editing that we recognize from the world of documentary and television production, where filmmakers inter-cut live footage from multiple, simultaneously running cameras.

5-3a The Insert

Between 1917 and 1929, from the advent of the Bolshevik Revolution and the embrace of a revolutionary film aesthetic through the rise to power of Joseph Stalin and state-imposed film censorship, many Soviet filmmakers who were part of the movement known as **Soviet formalism** applied Kuleshov's ideas about editing to develop a style characterized by the striking juxtapositions of shots. The formalist filmmaker and theorist Sergei Eisenstein referred to this style of editing as *collision*.

One goal of this editing style was to disrupt the continuity of cinematic time and space. One unusual technique was **overlapping editing**, in which a single event is shown multiple times. In Eisenstein's *Battleship Potemkin*, for example, several acts of violence in the Odessa Steps sequence are shown and then reshown from another angle. Here the overlapping editing expands an on-screen action's duration and, through repetition, underscores its significance.

Another discontinuous editing technique is the **nondiegetic insert**, in which an image from outside the world of the story interrupts and comments in some way on the action. Eisenstein used the nondiegetic insert in his final silent film, *Old and New* (1929). He inserted images of flowing fountains into a dairy farm sequence otherwise composed of close-ups of a cream separator and peasants' ecstatic faces. The fountain is not present in the real space of the story and there is no suggestion that the peasants see or have ever seen the fountain. It is instead meant to comment upon or highlight the *feeling* of the scene. More modern uses of nondiegetic inserts include the use of printed text instructions in the work of Jean-Luc Godard. While Eisenstein uses the nondiegetic insert to heighten the impact of a scene, Godard uses it to insert an authorial commentary; indeed, at a key moment in his 1967 film *Week End*, Godard uses a nondiegetic insert to offer a useful bit of instruction; he tells us simply to "ANALYSE."

Not all uses of inserts are nondiegetic, however; sometimes an insert can be a cut to a closer look at a portion of a figure or object within the story. In the Odessa Steps sequence in *Battleship Potemkin*, for example, inserts direct our eyes in an otherwise chaotic scene of a peasant rebellion suppressed by the Cossacks. At one point, we see a woman shot. First we see a close-up on her face in anguish (fig. **5.80**), then an insert of her buckled sash (fig. **5.81**). The insert of the sash offers an intimacy of sorts as it interrupts the flow of images and focuses our attention on a specific part of her costume: her belt buckle (with its symbolic swan)

5.80 A woman in pain in the legendary Odessa Steps sequence in Sergei Eisenstein's *Battleship Potemkin* (1925).

5.81 An insert suggests the location of her wound. The swan is at the center of the image, against a dark background, so that it will be noticed.

Soviet formalism A film movement in the Soviet Union that took shape during the Bolshevik Revolution (1917) and unraveled in the early years of Joseph Stalin's repressive regime (1929). Soviet formalist filmmakers—including Sergei Eisenstein, V. I. Pudovkin, and Dziga Vertov—believed that the essential unit of meaning in cinema is the cut.

overlapping editing The repeated presentation of a plot event, expanding its on-screen duration and underscoring its significance.

nondiegetic insert An image inserted into a scene that comes from outside the world of the story.

5.82 This image of the riot on the steps is intercut with the shots of the woman.

5.83 A final insert shows the wound again, oozing blood. Beauty, refinement, peace—all symbolized by the swan—have been destroyed by the Cossacks.

and the wound above it. A long shot follows, showing what is happening simultaneous to the shooting of the woman (fig. **5.82**). We then return to the insert: blood flows from the wound, engulfing the swan (fig. **5.83**). Not only does the insert evoke our sympathy and humanize this scene of mass murder, but it also makes a larger statement about the values of the two sides.

The inserts in this sequence are *metonymic*; they focus on a part of an image to refer to the whole. As such, they break up the flow of images stylistically, but they do not affect the narrative continuity of the scene. We understand that the character whose face we see in figure **5.80** is the same woman whose wound we see in close-up in figures **5.81** and **5.83**.

Like Eisenstein, who pioneered a revolutionary film aesthetic to match a revolutionary political agenda, the surrealist filmmaker Luis Buñuel experimented with editing to deliberately fragment cinematic time and space and to shock bourgeois audiences out of their complacent embrace of the status quo. In the most disturbing sequence in his provocative film *Un Chien Andalou* (*An Andalusian Dog*), created with the surrealist painter Salvador Dalí, Buñuel simulates the brutal act of severing an eyeball with a razor. The sequence is composed of three shots: a woman unimaginably calm as the razor is raised to her face (fig. **5.84**), an unrelated insert of the night sky (fig. **5.85**), a close-up of the simulated violent act (fig. **5.86**). The second shot offers an apparent visual parallel between the movement of the clouds and the movement of the razor, but Buñuel offers no narrative or thematic connection between the

jump cut A cut that seems to suggest a glitch or skip in the film.

shots. Instead he aimed to establish something akin to the workings of the unconscious mind, in which images do not follow a continuous or coherent narrative.

5-3b The Jump Cut

Buñuel viewed continuity editing as bourgeois, as constricting and conventional. In its place he introduced an avant-garde editing style that approximated the discontinuity of the dream state (see the section on surrealism in chapter 8). Thirty years later, several of the French New Wave filmmakers—most famously Jean-Luc Godard and Alain Resnais—would again deliberately break the rules of continuity editing, creating the jump cut in an effort to breathe new life into film form.

The **jump cut**, so-called because it seems to suggest a jump, glitch, or skip in the film, is achieved by breaking the 30 degree rule, which specifies that the juxtaposition of two shots of the same subject must vary by more than 30 degrees in camera position. (Paired with the 30 degree rule is the guideline that when juxtaposing shots of the same subject, the focal length of the lens should change by at least 20 millimeters.)

A jump cut can appear amateurish, as if a shot has been interrupted by a flubbed line or some technical snafu and then simply resumed as if nothing had happened. Yet the jump cut can also be expressive, speaking to the ever-faster movement of images in our lives. The jump cut in this second context is a kind of abbreviation or visual shorthand, a simulation of the fast and fragmented images that abound in modern culture.

Godard's jump cuts in *Breathless* (fig. **5.87–5.89**) are glitchy and disruptive; they are cheeky in-jokes, references

5.84–5.86 Discontinuity editing in *Un Chien Andalou* (*An Andalusian Dog*, Luis Buñuel and Salvador Dalí, 1928).

▶ **5.87–5.89** Three cuts of a banal conversation, each one breaking the 20 mm/30 degree rule. Here the jump cuts enable Godard to offer commentary on the characters' conversation and on the cinematic convention of continuity editing. *Breathless* (*À bout de souffle*, Jean-Luc Godard, 1960).

to how conventions of film form and style shape filmic representation. For Godard, the jump cut functions as a critique of traditional continuity editing and as a satirical comment on the action on-screen. For example, as the car thief Michel and his American girlfriend Patricia

converse in a car, Godard places the camera in the back seat. Such a camera position is unusual, especially since there is no character in the back seat to identify with. The camera position frustrates our access to the characters; we hear them but can't see their lips move. Moreover, Godard repeatedly breaks the 20 mm/30 degree rule, cutting from one image of Patricia's head to another without changing angle or camera lens sufficiently (fig. **5.87–5.89**). The editing scheme here undermines narrative verisimilitude; we are not asked to view the action on-screen as in some way an aspect of a "real" story we are witnessing but instead as a completely contrived re-presentation that, in this case, the author himself finds amateurish and amusing.

The jump cut disrupts the flow of images and implies something missing, something deliberately cut out. This should not be confused with techniques that compress and elide action. Such manipulations in duration are commonplace as filmmakers endeavor to tell a potentially long story in a compact amount of time. The jump cut calls attention to what's missing just as continuity editing suggests a logical flow from one shot to the next.

The term *jump cut* has over the years been used more loosely to denote any cut that calls attention to a break in the spatial or temporal continuity of a sequence. In *Bonnie and Clyde*, a film originally offered to Godard and made with the French New Wave very much in mind, we are introduced to Bonnie as she whiles away the time alone in her room (figs. **5.90–5.93**). This variation on jump cut editing suggests a series of snapshots pasted together, absent transitions and absent the usual seamless changes in angle or focal length. The editing style here is not, as it was in *Breathless*, a satirical commentary but instead a decidedly modern stylistic gesture that

5.90–5.93 Bonnie Parker roams her bedroom in the opening scene of Arthur Penn's *Bonnie and Clyde* (1967). In close-up we see Bonnie turn her head (5.90); mid-turn, the film jumps to a medium shot (5.91). Another visible skip occurs when Bonnie lies down on her bed. First she is sitting, her back to the camera (5.92); next she is reclining, mid-action (5.93). The jump cut style suggests Bonnie's restlessness.

5.94–5.97 Shots of the Beatles performing are intercut with shots of mostly female audience members reacting to their performance.

leaves us feeling much as Bonnie feels at this moment in the film: impatient, restless, and anxious.

5-3c TV-Style Editing

Live TV production of talk and news shows routinely involves three cameras running simultaneously. TV coverage of live sports often involves as many as ten. An editing team in a studio booth or in an adjacent production trailer cuts from one camera view to the next as the event unfolds. This type of coverage allows our gaze to be mobile (or at least multiple). And it is directed by the choice of camera used in a given shot.

To simulate this "live action" effect, some filmmakers cover a given scene with several cameras running simultaneously and then, in the editing suite, intercut these synchronized images. This technique is frequently used for concert scenes. We hear the steady stream of audio (the song that plays uninterrupted on the soundtrack), and we see on-screen a mix of shots taken from multiple camera positions.

An example of this TV-style editing can be seen in Richard Lester's *A Hard Day's Night*, as shots of the Beatles performing are intercut with shots of mostly female audience members caught up in the event (figs. **5.94–5.97**).

Lester also includes inserts of the TV crew (fig. **5.98**). The editing of shots of the band, the crowd, and the production team give us rather complete access to the event in all of its complexity, as a live performance and as an event in the process of recording and production. There is an irony in play here. We have come to accept this editing technique as an aesthetic of realism not because it reproduces the sensation of watching a live event (which we generally watch from a single, fixed vantage point) but because it resembles familiar modes of representing live events.

5.98 This insert of the TV crew further implies an event captured on the fly.

CHAPTER SUMMARY

The decisions made in editing have an enormous impact on a film's narrative form and rhythm and on its visual, emotional, and intellectual power.

5-1 ELEMENTS OF EDITING

Learning Outcome: *Appreciate and understand the theoretical, historical, and practical foundations of film editing.*

- In Soviet montage theory, the meaning of one shot is always subject to the previous and subsequent shots. Meaning is a matter not of singular content but of context.

- Editing is used to create tonal (light-to-dark and dark-to-light) and graphic patterns in a sequence.

- Tempo or rhythm is created in editing by working with the length of shots. The long take, a single continuous shot of unusually long duration, may offer commentary on the boredom inherent in the modern condition, or it may be used to match the leisurely pace of premodern America. The use of editing techniques to speed up the tempo is characteristic of "thrill-ride" American filmmaking.

- Elliptical editing, where cuts move us along in the plot by removing parts of the larger story, is a crucial technique in the management of narrative time.

- The montage sequence is a technique in which a series of brief shots are edited together to summarize a section of the story. Filmmakers use montages to show time passing, relationships developing, and characters aging.

- Among the alternatives to the cut are the fade, iris, dissolve, and wipe.

5-2 CONTINUITY EDITING

Learning Outcome: *Recognize and analyze continuity editing as a storytelling technique.*

- Continuity editing supports the illusion that each scene unfolds in a continuous time and space, when in reality it has been assembled from multiple takes and different camera positions.

- The 180 degree rule maintains that there is an "axis of action" that runs along an imaginary horizontal line in a given sequence. This line bisects an imaginary circle, and the camera must stay within one-half of the circle, an area of 180 degrees.

- The establishing shot, or the master shot, establishes the spatial relationships among the characters and objects in the dramatic scene.

- The technique of shot/reverse shot involves alternating shots of two characters as they converse. With this technique, we not only see each character as he or she speaks, but we also get reaction shots that show us how the listener is responding.

- An eyeline match is two shots: one shot showing us someone looking and the next shot showing us who or what he or she is looking at.

- The process of cutting back and forth between parallel actions is called cross-cutting. It cues filmgoers to read the actions as parallel. This form of parallel editing is well suited to cinematic events like rescues and chases.

- Parallel editing is generally supported by consistent screen direction, which maintains the relationship between, for example, the pursuer and the pursued in a chase sequence.

5-3 ALTERNATIVE EDITING STYLES

Learning Outcome: *Identify and assess the expressive uses of discontinuous and live broadcast editing styles.*

- Some filmmakers are less interested in making editing invisible than in exploring the expressive possibilities of shot juxtapositions. Inserts are images that interrupt and comment on the action. They can come from within the story world (diegetic inserts) or from outside it (nondiegetic inserts).

- Surrealist filmmakers experimented with editing to deliberately fragment cinematic time and space and shock bourgeois audiences.

- The jump cut suggests a jump or glitch in the film. It is used to disrupt spatial and temporal continuity. Jump cuts can create a collage effect, suggesting a series of snapshots pasted together.

- Live TV production routinely involves several cameras running simultaneously. An editing team in a studio booth or in an adjacent production trailer cuts from one camera view to the next as the event unfolds. This type of coverage allows our gaze to be mobile (or at least multiple) and directed by the choice of camera used. Films that simulate this style reproduce the sensation of watching a live event.

Kathryn Bigelow's 2009 film *The Hurt Locker* follows a U.S. Army bomb squad (Bravo Company) in Iraq as it counts down to the end of its mission. In the following sequence of shots, the filmmakers skillfully mix a number of the styles and techniques we have examined in this chapter. Sergeant James attempts to dismantle a timed bomb that is strapped to a man's chest. The editing heightens the tension, as the number of cuts intensifies as time runs out. We are shown the scene from multiple vantage points in a handheld camera style that simulates documentary or news footage and adds to the sense of events unfolding in real time; nonetheless, we always know where the characters are in the scene. The final shot provides a kind of editorial commentary on what has transpired.

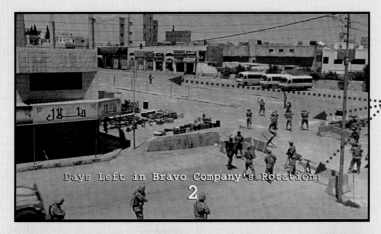

An establishing shot positions the bomber and troops in relation to one another and establishes the location of the action. The words we see superimposed on the image situate the event in story time: two days left in Bravo Company's rotation.

James has ordered the bomber to his knees and has told his partner to look out for snipers. We cut to an overhead view, which approximates a sniper's point of view. The bomber appears tiny, alone, and vulnerable, framed between the bars on a window in the center of the frame.

When James reaches the bomber (elliptical editing dispenses with his entire walk), the cuts offer various views that communicate the difficulty of the situation. This close-up presents a piece of important information: the bomb is set to explode in 2 minutes and 25 seconds. The rest of the scene proceeds in real time, but with more than fifty cuts.

James attempts to defuse the bomb. The editing alternates shots of James's intense concentration with eyeline matches to the bomb. The cuts also alternate between shots of James and the bomber, whose face registers terror.

The bomb explodes. Cut to James, thrown backward from the aftershock. After a pregnant pause, we see him move to pull off his helmet, and we know he has survived. He looks up at the sky.

The eyeline match is to a kite in the sky. Another beautiful day in Iraq.

ANALYZE EDITING

Use these questions to analyze how the basic elements, techniques, and strategies of editing contribute to the visual and story content of a film.

5-1 ELEMENTS OF EDITING		• Isolate and observe the individual shots in a sequence. What, if anything, do these individual shots mean on their own, independent of their context to previous and subsequent shots? How does their meaning change in context with the other shots in the sequence?
		• How would you describe the rhythm or tempo of the sequence or of the film as a whole? How does the editing contribute to this effect?
		• Do the filmmakers employ any alternatives to the cut, such as a fade, iris, or dissolve? If so, discuss how this effect works.
		• Can you discern any tonal or graphic relationships between the shots?
5-2 CONTINUITY EDITING		• Is the editing style of the film invisible, or does it draw attention to itself?
		• Identify the master shot in the sequence. How does that shot establish the spatial relationships in the scene?
		• Find a sequence that includes a prolonged conversation. Observe and discuss how techniques such as the 180 degree rule and shot/reverse shot are used to capture the visual and narrative content of the scene.
		• Does the sequence include an eyeline match? How is this technique used to communicate story information?
5-3 ALTERNATIVE EDITING STYLES		• Does the film draw attention to the editing in any way, and if it does, how does this affect your reading of the scene and/or the film?
		• Does the film use inserts, jump cuts, or TV-style editing to expressive effect? How and why?

6 SOUND

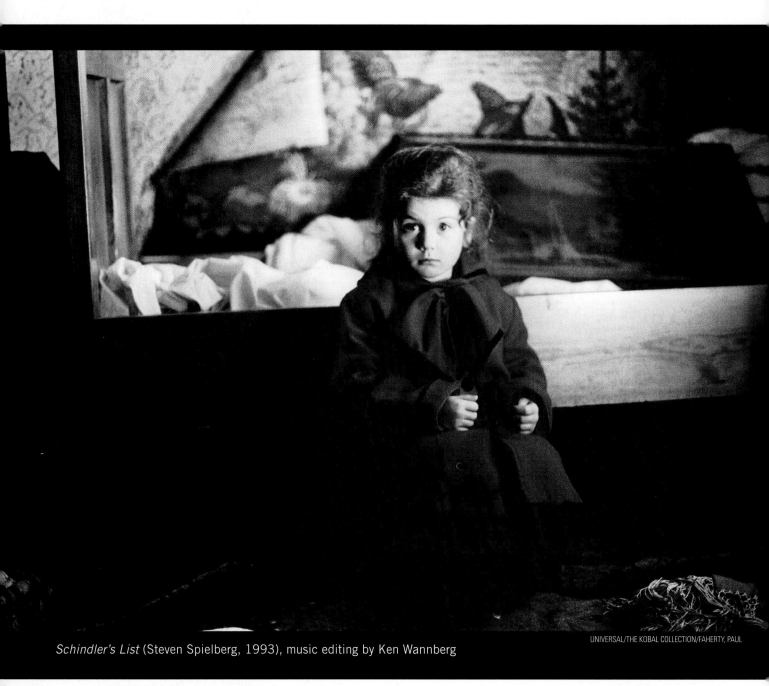

Schindler's List (Steven Spielberg, 1993), music editing by Ken Wannberg

When we talk about "reading" a film, it implies looking and processing information acquired in that act, much like reading a book. But close reading in film also requires attention to the variety of sounds that accompany the images on-screen. These sounds are as carefully designed, produced, and edited as the images and are integral to a film's meaning. (Indeed, one popular film journal is called *Sight and Sound*.)

Sound design is the careful composition of three main types of film sounds—spoken words, music, and sound effects. While some of these sounds are produced while the camera is rolling, most are recorded after a scene is shot and then synched with the visual track in postproduction. This chapter offers an introduction to the complex production and postproduction of film sound(s) and endeavors to more fully present a framework for the critical analysis of film as an *audio*-visual medium.

MAKING MOVIES

KEN WANNBERG ON MUSIC EDITING

Ken Wannberg is a music editor who has worked extensively with the composer John Williams on some of the biggest box office films of all time. His music editing credits include *Star Wars* (George Lucas, 1977), *Raiders of the Lost Ark* (Steven Spielberg, 1981), *JFK* (Oliver Stone, 1991), *Schindler's List* (Spielberg, 1993), and *Harry Potter and the Prisoner of Azkaban* (Alfonso Cuarón, 2004). In 1986 Wannberg won an Emmy for his sound editing on Steven Spielberg's *Amazing Stories* series.

Q1: Could you talk a little about what a music editor does?

A: He works with the composer in postproduction, after the film is done. We run the film with the director and make "spotting" notes—identifying moments or cues where music will be used. I then make a detailed breakdown of those cues. . .break it down into hundredths of seconds. And that breakdown goes to the composer, and he writes the music using the notes and time-cues as a guide.

Q2: How does the director decide how to balance the voice track, the effects track, and the music track?

A: You have a dialog mixer, a sound effects mixer, and a music mixer. We put [the film] up on screen, and then the fight begins (figuratively speaking). The music department doesn't usually win. . .because music is abstract in film. Sound effects are more organic. It's part of the film. Whereas music is the intruder.

Q3: Is it difficult or complex to work with "source music" (pre-recorded popular music not written expressly for the film)?

A: The only hard part about source music is if you are fitting it into a scene, and you're dealing with phrases—eight-bar phrases, sixteen-bar phrases—you can't take a pop tune that everybody knows and murder it, cut it. So if you're trying to fit it into a scene, you only have so much latitude. It's really expensive to use source music. Take for example a "needle drop". . .thirty seconds that you hear in the background, I mean that could be $60,000. You've seen the "roll-ups" [credits] at the end of films. . .how many songs are listed there. . .multiply that out. . .it's a lot of money.

Q4: Are you trying to get audiences to react a certain way to a scene by orchestrating or strategically editing music?

A: Well, sure. But the film dictates what the music should be.

The seamless integration of sound and image that we take for granted in contemporary films has its beginnings in the earliest filmmaking experiments. A full year before the first publicly exhibited, projected motion pictures, William Kennedy Laurie (W. K. L.) Dickson, working for the Edison Manufacturing Company, timed the operation of an Edison movie projector and an Edison phonograph to produce an early (albeit crude) sound film. Consistent with the "gee whiz" attraction of early cinema, the film focuses on the very production of movie sound, as we see Dickson playing a violin and two unidentified Edison employees dancing listlessly while a sound cylinder records the tune (fig. **6.1**). Dickson's process was ingenious but impractical; it depended too much on operator expertise and a little luck to get sound and image in synch.

While Dickson and some of Edison's competitors searched for alternative ways to synchronize recorded sound and images, exhibitors hired musicians to play during screenings. This live music functioned much as background music functions today (more on this later in this chapter): it was used to signal rising action, highlight moments of romance or suspense, accompany changes in pace, and in a larger way to set an appropriate mood for the story told in the film. Silent films were never meant to be fully silent.

The movie routinely credited with ushering in sound is *The Jazz Singer*, the story of a cantor's son who opts to sing jazz standards instead of the devotional music of his Jewish heritage. The film showcased

Warner Bros.' Vitaphone, a sound-on-disc technology developed by Western Electric that synchronized sound recorded on a disc (like a record album) with moving images projected on-screen (figs. **6.2** and **6.3**). To be accurate, *The Jazz Singer* was just one of several in a series of so-called hybrid sound films from Warner

6.2 The opening run of *The Jazz Singer* (Alan Crosland, 1927) at the Warners' Theater in New York. Note the billboard above the marquee—"The Jazz Singer with Vitaphone"—and the lamentable image of Al Jolson in blackface, a popular but nonetheless racist posture for white jazz singers of the 1920s.

6.3 Between musical numbers, Al Jolson looks directly into the camera and quips: "Wait a minute . . . Wait a minute . . . You ain't heard nothing yet." It was a routine part of Jolson's stage act to make such a promise—that there would be more songs and gags to follow; but in the context of film history, the line spoke to the massive industrial transition to come.

6.1 W. L. K. Dickson's 15-second "experimental sound film" (1894). The sound recording device is featured prominently at left.

6.4 A diagram explaining how sound film works from the 1929 animated film *Finding His Voice*, produced by Max Fleischer (who also produced the Betty Boop and Popeye cartoons) and F. Lyle Goldman for Western Electric. The film's explanation is rudimentary but none-theless offers a useful introduction to the new sound process. To paraphrase: Sound is a vibration. And that vibration can be photographed. A photographic record of that vibration appears in the form of a squiggly line on a piece of film. If you want to hear it back, you run a light through that squiggly line and those vibrations go to a speaker that reproduces the sound.

Bros. that mixed sequences containing synchronized dialogue and music with extended sequences shot as a silent film. Due in part to its star's performance and to the use of sound to highlight his songs, the film proved to be a popular sensation.

Filmgoer demand for more movie musicals like *The Jazz Singer*, and more sound films in general, motivated exhibitors to invest in amplifiers capable of filling a movie palace with sound and in film projectors that ran 24 frames per second instead of the 16 frames per second standard for silent film. (See figure **6.4** for an illustration of how sound projection works.) The changeover in pro-jection equipment between 1926 and 1928 meant that silent films—no matter how popular they remained—would have to give way to "talkies." By 1929 virtually every movie in America had synchronous sound.

The addition of recorded sound made movies more modern and more lifelike and more central to the evolving American experience. Soviet filmmaker and theorist Sergei Eisenstein observed that synchronized sound allowed for a "synchronization of the senses"; after all, we experience the world not just through sight but through sound as well. It also established an integrative filmmaking practice in which sound was designed to function in concert with (and occasionally in contradiction to) the moving image. We will look at some basic relationships between sound and image before examining the individual components of the soundtrack in greater depth.

6-1a Diegetic and Nondiegetic Sounds

Sound that originates from within the world of the film, either from the characters or from the setting, is called **diegetic sound**. (As noted in chapter 2, the term *diegetic* derives from the Greek word for narra-tive.) **Nondiegetic sound** does not have a source in the world of the film. Most films abound in both diegetic and nondiegetic sounds. For example, in *Mean Streets* Martin Scorsese accompanies a fight in a poolroom with the pop song "Please Mr. Postman." The song, we are told in the dialogue preceding the fight, is playing on the jukebox in the poolroom. It is diegetic; it has an identifiable source within the world of the film (fig. **6.5**). Later in the film, we hear music as the main char-acters, Charlie and Johnny Boy, hide from the police. They are on the streets, yet we hear a flute, bass, and drum providing a brief jazz riff (fig. **6.6**). The sound has no source in the world of the film; it is nondiegetic.

Diegetic sounds do not have to be produced and recorded during filming; indeed, many diegetic sounds are added in postproduction. In the poolroom scene, for example, Scorsese did not film the fight in one take. There are multiple camera setups and positions and several cuts in the scene. The production of the images involved several starts and restarts, but the music plays uninterrupted and at a perfectly modulated volume. The music was added in postproduction (and not sourced by a jukebox), but it is nonetheless diegetic.

It is common for filmmakers to use diegetic and nondiegetic sounds in the same scene. For example, early in *The Social Network* we see Mark Zuckerberg furiously tapping on a keyboard, cracking the firewalls that protect the e-mails at various houses across Har-vard's campus (fig. **6.7**). Much of what makes this oth-erwise familiar image interesting and informative are the sounds, both diegetic and nondiegetic. We hear the sounds of Zuckerberg's fingers furiously tapping and

diegetic sound Sound that originates from within the story.

nondiegetic sound Music, words, or effects from outside the story world that shape our experience of the film but do not originate within scenes.

6.5 A poolroom fight in Martin Scorsese's *Mean Streets* (1973) is accompanied by diegetic sound—music with an identifiable source in the world of the film: a jukebox. The song we hear, the Marvelettes' 1961 hit "Please Mr. Postman," has no relationship to the events on-screen. It's a girl-group number about a young woman hoping to get a letter from her boyfriend, but its rollicking beat underscores the frenetic action of the poolroom scuffle.

6.6 As Charlie and Johnny Boy find a hideout, we hear a flute, bass, and drum providing a brief jazz riff that has no source in the scene. This nondiegetic sound underscores the clandestine nature of their actions. It also adds a hint of comedy to the scene, so we are not particularly worried that they will get caught.

snippets of dialogue between Zuckerberg and his business partner Eduardo. These diegetic sounds are accompanied by a pulsing electronic music score that gives the scene an upbeat pace and lighthearted tone. The music is not, we learn soon enough, playing inside the dorm room; indeed we hear the same music when we cut to a party at a frat house. The music forms a **sound bridge** that connects the scenes in time.

In addition to the diegetic dialogue between Zuckerberg and Eduardo, we hear Zuckerberg read what appears on the computer screen and explain how he hacks the system. This commentary is nondiegetic, even though it derives from the same source (the character Zuckerberg) as the diegetic sound; Zuckerberg doesn't say these words in that room at that moment in time. The combination of diegetic and nondiegetic sounds allows the filmmakers to play out a scene *and* comment on that scene at the same time.

Identifying diegetic and nondiegetic sounds in a scene serves a critical purpose in film analysis. Diegetic sound matches our experience of the scene with the experience of the same scene by the film characters. Nondiegetic sound generally offers a point of view on the action or it establishes mood and tone; in other words, nondiegetic sound guides our reading of a scene much as a narrator's description might in a work of literary fiction.

> **sound bridge** A sound that connects two scenes. It could be a sound that carries over from one scene to the next or a sound from the second scene that is heard before the first scene ends.

6.7 A simple image, a complex use of diegetic and nondiegetic sounds. *The Social Network* (David Fincher, 2010).

6.8 "Tara is the only thing that matters." Scarlett hears voices in her head (and we hear them too). *Gone with the Wind* (Victor Fleming, 1939).

6-1b On-Screen and Off-Screen Sounds

Another useful distinction for analysis is between on-screen and **off-screen** sources for the sounds in a scene. On-screen sources are those we can see within the frame—a couple arguing, a door slamming, a car screeching away. Off-screen sound comes from a source we can't see. But unlike nondiegetic sound, we nonetheless acknowledge these off-screen sounds to be inside the world of the film—the sounds of the couple, the door, and the car heard while the camera stays focused on a child listening in her bedroom, for example. On-screen sounds create verisimilitude—the appearance of reality—while drawing our attention to various locations within the frame. Off-screen sound expands the space of the film beyond the frame and also allows the audience to identify more closely with the experiences

off-screen sound Sound that originates from a source that we cannot see but assume nonetheless to be part of the story world.

non-simultaneous sound Sound from the past or the future within the story world.

internal diegetic sound A character's thoughts and memories, heard but not spoken aloud.

of certain characters, such as the child in the example above.

6-1c Simultaneous and Non-Simultaneous Sounds

Sound can expand film time as well as film space, as the concept of **non-simultaneous sound** illustrates. Simultaneous sound corresponds in time with what is happening in the frame; non-simultaneous sound comes from the narrative's past or future. Non-simultaneous sound may represent memories, as when a character hears voices from the past that have influenced his or her way of thinking. At the end of *Gone with the Wind*, for example, Scarlett O'Hara ponders her future now that Rhett Butler has finally left her. We see her collapse on the stairway, forlorn. But in this, her lowest moment, she hears the voices of the men in her life—Rhett, her father, and Ashley Wilkes—reminding her that "Tara is the only thing that matters" (fig. **6.8**). Tara (the name of the former plantation), after all, has survived the Civil War and Reconstruction, the death of a child, and the loss of these three beloved men. Earlier in the story, when these lines were spoken directly to Scarlett, they were simultaneous; in this second iteration, they are non-simultaneous.

The simple message provided by the non-simultaneous sound helps pull Scarlett out of her funk. "After all," she notes at the end of the film, "tomorrow is another day." The device may by today's standards seem hokey or corny, but it nonetheless presents something otherwise very difficult to show on-screen: what is going on inside a character's head. This audible access to the internal workings of a character's mind is called **internal diegetic sound**; its source is very much inside the world of the story, even if it does not come from the external setting.

Diegetic/nondiegetic, on-screen/off-screen, and simultaneous/non-simultaneous are just a few of the relationships that constitute the complex audiovisual experience provided by the medium of cinema. In the sections to follow, we will examine more closely the individual components of the soundtrack: voice, music, and sound effects.

Filmmakers work with three general categories of sound—voice, music, and effects—each of which has unique expressive possibilities. The first, and in most films foremost, sound field is the voice track: actors, in character, read lines from a script, and these spoken words propel the film's story. Precisely how actors read these lines—alternatively called **line delivery** or **line reading**—can significantly affect meaning. Some actors, like Keanu Reeves, have characteristically flat line readings to signal disaffection, boredom, and detachment. Others, like Christopher Walken, indulge in more idiosyncratic line readings, often used to imply strangeness, even menace. Actors deliver lines at different volumes to suit different moods, motives, or narrative events. And even something as subtle as voice inflection, highlighting a word or phrase in a line of dialogue, can alter its meaning. "*You* talking to me?" "You *talking* to me?" "You talking to *me*?"

The voice track is generally reproduced for maximum clarity. There are exceptions to this rule, but in most films we are meant to hear and understand what people are saying both on- and off-screen. During exhibition in theaters equipped with multichannel sound, the voice track is often routed to speakers in the front of the auditorium so that it appears to come directly from the screen. This close connection between the image and voice tracks serves to highlight the importance of spoken words to the film experience.

6-2a Recording Dialogue

Dialogue—scripted or improvised conversation—can be, in certain controlled situations, recorded live on the set. Before a take commences, sound recordists routinely take in or record the "sound of the room" absent dialogue or movement. This so-called room tone is important later on during postproduction because it is used to provide a consistent or baseline background sound "presence" or atmosphere during sound editing (see section 6-5a). Once the room tone is recorded and the recording levels are set, the assistant director calls for quiet and the clapboard is brought in front of the

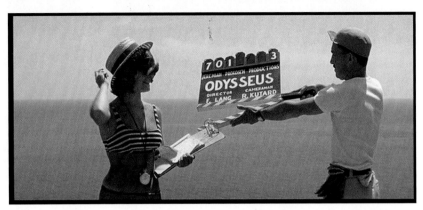

6.9 The clapboard marks the beginning of a take (scene 701, take 3) in *Contempt (Le Mépris*, 1963), Jean-Luc Godard's film about the making of a movie adaptation of *The Odyssey*.

camera. The board, or slate, identifies the scene and take number, and it is clapped to mark the synchronization of sound and image (fig. **6.9**).

For the initial live recording of dialogue, filmmakers often mount a microphone on a long pole (called a boom or fishpole) that is held just out of frame and thus just outside the borders of the final printed shot (fig. **6.10**). This type of microphone rig is particularly effective because it can pick up dialogue as it might be heard if we, the filmgoer, were somehow in the space of the scene (but just off camera, like the mike).

Live sound is recorded onto the film and also on a separate medium (analog audiotape, or a digital medium like digital tape or compact disc, or on a computer hard drive), which is called double-system recording—an industry standard for live sound capture. But even with double-system recording, it is not always possible to adequately capture synchronous dialogue live on the set. A number of variables can compromise the clarity of the initial voice recording: ambient or random sounds (especially outside, on location), the noise created as characters move about the set, and the relative volume and pitch of each actor's line delivery. As a consequence, the live recorded dialogue is considered a *guide track*, the first step in the process of producing a final vocal

line delivery the way in which an actor says the words from the script; also called **line reading**.

dialogue Words spoken between two or more characters.

6.10 A conversation recorded with a single microphone attached to a boom, or fishpole microphone, seen here dangling just above the actress Alexis Smith's head, in the Cole Porter bio-pic *Night and Day* (Michael Curtiz, 1946).

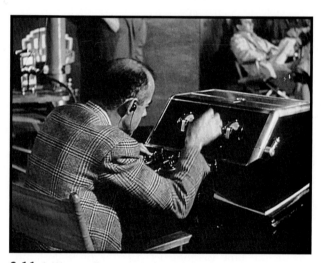

6.11 A Warner Bros. sound recordist adjusting the levels during the voice recording in the same scene from *Night and Day*.

track. When the guide track is not of an acceptable quality, the actors are asked to record their lines again in a studio. There they watch the footage on a monitor so that their delivery matches the movement of their lips on-screen. This process is called **dubbing**, or **looping**,

dubbing The process of rerecording dialogue and synchronizing it with shots; also known as **looping**.

fourth wall The imaginary wall or barrier between the audience and the characters that creates the illusion of a separate story world.

direct address A type of speech in which the character breaks the fourth wall and speaks to the camera or audience.

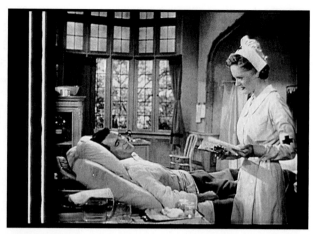

6.12 What the projector "sees": Note the soundtracks at the left of the image. Porter is in a military hospital and by chance meets an old flame. He remarks, "3,000 miles, three years and all of a sudden, you," to which his future wife smiles and replies, tongue-in-cheek, "I had it all planned that way." The dialogue accomplishes two things: it feeds into and off of a familiar romantic trope in Hollywood film (the chance meeting, true love as a product of fate), and it depicts larger-than-life characters (played by movie stars) who act "cool" in even the most anxious moments.

and in contemporary postproduction it is performed by a technique called ADR (automatic dialogue replacement). While not always necessary, ADR is generally superior to sound recorded on the set or on location.

The recording and rerecording processes are almost always designed and executed to highlight what the filmmakers want us to hear and what they want us to pay specific attention to. That is why dialogue is mostly audible and comprehensible. And when it is not, it is not for a reason. How well or poorly we hear what people are saying is not an accident. It is the result of sound mixing, not sound recording—a topic discussed in detail later in this chapter.

6-2b Direct Address

In a play, when a character breaks the so-called **fourth wall** (separating the audience from the world depicted on stage) and speaks directly to the audience, it is called **direct address**. This breach of the fourth wall is accomplished in film when a character looks directly into the camera and speaks to the viewer. Direct address interrupts the flow of the film and for a moment at least implies an awareness on the part of the fictional characters that they are in a film or at least that an audience is watching and listening to them.

6.13 The director Michael Almereyda offers a contemporary presentation of Hamlet's famous soliloquy. We hear "To be or not to be . . ." and see that Hamlet is pondering suicide. *Hamlet* (2000).

6.14 A play on direct address: the camera records Hamlet as he speaks into the camera.

6.15 Hamlet is framed by calls to "action" as he looks directly into the camera and ponders his fate.

In a number of the film adaptations of Shakespeare's plays, movie directors have opted to use direct address to frame a soliloquy, a key passage from a play in which a character moves to the front of the stage (the foreground of the frame) and speaks directly to the audience. In more traditional adaptations like Laurence Olivier's *Richard III* (1955) and Oliver Parker's *Othello* (1995), direct address allows characters to take us into their confidence, making us complicit in their nefarious plots or letting us in on their inner torment.

In Michael Almereyda's *Hamlet*, variation on direct address is used to stage the soliloquies. For example, when Hamlet ruminates "To be or not to be," Almereyda stages the soliloquy in a series of three formal frames, the last two of which involve direct address. First, we find Hamlet in his apartment looking at a recorded image of himself on a monitor, gun to his temple, delivering the first few lines of the soliloquy (fig. **6.13**). A second image offers a clever variation on traditional filmic direct address. As Hamlet starts the speech over and again intones "To be or not to be," he looks directly back at us, albeit captured and framed on a small TV screen within the larger film screen we watch (fig. **6.14**). The effect at once distances us (it is an image within an image) and reprises the initial image of Hamlet appearing trapped, with no way out of the screen that holds him. In the third staging, Hamlet delivers the full soliloquy, again looking directly into the camera (fig. **6.15**). This setting offers an ironic comment on his lines; he is in a DVD store where every film falls under the category "action," while the lines he delivers make clear that action is precisely what Hamlet, so far at least, has been unable to muster.

Direct address is often used in comedies to reproduce the dynamics of a stand-up routine. Woody Allen's *Annie Hall*, for example, opens with Allen's semi-autobiographical character Alvy

in medium close-up (fig. **6.16**) telling a joke that rather neatly fits the writer-director's attitude towards his (and Alvy's) life: "Two elderly women are at a Catskill Mountain resort. And one of them says: 'Boy, the food at this place is really terrible.' The other one says, 'Yes, I know, and such small portions.' Well, that's essentially how I feel about life. Full of loneliness and misery and suffering and unhappiness, and it's all over much too quickly."

In his first feature, *She's Gotta Have It*, Spike Lee gives each of his major characters extended **monologues** framed in direct address, using a technique borrowed not from stand-up comedy but from documentary filmmaking. The effect is nonetheless comic. The three principle male characters—Mars, Jamie, and Greer—have one thing in common, their affection for the film's central female character, the aptly named Nola Darling. Each of these characters uses direct address to convince the filmgoer that he is the right man for Nola and then to comment upon his eventual and inevitable failure to capture and keep her interest. Lee uses direct address so extensively that it doesn't so much disrupt the narrative flow as offer comment upon and counterpoint to it. Early in the film, for example, he quickly summarizes Nola's predicament through a series of direct address cameos of men (not the main characters) delivering an array of lame pick-up lines (figs. **6.17** and **6.18**). Here the director offers a neat variation on the technique; the men look at the camera and are photographed alone in the frame (typical of direct address), but the lines they deliver are meant for Nola. Complex as this sound technique may be, the point is fairly simple: Nola's presence here is unnecessary; these lines would hardly work on her.

monologue A lengthy speech by one character.

6.16 Alvy Singer/Woody Allen opening *Annie Hall* (Woody Allen, 1977) with a joke filmed/staged as direct address.

6.17 "You so fine, baby, I'd drink a tub of your bathwater." *She's Gotta Have It* (Spike Lee, 1986).

6.18 "Congress has just approved me to give you my heat- and moisture-seeking MX missile."

6-2c Voice-Over Narration

Much like direct address, **voice-over narration** simulates the action of a narrator (who may also be a character in the story) speaking directly to us, providing context for and commentary on the story. But unlike with direct address, we do not see the character as he or she speaks. Indeed the lines are intended for the film audience and are not heard by other characters in the story, which makes voice-over narration nondiegetic.

Voice-over is often used in literary adaptations in which verbatim passages from the original text are "read into" the film. In *The Assassination of Jesse James by the Coward Robert Ford*, for example, the actor Hugh Ross, who has no on-screen role, reads selected passages from the Ron Hansen novel of the same title (fig. **6.19**).

The pulp detective stories told in many 1940s and 1950s films noir often feature first-person voice-over in which the main character recalls his or her story of betrayal or self-deception. In Billy Wilder's adaptation of James Cain's notorious novel *Double Indemnity*, for example, colorful, tough-guy voice-over runs through the entire film. As with many films noir, the film moves from a monologue (the character speaking into a Dictaphone) to a voice-over that corresponds to a shift in narrative time from the seeming present to the past. This device allows the story to unfold on-screen as it is told in retrospect, in flashback. First we see the insurance agent Walter Neff, a bullet in his chest, headed to his office well after hours. He loads the Dictaphone and begins an "office memorandum" to his boss: "I killed Dietrichson . . . yes I killed him. I killed him for money and for a woman. I didn't get the money. I didn't get the woman" (fig. **6.20**). At this point in the story we don't know who Dietrichson is, nor do we know Walter, the film's luckless male lead. Though it shows us the end of the story first, this early monologue is used as a hook of sorts, not only into a narrative that will end with Walter dying as he confesses a murder we by then have seen him commit but also to a way of telling the story (in Walter's words) and reading the story (as it regards Walter, the insurance agent who killed a man for money and a woman and in the end got neither).

As we cut away from the insurance office to a Los Angeles street, we continue to hear Walter's monologue

6.19 "He was growing into middle age and was living then in a bungalow on Woodland Avenue." Third-person voice-over accompanies the introduction of Brad Pitt as Jesse James in *The Assassination of Jesse James by the Coward Robert Ford* (Andrew Dominik, 2007).

narrating the action on-screen, action that corresponds to the story he is telling, action that has already taken place (fig. **6.21**). We then shift from non-simultaneous sound to simultaneous sound, from voice-over to synched dialogue when Walter enters the Dietrichson house and gets his first look at Phyllis wearing only a towel at the top of the stairs (fig. **6.22**).

In some films, voice-over denotes a mastery of sorts; a character shares with us a story only he or she fully understands. In *Double Indemnity*, voice-over offers a critique of such a mastery and reveals the hubris at the heart of the hero's story. Such is the context for the voice-over of the dying or dead man, a key element in Wilder's subsequent noir, the 1950 Hollywood melodrama *Sunset Boulevard*, which is narrated by a dead man lying face down in a pool (fig. **6.23**).

In these two films directed by Wilder, voice-over is a deliberate strategy, one that appears in the films' original scripts. However, this is not the case with all films that employ voice-over. Because sound can be added late in postproduction, well after the production crew has moved on and the sets have been struck, voice-over is occasionally used to fix problems that crop up after test screenings, especially when test audiences complain that an early cut of a film is too difficult to follow. Such was the case with two well-known American films, *Apocalypse Now* (Francis Ford Coppola, 1979) and *Blade Runner*.

After poor test screenings, United Artists prevailed upon Coppola to add a voice-over track to *Apocalypse*

> **voice-over narration** Lines spoken by a narrator that are nondiegetic.

6.20 Walter Neff delivering his confession via Dictaphone in Billy Wilder's 1944 film noir, *Double Indemnity*. This opening scene sets up the extensive voice-over that follows.

6.22 The voice-over subsides and we get a subjective shot of Phyllis from Walter's point of view.

6.21 We continue to hear Walter talking into the Dictaphone as we see the scene he is narrating. Walter is both the narrator of (through voice-over) and a character in this scene (that's him at the center of the frame heading from his car to Phyllis Dietrichson's door).

6.23 "Well, this is where you came in." Just minutes before the film ends, we discover that we've watched a movie narrated by a dead man. *Sunset Boulevard* (Billy Wilder, 1950).

6.24 What we see when we first hear Deckard's voice-over in the 1982 studio version of *Blade Runner* (Ridley Scott): "They don't advertise for killers in the newspaper. That's my profession. Ex-cop. Ex-blade runner. Ex-killer."

Now to help audiences follow the director's hectic, hallucinatory representation of the Vietnam War. The director complied and hired the noted Vietnam War journalist Michael Herr to write the voice-over. The lines are read by the conflicted hero of the film, Captain Willard, who becomes through this voice-over the first-person narrator of the film. (This addition created another parallel between Willard and Marlow, the first-person narrator in Joseph Conrad's novella *Heart of Darkness*, upon which the film is based.) Herr's voice-over adds authenticity, a monologue insisting on the reality of the war from the viewpoint of someone who was there.

The voice-over added to *Blade Runner* works less well, or at least it more fundamentally changes the director's vision. When Scott added voice-over late in postproduction, he too used first-person commentary from the hero's point of view. But while the voice-over makes a difficult narrative easier to navigate, it turns the film into a noir detective story (fig. **6.24**). Ten years after the studio version was released, a "director's cut" absent voice-over was released theatrically. Without narration, the film more closely resembles its source, *Do Androids Dream of Electric Sheep*, a science fiction novel by Philip K. Dick. The director's cut challenges audiences to sort out the hero's conflicts (as he questions his role as a blade runner, as a killer of androids) and the larger thematic questions raised by the novel about what constitutes humanity. It is a very different film, and offers an object lesson in the net effect of voice-over in film narrative.

6-3 MUSIC

Well before audiences heard movies talk, music was a key part of the filmgoing experience. The term *silent film* is, as discussed earlier in this chapter, misleading because these early movies were never intended to be screened in silence. Musical accompaniment was provided by a small orchestra or, at smaller venues, by a lone piano or organ player. The music was wholly improvised, improvised from a series of prescribed or familiar musical motives or themes, or read from a prescribed score, as in screenings of D. W. Griffith's epic about the Reconstruction era, *Birth of a Nation* (1915). With the advent of synchronized sound, filmmakers continued to use music as a background to the action while also developing stories where music became integral to the characters' lives.

6-3a Background Music

The principal music track for most movies is the **score**, a musical accompaniment written specifically for the film. The composer of the score generally writes this music to suit already filmed scenes. The process corresponds directly to the function of this movie music; it is written and operates very much as a commentary on the images we see on-screen.

Though it comes late in the postproduction process, the score can have a significant effect on how we interpret a given scene. The beat, a mellifluous or dissonant harmonic scheme, and even the choice of musical instruments can be significant to the feeling we get, to our attitude towards the action on-screen. This music may be simple, like John Carpenter's minimalist electronic score for *Halloween* (1978), which involves the simple repetition of staccato notes. Carpenter strategically varies the time signature, picking up the pace to match a particularly tense moment in the film. Or it can be lush and orchestral, as in Max Steiner's score for *Gone with the Wind*.

The score functions primarily as nondiegetic background music. This background music is called underscoring because it underscores (highlights, punctuates, cues, or comments upon) the story as it plays out on-screen. To appreciate how underscoring works, let's consider Max Steiner's score for the epic *Gone with the Wind*. Steiner's score uses both original music and themes and variations from **stock music** from the antebellum and Civil War periods, including ten Stephen Foster songs, among them "The Old Folks at Home" and "My Old Kentucky Home"; Civil War standards like "The Battle Hymn of the Republic" and "When Johnny Comes Marching Home"; and spirituals like "Go Down, Moses." The stock music helps establish the historical context, and each song is associated with certain emotions as well. For example, when the camera pans across a field of Southern war dead, we hear an orchestral adaptation of "Taps," the mournful military song played at funerals (fig. **6.25**).

> **score** A nondiegetic musical accompaniment written specifically for a film.
>
> **stock music** Preexisting music that is repurposed for a score.

In addition to his adaptations and variations on stock music, Steiner's original music offers a compelling backdrop to the roiling melodrama concerning the quixotic Scarlet O'Hara and the two men she loves and loses, Ashley Wilkes and Rhett Butler. In the large-scale historical scenes, Steiner's orchestral score is sumptuous and rousing. To accompany the burning of Atlanta, Steiner scores fast descending and ascending scales to suggest the sound of wind and flames (fig. **6.26**). In the intimate scenes between Scarlett and Rhett on their honeymoon, Steiner softens the mood with an adaptation of Isaac B. Woodbury's lovely "Stars of the Summer Night," a mid-nineteenth-century devotional song (fig. **6.27**). When Scarlett and Rhett have one of their many heated arguments, Steiner highlights the strings and strategically heightens the pitch and volume of the music to emphasize the emotional impact of the scene.

Steiner also builds a repeated melody or theme into his score in order to establish a **musical motif**. The key (and by now legendary) musical motif in the film is Steiner's "Tara's Theme," named for Scarlett's plantation home and symbol of the Old South. Composed of eighteen notes played in sets of four, four, six, and then four again, the theme is introduced in the opening title sequence and then recurs in variation throughout the film. When it is used to accompany a scene in which Rhett and Scarlett celebrate their new marriage and their postwar wealth, the theme sounds positively triumphant. But the same motif played softer and in a different key has a more nostalgic effect in a scene of postwar hardship. Much like opera composers, film composers use repeated themes or motifs to connect scenes at different points in a film; for example, the shark theme in *Jaws* that plays whenever the shark is near. The composer John Williams's simple motif for the shark becomes so familiar in the film that when we hear it, we don't need to see the shark to know he's there (fig. **6.28**).

Motifs can be so strongly tied to a certain cultural property—a familiar TV show or movie franchise—that it simply must be used in any new version or adaptation. For example, for the 2009 reboot of the *Star Trek* series, a twenty-person music department and a full orchestra were employed to provide music for the film (fig. **6.29**). But the centerpiece for the score was still an adaptation of Alexander Courage's familiar *Star Trek* theme first introduced for the TV series in 1966. We hear that theme revisited and then expressed in musical variations throughout the film. The challenge for the music

musical motif A brief and recurring pattern of notes.

6.25 Over this extreme long shot of the Southern war dead, we hear "Taps." *Gone with the Wind* (Victor Fleming, 1939).

6.26 The orchestra performs descending and ascending scales to underscore the fires set by General Sherman during his infamous march to the sea.

6.27 Scarlett and Rhett's honeymoon on a riverboat begins on a peaceful note, thanks to the background music: Isaac B. Woodbury's spiritual "Stars of the Summer Night."

6.28 Perhaps the most familiar music cue in American film history: the shark theme in *Jaws* (Steven Spielberg, 1975) announces the arrival of the great white. The film audience knows what's on the hook before these fishermen do, and the suspense builds.

6.29 A full orchestra performs the familiar *Star Trek* theme and variations for J. J. Abrams's 2009 franchise reboot. Note the screen directly in front of the conductor, which includes scenes from the film over which the music will be played.

6.30 Afro-beat music on the soundtrack accompanies a riot in Mogadishu, Somalia. *Black Hawk Down* (Ridley Scott, 2001).

department working on this 2009 film was to maintain continuity from the TV show, through the previous film adaptations, on to the new film (the reboot).

Music can be used to establish a time and place and feeling, as in *Black Hawk Down*, Ridley Scott's film about the failed U.N. peacekeeping mission in Somalia in 1993. In order to establish the African locale, the background music scored by Hans Zimmer offers evocative variations on Afro-Beat music (fig. **6.30**). The music does well to give filmgoers a feel for the pulse and rhythm of such an exotic and dangerous place. The complex drum beat is incessant beneath vocals that alternate between chanting, call-and-response gospel, and blues-inflected funk. The music reminds us that we, like the American soldiers, are strangers in a strange land.

6-3b The Pop Music Soundtrack

Filmmakers may choose to use previously recorded popular music rather than or in addition to commissioning original scores. Pop music can be nondiegetic or it can have its source in the world of the story. A common instance of diegetic pop music are scenes in contemporary films that feature characters lip-synching or dancing to music playing on the radio or on a stereo: for example, Tom Cruise as the idle teenager Joel Goodsen dancing in his underwear to Bob Seger singing "Old Time Rock and Roll" in *Risky Business* (fig. **6.31**). The dance and lip-synch number is preceded by a shot showing Joel turning on the stereo, making sure the filmgoer registers the source of the music we hear.

The "Old Time Rock and Roll" scene in *Risky Business* is used to make a simple point: Joel is alone and a little bored, and though he doesn't quite know how, he wants to let loose. Later in the film, Joel merges his aptitude for

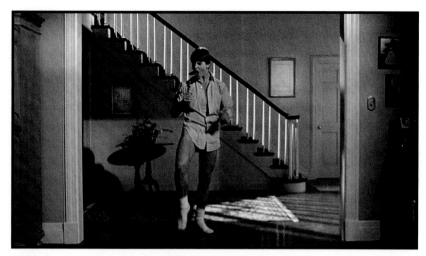

6.31 Tom Cruise as Joel Goodsen, celebrating his parents' departure for vacation by lip-synching and dancing to "Old Time Rock and Roll" in *Risky Business* (Paul Brickman, 1983).

6.32 Joel feels briefly all grown up, a man pimping on the mean streets of Chicago. The nondiegetic use of the Muddy Waters's blues standard "Mannish Boy" is deeply ironic: Joel is still very much what the singer claims he is not: a mannish boy, playacting at adulthood.

business administration with a nascent interest in Lana, a Chicago prostitute, whom he briefly agrees to pimp out to his friends. He is ill-suited for the job but nonetheless feels briefly adult and rather cool. As he struts down the street, we hear Muddy Waters's blues classic "Mannish Boy" (fig. **6.32**). The pop song is nondiegetic; no music is audible on the street at that time. It is used to comment on Joel's feeling of being fully grown up, and it also highlights the film's location, Chicago, Illinois, where Waters lived and played for over four decades. The song is also used ironically. The singer boasts that he is a man, no longer "a mannish boy." Joel at this moment in the film feels much the same way, but we know that he is not really a man and, moreover, that

he has no appreciation or understanding of the subculture Muddy Waters embodies and speaks to.

A far more complexly integrated use of diegetic pop music can be heard in George Lucas's *American Graffiti*. The early sixties music that plays throughout the film sets the place and time (cruising the strip in a typical American town, Modesto, California, in 1962), and its pervasive presence in the film aptly underscores the importance of popular music in the lives of the film's teenage characters. Though the music was all postproduced, a source for each song exists within the space of the film: the band at the high school hop, the AM radio blaring from the cruising cars, or the jukebox at the drive-in diner. Lucas selects the songs carefully to match the on-screen images; indeed, the songs to a great extent narrate the film. For example, we hear "Why Do Fools Fall in Love" when Curt first sees the mysterious blonde in the white T-Bird; a ballad about breaking up ("Smoke Gets in Your Eyes") plays when Steve and Laurie talk about dating other people and then are coerced into a spotlight dance at the hop (fig. **6.33**); "Maybe Baby" accompanies the underage Toad's attempt to get someone to buy liquor for him; "Since I Don't Have You" is the tune we hear when Laurie, forlorn after breaking up with Steve, gets into a car with the hotrodder Falfa just before the big race; and Lucas uses "You're a Thousand Miles Away" when Curt tries to find DJ Wolfman Jack, who, it turns out, is encamped close by.

Some directors use nondiegetic pop music to signal a transition from one scene to another, from one mood to another, from one character to another. In the closing sequence of *A Prophet*, the director Jacques Audiard uses an unusual version of the pop standard "Mack the Knife" to take us from one story, place, and mood to another. The film tells the story of Malik El Djebena, an Arab immigrant who plays all the angles in prison and in the end is released as something of an organized-crime kingpin. Though he has gotten to this place of authority through murder, betrayal, and a surfeit of financial and personal

6.33 Steve and Laurie's spotlight dance in *American Graffiti* (George Lucas, 1973). Steve wants to date other people when he goes off to college, and Laurie knows what that means. On the soundtrack we hear the romantic ballad "Smoke Gets in Your Eyes" performed by the Platters, a song about breaking up.

6.34 Malik (left) walks out the prison gate a free man. On the soundtrack we hear Jimmy Dale Gilmour's slow and sweet rendition of the Kurt Weill/ Bertolt Brecht ballad "Mack the Knife." The nondiegetic pop song is meant to signal an end to Malik's harrowing time behind bars. *A Prophet (Un prophète*, Jacques Audiard, 2009).

backstabbing, we feel exhilarated at his release from prison and see the promise for better times for this character. As Malik exits the prison into the sunlight, we hear Jimmy Dale Gilmour's slow and sweet rendition of the Kurt Weill ballad (fig. **6.34**). The song lightens, suddenly, a film that had for well over two hours been unremittingly dark.

6-3c Musicals

With the introduction of sound at the end of the 1920s came the advent of the movie musical, a genre dependent upon the integrated use of music in the telling of a film's story.

Two distinct subgenres of the Hollywood movie musical were introduced early on: the backstage musical and the musical comedy. In the **backstage musical**, the musical performances are staged in a revue format. They are quite simply rehearsed and performed on a stage. The songs are not integrated into the plot of the film. Indeed the drama and romance that composes the plot of the film are wholly separate from the performances. In contrast, people in **musical comedies** stop talking and start singing, and implausible as such an action may be, these performances are very much part of the story told in the film.

Among the first and most memorable of the backstage musicals was *42ⁿᵈ Street*, in which a down-on-his-luck director works to put together a show that will bring fortune and fame to everyone involved in the Depression-era production. The movie appears to be two films at once because that is exactly what it is—two films by two very different directors. In a manner consistent with the gritty, realist Warners' house style, Lloyd Bacon directed the melodramatic backstage scenes. But what makes the film so remarkable are choreographer Busby Berkeley's set-pieces, the kaleidoscopic and surreal musical numbers that Berkeley shot from a variety of camera placements in front, behind, and above the action (figs. **6.35** and **6.36**).

Rouben Mamoulian's *Applause* (1929)—the story of an aging burlesque star—was the first full-length Hollywood musical. Three years later Mamoulian followed this backstage musical with *Love Me Tonight*, a musical-comedy featuring songs by Richard Rogers and Lorenz Hart (including "Mimi," and "Isn't It Romantic?") integrated into the story of a tailor who, in an

backstage musical A subgenre of musicals in which the song and dance numbers are not integrated into the story.

musical comedy A subgenre of musicals in which characters break into song to express their feelings.

6.35 and 6.36 Al Dubin and Harry Warren's "Young and Healthy" is given the full Busby Berkeley treatment in the early Warner Bros. musical *42ⁿᵈ Street* (Lloyd Bacon, 1933).

effort to collect a debt from an irresponsible count, ventures to the nobleman's country estate, where he meets and falls in love with a princess. The tailor charms the princess, first in song and then with his skill with a needle and thread. In play are several elements that would become formulaic in later musical-comedy films: the fiery heroine, whose immediate rejection of the hero is a sign of attraction; the notion that persistence gets the girl; and the easy class reconciliation (it doesn't matter if you're rich or poor so long as you're in love).

The songs in *Love Me Tonight* are so cleverly integrated into the storyline that when characters burst into song, it seems like a natural expression of their emotions. For example, when Maurice, the tailor, first meets the Princess Jeanette, he sings the naughty little song "Mimi" because, quite simply, he's in love (fig. **6.37**). Later in the film, the song is picked up and in succession performed by members of the princess's household, each one taken in by Maurice's masquerade (as a mysterious count) and in their own way energized by the power of love (fig. **6.38**).

The movie musical has a long and rich history, and audiences in 1929 and 2012 alike willingly suspend disbelief as they enter a world in which characters break out in song. Sometimes the music is integral to aspects of performance, as in the RKO films featuring Fred Astaire and Ginger Rogers (*The Gay Divorcee*, Mark Sandrich, 1934), in which musical numbers offer a narrative rationale for the couple to dance. In others, performance is an aspect of the narrative, as in *Singing in the Rain* (Stanley Donen and Gene Kelly, 1952), which chronicles the professional and personal lives of a movie-star couple set against the movie industry's transition to sound. Here again the music is still the

6.37 Maurice bursts into song because he's in love. *Love Me Tonight* (Rouben Mamoulian, 1932).

6.38 No one can resist singing the catchy song "Mimi."

6.39 When the otherwise peaceful suburbanites of South Park break into song, they perform the bad-taste anthem "Blame Canada." The film and the TV series upon which it is based incorporate song and dance numbers much as live-action musicals do. *South Park: Bigger, Longer & Uncut* (Trey Parker, 1999).

Broadway musicals—plays first performed on stage then adapted for the screen—are among the most popular films ever made in Hollywood: for example, *West Side Story* (Jerome Robbins and Robert Wise, 1961), *The Sound of Music* (Robert Wise, 1965), and *Chicago* (Rob Marshall, 2002). The musical has also been important to the evolution of the animated feature, beginning in 1937 with *Snow White and the Seven Dwarfs*, and subsequently at Disney with *The Little Mermaid* (Ron Clements and John Musker, 1989), and *Beauty and the Beast* (Gary Trousdale and Kirk Wise, 1991). Animated musicals now include the R-rated satires *South Park: Bigger, Longer & Uncut* (fig. **6.39**) and *Team America: World Police* (Trey Parker, 2004), which attest to the flexibility of the genre.

context (and excuse) for the dance numbers featuring Kelly, Debbie Reynolds, Donald O'Connor, Cyd Charisse, and Rita Moreno.

6-4 SOUND EFFECTS

Sound effects are used primarily to contribute to the filmgoer's experience of the film's setting and action as real. As filmgoers, we expect the things we see on-screen to make the sounds we expect them to make. A car drives by, and we hear the engine's growl. We see the ocean and hear the dull roar of waves. We see a dog, and we hear him bark. Even if the actual source of the sound is not the same car, beach, or dog that we see on-screen, we nonetheless remain convinced of the fictional world depicted in the film.

Effects need not be realistic, which is to say that our movie experience need not match real experience; it need only match our expectations, some of which have been produced by previous experiences at the movies. What, for example, might a firefight with futurist weapons sound like (fig. **6.40**)? The challenge is not to reproduce a real sound (since no such sound exists) but to provide a sound taken from our collective experience as filmgoers. The challenge is to provide the dramatic feel for the event, even though the action we see on-screen is something we have never and will never experience.

6.40 A firefight in *Starship Troopers* (Paul Verhoeven, 1997). What might these future weapons sound like?

6.41 Foley artist Dennie Thorpe (standing in front of the screen at the center of the picture) was assigned the task of simulating the sound of a baby dinosaur's birth in *Jurassic Park* (Steven Spielberg, 1993).

6.42 Thorpe's challenge was to create these sounds: the dinosaur egg cracking, the newborn emerging from the shell, and the scientist cleaning the baby off.

6-4a Producing Sound Effects

A movie's sound effects might come from original recordings or they might be selected from previously recorded sounds. If a scene is set at a seaside cabin, for example, recordists venture to the coast and record the waves lapping against the rocks on the shore. For that sound, a trip to the beach might be skipped if the sound department has its own catalogue of "found sounds" or can locate a workable effects track from another movie in the studio's sound library. The sound of the surf used

Foley artist A member of the sound design team who creates sounds in a studio using various props.

6.43 Using grocery store items, Thorpe created sounds that matched the images on-screen. She scraped together two waffle ice-cream cones to re-create the sound of the egg cracking, pulled at the pulp of a ripe cantaloupe to simulate the wet sound of the baby emerging from the egg (shown above), and then rubbed the rough skin of a pineapple to match the scratchy sound of the scientist cleaning the newborn's rough skin.

in a 1975 film might be used again in a similarly set scene in a very different motion picture made thirty-five years later. There would be no way for the filmgoer to recognize this bit of sound sampling.

When no recorded sound source exists—because the sound itself is produced by an imaginary object, such as a spaceship or ray gun, or because the real sound is not convincing or sufficiently dramatic—the **Foley artist** steps in. Named for Jack Foley, a trailblazing sound-effects specialist who worked uncredited on movies from the 1920s through the 1960s, the Foley process is fairly simple but effective. The Foley artist watches a scene and, using simple actions and simple objects, matches or simulates appropriate sounds in real time (see figs. **6.41–6.43**).

Foley crews include the Foley artist, or "walker"—footsteps are the most frequently Foleyed sounds in post-production—and the sound recordists. To reproduce the sound of footsteps, the Foley artist must simulate the gait of an actor and must do so on a surface (cement, dirt, etc.) that matches the scene on-screen. Most Foley stages have multiple walking tracks and can look a bit like a cluttered attic with everyday objects littered about. An old phone book can be dropped on a cement floor to simulate the sound of a punch. Two coconuts can be clapped together to simulate the sound of horse hooves (fig. **6.44**). The art of Foley is a key aspect of so-called movie magic, a behind-the-scenes technique that enhances the reality and realism of a scene.

6.44 Filmmakers Terry Gilliam and Terry Jones make us laugh at the artifice of film sound in their 1975 farce *Monty Python and the Holy Grail*. We see King Arthur "riding" en route to another adventure, and the joke is that there are no horses in the scene. Instead we see the Foley artist (at left) producing the sound by clapping coconuts.

6.45 and 6.46 The innocuous, everyday sounds of TV static and a telephone ringing prove terrifying in Gore Verblinski's *The Ring* (2002).

6-4b Sound Effects and Narrative

Sounds can be purely atmospheric, or they can have a distinct and direct function in the telling of the story. First let's consider the use of sound effects for atmosphere or setting. In the horror film *The Ring*, Rachel, the investigative reporter who seeks the truth about the mysterious videotape connected with a number of teenagers' deaths, travels to Whidbey Island off the coast of Washington state. It's a rainy, coastal place and the sound of the rain and the surf can be heard throughout. The sounds have no immediate narrative function; instead they add to the mysterious setting or atmosphere in which the story takes shape.

Other simple sound effects—the sound of TV static and a phone ringing—are used strategically in the telling of the film's story (figs. **6.45** and **6.46**). The sound of TV static marks the start and end points of the cursed videotape; we hear it when the tape is cued up and then when it's over (and it's too late to save the character who has viewed it). And the sound of the telephone ringing cues what follows: a terrifying phone call with a voice giving the listener just seven days to live. Once we know what the voice on the other end of the phone line has to say, just the sound of the phone ringing is enough to remind us of the terrifying scenario.

Many of the film's horrifying effects are cued by these two simple sound effects. For example, at one point Rachel leaves her son with a babysitter. She comes home to the sound of TV static and predictably freaks out. But the sound, this time at least, is innocuous; the babysitter has fallen asleep and the channel she was watching has gone off the air. This time at least the TV static is just TV static.

The volume, pitch, and timbre of simple sound effects can have a significant narrative function. **Volume** regards degrees of loud and soft and can be used to heighten or reduce tension and to reproduce the intensity of real sounds. **Pitch** refers to the frequency of sound vibrations, described on a scale from high to low (or treble to bass). **Timbre** refers to the harmonic components of sound, what seems to give a sound a certain quality or feeling or, as some sound engineers describe it, color.

In Alfonso Cuarón's futurist film *Children of Men*, variations in volume, pitch, and timbre are used to define locations or settings and then, when they change, to foreshadow narrative events. The former political activist Theo travels from the city to the country—from London, circa 2027, which is a soundscape of constant noise (fig. **6.47**), to the hidden forest compound of an old cohort, which is so quiet that one can hear the sound of the wind rustling through the trees and the footfalls of a dog tromping through the fallen leaves on the forest floor (fig. **6.48**). The city is characterized by loud-volume, high-pitched sounds of car brakes and horns and a disharmonic timbre that makes us anxious. A marked drop in volume, and deeper and warmer sounds characterize the country retreat, where we experience a momentary sense of peace and calm. When Cuarón introduces loud, trebly, disharmonic noise into the quiet country landscape, the music makes the dramatic point that there is little hope of escape from the pervasive police state and the various terrorist insurgencies in this story's world.

Sound perspective refers to how the sound source is situated in the space of the film. A sound can seem to be near or far, right or left, and so on, depending on a quality that theorists describe as "presence." This presence is a function of volume, pitch, and timbre. Sound perspective is connected to visual perspective, so that the voices in a close-up, for example, would have more presence than if the characters were speaking from a distance. Sound engineers, recordists, and mixers also

volume The degree of loudness and softness.

pitch The frequency of sound vibrations, described on a scale from high to low (or treble to bass).

timbre The "color," quality, or feeling of a sound.

sound perspective The use of volume, pitch, and timbre to imply distance or location.

sound cue A musical theme or sound effect that signals the arrival of a character or the performance of an action.

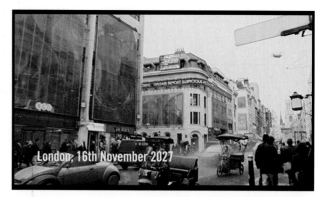

6.47 Sudden bursts of violence seem consistent with the sounds of the city in the grim world of 2027. *Children of Men* (Alfonso Cuarón, 2006).

6.48 The sounds of silence in the country—a lull before the next audio assault.

use effects to create a sense of the scale of a scene's location, another aspect of sound perspective. In *Citizen Kane* (1941), for example, Orson Welles uses an echo effect to aurally match the setting of an argument between Charles and Susan; it is in a hall so vast and empty that sound reverberates. Stereophonic, or multichannel, sound can also be used strategically to situate sounds in space. When, for example, we hear a noise that comes from our left in the movie theater auditorium, we assume that that object—a plane (as in *Lawrence of Arabia*, David Lean, 1962) or helicopter (in *Apocalypse Now*, 1979)—is approaching from that direction with regard to the framed image on-screen.

Sound effects, much like dialogue and music, can be used to tell us what is happening even before we see it on the screen. These kinds of effects are called **sound cues** because, like a stage cue in a play, they signal the imminent arrival of a character or performance of an action.

One common use of sound cues is to create suspense. For example, when a power outage has shut

6.49 Stuck outside the T-Rex cage, waiting for something to happen . . . Tim and Lex in Steven Spielberg's *Jurassic Park* (1993).

6.51 Image plus sound effect equals narrative cue. What else could be shaking the car (and thus stirring the water)? It must be the T-Rex.

6.50 A loud sound literally shakes the ground beneath them. "You feel that?" In a properly equipped theater we should too.

6.52 Sound effects signal the entrance of the T-Rex in *Jurassic Park*.

down the Jurassic Park theme park ride, action is briefly suspended (hence the suspense) while the characters, stuck just outside the T-Rex cage, wait for power to be restored. First we see Tim and Lex passing the time in the car: Tim is playing with a pair of night goggles; Lex is acting bored (fig. **6.49**). Then they hear a loud thump that shakes the car. Tim climbs over the seat to sit next to his sister. "You feel that?" he asks (fig. **6.50**). Next we see as well as hear the power of the sound waves: the water in two glasses stirs (fig. **6.51**). The sound effects track gets louder as the steps appear to come closer; here again our reading is guided by sound perspective. The high-pitched shriek of wires snapping and the deep roar of the huge prehistoric animal cue the on-screen debut of the T-Rex (fig. **6.52**).

6-4c Distorted Effects

Even a scene as fantastic as the escape of a T-Rex from a dinosaur park is made to appear more realistic by the

sound effects. But when realism is not the goal, sound effects can be used to heighten our attention, to comment upon, or to exaggerate the content of a scene. For example, in *Requiem for a Dream*, the director Darren Aronofsky dramatizes an older woman's descent into diet pill addiction by matching simple and in reality quiet actions—opening a pill container, shaking out a pill, popping the pill into her mouth, leaning back in her chair—with sound effects that exaggerate in volume, pitch, and timbre these simple sounds. The exaggerated sound effects make clear that this is no innocent procedure; this woman is in serious trouble (figs. **6.53–6.55**).

Sounds may be deliberately distorted or muffled to limit our knowledge to what a character can hear and create a sense of mystery or suspense. In *Rosemary's Baby* (Roman Polanski, 1967), for example, muffled chanting can be heard from the adjacent apartment. At first Rosemary thinks she is just hearing odd noises produced by the kindly old couple living next door. Later she begins to suspect that these neighbors are

6.53–6.55 Exaggerated sound effects dramatize an otherwise simple action (opening a bottle and taking a pill) in Darren Aronofsky's harrowing adaptation of Hubert Selby's *Requiem for a Dream* (2000).

members of a witches' coven, and the same muffled noises suggest sinister rites. At the end of the film, muffled noises from next door convince Rosemary that her baby is not dead.

The muffled sounds in *Rosemary's Baby* introduce a momentary shift in narrative point of view as we experience the situation through Rosemary's limited perspective. We hear only what she hears through the wall separating the two apartments, which makes us want to get better access to the source of the sounds, to know more about who is producing them and why. That desire is the key to our reading of the film. We are oddly hoping throughout that Rosemary is right about these sounds, that she is uncovering the truth (that her neighbors are devil worshippers) and not becoming unhinged as a result of her pregnancy.

Muffled sound effects can also simulate the mental state of a character: In *A Prophet*, Malik is high on heroin as he listens to his Gypsy friend Jordi singing in a prison Christmas show. We hear the song much as we expect Malik hears it in his altered state: muffled and barely audible, as if in a dream.

Absolute silence is another kind of deviation from "normal" film sound. Even when characters are not talking, the setting is quiet, and no background music is used, there is almost always ambient noise, which makes absolute silence so startling. It too may be used to simulate a character's altered state, such as drifting into unconsciousness or experiencing hearing loss after an explosion. *A Prophet* again offers an example: Malik enters a car and starts shooting. The blasts of gunfire—which we hear quite vividly—in such an enclosed space rattle his eardrums, and he briefly goes deaf (fig. **6.56**). Because we are meant to experience the scene from Malik's point of view, we cannot hear anything either.

6.56 Sounds of gunfire begin loud, then become muffled, and then disappear in a brief period of total silence as Malik's eardrums are rattled by the sounds of gunfire at close range. *A Prophet (Un prophète*, Jacques Audiard, 2009).

Once the components of the voice, music, and effects tracks are created, the final phases of sound design begin. **Sound editing** is the process by which the components of the voice, music, and effects tracks are chosen and synched, or matched, to the images on-screen. **Sound mixing** is the process through which these separate tracks are combined into a single soundscape, with attention paid to the way that the different perceptual characteristics of sound are balanced. Both sound editing and sound mixing significantly affect our interpretation of the events on-screen.

6-5a Sound Editing

The voice, music, and sound effects tracks are edited in relationship to the image track, which is assembled first. Sometimes the relationship is a precise match—synching moving lips with spoken words, dance steps with musical rhythms, or a slammed door with a loud thud, for example. But the relationship need not be precisely synchronous; sometimes the sounds are edited to complement rather than strictly match the shots. It is important in a nuanced critical approach to film form and style to recognize that image and sound are edited separately and that filmmakers recognize image and sound as two parallel processes, each one important to the overall meaning and impact of the film.

Sound editing can be crucial to a film's overall temporal and spatial scheme. In a fairly simple sequence in Olivier Assayas's *Clean*, for example, a single song plays uninterrupted on the soundtrack while we see a montage of scenes from different moments in Emily's day. The scene is meant to introduce us to her boring life: work, grab a cigarette, take a cigarette break, pop a few pills, get back to work (figs. **6.57–6.59**). The duration of the song matches the running time of the montage (approximately 3 minutes), not the length of time that transpires in the world of the story (an 8-hour workday). The goal here is to compress the 8-hour routine into a 3-minute sequence and the music implies a beginning, middle, and end—a complete sequence of actions to match a complete musical number.

In the expository montage in *Clean*, the sound editing links actions that occur at different points in time but in the same basic locale. In the climactic montage in *The Godfather*, sound editing links actions

6.57–6.59 Throughout a montage of images compressing the time passing during Emily's shift at the restaurant, we hear a single, uninterrupted, and unedited song on the music track. *Clean* (Olivier Assayas, 2004).

that occur simultaneously but in different locales. Scenes from the baptism of Michael Corleone's godson, Michael Rizzi, are intercut with scenes from the preparation and execution of a series of assassinations. To make clear the simultaneity of these events and to emphasize the thematic connection between the sacrament of baptism and the murders that are essential to Michael's business plan, Coppola uses a sound bridge. The music from the church organ and

sound editing The process by which the components of the voice, music, and effects tracks are chosen and synched to the images on-screen.

sound mixing The process by which separate tracks are combined into a single soundscape.

6.60 The master shot of the church. While images outside were intercut with images inside the church, the baptism ceremony and accompanying organ music audible in this space plays over both visual fields. *The Godfather* (Francis Coppola, 1972).

6.61 Michael renounces Satan.

6.62 The church organ swells and we see Moe Green assassinated.

the ritual discourse performed by the priest and Michael is heard continuously throughout the sequence, even when the scene on-screen is no longer in the church (fig. **6.60**).

The sound editing underscores Michael's hypocrisy, his pretense to being a God-fearing family man when he is in reality a cold-blooded gangster. The call and response between the priest and Michael that is essential to the baptism ritual is intercut with and thus used in counterpoint to the murders. The priest asks, "Do you renounce Satan?" Michael responds (fig. **6.61**): "I do renounce him." "And all his works?" the priest asks. As the sound of the church organ swells, we watch a Mafia soldier shoot Moe Green in the eye (fig. **6.62**). We then cut to see Cicci lock Cuneo in a revolving door. Accompanying the image, we hear but do not see Michael dutifully reply: "I do renounce them." The line cues Cicci's hit on Cuneo (fig. **6.63**) and another gunman's assassination of Philip Tattaglia. We then cut back to the church as the priest intones: "And all his pomps?" to which Michael responds: "I do renounce them." The church organ ascends a scale, and as the music reaches a crescendo, we cut to the parallel action outside as Barzini is shot and tumbles to his death (fig. **6.64**).

The final devotional discourse of the baptism is intercut with shots of the bloody aftermath of the murders of Tattaglia, Cuneo, and Barzini, shots to which, thanks to the sound editing, the priest seems to offer benediction: "In nomine Patris, et Filii, et Spiritu Sanctu." Both narratives—in the church and on the streets, on-screen and on the soundtrack—end as they began, in perfect harmony, as the priest blesses the infant. As he does so, he seems to speak as well to the baby's namesake Michael Corleone: "Go in peace and may the Lord be with you. Amen."

6.63 Willi Cicci kills Cuneo.

6.64 As the organ music reaches a crescendo, Don Emilio Barzini is shot.

6-5b Sound Mixing

The three basic sound fields (voice, music, and effects) work in relationship to one another as well as to the image track. The term sound mix refers to the modulation of levels within and between the various components of the soundscape. Typically, one element of the sound mix is highlighted while others might play supporting roles. In the conventional, classical Hollywood sound mix, the voice track is given prominence because talk is the medium's primary source of story information. The goal in such a sound mix is not to create a realistic sonic environment but rather to give the filmgoer easy access to the story information carried by the dialogue.

A good example of the classical Hollywood sound mix can be found in the famous closing scene of *Casablanca* as Rick and Ilsa have one last memorable conversation. As they stand face to face but at a distance from the camera, Rick tells Ilsa that he now accepts his role in the coming fight: "What I've got to do, you can't be any part of. Ilsa, I'm no good at being noble, but it doesn't take much to see that the problems of three little people don't amount to a hill of beans in this crazy world" (fig. **6.65**). The camera closes in for the payoff line: "Here's looking at *you*, kid" The sound levels don't change to match the camera distance (fig. **6.66**); throughout the scene, sound perspective takes a back seat to audible dialogue.

The *Casablanca* sound mix consistently values clear speech over sonic verisimilitude; there is very little background noise, despite the fact that the scene is set at an airport. Not until we cut to a shot of the airplane that will take Ilsa and Victor out of Casablanca do we first hear one and then a second propeller engaged (fig. **6.67**). As we cut away from Rick and Ilsa and dialogue abates, the sound mix is dominated by the propellers on the effects track.

Though the propellers continue to spin, the airplane noise subsides abruptly when we cut back to Victor, Ilsa, and Rick as they sort out some final details. Victor welcomes Rick "back to the fight." Ilsa recognizes her former paramour's romantic, selfless gesture: "God bless you, Rick." And Rick persists at being noble: "You better hurry or you'll miss that plane." His line cues their exit, but it isn't until Victor and Ilsa turn towards the plane that we hear the propellers at an appropriate volume again. Then as they walk towards the plane, the film's memorable theme, "As Time Goes By" soars on the music track, drowning out the sound of the plane (fig. **6.68**).

The sound mix is unrealistic but perfectly modulated to communicate meaning. We hear the significant dialogue. The sound effects of the plane remind us that there's a time issue ("hurry or you'll miss that plane"). And the music that takes us out of the scene reminds us of better times, of what might be lost if we lose the war,

6.65 The classical Hollywood sound mix emphasizes dialogue in the climactic scene of Michael Curtiz's *Casablanca* (1942).

6.67 Suddenly the sound mix is dominated by the sound of the airplane propellers.

6.66 "Here's looking at you, kid." We hear the dialogue clearly in an uncluttered sound mix in *Casablanca*.

6.68 The song "As Time Goes By" soars on the music track as Ilsa and Victor exit Casablanca.

of what must be sacrificed (romance, personal happiness) if we are to win.

The classical Hollywood sound mix emphasized audible dialogue over effects, often at the expense of aural realism. Orson Welles, who early in his career worked in radio, a medium composed entirely of sound, departed from this tradition by using radio-based techniques like overlapping dialogue and sound perspective to more realistically situate the listener/filmgoer in the world of the story. In the famous opening tracking shot in *Touch of Evil*, for example, Welles synchronized voice, music, and effects to the camera's movement, modulating the volume, pitch, and timbre of sounds not to highlight the narrative dialogue track but to match what we'd hear if we moved through the space along with the camera.

Today the dynamic range (the degrees of loud and soft) is wider than in previous decades, but realism is not necessarily the goal. Effects and not dialogue propel contemporary action narratives and the sound mix serves this altered scheme by using quiet mostly as a set up for noisier moments to come. Four films—*Lethal Weapon* (fig. **6.69**), *Die Hard* (John McTiernan, 1988), *The Matrix* (Lana and Andy Wachowski, 1999), and *X-Men* (Bryan Singer, 2000)—all produced by the action impresario Joel Silver, illustrate the primacy of loud effects in the contemporary action film's sound mix. In *Lethal Weapon*, the by now familiar story of a cop on the edge is told through a series of action set-pieces: shootouts, car chases, exploding houses, suicide leaps, and the inevitable *mano a mano* martial arts slugfest at the end. The plotline is at once incoherent and

6.69 One of the many action set-pieces highlighted by a sound mix emphasizing the effects track in *Lethal Weapon* (Richard Donner, 1989).

irrelevant because the point is to follow the cop from one exhilarating event to the next, each punctuated not by dialogue but by dynamic sound effects that accompany the visual pyrotechnics on-screen.

Die Hard fits into much the same pattern, as the hero, another rogue cop, upsets a multimillion-dollar robbery planned and executed by stylish European thieves. The smooth execution of the robbery is interrupted by a series of violent interventions and explosions staged by the hero, who through the course of the movie blows lots of things up. The sound-effects track is here again the film's dynamic barometer; the noisier the interruptions, the more successful we believe the hero to be. And we believe him to be the hero because he presides over all the fire and noise.

One of the narrative challenges of these action films is that the hero is by necessity really hard to kill. Riggs and McLane, the cop heroes of the *Lethal Weapon* and *Die Hard* films, are adept and persistent, and, though human, they are astonishingly resilient.

Neo, the new age hero of the *Matrix* films, is "the one" and thus possesses supernatural physical and mental powers. We're not sure exactly what it will take to kill him, but routine gunfire is inadequate. The staged effects thus need to be truly big to worry him . . . and us. In the *X-Men*, the mutant heroes and villains have unique abilities, and some, like Wolverine, get hurt but then quickly recover and regenerate. The explosions—the visual and audio effects—are by narrative necessity as well as genre design big and loud because the scope and scale of things in these films is oversized, because the amount of firepower required to make an impression on these heroes is huge.

The demands of the dynamic sound mix of these contemporary action films have been met by significant developments in sound recording and playback: Dolby, Sony's SDDS (Sony Dynamic Digital Sound), and Universal's DTS (Digital Theater Sound). (See chapter 7 for more on how these sound systems work.) The upside of this development is that filmmakers exploit these new and improved sound recording and playback technologies very creatively and in doing so invest more time, interest, and imagination in using sound in postproduction and exhibition. The downside is an ever-increasing dependence on dynamic sound, absent nuance, absent expository dialogue. Also lost is any semblance of the real. The effects tracks in these action films are by design over the top, bigger and louder than life, because the films concern heroes—edgy police officers who defy death, futurist messiahs, and indestructible mutants—that exist only in the movies, and only in action movies.

CHAPTER SUMMARY

Close reading in film requires attention to the variety of sounds that accompany the images on the screen. These sounds are as carefully designed, produced, and edited as the camera shots and are integral to a film's meaning.

6-1 SOUND AND IMAGE

Learning Outcome: *Appreciate the complexity of sound design and some key relationships between sounds and images.*

- Sound that originates from the world of the film is called diegetic sound. Nondiegetic sound generally offers commentary on the action or it establishes mood and tone.
- On-screen sounds originate from sources we can see in the frame. Off-screen sounds originate from sources we cannot see but assume nonetheless to be part of the story world.
- Simultaneous sounds correspond in time with what is happening in the frame. Non-simultaneous sounds bring in voices and other sounds from the past or future.

6-2 THE VOICE TRACK

Learning Outcome: *Analyze how different types of voice recordings (dialogue, voice-over, and direct address) are used to tell a story.*

- Live sound is recorded onto the film and also on a separate medium, which is called double-system recording—an industry standard for live sound capture.
- Direct address implies an awareness on the part of the fictional characters that they are in a film or at least that an audience is watching and listening to them.
- In voice-over narration an off-screen character or narrator speaks to the audience. Voice-over narration is nondiegetic; the narration comments on the story.

6-3 MUSIC

Learning Outcome: *Understand the various uses and functions of music in a film's soundtrack.*

- Musical accompaniment for silent-era films was performed live.
- The score is the principal music track for most movies. Much like opera composers, film composers often use repeated themes or motifs to connect scenes at different points in a film.
- Filmmakers may choose to use previously recorded popular music rather than or in addition to commissioning an original score. Like a score, this music highlights, punctuates, cues, or comments upon the story as it plays out on-screen.
- Two distinct subgenres of the Hollywood movie musical were introduced early in the sound era: the backstage musical and the musical comedy.

6-4 SOUND EFFECTS

Learning Outcome: *Recognize how sound effects contribute to the experience of watching a film.*

- A movie's sound effects might come from original recordings or they might be selected from previously recorded sounds. When no recorded sound source exists or because the real sound is not effective, the Foley artist simulates the sounds using simple objects.
- The volume, pitch, and timbre of sound effects can have a significant narrative function.
- Sound perspective refers to the use of volume, pitch, and timbre to imply distance or location.
- Distorting, muffling, or silencing sound can be used to heighten our attention, to comment upon or to exaggerate the content of a scene.

6-5 SOUND EDITING AND MIXING

Learning Outcome: *Identify and analyze how sound design affects our interpretation of the events on-screen.*

- Sound editing is the process by which the components of the voice, music, and effects tracks are chosen and synched and/or matched to the images on-screen.
- A sound bridge is used to connect events spread out in time but occurring in the same basic locale or to connect events taking place at the same time but in different locales.
- The sound mix involves the modulation of levels (of volume, pitch, and timbre) within and between the multiple recordings that compose each sound field.
- The conventional, classical Hollywood sound mix highlights dialogue because talk is the medium's primary source of story information.
- In many contemporary action films, the dynamic range (the degrees of loud and soft in the mix) is wider than in previous decades.

FOCUS on Sound: *Nashville*

The director Robert Altman is known for his complex sound mixes that present a realistic soundscape. Unlike most directors, Altman does not highlight dialogue over effects and music (see the sound-mixing example from *Casablanca* above); indeed, he often overlaps dialogue (from one or more conversations) and uses sound to place the viewer inside the purportedly real space of the film. In the first image below from his 1975 film *Nashville* (85 minutes into the film), we find Albuquerque, yet another aspiring country singer trying to make it in Music City, USA, performing at a stock car race. We have waited a long time to hear her sing (to see if she indeed has what it takes), but we can't hear her very well over the sound of car engines. The sound mix keeps us from hearing precisely what we want or need to hear in the scene. The second image comes from the end of the film (at the 152-minute mark), as Albuquerque takes the stage again. This time we hear her, and she's really good. Her big chance comes at the most unfortunate of moments (an on-stage assassination), but she nonetheless makes the most of it. The sound mix is once again complex. Altman highlights her voice (which after all is amplified on-stage) and uses it as a sound bridge to carry into the final credits.

Albuquerque takes the stage (1:25:00–1:25:30)	**Albuquerque takes the stage again** (2:32:11–2:37:00)
Music: What should be the loudest sound field in the mix—Albuquerque's singing—is the one we cannot hear very well. True to the reality of the scene—a singer getting her first big break singing at a stock car race—the guitarist and the singer are muffled and barely audible. Here Altman wrings humor out of the absurdity of the scene (a singer trying to perform a song at a stock car race) with a comically absurd (but nonetheless realistic) sound mix.	**Music:** In this scene at the end of the film, we finally hear Albuquerque sing. She's really good, better than most of the country music stars whose performances precede her in the film. The impromptu song she performs functions at once to quell a riot (a country music legend has been assassinated by a crazed young man) and to re-establish the setting: Nashville, Music City, etc. The song's refrain, "It Don't Worry Me," speaks to the events on-screen. We've just seen a murder that should worry us of course, but the point here (however we take it) is that the spirit of Nashville embodied in this music cannot be thwarted or silenced.
Voice: We hear clearly the sound of the raceway announcer calling the race. His voice is amplified over the raceway's public address system. The actor's line reading includes a pronounced Southern accent (to set the location), and it is carefully and clearly modulated to simulate a play-by-play commentary at such a scene. The sound is diegetic but comes from a source off-screen.	**Voice:** Typical of Altman, we hear a variety of conversations only partially and distinctly mixed "under" (softer than) the music. When Altman cuts to these conversations, we continue to hear Albuquerque sing but do not see her. During these moments when the music track is diegetic but off-screen, we see and hear dialogue that is at once diegetic and on-screen. Typical of Altman, he also mixes in diegetic, off-screen dialogue. This is mixed at a volume well below the volume of the music.

Albuquerque takes the stage (1:25:00–1:25:30)

Effects: The loudest sounds in the mix are the racing car engines. The sound is diegetic but comes from a source off-screen.

Sound perspective: The cars are loud and Altman modulates the volume of the engines to simulate the cars' movement around the track (louder when they are close to where the camera is placed on one side of the track and then somewhat softer when they are farther away). This use of sound perspective adds to the comic effect of the scene, as Albuquerque's on-stage movement seems to accompany these changes in volume.

Albuquerque takes the stage again (2:32:11–2:37:00)

Effects: We hear footsteps on-stage and crowd noise in the background. In the scene at the racetrack, the effects track was the loudest. Here it is the softest.

Sound perspective: The song, with its simple refrain, proves infectious and the other performers, musicians, and finally the crowd join in. As the camera moves back and away from the stage (a familiar gesture at the end of a film), we see the entire crowd (composed of people of different colors and generations) brought together, soothed by the music. As the camera moves back and away, Altman subtly increases the volume of the crowd's singing and decreases the volume of Albuquerque's singing. At the end, he holds on an image of a cloud-dappled sky and then increases the volume of Albuquerque's voice as he slowly decreases the volume of the crowd. He then fades out as we cut to black—and silence—at the end.

ANALYZE SOUND

Use these questions to analyze how the basic elements of sound recording, editing, and mixing contribute to the story content of a film. For a close analysis, it is better to pick a single scene. Begin by thinking about the overall effect of the sound design, and then focus on individual components.

- What do you learn about the story and characters from the sound design alone?
- What emotional effect does the sound design have on you?

6-1 SOUND AND IMAGE	• Take note of all the distinct sounds you hear. • Which sounds originate from the world of the film (diegetic)? Which sounds are nondiegetic? • How do the nondiegetic sounds affect your view of the scene? How might you read the scene differently if the sound were diegetic only? • Do any sounds originate off-screen? If so, how do they affect your reading of the scene? • Do any sounds extend from an earlier or later scene? How does that sound bridge connect story elements from the two scenes?
6-2 THE VOICE TRACK	• Take note of all of the individual voice tracks, especially dialogue and voice-over. • How do the actors' line readings affect your reading of the scene? • Is there a moment of direct address? If so, how does it affect the tone and meaning of the scene? • Is there any voice-over? What sort of commentary does it provide?
6-3 MUSIC	• Take note of all the instances and sources of music. • Describe the general qualities of the musical score. How does the score affect your reading of a specific scene? Of the film as a whole? • Are musical motifs used in the telling of the film story? If so, how? • Do you recognize any previously recorded music in the film? If so, how is it used? Does it comment on the action in any way? What does it contribute to the mood and tone?
6-4 SOUND EFFECTS	• Take note of all the distinct sound effects. • Do these effects (taken together) contribute to your impression of the setting as real? • Are sound effects used to build suspense or provide cues? • Are there instances of distorted or muffled sound effects? How are these used in the telling of the story?
6-5 SOUND EDITING AND MIXING	• Which component of the sound mix is most prominent—voice, music, or effects? Why? • How do the dynamics of the sound mix—the range of highs and lows—affect your experience of the action? • Is silence used at any time in the film?

A poster for *The Girl with the Dragon Tattoo* (David Fincher, 2011)

INDUSTRIAL CONTEXTS

O ur focus to this point has been on film as an art form. But for each creative decision about narrative, mise-en-scène, camera work, editing, and sound, there are also financial and practical considerations—for example, the cost of sets, equipment, effects, and other materials; the availability and cost of cast and crew; the logistics of a film's release; and how it will be marketed and exhibited to audiences. Indeed, the fundamental question of whether a movie gets made in the first place is in large part a business calculation, and the bottom line (in most cases) is that movies are designed to generate profits. For a complete critical understanding of movies, we need to recognize the financial and practical dimensions of filmmaking as well as the ways that marketing and exhibition strategies affect our expectations about a film.

LEARNING OUTCOMES

After reading this chapter, you should be able to do the following:

7-1 Understand and appreciate how decisions made during development, production, postproduction, distribution, and exhibition are economic as well as aesthetic, and practical as well as imaginative.

7-2 Identify and analyze various distribution strategies and the role of trailers and posters in the marketing of motion pictures.

7-3 Recognize and discuss the effect of exhibition on our experience of a film.

▶ **PLAY VIDEO ICON:** This symbol means that a corresponding clip is available in the eBook. Simply click on the image to play the clip.

Decisions made during development, production, postproduction, distribution, and exhibition are economic as well as aesthetic, and practical as well as imaginative. Casts and crews, equipment and film, sets and costumes all cost money. Since a great deal of money is at stake with virtually every movie made—from low-budget independents (which often cost around $1 million to $3 million to produce) to studio blockbusters (which can cost $100 million or more)—the filmmaking process has over the years been set up for efficiency as well as artistry, to maximize the investment and to balance the artistic and the commercial. Filmmakers often talk about how dreams are realized on-screen. Producers and distributors are anxious to add that these dreams cost money, often a whole lot of money.

Industry insiders use terms like "bang for the buck" and "the money is up there on the screen" to describe a successful relationship between financial investment and entertainment value. This success is measured in a variety of ways. First, there are "the numbers": the number of people who pay to see the film; the number of critics, festival, and industry award judges who applaud it; and the box office numbers. And then there is the film's entertainment value, which is more difficult to measure. Was the film diverting, exciting, moving? Was it something audiences would likely remember long after they leave the theater? These latter concerns may well be the primary goals of the filmmakers, but because they are not quantifiable, the business executives who run things in Hollywood prefer the numbers; they prefer to assess value with regard to revenues and profits.

7-1a Movies and Money

Thomas Edison famously quipped in 1931 that he was surprised to see that his invention, moving pictures, had in a little over thirty years become such an important

7.1 Blockbuster investments and blockbuster profits: *Avatar* (James Cameron, 2009) was budgeted at an estimated $250 million and grossed a jaw-dropping $2.8 billion in theatrical revenues.

7.2 *Harry Potter and the Half-Blood Prince* (David Yates, 2009), the sixth installment in the venerable franchise, cost an estimated $250 million to produce and earned close to $1 billion at the box office.

and expensive commercial medium. The inventor found the cost of producing a single film astonishing and remarkable. By 1931, several big studio productions had surpassed the $1 million mark. It is fair to wonder what he would think today as the production budget for a typical studio movie has reached $100 million and so-called event films cost over twice that amount.

The financial stakes of contemporary film production and distribution are indeed staggering. For example, in 2009 two films, *Avatar* and *Harry Potter and the Half-Blood Prince*, each cost an estimated $250 million to produce and another $80 million to promote and advertise (figs. **7.1** and **7.2**). *Avatar* grossed $2.8 billion

TABLE 7.1 A Partial List of Companies in Time Warner, Inc.

Film Studios	Television Networks	Books and Magazines	Other Holdings
Warner Bros. Pictures	HBO	Warner Books	Cable delivery outfits
Warner Bros. Pictures International	Cinemax	*Time*	AOL online services and Netscape
New Line Cinema	CNN	*People*	Theme parks
Turner Original Productions	TBS & TNT	*Entertainment Weekly*	CNN Radio
DC Entertainment	The Cartoon Network	DC Comics	TMZ.com

in theatrical revenues, that is, money made screening the movie in theaters. *Harry Potter and the Half-Blood Prince* brought in close to a billion dollars worldwide. As astonishing as these box office numbers are, theatrical box office for these films accounts for only part of their earning potential. Also of importance here are **ancillary revenues**, money available through TV and Internet licensing, DVD/Blu-Ray sales, and merchandising (including video games, fast food, and action figures).

For event films like *Avatar* and *Harry Potter*, the commercial investment, technical achievements, and huge audiences are as important as mise-en-scène and camera work to understanding the film's significance or value. *Avatar*, for example, is a film that is best appreciated when we consider the money and know-how that went into its production. The film is a spectacle, not just a futurist spectacle of scientific exploration undermined by the military-industrial complex (the plot of the film), but more importantly a spectacle of present-day Hollywood ingenuity, pushing past the limitations of the flat screen. There is a compelling narrative, but is it really why we're in the theater? Is it really why the film has value as entertainment, even art?

With regard to *Harry Potter and the Half-Blood Prince*, the same basic notions of value attend; spectacular investment yields spectacular images and effects. Additionally, as part of a series with a huge audience already in place from the books, the film had value for its studio, Warner Bros., as a "tent pole"—a virtually guaranteed success that makes possible the production of riskier titles. The Harry Potter franchise has alone kept the film division of Time Warner in the black for a decade and has provided the tent-pole title in 2001, 2002, 2004, 2005, 2007, 2009, 2010, and 2011. The total value of *Harry Potter and the Half-Blood Prince* thus is more than the nearly $1 billion it earned at the box office and the additional revenue it earned in ancillary markets. The value of this one Harry Potter film is part of a larger commercial scenario: the nearly $8 billion the eight-film franchise has earned at the box office and the billions more in ancillary revenues.

To fully appreciate the scale, scope, and stakes of the film business in the United States, we must consider the complex structure of the corporations that now control the Hollywood studios. At the end of 2011, six corporations dominated the corporate landscape of Hollywood and by extension, American mass media:

- Time Warner (see table **7.1** above),
- Disney (including the Disney film division—Buena Vista, Pixar, and Miramax; ABC and ESPN; *Discover* and *Us Weekly* magazines; Marvel comic books; and the legendary theme parks),
- The News Corporation (20th Century Fox and Fox Searchlight; the Fox network on TV, FX, and Fox News; the *Wall Street Journal*; and AmericanIdol.com),
- Sony (Columbia Tristar, Sony Pictures, Sony Pictures Classics, and Sony Pictures Imageworks; Sony Music including Columbia, Epic, and RCA; Sony electronics retail and Sony Ericsson Mobile Communications),
- Viacom (Paramount Pictures and Paramount Vantage; MTV and Nickelodeon; Shockwave Games), and
- Comcast (Universal Pictures and Focus Features; NBC, Telemundo, and Bravo, XFINITY TV/Internet and Voice; and the Philadelphia 76ers and Philadelphia Flyers sports teams).

These multinational conglomerates operate in a **vertically integrated entertainment marketplace** that exploits

ancillary revenues Money made on a film in addition to movie theater box office—including licensing, merchandising, network and cable television, and DVD/Blu-Ray sales.

vertical integration A strategy in conglomerate capitalism in which several subsidiary companies under a single corporate umbrella perform inter-related tasks with regard to a single product. The film business today operates as a vertically integrated entertainment marketplace with the large corporations that own the film studios controlling the filmed product from development through exhibition.

synergies, strategic relationships between the media and information companies that share corporate ownership.

Synergy has become the catchword of the new Hollywood. The studio conglomerates integrate the operations of their various holdings; they move filmed products through a variety of markets and venues all under a single corporate "umbrella." To see how synergy works, let's look at the *Batman* franchise at Time Warner. As of the end of 2012, there have been seven live-action Batman films all released by Warner Bros. Combined, the films have grossed well over $3 billion worldwide, but that is less than half of the films' overall value to the company. Batman is a DC comic character, licensed by LCA, the merchandising outfit with a stake in the profits of every Batman T-shirt, cup, comic book, and action figure. Both DC and LCA are Time Warner subsidiaries. The films have appeared on HBO and were delivered into homes across the country via cable systems owned by Time Warner. When the films were released on video and DVD, they bore the Warner Home Video label. The popular soundtrack recordings have been released by companies owned by Time Warner, featuring music by artists (like Prince) who were under contract (at the time) to Warner Music. Coverage—news and feature stories—appeared in Time Warner magazines like *Time*, *People*, and *Entertainment Weekly*. Seen from the perspective of even this single movie franchise, the value of synergy as a mode of industry and commerce is clear.

7-1b Movies, Money, and Modes of Production

The six companies mentioned above control approximately 95 percent of the film market in the United States. Operating under a significantly different economy of scale are smaller **independent film companies,** or "indies," making films on significantly tighter budgets and released to far fewer theaters. Unlike the majors, which can offset costs through the sheer volume and diversification of their corporate holdings and interests, independent films are financed individually and independently. It is a model that more simply matches a single film's gross revenues against its cost.

synergies Strategic relationships between media and information companies.

independent film company A company outside the conglomerate system. These companies make less-mainstream and less-expensive films.

Though the stakes are smaller, the risks are in many ways greater.

With these more modestly budgeted films, capital investment often guides aesthetic decisions. There is a maxim in indie filmmaking: "talk is cheap, action is expensive." Indeed, indie films generally concern relationships (between human beings) and use dialogue to further the comedy or drama. This is at once a narrative convention, an aesthetic tradition, and a financial consideration.

For all films of all types, casting decisions, wardrobe choices, and even the construction of sets are all impacted by budget. The number of days for rehearsal and shooting, the amount of time for postproduction (editing suites are often rented by the hour), the quantity and quality of the special effects, and the number, timing, and placement of print and television ads are all subject to budget concerns.

To see how these budget issues have an effect upon a film's narrative, mise-en-scène, camera work, editing, and sound, let's look at the indie film *Sugar*, which entered its limited first run during the same year as *Avatar* and *Harry Potter and the Half-Blood Prince*. Produced on a shoestring budget for (the Time Warner subsidiary) HBO Films and picked up for limited theatrical distribution by Sony Pictures Classics, *Sugar* earned a fairly typical indie gross of just over $1 million, a fraction of what the two blockbusters earned that year.

Sugar tells the story of an aspiring young baseball player from the Dominican Republic (nicknamed Sugar after his sweet curveball), who is drafted by a professional team in the United States (fig. **7.3**). The producers of *Sugar* did not and could not cast movie stars, transport and house a large cast and crew, "fix" or enhance scenes with postproduction special effects, or use licensed pop music to set the time or location or mood of the film.

Local casting kept costs down *and* lent the film realism and authenticity; none of the actors had the box office draw of movie stars. The lead actor, Algenis Peres Soto, had never acted before; at the time the film was made, he was an aspiring young Dominican baseball player. Peres worked for far less pay than a movie star, and he performed convincingly thanks to his experience as a ballplayer. His discomfort in the staged dramatic scenes actually helped his performance as a social outcast in the film's later scenes in Iowa and Arizona.

For each location—small towns like Consuelo (in the Dominican Republic), Burlington and Davenport, Iowa, and Mesa, Arizona—the producers employed local crews and talent to cut back on transportation

7.3 Real locations and unprofessional actors add to the authentic feel of Anna Boden and Ryan Fleck's indie feature *Sugar*. They also kept costs down.

and lodging costs. They used cheaply rented public sites and private homes and took advantage of the local denizens' interest in and excitement about their film. For example, locals helped the filmmakers dress the sets with props moved from one person's living room or kitchen to another. The net effect was an authenticity seldom achieved in bigger-budget films. This authenticity was in the end part of the film's success as a work of commercial art. But it is fair to add here that it was also the only practical strategy for the filmmakers given the budget and the mode of production they could afford.

There is an adage in the movie business: "you take the money, you lose control." Indeed, independent filmmakers are anxious to point out that they often work with far more autonomy than much better funded studio filmmakers. Because less money was at stake at both the investment and payoff ends, directors Boden and Fleck were able to tell the story they wanted to tell: a realistic story in which the young Dominican player is sent to a rural minor league outpost in Iowa where he does not overcome obstacles and does not become a success. Sugar instead suffers culture shock in small-town U.S.A. and becomes terribly homesick and runs away to join friends in New York City. His visa expires and he joins the legion of undocumented workers playing baseball not in the majors but in a rag-tag city league with other failed Dominican ballplayers. It's not the stuff of a rags-to-riches, feel-good studio movie, but then again it does not have to be; it's a low-budget movie targeted at a limited art-house audience.

This brief look at three 2009 releases illustrates that for every film there is a direct correlation between the financial investment, the film's content, and the filmgoing experience. As critical filmgoers, we need to develop an appreciation of the opportunities and constraints that the commercial context affords so that we can understand and appreciate what we see and hear in the movie theater.

7-1c Mass Production for a Mass Medium

The challenge for those who finance and make movies is to somehow transform the notoriously haphazard production of art into an industrial process that operates

Who's the Best Boy?

Here's a guide to some of the more unusual film job titles:

Boone Narr, animal wrangler.

KILLER FILMS/THE KOBAL COLLECTION

Animal wranglers train and take care of animals used on the set.

Best boys (men or women) assist the gaffer and the key grip.

Boom operators control the long pole from which a microphone is suspended for the capture of live dialogue.

Cablemen (or women) make sure the boom operator's path is clear of the many electrical cables on the set floor.

Gaffers serve as the production's chief electrician.

Grips are lighting and rigging technicians. The **key grip** supervises the grip crew.

Greensmen (or women) select and maintain the sets' plants.

Property masters acquire or build and keep track of the various props.

Video assist operators record scenes on videotape while the camera operators record scenes on film.

7.4 The Ford Motor Company's assembly line, circa 1935. Fordism—the style and mode of production developed by Henry Ford for the automobile industry—became the model for film production.

7.5 On the set of Rouben Mamoulian's *Becky Sharp* (1935). Note how many people are doing different jobs in order to produce this single shot: sound recordist Earl A. Wolcott (bottom right), director Rouben Mamoulian (in the suit with the white pocket square in the center of the picture), camera operator (most likely W. Howard Greene), the actors performing the scene (far left), and assorted crew members waiting for the shot to be completed so they can strike this setup and prepare for the next shot.

within a predictable schedule and budget. From the very early years of film production in the United States through today, this challenge has been met with industry cooperation and collusion, monopolization, conglomeration, and globalization. The first industry cartel was formed in 1908 as the ten biggest film companies joined forces to create the Motion Pictures Patents Company, or MPPC trust, with the main goal of standardizing and streamlining production and distribution policies and procedures in order to maximize profits.

When the MPPC fell apart and the nascent Hollywood studios took shape in the 1920s, they too sought to protect their investments by adopting a stable production system and strategic relationships to standardize and streamline their operations. The key to their new process was the assembly-line mode of production popularized by auto entrepreneur Henry Ford (fig. **7.4**), a collaborative system in which crew members skilled at a single task (lighting, camera operation, set building, etc.) worked simultaneously or sequentially to complete the final product (fig. **7.5**). The studios' version of **Fordism** was essentially a "contract system" that secured movie industry workers to fixed-term exclusive contracts: carpenters, painters, and electricians as well as writers, actors, and directors could be

Fordism A production system modeled on the assembly-line operation popularized by Henry Ford.

principal photography The phase of film production in which the scenes are shot.

tied to a single studio for as many as seven years. Film workers got steady employment, and the studios got ready access to an expert workforce.

The assembly-line model allowed studios in the classical era to time their many productions so that their contracted workforce might be moved from one film project to the next; once a carpenter finished building the sets for one of the studio's films, he or she moved on to the next production in the queue. The same basic system structured and timed the contributions of everyone under contract to the studio. This system not only optimized the workforce, it also created discernible studio styles because the same studio set designers, hairdressers, costume designers, cinematographers, writers, directors, and actors worked on several studio films every year. This created a continuity based on their expert work that we can observe from film to film.

After World War II, the contract system was slowly dismantled. Nearly everyone who works on a film today is an independent contractor hired on a film-by-film basis. But while the process of securing the services of an expert workforce has changed, the similarity to assembly-line production remains apt. Films are still shot in the most time- and cost-effective sequence that the producers can develop, so that **principal photography** is organized

Movie Making: From Story to Print

What follows is meant to follow "the life of a film" from idea through the completion of a final cut. This introduces the basic steps in the process and may well not apply to every film. The chart below is meant only to introduce the basic steps in the movie-making process.

DEVELOPMENT AND PREPRODUCTION

- The **producer** initiates the project and works with the **screenwriter** to develop the story. The producer lines up financing.

- A director and stars may become "attached" to the project.

- Business units are set up to manage the planning, scheduling, contracts, accounting, payroll, and other operations.

- **Executive producers** make sure that budgeted tasks and salaries are paid.

- **Line producers** supervise day-to-day production.

- **Casting agents** work with the producer and director to line up actors, who begin preparing for their roles.

- Other creative units, under the **director**, begin planning the production design, photography, and sound design for the movie. The **production manager**, who operates as a liaison between the producers and director, arranges for the crew and equipment needed on the set.

PRODUCTION

- Cast and crew report to work on the set at the times specified on each day's call sheet. The grip, electric, and production design crews ready the set for the camera and sound departments; the actors are sent to hair, makeup, and wardrobe.

- The **assistant director** (AD) prepares everyone on the set for the filming of a scene, while the director calls "action" and "cut." Most scenes involve several setups (camera angles) and takes.

- The actors, director, sound and camera operators review the scene via video-assist or dailies.

POSTPRODUCTION

- In collaboration with the director, the **editor** supervises the cutting and assembling of the film.

- The **sound designer** (often the supervising sound editor) creates (edits and mixes) the soundtrack, working with units who rerecord the actors, produce sound effects, and compose or acquire music.

- **Visual effects artists** add effects and imagery that are not possible to create on a set.

- **Lab technicians** work to create a number of prints of the film, culminating in the final version. Color corrections are made at this stage.

Director Todd Haynes and composer Elmer Bernstein at work on the *Far from Heaven* score (2002).

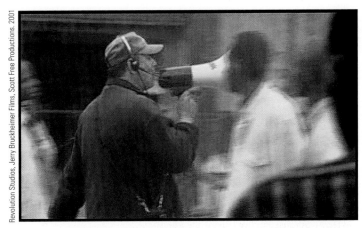

Assistant Director (AD) Terry Needham on the location set of Ridley Scott's *Black Hawk Down* (2001).

▶ **7.6–7.9** Four scenes set aboard the doomed jetliner in *United 93* (Paul Greengrass, 2006). Though these scenes occur at different times in the film (the 11, 59, 72, and 97 minute marks, respectively) and are interrupted by numerous scenes set elsewhere, they were undoubtedly all filmed during the same time period, before the crew moved on to another set.

not by the sequence of scenes laid out in the script but instead in concert with the use of certain sets and actors.

For example, let's consider how the organization of shots differed in the script and in the shooting schedule for *United 93*. The film tells the story of the September 11 airplane hijacking by cutting back and forth between two parallel (and simultaneous) narratives. The first tracks the hijackers, the passengers, and the crew of United 93; the second takes us inside several air-traffic-control centers as well as FAA headquarters and the U.S. Air Force Command Center and shows the workers in each of these places as they discover the awful truth about the hijacked plane. For practical reasons, the shooting schedule did not follow the sequence of events laid out in the script. For example, the crew filmed all of the scenes that happened on board the jet (figs. **7.6–7.9**) before moving on to a new location or set. Only when their work was complete on the airplane set did the crew (and different members of the cast) shoot scenes that used other sets: the air traffic control centers, for example. In the story we see unfold on-screen, we switch back and forth from one location to another. But this narrative sequence is a product of editing, carefully designed to hide the means of production, as we saw in Chapter 5.

7-2 DISTRIBUTION AND MARKETING

As of the end of 2011, approximately 90 percent of the film distribution in the United States was controlled by Disney, Fox, Paramount, Sony (which owns Columbia), Universal, and Warner Bros. film studios. These Hollywood studios controlled the planning and execution of promotion and merchandising (the production of

print The developed film (or positive print) sent by the distributor to the exhibitor and meant to be screened on a motion picture projector.

trailers, the design of posters, and the coordination of test screenings) as well as the duplication and trafficking of **prints** to theaters for exhibition.

In exchange for the money invested during this phase of a film's journey from development to exhibition, the studios secure the copyright to every film they distribute. Indeed, the very first thing you see when a film is unspooled is the corporate logo of the distributor: the MGM lion, Columbia's woman with a torch, Warner Bros.' WB, and so on. In American moviemaking there is a difference between authorship and

7.10 The director Quentin Tarantino on Jimmy Kimmel Live promoting *Kill Bill: Volume 1* in 2003. The director's appearance got the word out to the hip audience for Kimmel's show that a film targeted at them had just been released.

ownership, between the creative talent that "makes" the movie and the financial talent that takes the film from development through exhibition. That corporate logo then is a significant gesture, one that serves as a reminder from the moment the picture unspools that the film belongs to the studio and the film's credited director works for them.

7-2a Positioning

Movies, like plays and concerts, are a unique consumable; the customer need only "bite" once. To pique our interest, distributors provide just enough of a taste of the final product to convince us to see their films. Promotion and advertising is so important that in the contemporary U.S. industry, marketing routinely adds an additional 33 to 50 percent to a film's overall budget.

Movie executives talk about **positioning** films in the marketplace because that is exactly what they set out to do: to generate and manage the discourse, or "buzz," surrounding a film in companion media, including print, TV, and the Internet. This involves trailers, posters, feature stories strategically placed in the popular press, postings on the web, and appearances by movie stars and filmmakers on TV talk shows all staying, in the parlance of the industry, "on message" (fig. **7.10**).

Positioning a film is not unlike orchestrating a political candidate's public relations campaign. First, you play

to your base; you make sure that those likely to be interested in the film because of its genre, its stars, or its politics know about the film's scheduled opening and are reminded and enticed to go see the film. And then you reach out to those folks in other demographics—other age brackets, geographical regions, membership in oppositional political parties that might be interested if only they knew more, or at least knew what the studio marketers want them to know about the film.

Let's take a quick look at the positioning strategy employed by Sony Pictures in advance of the release of David Fincher's 2011 remake of the 2009 Swedish film *The Girl with the Dragon Tattoo* (Niels Arden Oplev), itself based on a popular novel of the same title written by Stieg Larsson. The Sony marketing team appreciated that their first task was to excite and reassure fans of the original, the project's core audience. To do so, six months before the Hollywood remake was scheduled to premiere, the marketers released a trailer to theaters at the height of the summer season. The trailer featured a fast-paced montage of images recalling the first film. Set to a sped-up version of Led Zeppelin's "The Immigrant Song," reworked by popular recording artists Trent Reznor and Karen O (to give the trailer an aura of modern cool), we see images of a frozen landscape, the "girl" on her motorcycle, the tattoo in question on the "girl's" naked back, the popular movie star Daniel Craig in the lead male role, and the actress Rooney Mara transformed to match the punk look of Noomi Rapace as Lisbeth Salander, the "girl" in the original film (figs. **7.11** and **7.12**).

Months later, a NSFW (Not Suitable for Workplace) poster and trailer was leaked on the web that seemed to be designed to reassure fans of the original that the Hollywood version would not be "soft." The audacious positioning campaign was summed up in the all-audiences trailer with the tagline: "The feel bad movie of Christmas." Well before the film's release date, Sony was positioning the film with regard to the other Christmas season films.

positioning A marketing term that refers to the work of generating and managing the discourse surrounding a film.

7.11 Rooney Mara as Erica Albright, the young woman who breaks Mark Zuckerberg's heart in *The Social Network* (David Fincher, 2010).

7.12 Rooney Mara one year later as Lisbeth Salander in the trailer for *The Girl with the Dragon Tattoo* (David Fincher, 2011). Sony used the trailer to assure filmgoers that the Hollywood blockbuster would not veer far from the original 2009 version of the film, directed by Niels Arden Oplev.

7-2b **Trailers and Posters**

One of the principal challenges of positioning a film in advance of its release is settling upon a message that can be capsulized in what's called a **tagline**, for example: "Ice cold. Hot wired." for the car thief movie *Gone in Sixty Seconds* (Dominick Sena, 2000) or "He was dead. But he got better." for the unlikely sequel *Crank: High*

tagline A line used in marketing that communicates the message of the film for audiences.

Voltage (Mark Neveldine and Brian Taylor, 2009). Also important are visual promotions—trailers and posters that in a 90-second series of clips from the movie or a single captivating print image give potential filmgoers a taste of what's to come . . . a taste good enough or interesting enough to get them to buy tickets to see the film.

Two types of trailers are used for commercial films. The "teaser" trailer, like the trailer for *The Girl with the Dragon Tattoo* discussed above, is released six months before a film is scheduled to reach theaters. It enables distributors to advertise summer blockbusters during the Christmas season and Christmas movies in the summer. Teaser trailers are designed to reveal little about a movie's actual content; instead the focus is on the stars and the genre. The theatrical, or "story," trailer follows several months later to further position the product in the marketplace. Story trailers are at once a free sample designed to get potential filmgoers to pay for the real thing and works of art unto themselves. They are 90-second films that showcase expertly compiled and edited footage from the feature to express the studio's message about the movie.

Posters are another key aspect of the marketing campaign. A successful poster, like a successful trailer, answers the two key questions: Who is in the picture? What is the picture about? Successful poster design keeps the larger promotional scheme on message, and in doing so positions the film. Posters are used to announce a film's arrival in the marketplace; they are strategically placed in theater lobbies, in newspapers and magazines, and on the Internet. Combining text and image in a single dramatic visual, the poster suggests the kind of experience the movie will offer audiences.

Posters can be revealing about what marketers want to highlight and what potential problems a new film release might face. For example, the poster for the 2008 film adaptation of the popular television show *Sex and the City* makes sure that the target audience knows that the film will feature the same characters and

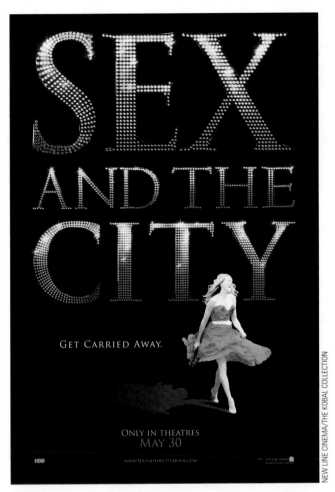

7.13 The simple but effective poster hawking the film adaptation of the popular television show *Sex and the City* (Michael Patrick King, 2008).

actors (fig. **7.13**). This is revealed in the play on words in the tagline: "Get Carried Away," which subtly refers to the character "Carrie" played by the actress Sarah Jessica Parker, whom we see in full figure just below the title. The choice of pink letters (using the typeface of the original HBO series) carries the "chick flick" message and the black background hints at the swinging nighttime lifestyle enjoyed by the young women on the show. The billowy pink dress (reminiscent of the dress Carrie wears in the opening sequence of the TV show) speaks to the show's fashion consciousness, another aspect of the film that the New Line marketers (who work for Time Warner, which also owns HBO) want to highlight. Finally, there is the parenthetical phrase just above the May 30 release date: "(Only in Theaters)," which brings us to the primary challenge for the marketers. With reruns of the show on HBO and basic cable, marketers used the phrase to remind fans the only way to see a *new* episode is to see the feature on the big screen.

7-2c **Test Screenings**

Before a film is released and the promotional campaign fully realized, distributors routinely conduct **test screenings** to see how audiences react to the film. In order to generate a diverse sample and to approximate future box office performance as closely as possible, test screenings are staged in a variety of geographic sites (urban, suburban, and rural; north, south, east, and west; red state and blue state) and with filmgoers codified by gender, education, income, and religious affiliation.

Test audiences are asked to fill out comment cards after the screening. Responses at test screenings can have a significant impact on the final cut of a film. For example, test audiences rejected the original ending of Adrian Lyne's *Fatal Attraction* (1987), in which the scheming adulteress Alex Forest commits suicide and in doing so implicates Dan, her married lover, whose prints the police find all over the knife she uses to kill herself. Test audiences hated that the Alex Forest character seemed to win in the end and the comment cards overwhelmingly disapproved of the ending. So the director Adrian Lyne, at the behest of Paramount Pictures executives, rewrote and reshot the ending, having Dan's wife Beth gun down Alex to save her man and her marriage.

Sometimes positive remarks on the audience cards lead to significant changes as well. When test audiences responded positively to the actor Rupert Everett in *My Best Friend's Wedding*, Columbia/Tri-Star executives ordered new scenes showcasing the actor (fig. **7.14**).

Though reshoots and re-editing make for dramatic industry copy, any significant delay in a film's release is expensive and risky. More often test screenings are used to predict a film's potential at the box office, a projection that often impacts the budget provided for promotion and advertising. Test screenings are also used to shape the marketing message and positioning of the film in parallel media.

Another market concern that may affect a film's release regards the **Voluntary Movie Rating System**, the G, PG, PG-13, R, or NC-17 imposed by the Classification and Ratings Administration (CARA) for the Motion Picture Association of America (MPAA).

test screening A prerelease film screening to gather reactions from sample audiences.

Voluntary Movie Rating System The system of assigning a rating that is meant to provide information about the appropriateness of a film for audiences 17 and under. Managed by CARA (the Classification and Rating Administration) for the MPAA (the Motion Picture Association of America).

7.14 The consensus among the comment cards at test screenings was that Rupert Everett's performance was the best thing about *My Best Friend's Wedding* (P. J. Hogan, 1997), so Columbia/Tri-Star executives called for a few new scenes featuring (more of) his character.

7.15 *Iron Man 2* (Jon Favreau, 2010) grossed over $200 million in its opening week then dropped off to just $40 million during its second week. Despite the dropoff, the film was considered a huge success.

Contracts with filmmakers routinely include "guarantees" of delivery of a final print that falls within a certain classification. So, for example, if CARA gives a film an R and the filmmakers have agreed to deliver a PG-13 print, they must negotiate with CARA and make appropriate changes to get the designation changed.

This comes up as well when directors agree to deliver an R-rated film and get stuck with an NC-17. In the summer of 1999, for example, two very different films that had contractual provisions for delivery of an R-rated version initially received an NC-17: *Eyes Wide Shut* (Stanley Kubrick) and *South Park: Bigger, Longer*

marketability A film's potential as a commercial property independent of its quality.

playability A film's creative quality independent of its commercial potential.

saturation distribution strategy A strategy that aims for a big payoff on a film's opening weekend.

& Uncut (Trey Parker). To get an R, Kubrick supervised the addition of computer-generated human figures to obstruct our view of the action during a long orgy scene. And to get their R, the animators producing the *South Park* film submitted six versions of their film, each with modification in the outrageous language and content of their satire, before finally getting an R. Hollywood movies are products of collaboration and compromise; what we see on-screen is often a balance of creative inspiration and commercial practicalities.

7-2d Distribution Strategies

The decisions regarding the promotion, advertising, and positioning of a film in the marketplace culminate in the actual distribution of film prints to theaters. Distributors opt to open big or small (to a lot of theaters or to just a few) depending on the scale of the production and their investment, the budget secured for advertising and promotion, the targeted audience (e.g., everyone, just teenagers, just the art house crowd), and marketing assumptions based on test screenings regarding a film's **marketability** (its potential as a commercial property independent of its quality) and "**playability**" (its creative quality independent of its commercial potential). Where and when a film will open and how many prints will be made available are calculations aimed to maximize the return on investment. For filmgoers, the distribution strategy to a large extent determines what films we will have access to in the local multiplex or art theater, when we will have access to them, and for how long.

In order to open big consistently, the contemporary studios have opted to focus almost all of their energy on "presold properties": adaptations of bestsellers and comic books, sequels, and remakes that have such universal name recognition that they effectively sell themselves. For example, Paramount Pictures opened its presold property *Iron Man 2* "big" to 4,380 screens on the weekend of May 7–9, 2010 (fig. **7.15**). This smart, albeit predictable **saturation distribution strategy**—so named because the

7.16 *Gone with the Wind* (Victor Fleming) in its exclusive engagement at the Astor Theater on Broadway in Times Square, winter 1939.

a **showcase distribution strategy** (aka "road show" or "reserve seat engagement"), in which distributors made available a limited number of prints for which only the biggest urban movie houses might negotiate a licensing deal. The slow buildup from the limited showcase engagements to a full nationwide release created demand by limiting supply.

The classical Hollywood blockbuster *Gone with the Wind* was released following a roadshow strategy (fig. **7.16**). The film premiered on December 15, 1939, at just one theater in Atlanta, then, later that week opened at just one more in New York City. In subsequent weeks the film was released to a handful of other big cities in exclusive, reserve-ticket engagements. *Gone with the Wind* did not reach smaller venues until early in 1941, over a year after its premiere. The roadshow release built upon the essential glamour of Hollywood and the strict limits on the number of screening venues fueled filmgoer demand.

Releasing big films is expensive, but the return on the investment is fast and predictable. More care must be taken with "smaller" films, "independent" or niche films, and movies produced outside the studio system. For these films, distributors often open with a "limited release," a playoff at select venues, hoping to build to a wider release from positive word of mouth, the buzz created by the few filmgoers and critics who see the film during its opening weeks in release.

For a low-budget film like Nicole Holofcener's *Please Give* (fig. **7.17**), released just 90 days before *Iron Man 2*, the opening weekend called for only five prints. Once the film gained some traction in the art-film market, Sony Pictures Classics (a boutique division of the multinational studio Sony Pictures) ordered 21 more. The height of its release was a full seven weeks into its first run as the studio had in release 272 prints. But even at its peak, *Please Give* reached just over 6 percent of the screens accessed by *Iron Man 2*.

Alternative films require alternative distribution strategies. One such strategy used in the 1930s through

market appears saturated by prints of a given film—succeeded: *Iron Man 2* earned over $128 million on its first weekend in release.

The saturation release strategy is simple: put a film into as many theaters and onto as many screens as possible from the very start of its nationwide run. Most big contemporary Hollywood films today get a saturation release. In the summer of 2010, four other studio blockbusters similarly saturated the marketplace during their first week in release: *The Twilight Saga: Eclipse* (David Slade) and *Toy Story 3* (Lee Unkrich) opened on over 4,000 screens and *The A-Team* (Joe Carnahan) and *Sex and the City 2* (Michael Patrick King) both opened on over 3,500. With the saturation release, the opening weekend gains a singular importance. In the twenty-first-century U.S. market, the first weekend can account for as much as 40 percent of a big film's overall take at the box office.

The saturation release corresponds to a growing demand among contemporary consumers for instant access. Marketing campaigns for big films highlight such accessibility. In 1996, for example, the poster heralding the release of the summer blockbuster *Independence Day* (Roland Emmerich, 1996) noted simply that the film was set to open on July 3rd "everywhere."

The saturation release strategy was not used much for blockbusters produced between 1915 and 1980. These big studio films were generally released following

7.17 For the opening weekend of the low-budget *Please Give* (Nicole Holofcener, 2010), Sony ordered just five prints. When the film gained a little traction, the studio upped its order slowly and cautiously, peaking at 272 screens in its seventh week in release.

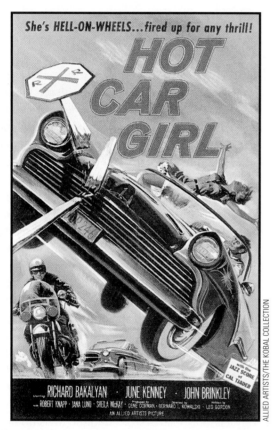

ALLIED ARTISTS/THE KOBAL COLLECTION

7.18 A poster promoting the 1958 exploitation feature *Hot Car Girl* (Bernard L. Kowalski). Four-walling a film like this allowed Allied Artists, the film distributor, to screen the film and then get out of town before local censors could shut the screening down or, worse, seize the print.

four-walling A strategy of renting a theater for a day or so before moving the print to a new town.

Motion Picture Production Code The strict set of censorship guidelines adopted by the Hollywood studios in the 1930s and enforced through the 1960s.

the 1960s was **four-walling**. Often used by distributors of exploitation films—low-budget, mostly genre pictures that featured exploitive content (otherwise banned in mainstream films)—as well as indie distributors of G-rated family-oriented pictures (like Mulberry Square Releasing's playoff of its 1974 picture, *Benji*, directed by Joe Camp), this method involved renting a theater (all four walls, hence the term) for a limited engagement, often as brief as a single day. This method of distribution and exhibition benefited both parties: the exhibitor got a flat rental fee for the theater up front at no risk, and the distributor did not have to share ticket revenues with the exhibitor should a big crowd arrive. Since many exploitation films defied some basic premise of the **Motion Picture Production Code**, the strict set of censorship guidelines adopted by the Hollywood studios in the 1930s through the late 1960s, four-walling enabled the distributor to get out of town before local censors could shut down the screening or, worse, seize the print.

Different modes of distribution present films differently to the public. For example, seeing *Hot Car Girl* in a four-walled playoff in 1958 gave the audience the sense that they were witnessing something clandestine and taboo (fig. **7.18**). People who saw *Iron Man 2* in a multiplex during its opening weekend in May 2010 or *Gone with the Wind* in its showcase run at the Astor Theater in New York City in the winter of 1939 likely felt excitement at being among the first to experience an event of pop-culture significance. And those who "discovered" *Please Give* in its limited opening weekend or in its brief wider run felt like they had the inside scoop on a neat alternative to the mainstream releases that otherwise dominate the marketplace. The key here is how the distribution strategy influences our expectations, experience, and critical understanding of a given film.

7-2e Cross-Promotion and Merchandising

For their bigger titles, studios now exploit the synergistic relationships not only among the various audiovisual media (network and cable TV, DVD, video-on-demand, streamed movies on the Internet, etc.) but among consumer and fast-food industries as well. This

cross-promotion involves the use of alternative media (television, the Internet, newspapers, and magazines) and cooperative deals with toy and fast-food companies to mount a saturation marketing campaign. This style of marketing is used to kick-start the inevitable saturation distribution strategy.

Cross-promotion is designed to suit the movement of a film through multiple access points: theater, TV, computer, tablet, smart phone, and so on. The 2010 summer hit *Iron Man 2*, for example, exploited TV and magazine spots for Burger King and Audi automobiles (which also included prominent "product placement" in the film: the hero Tony Stark drives a white Audi R-8 with numbered vanity plates, making sure we know he has several such German supercars). Through Marvel Entertainment (which owns the Iron Man brand), Paramount licensed an array of action figures, lunch boxes, and toys, including Burger King Happy Meal collectibles and an Iron Man Mr. Potato Head. The goal is ubiquity: everywhere you look (or eat), there is a reminder of the film.

7-3 EXHIBITION

Distributors get their films into theaters through booking agents or by working directly with theater owners or managers. Exhibitors provide the venue (the movie theater) and they preside over each movie screening. Though we may not think that much about the mechanics or the business of exhibition (except when things go wrong in the theater), the way a film is screened—how the images are projected and how the sounds are played back and amplified—is very important to the overall filmgoing experience.

Exhibitors rent or license a single positive print of a film for the purposes of screening it (and charging admission) to an audience. In exchange for permission to screen the movie in their theaters, exhibitors pay a licensing fee to the distributor. A typical distribution/exhibition agreement involves a shared percentage of a film's box office revenue (as much as 90 percent to the distributor in some cases, especially during a film's initial week in release) calculated against a minimum flat fee called the guarantee. After the film's run is complete and revenues are calculated, theater owners must pay the film distributor either the negotiated percentage or the guarantee, whichever is higher.

Exhibition today has expanded beyond the movie theater to include an array of modes of multimedia reception. Movies are accessed legally through cable and satellite TV and pay sites like iTunes, Amazon, and Netflix and surreptitiously on the web through torrent sites (which allow for the mostly clandestine and unlicensed sharing of uploaded movies on the Internet). While it is worth thinking about how each of these many new venues for home entertainment has changed the "filmgoing" experience, we will focus here primarily on theatrical exhibition, the first and most important access point in contemporary distribution and exhibition.

7-3a From Storefront Theaters to the Modern Multiplex

The commercial exhibition of motion pictures dates to April 1894 with the opening of the Holland Brothers Kinetoscope Parlor on Broadway in New York City. For this first commercial exhibition, patrons watched films by peering into a Kinetoscope, a hand-cranked moving picture viewer (fig. **7.19**).

Within two years, projected movies had been screened in France, England, and the United States. The dynamics of these two modes of exhibition (hand-cranked and projected) were different, but both highlighted the medium's essential conceit that movies are made for public exhibition.

In the late nineteenth century and through the early 1900s, films were shown at a variety of public venues: at vaudeville (traveling variety) shows, in saloons, at penny arcades in amusement parks, and during intermission at theater productions. But as the medium caught on, storefront theaters called **nickelodeons**, so named because it cost a nickel to view a program of short motion pictures, became popular (fig. **7.20**).

Not all movie theaters and, as a consequence, not all moviegoing experiences are created equal. Early cinema began as a novelty, a curio of the machine age. Nickelodeon parlors and storefront theaters enabled viewers to intimately peruse the new invention. But as movies

cross-promotion The use of partnerships with toy, fast-food, and media companies to build the visibility of an event film.

nickelodeon A storefront theater that showed films during the early cinema era. A series or group of short films were available for viewing for a nickel.

7.19 Inside a Kinetoscope parlor, 1895.

7.20 A nickelodeon theater in Waco, Texas.

movie palace An opulent standalone theater that brought glamor to the moviegoing experience. In the 1910s movie palaces had seating capacities approaching 1,000. By the 1940s, some movie palaces could seat over 5,000.

multiplex A single venue with multiple screens. A venue with 16 screens or more is known as a **megaplex**.

art house A theater, also known as an independent movie theater, that typically screens independent and foreign-language films.

caught on and moviemaking became more ambitious and sophisticated, movie theaters quickly became an important public space, especially in working-class American culture. Even when ticket prices were doubled (from a nickel to a dime around 1910), moviegoing remained a fairly cheap form of entertainment, very much tied to working-class culture.

In the 1910s opulent theaters with capacities approaching 1,000 patrons opened for business. These **movie palaces** cemented the medium's communal dynamic, bringing people from all walks of life together in the dark for a couple of hours. By the 1930s, the movie palace was a hallmark of classical Hollywood, providing for the working-class filmgoer a step into a glamorous world to which he or she would otherwise never gain entrée (fig. **7.21**).

The movie palace was the model for United States and worldwide film exhibition until the 1960s when the **multiplex**—a single venue with multiple screens—became popular. The multiplex enabled theater owners to increase revenue with little additional overhead. Exhibitors did not have to "come off" (end the run of) a successful film before licensing another picture, and they could with the same basic staff access revenue from more than one film at a time.

The multiplex and its gargantuan sibling the **megaplex** (a term exhibitors use for venues with sixteen or more screens) have changed the dynamics and to an extent diminished the quality of the filmgoing experience. That many multiplexes are situated in shopping malls—suburban sites that offer one-stop shopping—renders analogous the consumption of fast food (at food courts), cheap consumer products (clothing, etc.), and movies.

Most multiplexes are owned by theater chains like Regal, AMC, Cinemark, and Carmike. With this conglomerate ownership has come standardization; one multiplex theater is more or less like any other. The screens have gotten smaller and so have the individual theaters as so-called stadium seating has enabled exhibitors to literally stack filmgoers one on top of the other. Theater owners once fashioned themselves "showmen" and valued "presentation"—how the movie show is presented to filmgoers. As smaller screens have become the norm, and sound leakage from theater to theater an everyday occurrence, quality presentation has become less important to theater owners than the volume of business they can bring in (fig. **7.22**).

The **art house** or independent movie theater offers an alternative to mainstream movie presentation, routinely booking films that the multiplexes don't. Art houses tend to be more intimate (like the films shown there) and

7.21 The movie palace as a signifier of Hollywood glamour. Grauman's Chinese Theater on Hollywood Boulevard, circa 1946.

7.22 So many choices . . . exhibition in the era of the multiplex is all about volume: more movies, more screenings, more seats, more money.

can be quirky little establishments with a funky charm, unusual concessions, and owner-operators who get to know their customers. These venues persist despite tough economic times for the consumer, for the independent filmmaker and independent film distributor, and for art theater owners nationwide. Art houses can be found in college towns (like the Darkside Cinema in fig. **7.23**) and urban centers and often become mainstays in the larger alternative, progressive political subcultures where they are situated.

Where we see a film and how that film is presented influences our reception, appreciation, and critical understanding. The sites themselves offer a critical context; where the film is shown to an extent defines what sort of commercial product it is: a multiplex blockbuster or an art-house film, for example. Seeing a movie in a

7.23 The funky charm of the Darkside Cinema, an art house in Corvallis, Oregon.

crowded multiplex theater makes moviegoing an event, and the shared energy in the theater certainly affects our reception of the film. Laughing comes easier when others are laughing. Tension seems all the more tense when others share in the anxiety. The more sober, intimate atmosphere of the art house situates in a different way the film and the filmgoer. As critical filmgoers, it is worth thinking about how site-specific our reactions to and readings of films are.

7-3b Theatrical Formats: Flat and Widescreen

The overall look of a film depends on its **aspect ratio**, the ratio of frame width to frame height. The standard frame proportions of Hollywood film through much of the silent and early sound era were 1.33:1 and then 1.37:1 (approximately 4:3). In the 1930s the Hollywood-based Academy of Motion Picture Arts and Sciences (AMPAS) gave this screen shape its name: the **Academy ratio** (fig.**7.24**).

When television, which initially shared the Academy ratio's basic shape, emerged as a competitive medium, moviemakers and exhibitors began experimenting with aspect ratio as a way to add value to the filmgoing experience. A variety of **widescreen** ratios were introduced, including 1.66:1 and later 1.85:1. In

aspect ratio The ratio of frame width to frame height. The **Academy ratio** was the standard during much of the silent and early sound era. **Widescreen** formats include Cinemascope and Panavision.

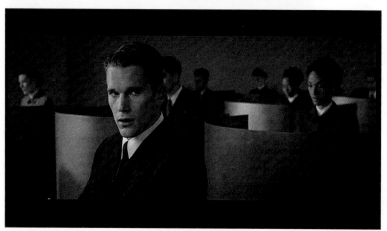

7.25 Contemporary Panavision (2.40:1) in Andrew Niccol's sci-fi parable *Gattaca* (1997).

7.26 Same image, same film, different impact—*Gattaca* reformatted for "full-screen" TV. Note how the formatting affects the framing of the film's hero Vincent (he now appears closer to the front of the frame) and crops out some of the other figures in the scene.

▶ **7.24** *The Maltese Falcon* (John Huston, 1941) shot and presented in the Academy ratio (1.37:1).

1953, Cinemascope (2.35:1) was introduced, and then in the 1960s filmmakers and exhibitors began experimenting with 70mm (2.21:1).

The current format of choice is Panavision, the letter-box-shaped frame of many contemporary movies, which established a standard widescreen ratio of 2.40:1 (fig. **7.25**). Some DVDs and TVs give the viewer the choice of watching a "letterbox" image that matches the proper aspect ratio of the film but fills only a portion of the home screen or reformatting that image to fill the TV screen (figs. **7.25** and **7.26**). While reformatting may provide a bigger image, it betrays the fundamental look of the film and can affect meaning.

While films are produced with an aesthetic based on a certain-shaped frame, the print itself may be delivered in the Academy ratio and exhibitors are then called upon to "mask" the film to create a widescreen aspect ratio. Masking is executed by attaching an aperture plate or hard matte to the projector (or if masking is done during production, to the camera). Failure to properly mask the image during exhibition might leave production equipment visible in the frame, an embarrassment for everyone concerned.

Another way to exhibit widescreen is through the use of an anamorphic print and lens. This lens squeezes the image horizontally either during production or at the lab when the film is developed. Cinemascope, which involves the use of an anamorphic lens, introduced an aspect ratio of 2.35:1. This was later adjusted to match the aspect ratio of Panavision, which also uses an anamorphic lens to achieve a ratio of 2.40:1, the standard widescreen shape today.

It is vital for the exhibitor to get the shape of the image correct and to use the appropriate lens on the projector. Proper presentation allows the film to be screened as its makers intended and offers the filmgoer a full appreciation of the film's overall design, mise-en-scène, and camera work.

7-3c The Future of Film Exhibition: IMAX, 3-D, and Digital Cinema

While multiplexes function on an economy of scale—more screens, more films, more patrons, more popcorn

and pop—selected theaters have adopted new immersive widescreen formats in order to offer a dramatic alternative to the conventional filmgoing experience. IMAX, the best known and most widely implemented of these new formats, was introduced at the 1986 Expo in Vancouver, British Columbia, and then found a home at science and industry museums worldwide (fig. **7.27**).

Feature film presentation in IMAX began in 2002 with *Apollo 13* (Ron Howard). Since then, selected studio titles (action blockbusters and animated films mostly) have been adapted for the huge screen with IMAX's DRM (Digital Re-Mastering) technology. IMAX offers a spectacular widescreen experience, projecting remarkably clear images from film stock approximately ten times larger than standard 35mm, moving through the gate at 48 frames per second, twice the standard speed. Bigger is indeed better with IMAX: the image is projected onto screens over seventy feet wide and fifty feet high, and sound is pounded out via 12,000-watt six-channel sound.

The overall effect of the IMAX show is that of a thrill ride, which perfectly suits the contemporary action features that are remastered for the format. With IMAX, every explosion, every punch, kick, and gunshot are vividly reproduced, not in lifelike image and sound but in motion captured with hyper-real visual clarity and audio that stands your hair on end and pins you to your seat.

Another alternative to conventional 35mm movie presentation is 3-D. Like IMAX, which hearkens back to immersive formats like Cinerama (which used a deeply curved screen and 70mm widescreen Ultra-Panavision technology), contemporary 3-D is a variation on an old theme, rooted in exhibition innovations that were first introduced in the 1950s to combat the introduction of free TV. Director Arch Oboler pioneered a technique called Natural Vision in the 1950s, using two simultaneously running cameras positioned to simulate the distance between an average person's two eyes to produce two negatives for every scene. Projecting Natural Vision required two synched projectors positioned to match the angle created by the two cameras during production.

Twenty-first-century digital 3-D is a revelation compared with its 1950s predecessor. The state of the art is certainly James Cameron's 2009 feature *Avatar*, for which the director put into use his proprietary 3-D fusion camera system. Like Oboler's Natural Vision, it also employs two synched cameras, but the line of sight of both cameras is infinitely adjustable and so precise it can shift focus from foreground to background (from near to far) to better match human sight (fig. **7.28**).

The future of film exhibition may not be IMAX or 3-D. But it will definitely involve an embrace of digital technologies. Indeed, that future is here.

Throughout the twentieth century, commercial exhibition involved the screening of 35mm prints of films shipped from studio to theater and then from theater to theater until the "run" was complete. The system worked, but not without the occasional headache: multi-reel 35mm prints are very heavy and the films themselves are susceptible to damage.

An alternative to 35mm film presentation is digital exhibition. These features are stored on a computer or server that transmits the "film" (via satellite or a fiber-optic network) to a digital projector. Some smaller theaters use physical media like enhanced DVDs or Blu-Ray disks. Digital files and digital media cost little or nothing to ship, but there is one drawback. Problems at either end—the delivery end or the exhibition end—or damaged media will leave the exhibitor with a "dark" screen, nothing at all to show. Even when a 35mm print arrives damaged, a screening is almost always salvageable.

For most filmgoers, discerning whether they are watching digital

© Jose Fuste Raga/Corbis

7.27 IMAX at the museum: the Science Museum Principe Felipe (left) and L'Hemisferic, (right) the adjacent IMAX theater at the breathtaking City of Arts and Science Park in Valencia, Spain. The sci-fi design and science museum setting were meant to frame the IMAX experience as at once futuristic and the product of modern technological know-how.

7.28 An audience at James Cameron's 2009 3-D feature *Avatar*.

Optical playback has been the industry standard for over seventy years: the film passes the audio pickup on the projector and at that moment the exciter lamp flashes a bright light focused by a lens through the transparent strip. This light shines on a photocell, a solid-state device that converts light into electrical energy. The advent of digital sound recording and playback has changed motion picture presentation as dramatically as the recording industry's shift from the phonograph record to the CD changed music playback. With digital film playback, an optical reader is mounted on (or integrated into) the projector. As in analog audio pickup, the reader uses a light-emitting diode (LED) to focus light through the film and onto a photocell. This creates pulses of current that the reader decodes. This digital information is then transferred to a computer where it is compressed onto a CD. The six tracks (right, left, center, left-surround, right-surround, and subwoofer) of the digital soundtrack are compressed onto one or two CDs, depending on the length of the movie.

The equipment necessary to present multitrack stereo was through 1970 prohibitively expensive until Dolby Laboratories introduced the Dolby Cinema Processor. Named for its inventor, Ray Dolby, Dolby Laboratories have been instrumental in the evolution of modern sound playback and amplification. Dolby SRD, introduced in the early 1990s, is one of several digital sound reduction/enhancement technologies that dramatically improve the signal-to-noise ratio for theatrical exhibition. (The other major digital sound technologies are SDDS and DTS).

If you sit through the entire closing credits of a contemporary commercial film, you will likely see the logo for THX. This logo refers not to a specific technology but to a quality-control certification system first implemented at movie theaters by George Lucas's Lucasfilm for the first run of the 1983 film *The Return of the Jedi* (Roger Marquand). The THX logo is virtually ubiquitous at first-run movie theaters today and on high-end consumer home theater equipment.

or 35mm presentation is difficult and probably irrelevant. Cine-purists claim that they miss the texture of proper celluloid prints as well as the depths and decay of analog audio, but for the exhibitor the pristine look and sound of digital delivery makes presentation easier. As of 2010, the big theater chains had invested $1 billion in converting their theaters from 35mm to digital presentation.

7-3d Theater Sound

When sound was introduced in motion picture exhibition, the monaural, monophonic, or mono signal was the standard. For mono playback, the same sound information is delivered to every speaker in the theater. In 1940, stereophonic (two-channel) sound was introduced for the Disney animated feature *Fantasia* (James Algar et al.), notably a film with a prominent musical score and no synched dialogue. Stereophonic sound splits the mono signal into two distinct channels, each delivered to a separate speaker in the hall.

Mono sound involves a single sound strip on the film. Stereo sound employs two strips that appear as parallel squiggles on the celluloid print. Digital sound, the standard for commercial films today, looks to the naked eye like a string of dots or dashes.

CHAPTER SUMMARY

Film is a business as well as an art form. Film literacy involves understanding the financial and practical constraints upon filmmakers as well as the ways that marketing and exhibition strategies affect our expectations about a film.

7-1 THE BUSINESS OF FILM

Learning Outcome: *Understand and appreciate how decisions made during development, production, postproduction, distribution, and exhibition are financial as well as aesthetic, and practical as well as imaginative.*

- Six corporations control approximately 95 percent of the film market in the United States. They optimize synergies—strategic relationships that allow them to move filmed products through a variety of markets and venues in order to maximize profits.

- So-called indie, or independent, film companies make films on tighter budgets. Their films are released to far fewer theaters than bigger, more expensive studio films.

- Capital investment often guides aesthetic decisions; for all films, casting, production design, sound design, and even camera and lighting decisions are constrained by budget.

- The challenge for those who finance and make movies is to transform the notoriously haphazard production of art into an industrial process that operates within a predictable schedule and budget.

7-2 DISTRIBUTION AND MARKETING

Learning Outcome: *Identify and analyze various distribution strategies and the role of trailers and posters in the marketing of motion pictures.*

- Positioning a film in the marketplace involves generating and manipulating the "buzz" about a film in print, on radio, on TV, and over the Internet.

- One of the principal challenges of positioning a film in advance of its release is settling on a message that can be distilled to a tagline.

- Two types of trailers are used for commercial films: teaser trailers, meant to create awareness many months in advance of a big film's release; and story trailers that feature scenes from the actual film, meant to get audiences into theatres.

- Posters are a key aspect of the marketing campaign. A successful poster, like a successful trailer, answers two key questions: Who is in the picture? What is the picture about?

- To help executives predict a movie's success and plan a marketing campaign, test screenings are staged in a variety of geographic sites and with filmgoers codified by such demographics as gender, education, income, and religious affiliation.

- Another key factor in planning a film's release is the rating imposed by the Classification and Ratings Administration (CARA) for the Motion Picture Association of America (MPAA).

- Distributors opt to open big or small depending on the scale of the production and their investment, the budget secured for advertising and promotion, the targeted audience, and marketing assumptions based on test screenings.

- Distribution strategies include the saturation, showcase, limited release, and four-walling strategies.

7-3 EXHIBITION

Learning Outcome: *Recognize and discuss the effect of exhibition on our experience of a film.*

- Exhibitors rent or license a single positive print of a film from distributors for the purposes of screening it, for an admission price, to an audience. In exchange for permission to screen the movie in their theater, exhibitors pay a licensing fee to the distributor.

- In the late nineteenth century and through the early 1900s, films were shown at a variety of public venues: at vaudeville shows and plays, in saloons, and at amusement parks. Venues then evolved from storefront theaters (nickelodeons) to movie palaces to multi- and megaplexes. The art house, or independent movie theater, offers an alternative to the multiplex.

- The overall look of a film depends on its aspect ratio, the ratio of frame width to frame height.

- Sound projection and amplification has evolved with the size of film venues, along with technologies to improve sound quality.

Mission: Impossible—Ghost Protocol was a Christmas season release in 2011. It was a tent-pole title for its distributor Paramount Pictures and the fourth in the *Mission: Impossible* franchise, a rebooted adaptation of a popular television show than ran from 1966 to 1973. Budgeted at nearly $150 million and with an advertising budget of at least another $50 million (studios do not often publicize ad budgets), the film was in every way a big-budget studio event film. The investment paid off with over a half billion dollars in worldwide theatrical revenues in its first month in release. The poster announcing its forthcoming release rather simply embodied the studio's message, positioning the film simply and successfully in the marketplace. Because *Mission: Impossible* is a high-concept, presold property, the studio marketers believed the simpler the message, the better.

Paramount is banking on the star appeal of Tom Cruise. He is literally the face of the franchise.

His eyes set the mood—this is a serious film.

His face is stubbled to suggest toughness—a rough-and-ready attitude.

The black background highlights the images.

The lit fuse alludes to the opening of the TV show.

His head is hooded to signal his clandestine activity as a superspy.

Paramount is branding this episode as at once something familiar (another *Mission: Impossible* movie) and something totally new—a reboot with its own title. Its predecessor was advertised more simply as just another entry in the franchise: *M:i:3* (J. J. Abrams, 2006).

This is a big-budget, Christmas season, studio event film. The opening weekend date will be announced in future ad spots and trailers on TV, on the Internet, and in theaters.

PARAMOUNT PICTURES/THE KOBAL COLLECTION

What's left off the poster: (1) Tom Cruise's name; he's such a big star, it is unnecessary here; (2) the rest of the cast—Cruise is such a big star he is able to "open" the film on his own; (3) the director Brad Bird, well known for his work in animation (*The Incredibles*, 2004). Bird's name, and the story of his debut as a live-action director, distract from the message of the film.

ANALYZE COMMERCIAL AND INDUSTRIAL CONTEXTS

Use these questions to consider how the aspects of industry and commerce (financing, distribution, and exhibition) affect the audience's perception of the film you are analyzing. For basic information on budgets and box office, go to www.imdb.com or www.the-numbers.com.

- How does the commercial and industrial context shape the meaning of the film?

7-1 THE BUSINESS OF FILM		• How do the production values of the film reflect its budget? How extensive is the list of cast and crew? How elaborate are the costumes, sets, effects, score, and so on?
		• If the film was a big-budget Hollywood "event" film, which of the six big conglomerate studios produced it? What kinds of synergies did they draw upon?
		• If the film was a low-budget independent production, what aspects of production, distribution, and exhibition distinguished it from a big studio film?
		• Was the film considered to be a financial success, and what factors account for its success or lack of success in the marketplace? Was the film a creative success?
7-2 DISTRIBUTION AND MARKETING		• What did you know about this film before seeing it, and how might your expectations have shaped your reaction to it?
		• Did you see any of the film's cast in the media, and what message did they deliver about the film? Where did they appear, and what does that tell you about the intended demographic?
		• Study the trailers and posters created for the film. What message did they convey? What demographic did they seem to be designed for?
		• What was the rating designation of the film? How did the rating affect the marketing campaign?
		• What sort of distribution strategy was employed? Was it appropriate? Did it work?
7-3 EXHIBITION		• Describe the theater and the audience for the screening. How did the environment in which you watched the film affect your experience of it?
		• What is the film's intended aspect ratio? What format did you see it in? If you are able, compare a scene from the film in the intended format and reformatted for TV and describe the differences.
		• In the theater, notice where the sound seems to come from (what part of the auditorium) and whether different parts of the soundtrack are coming from different locations. Also observe the volume and sound quality.

This Film Is Not Yet Rated (2006), directed by Kirby Dick

ANIMATED, AND

I n film studies there are various ways to categorize the range of movies that compose the medium. We can organize movies by date, by nation, by language, by author, and by genre. We can further distinguish between films with regard to fiction/nonfiction, live-action/drawn, fabricated or constructed, and narrative/nonnarrative, which brings us here to three distinct alternative film categories: documentary, animation, and experimental. These alternative films use the constituent elements of mainstream live-action fiction—mise-en-scène, camera work, editing, and sound—but do so in often unique ways.

Documentary films endeavor to re-present lived experience, focusing on real people and real events. **Animated films** are produced by changing drawings or images or deftly manipulating objects frame by frame, and though these films stage gags or tell stories much as live-action pictures do, they seldom feature live actors or nature captured in motion by a camera. **Experimental films**, as the term suggests, experiment with form and style. Many experimental films are also labeled **avant-garde** because they push the boundaries of accepted norms with regard to storytelling, artistic presentation, and cultural representation.

Documentary, animated, and experimental films offer a rewarding alternative to live-action narrative films. A close reading of these films can examine how they adhere to and deviate from the principles of film form that we examined in chapters 2 through 6.

documentary Films that present themselves as works of nonfiction, as factual and trustworthy, and ask us to view them as such.

animated film An alternative to live-action film composed of pen-and-ink drawings, illustrations on transparent cels, fabricated models, or computer-designed images.

experimental, or avant-garde, film A type of film that challenges widely held notions of what movies can or should be and that often challenges the status quo.

CHAIN CAMERA PICTURES/THE KOBAL COLLECTION

KIRBY DICK ON DOCUMENTARY FILMMAKING

Kirby Dick is a documentary filmmaker who has made some of the genre's most thought-provoking and controversial films. His directing credits include *Private Practices: The Story of a Sex Surrogate* (1986); *Sick: The Life and Death of Bob Flanagan, Supermasochist* (1997); *Twist of Faith* (2004); *This Film Is Not Yet Rated* (2006); and *The Invisible War* (2012). He received an Academy Award nomination for his feature documentary *Twist of Faith* in 2005 and won the Audience Award at the Sundance Film Festival in 2012 for *The Invisible War*.

Q1: **How do you define a documentary film? What distinguishes it from a narrative, fiction film?**

A: Defining a documentary is always interesting . . . if somebody calls something art, it's art. If someone calls something a documentary, then it's a documentary.

Q2: **How do you choose a topic for a documentary?**

A: If I'm going to spend two years of my life on something, I want to make sure that I end up with something worthwhile, but more importantly, it has to be something I will be interested in the whole time. I look for complexity. I look for subject matter that can operate on a number of levels. I look for a story arc. I look for some sort of political content. I've always looked for some kind of psychological content. Dealing with psychological content allows you to reflect on the subject matter in the deepest way. Finally, I look for a way of covering something that hasn't been done before.

Q3: **Many documentaries take shape in the editing room. How do you decide what footage to use and what not to use?**

A: I try to shoot anything and everything I might possibly want to use—because you will be surprised on occasion. I give cameras to my subjects and let them shoot. I look for any kind of home video material. I look for letters. I take stock footage and news footage. Sometimes I get people together who might not otherwise get together. While I'm shooting a scene I can usually figure out how I might use a line or a certain vérité moment. But once I get into the editing room . . . that's the writing stage. I think about what is the arc of the film—the narrative arc, the emotional arc, the intellectual arc, an argument that's moving forward. I have this idea in advance of what will probably work. I want to set up a situation for discovery in the editing room. I know what I'm looking for, but I don't necessarily know what I'll get.

Q4: **Jean-Luc Godard once said that "film is truth at 24fps." And Josef von Sternberg stated that "all film is fiction film." Where do you stand on this debate?**

A: I go with von Sternberg. You know, Godard's statements are always said with tongue in cheek. This idea of objectivity or truth in documentary—and truth, that's a word I cringe at when I hear it—this notion that documentary filmmakers are truth-tellers suggests that they are somehow more truthful than other artists. I don't buy it.

CENGAGE brain.com **LINK TO THE FULL INTERVIEW** http://cengagebrain.com

The filmmaker Jean-Luc Godard famously quipped that "film is truth at 24 frames per second," a remark that suggests that whatever the camera films and the sound recordist records is a true capture of a given moment in time. Josef von Sternberg, another legendary movie director, put forward an alternative: "All film is fiction film," suggesting that the moment a camera is engaged and a tape recorder switched on, reality is inevitably altered and affected. We need not settle on one or the other, but it is important to acknowledge that cinema uniquely captures and re-presents reality just as it sensationalizes it, and that movies render their subjects larger than life—even if what they capture is essentially the stuff of everyday life.

Film scholars routinely distinguish between realistic fiction films and documentaries by focusing on two things: (1) the way the films are presented to audiences (how they are defined by the films' makers) and (2) the consequent expectations audiences bring to the screening of the films. In other words, documentaries identify themselves as works of nonfiction—as factual and trustworthy—and ask us to view them as such. That said, when we watch a documentary, we are presented with the same basic ingredients or elements of form and content—mise-en-scène, camera work, editing, and sound—as we would have with a fiction film. And though documentaries seldom follow narrative formulas (like genre films do, for example), they do tell a story. And that story can be told with varying degrees of authorial intervention and varying amounts of narration and commentary.

This chapter introduces five types of documentary films: actualities, ethnography (including travelogue), propaganda, direct cinema, and the subjective (or first-person) documentary. The goal here is to discuss a range of documentary projects that evince different styles and goals and then, with regard to each of these categories, to establish a foundation for critically reading.

8-1a Actualities and Other Slices of Life

The first public demonstration of Edison's Kinetograph (the photographic apparatus that produced the pictures) and Kinetoscope (the "peep-show" viewing machine that exhibited them) at the Brooklyn Institute of Arts and Sciences in May 1893 featured a documentary

8.1 *Blacksmith Scene* (1893), the first of many slice-of-life documentaries produced for the Edison Manufacturing Company.

short titled *Blacksmith Scene*, which showed three men, all Edison employees, pounding on an anvil for approximately 20 seconds (fig. **8.1**). The "performers" in the film are not blacksmiths. And the anvil is not in a blacksmith's workshop but in the Edison film studio. The question of authenticity is already at issue here in this very early documentary, but the filmmakers' little deception is not the defining issue.

Documentaries are defined in part by their mode or style or form of presentation, not only or not necessarily by their representation of an absolute fact or truth. Audiences are of course free to consider and evaluate a documentary's "truth claim," its formal and philosophical relationship to some objective reality or realism. Here Edison endeavored to preserve for posterity an occupation very much in evidence in the 1890s but likely to have diminished importance in the coming century. It was much easier to shoot the scene at the studio, so that's what he did. As we consider the film's truth claim, it is worth considering whether it matters much that, while the blacksmith tasks depicted are indeed accurately represented, as in a fiction film the setting is constructed and contrived.

Subsequent Edison **slice-of-life documentaries** (e.g., *Edison Kinetoscope Record of a Sneeze* [aka *Fred*

slice-of-life documentaries Short films produced for the Edison Manufacturing Company that captured everyday events.

8.2 Edison's slice-of-life documentary *The Barber Shop* (W. K. L. Dickson and William Heise, 1894).

8.3 Eugene Sandow, the strongman, whose "pose-down" was captured in a documentary short for the Edison Manufacturing Company. *Sandow* (W. K. L. Dickson, 1896).

Ott's Sneeze, Dickson, 1894] and *American Gymnast* [1894])—shared a basic goal to preserve for posterity everyday life. And they shared a simple aesthetic. Akin to the still-photo portrait, filmed figures are posed in front of a flat, black backdrop captured by a stationery camera placed at a right angle to the action. The films are composed of a single shot, or take, and begin as the camera is turned on and end as the film magazine runs out and the camera is shut off. Such a style simulates for the filmgoer the experience of attending a live event: an unobstructed, unmediated, and unedited view of the action.

This same basic premise is in play in *The Barber Shop* (fig. **8.2)**, an early Edison short that showed a barber plying his trade. It too was shot at the Edison studio, but *The Barber Shop* presents a significant aesthetic change: the addition of props (the barber pole at screen left and the sign at the rear of the frame: "The Latest Wonder . . ."). The props set the scene of a real barbershop for filmgoers, further distracting from the reality of its production (at Edison's studio).

Among the many slice-of-life Edison films made for commercial exhibition in the 1890s were shorts featuring some of the era's celebrities, for example, the Austrian muscleman Eugene Sandow, who agreed to appear in the film in exchange for a chance to meet Edison in person (fig. **8.3**), and the markswoman Annie Oakley in the *Wild West Show* films (1894). From these films we get a look at what passed for beauty or excellence, and at what interested people, at a certain moment in history.

On December 28, 1895, Auguste and Louis Lumière became the first filmmakers to screen a program of projected motion pictures to a paying audience. The first film on the bill, *Leaving the Lumière Factory*, employed a stationary camera placed strategically to depict two doorways, one large and one small, that are eventually filled as the workers exit the factory (fig. **8.4**). Unlike the Edison films, these **actualities** (so-called because they realized on film actual scenes from everyday life) were shot outdoors. Such a mobile documentary technique suggests a greater truth claim than Edison's studio-bound films at the time, but this is misleading. To suit certain basic aesthetic goals, when the Lumières arrived at a location, they endeavored to direct or choreograph action with regard to camera position and distance. The

8.4 *Leaving the Lumière Factory (Sortie d'usine)*, an actuality produced by Auguste and Louis Lumière in 1895.

actualities Slice-of-life documentaries produced by the Lumière brothers at the end of the nineteenth century.

▶ **8.5** *The Baby's Meal (Repas de bébé)*, a Lumière brothers' actuality and most likely the first home movie (1895).

8.6 Pictorial realism in Joseph-Louis Mundwiller's 1909 travelogue *Moscow Clad in Snow.*

participants are blocked and move about the frame strategically, and the camera is placed with an eye on symmetry or three-dimensionality (as opposed to providing a right-angle view of the action).

Another film from the show on December 28 was *The Baby's Meal* (fig. **8.5**). It was basically a home movie designed to be a model for future consumer-made home movies. Such a future has of course been realized as many of our own lives have indeed been captured and saved for posterity on Super 8 and video. Home movies are documentaries, capturing the everyday lives of everyday people.

8-1b Ethnography and Travelogue

As movies became more of a commercial enterprise in the early twentieth century, documentary filmmakers needed to attract audiences with something sensational or exotic. Indeed, one of the most popular silent cinema genres was the **ethnographic film** and its subset, the **travelogue**. These anthropological studies and exotic travelogues used the new invention of cinema to give filmgoers who could scarcely dream of travel a look at places and cultures from the far reaches of the globe.

A noteworthy early documentary was Joseph-Louis Mundwiller's 1909 travelogue for Pathé Frères, *Moscow Clad in Snow* (fig. **8.6**). Less concerned with the history of the city of Moscow or the lives of any individual living there than he is in the look of the city, Mundwiller provides an elegant tour—the sort of thing a very lucky tourist might get on a picturesque winter's day. The film is composed of a series of tableaus, carefully framed images that offer no pretense to spontaneity. Instead Mundwiller

offers beautifully framed and filmed images that present Moscow "clad in snow" as a wonderful place.

The best-known ethnographic filmmaker during the late silent and early sound era was Robert Flaherty, an American-born explorer who fully embraced the Rousseauian ideal that human beings are happiest when living simply and in harmony with nature. Flaherty's two best known films, *Nanook of the North* (fig. **8.7** and **8.8**), set in the frozen terrain of Canada's Hudson Bay region, and *Man of Aran* (fig. **8.9**), set on the rugged Aran Islands off the coast of Ireland, focus on two unlikely destinations for even the most intrepid traveler. Flaherty was drawn to these exotic places by his interest in filming people unaffected and uncorrupted by modernity, clinging still to the traditions and tasks that had been practiced there for centuries.

Flaherty was a true documentarist; he lived with his subjects for a year or more in order to observe and understand their everyday lives. That said, by contemporary standards, his ethnographic work is more romantic than realistic. For example, in one of the most memorable sequences in *Nanook of the North*, Flaherty films a walrus hunt (fig. **8.7**). The scene supports the film's central paradox of man's harmony in and struggle with nature, but the mise-en-scène, camera work, and composition reveal that the scene is carefully staged. The camera is placed in the perfect spot. Nanook goes to his mark, waits, and then in frame performs the task at hand.

ethnographic film A film that documents the way of life in a foreign land.

travelogue A film that presents a tour of a foreign land.

8.7 Nanook the Eskimo in *Nanook of the North* (Robert Flaherty, 1922).

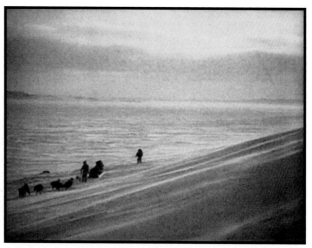

8.8 Nanook and his family captured in an extreme long shot, rendered small against the vast white landscape of the arctic.

Later in the film, Nanook hunts a seal swimming beneath the ice. Again, Flaherty films the scene with a stationary camera strategically placed to give the viewer an ideal look at the action. He places us close enough to really see how this premodern form of hunting is performed. The scene runs for nearly 5 minutes, an unusually long duration that highlights the difficulty of the task. Flaherty is interested both in documenting a process or task from start to finish and in lingering on a beautiful, romantic, even sentimental image. This is evident as well in the many extreme long shots of the arctic landscape, the very sort of long take that would later come to characterize and romanticize the movie western. Flaherty uses these shots to make a point about scale: as in figure **8.8**, we see Nanook, his family, and his sled dogs rendered small against a vast landscape.

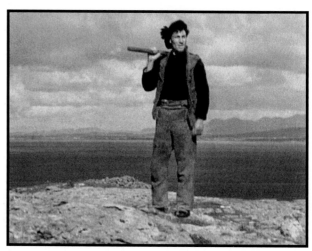

8.9 A full-figure shot casting the hero, a premodern hunter-gatherer against the treacherous yet beautiful elements in Robert Flaherty's *Man of Aran* (1934). Note the similarity between this shot and the shot of Nanook in figure **8.7**.

8-1c The Propaganda Film

During the worldwide economic Depression of the 1930s, the lead-up to World War II, and then the war years themselves, many nonfiction filmmakers fully embraced the persuasive power of the big screen and produced **propaganda films** to propose and promote a political agenda. These films were often financed and supervised by nationalized film industries or film agencies within the government. We tend to view propaganda as a pejorative term today, as work designed to trick or mislead. But such a narrow view fails to account for the primary goal of propaganda films: to persuade.

propaganda film A film that promotes a political agenda.

In the United States, for example, filmmakers like Pare Lorentz (*The Plow That Broke the Plains*, 1936), financed by the federal government, offered a political commentary on the struggles of the everyday American during the Depression. Others, like Willard van Dyke and Ralph Steiner (*The City*, 1939) outlined possible avenues towards fixing some of America's economic and social problems. These films do not endeavor to trick or mislead, but they do carry an overt political message, one consistent with the New Deal and the politics of the Roosevelt administration, the very political establishment that financed their production.

After the attack on Pearl Harbor, the United States Film Unit, established in 1938 to promote the agenda of President Roosevelt's New Deal, worked with the Office of War Information to introduce the *Why We Fight* series. These films were produced to combat lingering isolationism (doubts about our entrance into the war) and to educate American servicemen and the American public about the causes and potential consequences of the global conflict. These wartime documentaries were produced and directed by a who's who of Hollywood narrative moviemakers—Frank Capra, John Huston, and William Wyler—who established a variety of documentary techniques widely used today: maps, charts, and other informative graphics (fig. **8.10**), voice-of-God narration (in which an authoritative off-screen voice narrates the images on screen), talking-head segments (in which an expert uses direct address to offer commentary), and the sampling or compiling of film clips from other documentary sources recontextualized to fit the agenda put forth in the film (e.g., the use of clips from Nazi documentaries, first produced in Germany to celebrate the Nazi regime, then re-cut and re-contextualized to reveal, in the U.S. documentaries, the inherent threat posed by Hitler's Germany).

In Great Britain as well federally funded social-realist films focusing on everyday people struggling with everyday challenges during the Depression gave way to wartime propaganda films. In the 1930s, the celebrated documentary producer John Grierson headed the government funded GPO Film Unit and supervised the production of films that, much like the United States Film Unit, focused on social issues during the years leading up to the war, for example, Arthur Elton and Edgar Anstey's *Housing Problems* (1935) and Alberto Cavalcanti's *Coal Face* (1935). After England was drawn into the war, the GPO Unit was renamed the Crown Film Unit. It sponsored wartime documentaries, some of which focused on military battles (*Desert Victory*, David MacDonald, 1943) while others like *Listen to Britain* (fig. **8.11**) focused on the little things of everyday life that the war had disrupted.

We tend to view the propaganda that supports the victorious side differently from that of the vanquished, and we tend to view films that traffic in political persuasion that we agree with differently from films that may be structured similarly but promote a political argument we fundamentally reject. The Nazi-era documentaries made by Leni Riefenstahl—*Triumph of the Will* (1935) and *Olympia* (1938)—were financed by the Ministry of Propaganda, a federal agency supervised by the ruling party. With regard to mode of financing and their support of the nation's ruling party, Reifenstahl's films are

8.10 A voice-of-God narrator describes the Nazi invasion of Czechoslovakia as a graphic map of Europe shows the extent of German imperialism in *The Nazi's Strike* (1943), a *Why We Fight* film.

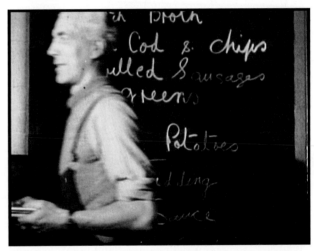

8.11 Crown Film Unit documentaries often focused on quaint English traditions that might be lost if the Nazis won the war—for example, the freedom to congregate in and enjoy a meal at a proper British pub. *Listen to Britain* (Humphrey Jennings, 1942).

similar to the *Why We Fight* series and the Crown Unit films. The otherwise significant differences among these films rest not in production context, but in content.

In *Triumph of the Will*, Riefenstahl filmed a 1934 Nazi Party rally, presenting flattering images of its leader (fig. **8.12**) and his followers, veritable poster children of the so-called master race (fig. **8.13**). Riefenstahl's primary goal was to generate excitement about a Nazi future, and she did so with the financial support of the German government. Of course the cause she served perpetuated a holocaust, the annihilation of a civilian population unprecedented in the history of the modern world.

After the war, Riefenstahl claimed that she was just a filmmaker for hire and that she was primarily interested in the aesthetics, not politics, of the new Nazi regime. Neither argument seems to hold up against the historical evidence of her complicity, and her motives may not matter much when we factor the considerable success of her imagery to rouse the populace to such hideous ends.

Reifenstahl's visual style was unusual for a documentary filmmaker; unlike her American and British counterparts who worked with fairly tight budgets, she was funded lavishly and thus was able to shoot with multiple cameras. Her films took shape in the editing room, where she had the luxury of choosing shots from a number of camera angles and distances to find one that best suited her argument. In *Triumph of the Will*, she used low-angle close-ups to glorify individuals (Hitler, of course, and other ranking Nazis) and high-angle long shots to dramatize the unity and power of the crowd (fig. **8.14**).

Riefenstahl's use of sound was more conventional. She used diegetic sound sparingly (mostly for the Nazi speeches at the political rally). For the most part she resorted to nondiegetic and nonsynchronous sound. Most prominent was a bombastic, martial, orchestral score that she used much as such music might be used to underscore a dramatic feature. The music lent gravitas to the visual display of Nazi iconography: the banners, the military procession, the architecture.

8-1d Direct Cinema

The **direct cinema** movement that took shape in the United States in the early 1960s was built on technological advances in lightweight cameras and portable sound equipment and the sudden significance in American popular culture of televised news and nonfiction television. Footage picked up by mobile film crews transported viewers to the news. Direct cinema filmmakers used the mobile equipment and exploited this new TV reporting sensibility to move away from the dated romantic realism of Flaherty and his pictorial tableaus and the dull maps, charts, talking heads, and voice-of-God narration of the war-era films. The documentary filmmakers in the direct cinema movement—Robert Drew, Richard Leacock, D. A. Pennebaker, Albert and David Maysles, Charlotte Zwerin, and Frederick Wiseman—placed themselves and the viewer in the space of the action. The images were captured as they occurred by a seemingly

direct cinema A documentary movement in the United States in which the camera acts as an objective, disinterested observer, capturing events as they unfold.

8.12 The face of the Nazi leader rendered in low-angle to imply authority and gravitas in Leni Riefenstahl's *Triumph of the Will* (1935).

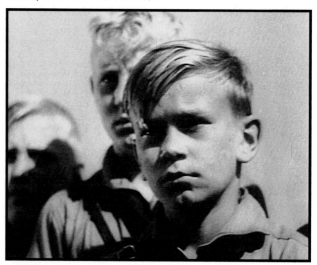

8.13 The faces of Germany's future: portraiture as persuasion in *Triumph of the Will*.

8.14 The adoring crowd in *Triumph of the Will*.

objective witness to the events on screen. And all of the sound was diegetic and recorded "wild," or live.

Direct cinema was characteristically intimate, and the often out-of-focus, variable-focused, or rack-focused aesthetic implied real life captured as it unfolded. For example, David and Albert Maysles and Charlotte Zwerin in their 1968 film *Salesman* filmed a meeting held for traveling Bible salesmen. A simple pan of the audience brings into focus two of the men in whose lives we are most interested (figs. **8.15–8.17**). The pan is fairly quick, and the focus is meant to appear not only variable (highlighting key characters, obscuring others) but also rushed; these are events the camera operator must capture on the fly, with necessary adjustments in focus as we go from character to character, and from one part of the room (and distance from the camera) to another.

The direct cinema filmmakers used techniques that implied a purity and objectivity to present an unmediated event. Long takes let reality unfold before the camera; the live sound is often muddied by crowd noise or footsteps or a car driving by. Absent are techniques tied to commentary (e.g., title cards, voice-of-God narration, interviews, or talking heads).

Despite such a commitment to objectivity, in direct cinema filmmakers occasionally develop a relationship with their subject(s) and even enter into conversation with them. In *Grey Gardens*, for example, Little Edie dresses up and flirts with David Maysles; she performs musical numbers in costume especially for him. At one point in the film we see David Maysles behind the camera in a reflection in a mirror (fig. **8.18**). Maysles affirms his presence in the lives of his subject. This is not a mistake; after all, it could easily have been edited

8.15–8.17 The camera pans the audience at a Bible sales conference, catching its subjects unawares. *Salesman* (David and Albert Maysles and Charlotte Zwerin, 1968).

8.18 David Maysles behind the camera in *Grey Gardens* (David and Albert Maysles, Ellen Hovde, and Muffie Meyer, 1976).

out of the film. Instead it makes a statement about the transparency of his filmmaking process.

Perhaps the most extreme or austere version of direct cinema is evident in the films of Frederick Wiseman, whose work seems steadfastly objective, with no suggestion of performance or commentary. Wiseman's focus is on American institutions: *High School* (1967), *Hospital* (1970), *Basic Training* (1971), *Juvenile Court* (1973), and *Welfare* (1975); industries and occupations: *Meat* (1976), *Model* (1980), and *Ballet* (1995); and interesting places: *Canal Zone* (1977), *Racetrack* (1985), and *Zoo* (1993). His methodology is fairly simple: he stays with his subjects for weeks, shooting reel after reel of film. The goal is unmediated reality recorded in moments when his subjects finally forget they are on camera (which is always there, always running). The finished film, then, is very much the product of careful editing, assembled from the thousands of feet of exposed film into a document of a certain place and time.

For his 1967 feature *High School*, Wiseman (who records the sound) and Richard Leiterman (the camera operator) went to Northeast High School in Philadelphia, Pennsylvania, and used a "fly-on-the-wall" approach to present a typical day at an American school. The film begins with the drive to school as we listen to the car radio and the Otis Redding song "Sittin' on the Dock of the Bay"—notably a song about boredom and "wastin' time"—and climaxes with a faculty meeting after the final bell. The "fly-on-the-wall camera" epitomizes the conventions of direct cinema: variable focus (suggesting images captured just as they happen) and awkward framing (images rendered from less-than-ideal camera positions, again suggesting the camera operator's attempt to "keep up").

The classroom scenes that compose the majority of the film present a stultifying world of endless, mindless repetition. We visit a foreign language class in which students repeat phrases they don't understand. Later the camera surreptitiously watches from the back of the gym as some girls dance to a routine following the basic commands elaborated in the pop song "Simple Simon Says" by the 1910 Fruitgum Company (fig. **8.19**). A teacher spends his lunch hour patrolling the hallways, and when he spies a student on the pay telephone, he tells him to hang up; he's not interested in why the student is on the phone or to whom he is speaking. The student simply shouldn't be in the hallway because it's against the rules (fig. **8.20**).

Rules in high school exist to be mindlessly followed. And conformity is a goal, one openly celebrated at the end of the day and at the end of the film, as we see

8.19 Simple Simon Says . . . The "fly-on-the-wall" camera is a witness to the incessant model of repetition characteristic of a system that rewards obedience at all costs. *High School* (Frederick Wiseman, 1968).

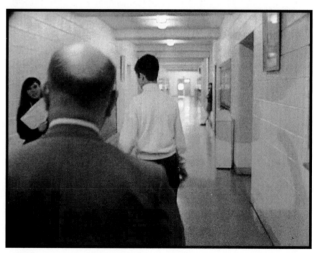

8.20 A teacher in search of students without hall passes. This all-too-familiar scene is just one of many in the film that reveals just how much the teachers and administrators have invested in pointless rules.

a teacher reading from a letter written by a soldier in Vietnam, a former Northeast High School student about to embark on a suicide mission. The letter concludes: "I am only a body doing a job." The teacher looks up from the letter and, captured in a low-angle close-up, says proudly: "Now when you get a letter like this, to me it means that we are very successful at Northeast High School" (fig. **8.21**). Absent narration and apparent authorial commentary, the implication is nonetheless clear: the teacher fails to appreciate what Wiseman and the filmgoer by this point understand: that it's fundamentally horrifying that "bodies doing a job" are what the school endeavors to make of their students.

8.21 Audiences in 1968 (when *High School* was released) were no doubt split in their reaction when this teacher read a letter from a recent graduate stationed in Vietnam. The young man writes that he's "just a body doing a job." The teacher proclaims this proof "that we are very successful here at Northeast High School."

8-1e Subjective, or First-Person, Documentary

Though many direct cinema documentaries had an underlying political message and the filmmakers themselves often ended up making a political argument (e.g., Wiseman's chilling conclusion to *High School* affirming the teachers' success in dehumanizing students), a seeming objectivity characterized the movement. This claim to objectivity was challenged first by magazine writers. These so-called New Journalists—Hunter S. Thompson and Tom Wolfe—questioned the notion that real events can ever be captured with third-person objectivity and opted instead for a more straightforward first-person subjectivity; they placed themselves in the story and made clear from the start their points of view.

Many contemporary documentary filmmakers have adopted the New Journalism style. These films are built upon a fundamental subjectivity; the authors appear in the films, they freely comment upon what they find (and what we see and hear), and they often stage scenes, especially confrontations, that put people on the spot.

Two of the best-known filmmakers to use this overtly subjective technique are Nick Broomfield, who with Joan Churchill directed *Aileen: Life and Death of a Serial Killer* (2003) and Michael Moore (*Roger and Me*, 1998; *Bowling for Columbine*, fig. **8.22**; and *Sicko*, 2007). As on-screen characters and commentators, these filmmakers openly interact and comment upon the scenes as we witness them together. The effect is seductive because the directors speak directly to us about images we see at the same time as they do.

In *Aileen: Life and Death of a Serial Killer*, the documentary filmmakers Nick Broomfield and Joan Churchill question the legitimacy of sentencing to death the serial killer Aileen Wuornos, shown in figures **8.23** and **8.24** in her last interview with Broomfield. Throughout the scene she addresses "Nick" directly and finally tears off her microphone in frustration and confusion. Because of Churchill's handheld, first-person camera work and Broomfield's on-screen "performance," we tend to read the film in concert with their point of view. The scene leaves little doubt that Wuornos is insane. So how, the filmmakers ask us here, can a civilized society justify her execution?

Michael Moore never pretends to be "fair and balanced." And in refusing to hide behind an impersonal impartiality, he, like Broomfield and Churchill, is on a very basic level telling the truth about his politics and his goals for his films. In *Roger and Me* (figs. **8.25** and **8.26**), for example, Moore crashes a General Motors stockholder meeting. We hear Moore first in voice-over, much like a fictional character in a fiction film, setting the scene: "It was time to confront Roger Smith face to face." Then we see GM chairman Roger Smith, the

8.22 Agitprop: Michael Moore, documentary filmmaker and political activist, in *Bowling for Columbine* (2002).

8.23 The documentary filmmakers Nick Broomfield and Joan Churchill question the legitimacy of sentencing to death the serial killer Aileen Wuornos, shown here in her last interview with Broomfield. *Aileen: Life and Death of a Serial Killer* (2003).

8.24 Wuornos asks a guard to take off her microphone after she takes out her frustration on Broomfield, whose sympathetic narration has throughout challenged our assumptions about Wuornos's culpability. The reference to the microphone allows Broomfield and Churchill to show the audience the sound technology they used to mediate this live event.

target of Moore's ire, from a distance roughly matching the distance between Smith and Moore in the hall. We then cut to a shot of Moore, poorly lit in the crowd (after all this is a documentary, not a professionally lit fictional scene) preparing to pose a question, only to have Smith move to adjourn the meeting. The scene reveals Smith's reluctance to speak to Moore, which, since we move through the film "with" Moore, frustrates us as much as it frustrates the filmmaker.

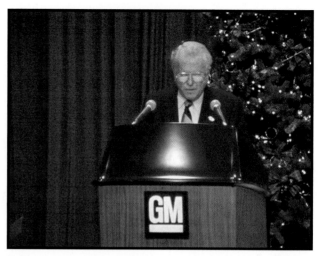

8.25 Roger Smith, chairman of General Motors, delivers his Christmas message. *Roger and Me* (Michael Moore, 1989).

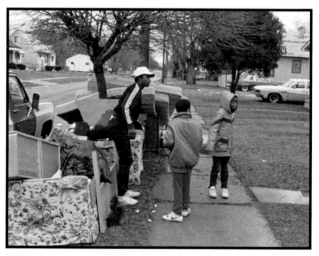

8.26 Intercut with Smith's speech is a harrowing scene of a former GM employee's family being thrown out of their house.

We later see Smith's annual Christmas message, which ends as the chairman reads from Charles Dickens's *A Christmas Carol*. "I have always thought of Christmas as a good time . . ." (fig. **8.25**). We then cut to the family of a recently laid-off GM worker getting tossed out of their home (fig. **8.26**). We hear a mix of diegetic sound (the mother shouting at her kids to get their coats on—they're being tossed out on a cold Michigan winter's day) mixed evenly via a sound bridge with extra-diegetic sound (Smith's speech, reading still from Dickens, touting: "a kind, forgiving, charitable, pleasant time").

Taking this first-person documentary format even further, Morgan Spurlock, in *Super-Size Me* (2004), investigates the health risks of eating too much fast

8.27 The filmmaker Kirby Dick (right) unsuccessfully negotiates an alternative to an NC-17 rating for his documentary about the motion picture rating system, *This Film Is Not Yet Rated* (2006). On the other end of the phone line is Classification and Rating Administration chairwoman Joan Graves, depicted in an animated facsimile.

NC-17 rating. When he tries to appeal the decision, he is stonewalled by Joan Graves (the chairwoman of the Classification and Rating Administration, or CARA), in a conversation that one really needs to see and hear to believe. Dick films and records the conversation and at that moment becomes the subject of his own documentary (fig. **8.27**). Here Dick shares with Broomfield, Moore, and Spurlock a basic truth claim, a transparency with regard to his point of view.

By affirming a subjective point of view, by making no claim to objectivity, and by going so far as to imply that objectivity is impossible, these filmmakers ably frame their work as a real or live event that has cried out for commentary, an event about which the filmmakers simply cannot keep their mouths shut. As we ponder the truth claims made by these subjective documentaries, we are brought back to the two defining characteristics of documentary moviemaking: (1) the way the film is presented to audiences (how it is identified or defined as a documentary by its makers) and (2) the consequent expectations audiences bring to the screening of the film (that the film they are about to see is a documentary). Even though these films feature plenty of commentary and seem to develop the character of the filmmaker as completely and complexly as a fiction film might, the criteria are still met: the filmmakers present their work as documentaries, and audiences have come to expect and appreciate this approach as a more modern and more personal version of the venerable genre.

food by eating too much fast food. Like Moore, Spurlock is both a documentary filmmaker and a comic provocateur. The film may well be all about Spurlock first and foremost, but the stunt proves an effective mode of telling the story he wants to tell: if you eat too much fast food, you'll get sick.

Broomfield, Moore, and Spurlock seem to relish their face time on camera. Other contemporary documentary filmmakers enter the space of their films only when the story they tell finally includes them. For example, in *This Film Is Not Yet Rated* (2006), the director Kirby Dick mostly stays at the periphery. But as he readies for distribution his exposé of the MPAA movie rating system, the film gets saddled with an

8-2 ANIMATION

Simulations of movement using pen-and-ink drawings—a form of moving picture animation and a direct antecedent to what we call (for a reason) "moving pictures"—dates to 1828, just four years after Paul Roget first described the phenomenon of "persistence of vision" (see chapter 1). These first experiments in animation used a crude motion toy called a Thaumatrope, which is a simple device composed of a disk attached to a pole with a string (so the disk could be twirled). Each side of the disk contained an illustration: for example, a bird on one side, a cage on the other (fig. **8.28**). Twirling the disk

merged the two illustrations so the bird appeared to be in the cage. When these still images were transferred to glass plates, and the pole and string abandoned in favor of a larger, sturdier motion toy, audiences got their first glance at multiple, continuous, projected moving images.

We have come a long way from these crude demonstrations of the persistence of vision. Cine-animation began with hand-crafted, pen-and-ink drawings, then moved on to illustrations on transparent celluloid strips produced by studio teams and then photographed by a camera designed to produce a single image from multiple

8.28 An illustration of a Thaumatrope, an early motion toy. One side of the card is a cage; the other, a bird. If you make the images move fast enough, the bird appears to be in the cage.

8.29 Pen-and-ink animation by J. Stuart Blackton, circa 1905.

layers, to stop-motion figure manipulation, and most recently to computer modeling and imaging captured in 3-D. The history of animation is at once a matter of technological development and creative enterprise; it is tied as much to evolving techniques and industrial innovation as it is to creative impulse and imagination. Then and now our appreciation of animated movies has depended upon the gee-whiz factor—a marveling at the technology and techniques that made the work possible. So, whether we are talking about the late nineteenth- and early twentieth-century "lightning drawings" made by J. Stuart Blackton (showcased first via magic lantern and then on film, fig. **8.29**) or a modern computer-animated feature like *Toy Story* (fig. **8.30**), animation is meant at once to entertain and astonish.

8.30 Modern computer animation: *Toy Story* (John Lasseter, 1995).

The following section is a selective survey of cine-animation from the comic-strip style of Winsor McCay and Otto Messmer, through the landmark early work at the Walt Disney and Warner Bros. studios, to modern stop-motion and computer-animated features. The goal here is to begin to understand and appreciate animation as a significant mode of cinematic art.

8-2a Early Animation

In the 1910s Winsor McCay touted himself as the world's greatest cartoonist. Though such a title is subject to debate, McCay, a newspaper cartoonist for the *New York Herald*, was at the time the most world's best-known

film animator, ably adapting the style of multiframe print comic strips to multiframe filmed animation. His films featured pen-and-ink line-drawn caricatures, thought, and dialogue bubbles, and an emphasis on a single gag or stunt as opposed to a developed storyline.

McCay adapted his comic strip character, Little Nemo, in *Winsor McCay, the Famous Cartoonist of the N.Y. Herald and His Moving Comics* (AKA *Little Nemo*, fig. **8.31**). The short begins with an affirmation of process and its complexity and difficulty; before we get to the cartoon, we watch live-action footage of McCay drawing his characters, as a title card tells us that 4,000 drawings went into the production of the 2-minute animated film. From the start, the appeal of animation regarded the wonder of its own creation. Unlike live-action, which often endeavors to conceal the process of its production, with animation we are meant to appreciate the creators as well as the creation. Indeed, the first drawing in

8.31 A simple pen-and-ink line-drawing and a simple request: "Watch me move." *Winsor McCay, the Famous Cartoonist of the N.Y. Herald and His Moving Comics* (AKA *Little Nemo,*1911).

8.32 The Coney Island (fun house) mirror gag.

8.33 Nemo and his princess exit in the jaws of a dragon drawn to look like a fixture on a carousel, though this dragon has teeth and it moves on its own.

McCay's first film asks the audience to appreciate the simplest of on-screen actions: "Watch me move."

McCay's characters move about against a flat, white background, a reminder that the image we see is a photograph of a two-dimensional drawing on paper. McCay focuses on simple visual gags, many of which became staples of future animation: the Coney Island mirror gag in which the characters are stretched lengthwise and widthwise in front of the fun house mirror (fig. **8.32**) and trippy mismatches of human characters and mythical creatures (the dragon that carries off Nemo and his princess at the end of the film, fig. **8.33**).

By the early 1920s, the Famous Players Lasky Corporation and Paramount Studios began distributing a new animated series featuring Felix the Cat, animated and produced by Otto Messmer and Pat Sullivan (figs. **8.34–8.37**). The Felix the Cat cartoons look much like McCay's comic strip adaptations; we see the same decidedly two-dimensional, pen-and-ink drawings. The goal for Messmer and Sullivan was not a pictorial realism: the animals are **anthropomorphized** (Felix walks upright), the humans are mere caricatures, and objects and buildings often are labeled (the jam jar in fig. **8.36**; the gas works in fig. **8.37**) because they are mere sketches of the real thing.

8-2b The Wonderful World of Disney

Felix the Cat became an iconic film character, as familiar to American film audiences as the silent movie stars Charlie Chaplin and Mary Pickford. After almost ten years in the limelight, Felix was supplanted by another iconic cartoon figure, Mickey Mouse, created by the animators working for the producer Walt Disney. The film that made Mickey a star and Disney a household name was the innovative black-and-white sound cartoon *Steamboat Willie* (1928). In this early incarnation, Mickey is a lovable scamp, a crudely drawn character with funny short pants and oversized clown-like shoes. Though the drawn animation is still basically pen-and-ink, the Disney animators—the team of tracers and inkers and technicians that made the production of these cartoons possible—made the background more a part of the illustration and thus made the cartoons less like newspaper comic strips.

The addition of sound was the most telling innovation in *Steamboat Willie* and, to Disney's credit, it proved seamless from the start. Though it was not exactly synchronized—after all, cartoon characters

anthropomorphize To give human qualities to a nonhuman creature or object.

8.34 Comic strip–styled dialogue boxes in Otto Messmer and Pat Sullivan's *Feline Follies* (1919).

8.36 Felix the anthropomorphized cat. *Feline Follies* (Otto Messmer and Pat Sullivan, 1919). Note the pen-and-ink style and the label on the jam jar.

8.35 A deft mix of faux film technique (the iris shot suggested by the drawn image) and comic strip style (the Z-Z-Z suggesting sleep).

8.37 Felix switches on the gas and takes his life. Early cartoons were not made for children.

cannot actually whistle (fig. **8.38**) or play pots and pans as if they were musical instruments (fig. **8.40**)—it nonetheless functioned much as soundtrack music functioned in live-action films. The music underscored and commented upon actions on screen; the sound effects accompanied and at times exaggerated real-life sounds. Sometimes music and effects are combined; taking the transformation of objects so prominent in McCay's *Little Nemo* film (the dragon that becomes a coach) and in Messmer and Sullivan's *Feline Follies* (ink spots on the floor become holes out of which mice emerge) one step further, we see Mickey transform a farm animal into a wind-up record player (fig. **8.39**) and hear first the sound of the animal, then the sound of music.

Mickey proved to be a versatile character—a gaucho, a fireman, a pioneer, a football star—easily plugged into a scenario and setting. There were some

cosmetic changes over the years: Mickey drawings are more rat-like in *The Gallopin' Gaucho* (fig. **8.41**); he gets his white gloves and more rounded features in *The Fire Fighters* (fig. **8.42**). But for the most part Mickey Mouse was a consistent comic persona who persisted through a variety of settings and scenarios for decades.

A look at the mise-en-scène, in this case the sets and scenes drawn by the Disney artists, reveals increasing attention to expressive if not fully realistic backgrounds: note the city in the distance in *The Fire Fighters* (fig. **8.42**). We are by this point in the history of animation fully free of the comic-strip style and moving towards narrative, or story, cartoons. The 1934 short *Gulliver Mickey*, for example, is a loose adaptation of Jonathan Swift's eighteenth-century novel *Gulliver's Travels* (fig. **8.43**). The film banks on audience familiarity with the famous story and uses that narrative to frame a series of gags exploiting the

8.38–8.40 Walt Disney's breakthrough film, the sound cartoon *Steamboat Willie* (1928), starring Mickey and Minnie Mouse.

8.41 and 8.42 The ever versatile cartoon mouse: *The Gallopin' Gaucho* (1928) and *The Fire Fighters* (1930).

8.43 From comic strips to classics: Disney's move into narrative: *Gulliver Mickey* (1934).

comical notion of a giant Mickey Mouse, several times the size of the Lilliputians who torment him. Another film of the same year, *Two-Gun Mickey*, is a gentle parody of the movie western and melodrama and as such frames the gags in familiar narratives. Mickey's nemesis in the film is Peg-leg Pete, who kidnaps Minnie. Pete is twice Mickey's size, and his goal seems similar to that of the outsized

8.44 Snow White and assorted friends from the forest whistle while they work. William Garity's new multiplane camera facilitated the painterly style of and depth-of-field image in Disney's first narrative feature-length cartoon. *Snow White* (1937).

8.45 In *Pinocchio* (1940) Disney animators were able to simulate cinematic mise-en-scène. Note the apparent lighting of the shot (the key, or spot, light on Pinocchio and the resulting shadow). Note also the apparent depth to the image, a boon to animators using the multiplane camera.

villains in movie melodramas: he has designs on Minnie that are unsavory. Things are solved much as they would be in a live-action western.

In 1937 drawn animation was revolutionized by William Garity's multiplane camera, a vertical photography device that allowed animators to layer glass plates and later celluloid strips (**cels**) to control separately as many as seven fields of vision at once for each shot. The multiplane camera improved upon the groundbreaking work on transparent cels and overlapping images designed and patented by John Randolph Bray and Earl Hurd dating as far back as 1915 and it made possible the more complex pictorial design and painterly look of Disney's first full-length narrative feature *Snow White* (fig. **8.44**). It enabled animators to control separately foreground and background and thus introduce depth to the cartoon image and simulate camera work, especially moving camera, as figures in the foreground appear to move through changing backgrounds.

The multiplane camera allowed for the increased division of labor necessary for the production of such long and complex animated films as *Snow White* and *Pinocchio* (fig. **8.45**). Much like live-action movies, the production of animated features involved a lot of people with particular expertise—animators drawing, tracing, coloring, and photographing the layered cels—working simultaneously or sequentially to create

the finished product. It also streamlined production because only the aspects of the frame in motion had to be changed from frame to frame. Each layer need not be reproduced for every shot. This allowed for the more complex, deeply composed images to be more quickly produced and reproduced. Such a Fordist model (see chapter 7) was essential to the drawn animated feature.

Much like McCay, Messmer, and Sullivan, part of the attraction to Disney's animated films was the process of creation itself, the genius behind (and the Herculean task involved in) each movie's creation, development, and execution. Interestingly, this focus on the mode of production did not detract from the films' fundamental appeal to, as the circus ringmaster used to put it, "children of all ages." Disney (the Disney Studio) did the work, so we could sit back and have fun, a consistent formula for success for the enduring Disney entertainment empire.

8-2c Warner Bros.

An alternative to the Disney house style took shape at Warner Bros. in the 1930s, where animators stayed true to the gag-based, animated, short-subject formula, producing mostly character-based slapstick comedies featuring the likes of Porky Pig, Bugs Bunny, Elmer Fudd, Daffy Duck, Wiley Coyote, and the Roadrunner. The animators—Friz Freleng (who began his career with Disney), Robert (Bob) Clampett, Tex Avery, and Charles (Chuck) Jones—created and exploited the anarchic, anything-goes spirit of the series' protagonists. The WB house style involved free play with

cel A painting or drawing made on celluloid for use in an animated film.

8.46 *Duck Dodgers in the 24 ¹/2th Century* (Chuck Jones, 1953).

8.47 The cartoons allowed Warner Bros. to elicit a laugh at their own expense, or at least at the expense of the movie business. As we hear Daffy Duck shouting "You're killing me!" to a movie executive, we see a cartoon drawing of the familiar Warner Bros. lot where, we gather, executives occasionally failed to appreciate the peculiar genius of its other, live, contract actors. *The Scarlet Pumpernickel* (Chuck Jones, 1950).

exaggeration—developing gags based on size and scale—and banked on the comedy antics of anthropomorphized, wisecracking animals. In the 6- to 8-minute short-subject format, the animators made good use of vivid color that showed off the Technicolor process, radio-style sound effects, the expert voice-work of Mel Blanc, punning wordplay on the dialogue track, and, to highlight the on-screen action, sped-up variations on classical music themes (supervised by Carl Stallings).

The key to WB's Merrie Melodies and Looney Tunes cartoons were the "stars," who were so well developed and so familiar to audiences that simply plugging them into a scenario was enough to get the audience laughing. Take for example the irascible, ever-combative Daffy Duck, a comic persona with unbridled energy, a profound mischievous streak, and a characteristic lisp. Daffy was first introduced in 1937, and by the early 1940s he could be usefully moved from story to story, genre to genre, movie parody to movie parody. In *Duck Dodgers in the 24 ¹/2th Century*, for example, Daffy stands in for the movie serial sci-fi hero Buck Rogers and is moved freely through a lampoon of futuristic (and mostly bad sci-fi movie) special effects (fig. **8.46**).

The Scarlet Pumpernickel, a 1950 Chuck Jones parody of the popular film *The Scarlet Pimpernel*, casts Daffy first as a Warner Bros. character actor miffed at typecasting (as a daffy comic, of course) (fig. **8.47** and **8.48**). The cartoon opens as Daffy hawks a 2,000-page script to a Warner Bros. executive. As he begins reading, the script comes to life with Daffy in a dual role: English aristocrat by day, swashbuckler by night. He is joined by a who's who from the Warner Bros. (cartoon) stable of stars: Porky Pig, Sylvester, and Elmer Fudd. The cartoon ably spoofs swashbuckler films, actors who take themselves

8.48 Daffy may be playing the swashbuckling Scarlet Pumpernickel, but he's still Daffy Duck and always game for a pratfall or two. *The Scarlet Pumpernickel* pokes fun at a studio system that did indeed typecast actors, though in the end even Daffy realizes he's best suited for the sorts of films the studio assigns him.

too seriously, and the random big finish of so many commercial movies of the era. When Daffy discovers that his 2,000-page script has no ending, he ad-libs a flood, a volcanic eruption, and runaway inflation in which a single kreplach, a Jewish dumpling, sells for $1,000.

The filmmaking process is again a source of laughs in the wildly creative *Duck Amuck*, in which Daffy is

▶ **8.49** Here the mysterious animator erases Daffy's parachute and draws in its place an anvil. In a clever way, *Duck Amuck* (Chuck Jones, 1953) is very much about its own fabrication.

pushed to the limit of his already limited patience by an unknown animator, who keeps recasting (drawing new and erasing old) scenarios into which Daffy must adapt (fig. **8.49**). The backdrops still betray a hand-drawn and painted aesthetic, but Jones creates a fluid and colorful visual style to match the speedy, anarchic flow of images and sounds. *Duck Amuck* simulates cinematic technique, as the entire film appears to be a single shot; we see Daffy in the foreground moving into and out of a series of changing backdrops. The distinction between foreground (Daffy) and background (drawn by the animator character) also subtly alludes to the multiplane camera used to produce the cartoons of that era.

The cartoon has the prototypical kick-in-the-pants ending characteristic of the silent film comedy. Beleaguered at the end of the cartoon short, Daffy finally demands to know "who is responsible for this?" at which point Bugs Bunny reveals himself, mugging for the camera and pondering rhetorically: "Ain't I a stinker?"

8-2d Contemporary Animation

Most contemporary animation is computer generated and can be traced to image-processing technologies developed initially for the medical and mining industries. Early computer animation was first screened at trade shows to showcase new software. Commercial exhibition was a lucky afterthought.

To appreciate the work of these early computer animators, a little perspective: the average smartphone in 2011 is 100 times as fast as the computers animators worked with in the mid-1980s. Part of the gee-whiz factor, then—and this recalls the 1911 audience's response to McCay's early hand-drawn cartoons—involved a marveling at the dedication and effort involved in the work's creation.

At Pixar, the company that pioneered and has since become the forerunner in computer animation, the project begins with a gag and later a story. Then a rough series of images are worked out on paper. Rough sound (voice-work, effects, music) is then added. Modelers then get to work on the characters while the layout department works out the essential task of making the characters move. At the same time, the art department goes to work on the backgrounds, much as the art department in a live-action film designs and builds sets. The sound work then begins again to better fit the more polished images and scenes. When this later stage of sound and image is complete, "lighting" effects are added to better simulate live-action cinema. Then the rendering process begins. There are some single frames—and remember that a projected film runs at 24 frames per second—that are so packed with "information" they take a full 40 hours to render. Finally, once the image track is fully formed, the sound mix is polished and completed. The process is arduous and painfully slow; the average production time allotted for a Pixar feature is about four years. That part of its appeal is a marveling at the process of its production is certainly well placed.

Early Pixar films, like the Oscar winning *Tin Toy* (John Lasseter and William Reeves, 1988), were composed of rudimentary wire-framed shapes: circles,

8.50 All of the birds are rendered from identical, tear-shaped wire frames, but the animator Ralph Eggleston nonetheless gives them unique identities through subtle facial gestures. *For the Birds* (2000).

8.51 With *Wall-E* (Andrew Stanton, 2008), Pixar seamlessly merged the silent-movie, gag structure of the shorts with the story structure of the features. The peculiar genius here is again found in the details, as the animators not only make Wall-E move, they give the robot character: emotions, desires, and so on.

8.52 A puppet fabricated to look like North Korean leader Kim-Jong II in Trey Parker's low-tech "supermarionation" cartoon *Team America: World Police* (2004).

teardrops, and parallelograms. For a later short film, *For the Birds* (fig. **8.50**), the repetition of simple shapes and a simple gag structure suffices. We see a group of birds rest on a wire. A big, goofy bird wants to join them. They resist, and, as they wrest the big bird from their midst, they slingshot themselves skyward, returning to the earth featherless and quite embarrassed. What is most notable about this single-gag cartoon is the realistic and subtle expressions on the anthropomorphized birds' faces. Absent dialogue, we read the short film like a silent four-reel comedy: bodies in motion in a simple gag composed of setup, execution, and postmortem. The joke structure is enhanced by telling reaction shots.

The move into feature-length Pixar animated films with *Toy Story* in 1995 (see fig. **8.30**) brought with it a move away from the gag structure of the shorts and towards the telling of a more coherent story. The animation itself looked fundamentally different from the hand-drawn caricatures that had dominated animation for half a century; the figures were all more lifelike, their movements more fluid, the match-up of foreground and background less distinct and more seamlessly integrated.

Toy Story was a huge hit at the box office and Pixar has gone on to average a feature every eighteen months. As we read these films (*Toy Story* and the other Pixar features such as *Monsters, Inc.* (Pete Docter, David Silverman, and Lee Unkrich, 2001), *Finding Nemo* (Andrew Stanton and Lee Unkrich, 2001), and *Wall-E*, fig. **8.51**, that followed), many of the same critical concepts we use to read live-action films come into play: there is a narrative organized into three acts, often structured around complex characters (or at least characters with complex emotions); there is a discernible mise-en-scène with simulated sets and simulated lighting effects; camera work is simulated (as opposed to mechanically performed), but we can nonetheless interpret the way images are framed and focused; editing is by and large a similar process to live-action, and again continuity is a key; and finally sound rounds out the process as voice-work is mixed with sound effects and music.

While Pixar prides itself on cleanly rendered images, other contemporary animators have produced a rough and raw alternative, sporting an undisciplined look meant to match counterculture content. Pixar films, consistent with the Disney image, are made for children and the child in all of us. The animated films made by Trey Parker (the clunky cutouts used in *South Park: Bigger, Longer & Uncut*, 1999; and the puppets used for *Team America: World Police*, fig. **8.52**) and Mike Judge (the crudely drawn, comic-book style illustrations used in *Beavis and Butthead Do America*, fig. **8.53**), for example, are made for young adult and adult filmgoers acquainted with a junky, TV-cartoon style. These cartoons have decidedly adult content ranging from outrageous political commentary to off-color jokes about sex.

Many contemporary animated films are created by the subtle manipulation of three-dimensional objects captured frame by frame in what animators call

stop-motion. Animators working in the stop-motion genre use a variety of materials, including molded clay (Will Vinton's *Closed Mondays*, 1974, and Nick Park's *Wallace and Gromit* series), and **found objects** like ice-cream sticks, pipe cleaners, buttons, ball bearings, gears from toy motors, speaker wire, and random pieces of fabric (Henry Selick's *The Nightmare Before Christmas*, fig. **8.54**, and his 3-D stop-motion feature *Coraline*, 2009). The appeal of these films seems again tied to the creative genius that produced the work—the animators who transform these objects into characters and then carefully pose these characters in the telling of a story.

The preproduction phase (storyboarding, design, and fabrication) of *Coraline*, for example, took 2 full years; the production phase, another 18 months. There are nearly thirty different models or puppets used in the film. Many took 3 to 4 months to produce. Add to this the painstaking process of posing the figures, assembling and serially tweaking the backgrounds frame by frame, to add up to a 96-minute film. The simple come-on in McCay's first cartoon—"Watch me move"—that signaled animation's gee-whiz appeal remains the key 100 years later.

The film critic James Agee once remarked that animation was the one, true American art form. Film historians mostly follow Agee's lead and routinely focus predominantly if not exclusively on the American animated film. But animation does exist elsewhere; there were animated films in Russia produced as early as 1906. And especially since the time of Perestroika—the internationalization of the Soviet industry and the later breakup of the Soviet bloc—to

stop-motion A method of animation in which three-dimensional objects are moved and photographed for each frame.

found objects Everyday objects that are repurposed to create art.

▶ **8.53** The stoner caricatures Beavis and Butthead pose in front of a sign they no doubt find absolutely hilarious. The animator Mike Judge isn't interested in seamless or attractive rendering; instead his aesthetic fits the dim-witted worldview of the title characters. *Beavis and Butthead Do America* (1996).

8.54 Henry Selick's *The Nightmare Before Christmas* (1993), produced by Tim Burton.

8.55 Hayao Miyazake's *Spirited Away* (2001) showcases the animator's painterly, multiplane images.

today, a rich and varied and often experimental cine-animation has emerged, including work in traditional pen-and-ink, stop-motion (with found objects and puppets), and etchings on glass plates.

The best-known contemporary animation outside the United States is in Japan, where stylized adaptations of Manga (young adult magazines and graphic novels, like Shirow Masumune's *Ghost in the Shell*, which was adapted into an animated feature by Mamoru Oshii in 1995), video games, and toys (the Pokemon phenomenon), as well as other pictorially distinct work have created what historians and critics and fans term **anime**. The most celebrated among the new Japanese animators is Hayao Miyazake, the founder of Studio Ghibli and the director of *Princess Mononoke* (1997), *Spirited Away* (which won an Oscar in 2002, the first animated film made outside the United States to do so; fig. **8.55**), and *Howl's Moving Castle* (2004). In an era dominated by the digital image and computer-generated animation, Miyazake's films are a throwback to the painterly style of Disney features like *Snow White* and *Pinocchio*. But despite the reverence for and allusions to old-school hand-drawn and painted multiplane images, Miyazake's films retain the gee-whiz factor at the heart of animation's enduring appeal, in this case built upon audience appreciation for craft in an era otherwise dominated by mechanical or computer rendering.

8-3 EXPERIMENTAL FILM

Experimental and avant-garde filmmakers dramatically push at the boundaries of cinematic expression and in doing so challenge widely held notions of what movies can or should be. Their films are deliberately unorthodox, nonconformist, and difficult.

All of the elements of film form that we have examined in chapters 2 through 6 may be upended in experimental movies. In place of story, for example, we may find a tightly focused attention to the mysteries of anatomy (Willard Mass's *Geography of the Body*, 1943), or the unconscious workings of the human mind (Luis Buñuel's *Un chien andalou*, 1928), or the subconscious urges and anxieties of a seemingly desperate woman (Maya Deren and Alexander Hammid's *Meshes of the Afternoon*, fig. **8.56**). The point in these films is not to represent reality through narrative but to evoke the personal, the psychological, and the intimate through filmic images and sounds.

Experimental films may be entirely **nonnarrative**, focusing on images and/or sounds in and of themselves. Some experimental filmmakers closely explore shapes and movement (fig. **8.57**). Others, like Stan Brakhage, play with the plastic material of film itself, painting directly on the film surface (*Garden of Earthly Delights*, 1981) or sandwiching natural detritus (leaves, dirt, a moth's wings) between strips of 16mm celluloid (fig. **8.58**).

When we watch experimental films, our attention is even more keenly focused on the constitutive elements of filmmaking: mise-en-scène, camera work, editing, and sound. As we pay attention to how a particular film offers a new approach to these elements, we can begin to analyze how the film's experiments with form relate to its purpose, its effect, and, ultimately, its meaning.

8-3a Surrealism

Surrealism was a creative movement of the 1920s and early 1930s in literature, painting, sculpture, photography,

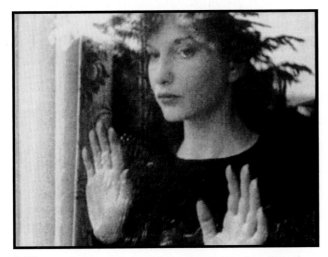

8.56 The theme of interiority—repression, loneliness, helplessness—captured in a single, soft-focus image: *Meshes of the Afternoon* (Maya Deren and Alexander Hammid, 1943).

anime A style of Japanese animation that includes a range of styles and types including adaptations of Japanese Manga (young-adult magazines).

nonnarrative Structured by a focus on something other than story.

surrealism An avant-garde movement of the early twentieth century that explored the workings of the unconscious.

8.57 A striking image from Robert Florey's 1929 experimental short *Skyscraper Symphony*. A critical reading of the film would not involve tracking a story—there isn't one. Instead, the film's evocative camera work and composition creates an impression of the New York City skyline.

8.58 Stan Brakhage's *Mothlight* (1963) merged collage with filmmaking and in doing so altered the very composition of the film itself. The effect is at once abstract and profoundly realistic, given that the film captures not a photographic representation of an object but the object itself.

and cinema that explored the illogical "narrative" of the dreamwork and its various meaningful and symbolic associations and images, drawing on ideas from Sigmund Freud. In order to highlight the unconscious or subconscious over the conscious realm, surrealists created and juxtaposed images and utterances devoid of reason, control, order, or moral preoccupation.

In their camera work and mise-en-scène, surrealist filmmakers experimented with such basic visual

8.59 An intimate encounter we must struggle to see, let alone understand, in *L'Etoile de Mer* (*The Starfish*, Man Ray, 1928).

elements as camera focus, makeup, and props, and created images that are deliberately obtuse or shocking. For example, in Man Ray's 1928 surrealist short *L'Etoile de Mer*, we follow a couple upstairs and watch a woman undress. Then the man leaves. It is a simple enough scenario complicated by Ray's visual style. We watch the encounter as if looking through a smoked-glass window. We struggle to see the image and struggle to understand its significance to a film composed entirely of indistinct images and a narrative that defies the logic and trajectory of coherent storytelling (fig. **8.59**). In *Emak-Bakia*, another Man Ray film that also includes scenes with misleading images, we see (clearly) a woman with unusually large eyes (fig. **8.60**). She then opens her eyes and in doing so reveals that what we first saw were eyes painted on her eyelids (fig. **8.61**). These surrealist experiments call attention to the act of seeing and movie artifice in a way that mainstream filmmakers of the period consciously avoided.

While mainstream cinema tells stories that have a cause-and-effect logic, surrealist cinema is by design and intent more random and absurd. The editing in surrealist films is often fascinatingly and frustratingly discontinuous: images follow one and another as a seeming matter of chance and circumstance. It manifests an associational form, in which there is a poetic as opposed to immediate or direct or logical connection between the images strung together in the editing room. In a particularly striking sequence in Man Ray's *Les Mystères du Château du Dé*, each image is beautifully set and shot, but despite a moving camera that seems to be taking us from one place to the next, the relationship between the images and the sets is associational and

8.60 and 8.61 Two successive images in *Emak-Bakia* (Leave Me Alone, 1926). The first appears to show a woman with unusually large eyes. The second shows the woman opening her eyes, revealing that what we first saw were eyes painted on her eyelids.

8.62 and 8.63 Two successive shots from Man Ray's 1929 film *Les Mystères du Château du Dé* (*The Mysteries of the Chateau of Dice*). A moving camera and the logic of editing suggest a connection between the two shots, but for Ray the logic is associational, poetic, and a matter of design and composition.

poetic. The camera movements and cuts seem solely aspects of design and composition; there is no apparent cause-and-effect narrative. The film is the record of one moment and then the next (figs. **8.62** and **8.63**). Meaning is fleeting and personal: as one might try to make sense of the run of images in a dream, the very form seems wide open to a variety of interpretations.

Surrealist visual artists like Ray and Salvador Dalí saw film as a medium that might enable them to build upon their more static work on paper and on canvas. Both turned to cinema because it was new and modern and industrial and largely derided by the high art establishment. Ray, Dalí, and the surrealist painter and conceptual artist Marcel Duchamp used cinema to efface the distinction between high art and commercial

art. For example, in his 1926 short *Anemic Cinema* Duchamp juxtaposed images and slogans—a merging of high and commercial art that was already in play in his paintings and collages. *Anemic Cinema* is composed entirely of swirling shapes in constant movement. The spirals are intercut with revolving absurdist slogans like "If I give you a penny, will you give me a pair of scissors?" (figs. **8.64** and **8.65**).

In all of their visual artwork, the surrealists endeavored to undermine the larger, bourgeois notion of high art. For these artists, film proved to be an ideal modern medium because it was so clearly tied to industrialism and mechanical reproduction on the one hand and popular culture on the other. This savage satire of artistic pretension was nonetheless complicated by an

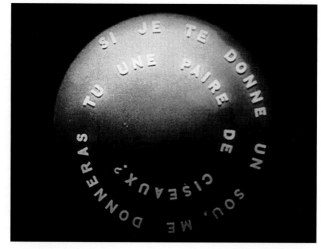

8.64 and 8.65 Marcel Duchamp's film *Anemic Cinema* (*Anémic Cinéma*, 1926) links simple abstract shapes in movement with absurdist titles.

unavoidable aspect of experimentalism in art. Although these artists meant to speak to an audience that was suspicious of high art, their work was for the average filmgoer difficult, cerebral, even inaccessible. This was a final absurdity of the movement: that its very conceptual nature turned it into a kind of high art itself, limited to exhibition in galleries, museums, and other alternative venues.

8-3b The New York Underground

The term "new American cinema" is used most often today to refer to postclassical Hollywood, the period beginning with the industry-wide adoption of the Voluntary Motion Picture Rating System in 1968 and the advent of the seventies' auteur renaissance and culminating in the current multinational universe of blockbuster sequels and remakes. (We will return to these developments in the next chapter.) But in its initial incarnation, the **New American Cinema** referred to a group of New York–based avant-garde filmmakers—Lionel Rogosin, John Cassavetes, Shirley Clarke, Alfred Leslie, and Robert Frank among others—who, along with Jonas Mekas, a journalist for the *Village Voice*, proffered an anti-Hollywood movie manifesto in which the filmmakers rejected the formal strategies and finance model of mass-market moviemaking. These filmmakers decried studio interference and industry censorship,

> **New American Cinema Group** A group of avant-garde filmmakers whose anti-Hollywood manifesto was responsible for initiating the New York film underground of the 1960s.

rejected the big-budget, feature-length model, and in its place promised a modestly and independently financed, fully independent cinema composed of smaller, more personal movies distributed by a filmmakers' cooperative. Whatever profits this new cinema might produce, the filmmakers agreed to put into a fund to support the work of other struggling artists. With this alternative model, a New York film underground was born.

The most famous filmmaker to emerge out of this group was John Cassavetes, a successful actor who used his money and connections to finance experimental films like *Shadows* (1959) and *Too Late Blues* (1961) and later independent films like *Faces* (1968), *A Woman under the Influence* (1974), and *The Killing of a Chinese Bookie* (1976). Rather than focus on heroic, star-driven narratives, Cassavetes attended the struggles of everyday people and everyday life—husbands and wives, mostly—and found a new cinematic realism by slowing down the pace of scenes, allowing for scripted and unscripted dialogue and actions. The camera work has an improvisational feel as well, and the mise-en-scène is often so stripped down as to appear found rather than set and dressed. Even the lights seem to be oddly placed, as if we are watching a documentary captured live and on the fly. Cassavetes worked with an ensemble group of actors (Ben Gazzara, Peter Falk, his wife Gena Rowlands) and freely mixed in amateurs (fig. **8.66**). As a result, there are a lot of clunky moments, lucky and unlucky accidents that Cassavetes left in the films. But just as often, he produced scenes so real they don't appear to be acted or scripted but instead emerge organically out of the interplay between the performers. Most Hollywood films try hard to mask artifice and to

8.66 Cassavetes often mixed professional movie actors like Ben Gazzara (middle of the frame) with inexperienced, unprofessional amateurs to create a more organic feel to his films; the pace is slower and the interactions are at times awkward, even clunky. The overall effect is an alternative, experimental style. *The Killing of a Chinese Bookie* (1976).

8.67 Dressed-down settings (the awful wallpaper, the "Apartment for Rent" sign on the wall), and a conspicuously misplaced lamp (that seems to screw up the lighting of the scene) introduced an alternative, experimental cine-realism.

correct imperfections in mise-en-scène, camera work, editing, and sound. Cassavetes, true to his roots in the New American Cinema group, endeavored to create an anti-Hollywood, alternative, realist style (fig. **8.67**).

The roots of the New American Cinema style can be found in the New York City beatnik, or Beat, subculture, the increasingly public gay and lesbian subcultures, alternative theater, and Be-Bop jazz. Robert Frank and Alfred Leslie's *Pull My Daisy* illustrates these influences. At first glance, the film appears to be little more than a home movie showing a handful of friends, albeit famous friends—Beat poets Allen Ginsberg, Peter Orlovsky, and

Gregory Corso, and the jazz musician and painter Larry Rivers—hanging around a Bowery apartment (fig. **8.68**). The film is at once an invaluable historical document of a certain place and time and a nonnarrative "day-in-the-life" documentary. What makes the film so remarkable is not its content but its attitude—a snarky, playful cynicism elaborated in a commentary written and read by Beat writer Jack Kerouac. Like a lot of experimental films, *Pull My Daisy* includes only asynchronous sound: Kerouac's narration, in which he comments on and even voices the characters on screen; sound effects obviously added after the fact; and the postdubbed, impromptu jazz session. The film offers a free-form alternative to the classical Hollywood style in which image and sound, as well as live and postproduction sound, are fully and seamlessly integrated.

Just as *Pull My Daisy* presents a hip urban beatnik subculture, Jack Smith's outrageous *Flaming Creatures* focused on the then-closeted gay and lesbian world. Not only does the film feature on-screen homosexual acts—an absolute impossibility in a mainstream Hollywood movie in 1963—and a number of scenes in which the camera studies the faces of male transvestites, it also showcases a film style filled with camp images and iconography, images that at once celebrate and lampoon gay stereotypes (fig. **8.69**). *Flaming Creatures* makes no pretense to narrative or conventional characterization. Instead Smith offers overlong sequences of obviously simulated sexual action that are also absent motivation and narrative logic. These highly stylized moments of intervention and revelation challenge the strictly censored images of Hollywood cinema and offer glimpses into a subculture foreign to most filmgoers.

By far the most famous experimental filmmaker in New York in the 1960s was Andy Warhol, whose early films took the impromptu, slice-of-life formula to ridiculous lengths. The 5-hour film *Sleep* (1963), for example, showed John Giorno sleeping in real time, and *Empire* (fig. **8.70**) was composed of a single, stationary

8.68 Three men on a couch. From left to right: the Beat poets Gregory Corso, Peter Orlovsky, and Allen Ginsberg. *Pull My Daisy* (Robert Frank and Alfred Leslie, 1959).

8.69 Jack Smith's camp experimental film *Flaming Creatures* (1963) ironically and theatrically exploited gay iconography and stereotypes. The film's graphic depiction of hetero- and homosexual sex offered a startling alternative to Hollywood films hamstrung by the commercial industry's regime of censorship.

8.70 Andy Warhol's 6-hour hyper-realist film *Empire* (1964).

8.71 Paul America in Andy Warhol's *My Hustler* (1965). Gay iconography dominates many of Warhol's experimental films.

camera focusing on the Empire State Building from 8:06 P.M. to 2:42 A.M. Warhol endeavored to upset the filmgoing experience. Per Warhol's suggestion, filmgoers might leave mid-film, have dinner and a walk, and then return without missing much of anything.

In the 1960s Warhol began ironically celebrating American celebrity culture, presiding over a coterie of the young and hip. These oddball celebrities—the transvestite Holly Woodlawn, the diva-esque Viva, gay studs like Paul America (fig. **8.71**), and the fashion model Edie Sedgwick—were famous mostly for being famous. Warhol's peculiar celebrities behaved outrageously, self-reflexively lampooning the essential narcissism of Hollywood celebrity culture. While Hollywood maintained the fiction that all of its movie stars were talented and thus deserved the privileges of stardom, Warhol's celebrities seemed content to be viewed as selfish brats with no apparent talent.

Among the most interesting directors on the post-Warhol, New York experimental scene is the photographer Richard Kern, who shoots explicit sadomasochistic fantasies that evince a powerful punk vibe (fig. **8.72**). These films (*The Right Side of My Brain*, 1984; *Manhattan Love Suicides*, 1985; and *Submit to Me Now*, 1987) are not for the timid or the prudish, and though they seem deliberately "dirty" in many

8.72 A provocative image from Richard Kern's experimental film *X Is Y* (1990).

8.73 George Kuchar's garish, decidedly low-tech experimental film *The Fury of Frau Frankenstein* (2005).

senses of that word—unusual sex acts, grubby nonprofessional actors, dressed-down slum apartments—they are also oddly compelling. Kern's films are violent, sexist, and often disgusting and are by design shocking, even insulting. Such provocation is at the heart of experimental films in general, matching an aggressively unusual visual style and narrative structure to topics mainstream films dare not take on.

Experimental films anticipate an audience that is in on the joke, so to speak, which explains why a camp sensibility—the ironic celebration of bad taste (as well as bad acting, cheesy props and sets, and amateurish lighting)—is at the heart of a lot of the films. Both Smith and Warhol embraced camp wholeheartedly, as did their San Francisco counterpart George Kuchar. From his post at the San Francisco Art Institute, Kuchar,

occasionally with his twin brother Mike, and occasionally with students from his classes at the Institute, produced wildly messy parodies like *The Naked and the Nude* (1957), *Hold Me While I'm Naked* (1966), *I, An Actress* (1977), and *The Fury of Frau Frankenstein* (fig. **8.73**). The films proudly celebrate a low-tech, bad-taste aesthetic: ugly sets, a garish use of color (costumes, filters, and processing); amateur actors overacting, delivering (and sometimes flubbing) comically hackneyed dialogue that is often poorly postdubbed and out of synch; and clunky special effects that look, and are, cheaply made.

8-3c Feminism and Experimentalism

Women have played a significant role in the history of experimental and avant-garde cinema. Underrepresented and marginalized in the mainstream industries in the United States, Europe, and elsewhere, female filmmakers have created a sizeable and significant body of experimental work, finding an audience for movies that depart from mainstream style and content. Some of these filmmakers have set out to produce films with a **feminist** agenda, offering a range of unique perspectives on women's experiences in both the private and public spheres. Others have been key participants in alternative or avant-garde film movements embracing, like the men in these movements, an alternative cinematic form and style.

Among the most interesting people making movies during the silent era was the experimentalist Germaine Dulac. The director had ties to two avant-garde traditions: **impressionism** (which celebrated the essential poetry of moving images and at the same time resisted set narrative forms and formulas) and surrealism (discussed above). Her short film *The Seashell and the Clergyman*, released in 1926, was celebrated in avant-garde circles as an impressive contribution to both movements. Dulac satisfies the impressionist criteria with her poetic imagery and nonnarrative scheme, and she employs many of the techniques and preoccupations of the surrealist filmmakers, especially the attempt to find a visual language and narrative shape for unconscious and subconscious thoughts and dreams. *The Seashell and the Clergyman* evinces a fundamental irreverence characteristic of experimental

impressionism An avant-garde style that celebrated the poetry of moving images while resisting narrative forms and formulas.

feminist films Films that challenge gender inequality and/or assert female identity.

8.74 and 8.75 The priest cowers in shame then briefly realizes his fantasies by snatching off a parishioner's brassiere. *The Seashell and the Clergyman* (Germaine Dulac, 1926).

8.76 and 8.77 The general and his sword drawn and ready and held at an intentionally suggestive height. The sword glistens as it enters a space meant to suggest female genitalia.

film in general, in this case to the dominant religion in France at the time, Catholicism (figs. **8.74–8.77**). The story itself explores blasphemy and taboo as it presents through a series of transparently sexual images (swords, candelabra shaped like fallopian tubes) the erotic fantasies of a priest who holds improper feelings for a general's wife. And in its mocking depiction of both the priest and the general, it suggests a critique of patriarchy, and male-dominated institutions.

Among the feminist aspects of the film is its attention to how the male gaze objectifies women (a concept that would be articulated decades later in feminist theory). At one point we see the priest depicted in close-up, his face obscured except for his eyes. This image is meant to reveal the furtive nature of his gaze at the woman he desires; it implies an act of voyeurism. Then, as he gives in to his desires, we see him

beckon the woman to the confessional and then strip off her brassiere. In a striking high-angle shot we see him twirl the brassiere in the air (fig. **8.75**). The undergarment appears to glow, a neat special effect harkening back to an earlier FX image of the general's sword glistening at its tip, and symbolic of its sexual charge (fig. **8.77**).

The imagery in *The Seashell and the Clergyman* follows a trajectory from shame and restraint to the priest's surrender to desire. But it otherwise does not have a discernible narrative arc, relying instead on mise-en-scène, camera work, editing, and special effects to evoke a world of male fantasy and shame. The result is at once perplexing and powerful. When The British Board of Film Censors screened the film, they found it "apparently meaningless . . . if there is a meaning, it is doubtless objectionable." It is quite possible that Dulac appreciated their confusion

and agreed with their larger assumption about its content.

Many of the women filmmakers who came after Dulac have used the marginalized discourses of experimental film to pointedly and politically explore women's issues from a feminist point of view. Among the best-known contemporary feminist experimental directors is Chantal Akerman, whose hyper-realist experimental films include *Hotel Monterey* (1972), *Les Rendez-Vous D'Anna* (1978), and most famously the 198-minute *Jeanne Dielman, 23, quai du Commerce, 1080 Bruxelles*. The title of Ackerman's best-known film is composed of a woman's name and address, which is meant to summarize her life with the home she "makes."

Jeanne Dielman, 23, quai du Commerce, 1080 Bruxelles is often viewed as a work of "structural cinema" because of its static framing and long takes, its merging of feminist politics and anti-illusionist film-making techniques. The film tells the story of a housewife whose days are dominated by a stultifying routine (fig. **8.78**); things are always in their place and she treats every-thing—every action, including serial liai-sons with clients with whom she sleeps for money—with a disturbing absence of affect and emotion. Akerman creates dramatic ten-sion not through rising action but through subtle changes in the woman's routine. As we watch the film from a seemingly objective distance—Akerman eschews techniques like eyeline matches and reverse shots that place us in the world of the film—little things start to go wrong: dinner is overcooked; what to do with a dropped spoon confuses her. The

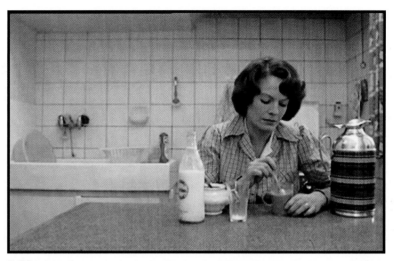

8.78 Chantal Akerman's hyper-realist *Jeanne Dielman, 23, quai du Commerce, 1080 Bruxelles* (1975) attends the maddening drudgery and ennui of a housewife's life. The film's glacial pace as the camera attends household tasks in real time is meant to frustrate the viewer much as the life she is leading frustrates the title character.

8.79 A deceptively simple image in Chantal Akerman's *Les Rendez-Vous D'Anna* (1978). One woman, two beds, and lots of time for the filmgoer to ponder the significance.

film's length and its glacial pace are meant to give the filmgoer the experience of waiting for something to happen, an experience that certainly matches Jeanne's. When something finally does happen, when her final liaison with a male client stirs something inside her, something like feeling or emotion, she reacts violently; she grabs a pair of scissors and stabs him to death.

The principal character in Akerman's *Les Rendez-Vous D'Anna*, released three years later, is a success-ful filmmaker whose restlessness and rootlessness are exposed through the director's characteristic glacial pace and objective camera work. Anna's life is com-posed of a series of casual encounters of the social,

professional, and sexual kind. Like the housewife in *Jeanne Dielman, 23, quai du Commerce, 1080 Brux-elles*, the filmmaker is at once independent and desper-ately lonely, a predicament exposed in carefully lit and staged tableaux (fig. **8.79**).

Akerman's films abound in the looks and sounds of ordinary things. Filmgoers have found this so-called **structural, or minimalist, cinema** alternatingly

structural or minimalist cinema Films characterized by static framing and long takes, that employ anti-illusionist filmmaking techniques.

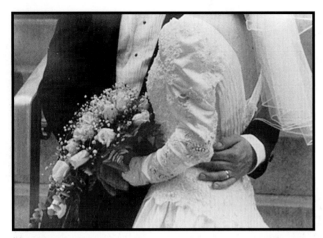

8.80 The romantic setup in Su Friedrich's 1991 film *First Comes Love.*

transfixing, hypnotic, mind-numbing, and (in and of itself) boring. What Akerman accomplishes is a match between real and filmed lives. We are meant to forget the camera and in doing so gain access to events that transpire as they might in real life and real time. The fundamental narrative techniques of elision and compression and the use of editing to supplant lengthy transitions are replaced here by careful attention to every gesture, every audible sound. We have ample time to linger over the images (the carefully composed and framed stationary camera shots) and to listen carefully to the sound of the room (the very thing sound engineers record to set the baseline for sound in a scene). In doing so, Akerman fundamentally alters the filmgoing experience, making it at once more realistic, more intimate, and less dramatic.

While Akerman's films offer a departure from the conventions of mainstream fiction, Leslie Thornton's films experiment with the conventions of documentary to create a radically different experience for audiences. In *There Was an Unseen Cloud Moving* (1983), for example, she merges ethnography, travelogue, talking-head commentary, and staged dramatizations to tell the story of Isabelle Eberhardt, a nineteenth-century European woman who traveled through North Africa masquerading as a man. Thornton compiles archival images that are both representational (the desert landscape Eberhardt traversed, for example) and metaphoric (the lunar landing, for example, to suggest the desert's strangeness to her European eyes) and then intercuts these images with dramatizations of Eberhardt's story played by different actresses and with interviews with contemporary women who also

struggle with sexism. While the compilation of found footage, reenactments, and talking heads evince a familiar documentary format, Thornton's approach is nontraditional and difficult to fully grasp—a perfect match for her outsider heroine. Thornton's nontraditional take on the compilation form is also evident in *Another Worldly* (1999), a short film that juxtaposes old Hollywood dance footage with ritual performance by indigenous, "primitive" cultures all set to a modern techno-beat. The effect of these films is fragmented and fragmentary, part ethnography, part social commentary, part biography, part rumination on sexism.

Su Friedrich, another experimental feminist filmmaker, also uses documentary as a take-off point. In her 1991 film *First Comes Love*, we see a series of black-and-white images from four church weddings (fig. **8.80**). On the soundtrack we hear asynchronous, nondiegetic pop music, which serves to highlight the sweet, romantic images on screen. The payoff comes at the end of the film as Friedrich's otherwise romantic slice of life takes a sudden turn. In the closing credit sequence she lists all of the countries that in 1991 outlawed same-sex marriages. This title sequence asks us to reread the film; the scenes we have seen in the film and the romantic music that helps set the mood are tied exclusively to heterosexual romance, something, this title sequence reminds us, same-sex couples cannot, by law, experience.

Experimental films ask us to confront difficult material presented in an unfamiliar and challenging form. These films make the difficult entertaining, or by design challenge the notion that cinema should or must be diverting; the filmmakers take us out of our comfort zone, so to speak, and ask us to focus even more keenly on the constitutive elements of film form: mise-en-scène, camera work, editing, and sound. With experimental films the question "what was that film about?" can't be answered, even initially, with plot summary or an easy comparison to another similar film. Instead, experimental films require of us some hard work and a willingness to indulge and explore the ways in which nontraditional forms and styles might be used on-screen.

The pleasure of these texts, then, is much like the pleasure felt at solving a puzzle. These films ask us to reflect on our basic assumptions about film form and mass culture; they pose alternatives that prompt reflection and analysis. When we watch these films, we acknowledge that art need not be easy or accessible or user-friendly to be meaningful.

CHAPTER SUMMARY

Documentary, animated, and experimental films offer a rewarding alternative to live-action narrative films, with unique histories and concerns. A close reading of these films can examine how they adhere to and deviate from the principles of film form that we examined in chapters 2 through 6.

8-1 DOCUMENTARY

Learning Outcome: *Identify and analyze the different goals and techniques of documentary filmmaking from the earliest short films to the present.*

- Documentaries present themselves as works of non-fiction, as factual and trustworthy, and ask us to view them as such.

- Slice-of-life documentaries and actualities in early cinema shared a basic goal: to preserve for posterity everyday life.

- One of the most popular late-silent/early-sound era documentary genres was the ethnographic (including travelogue) film. These films gave filmgoers a look at places and cultures from the far reaches of the globe.

- During the worldwide economic Depression, the lead-up to World War II, and then the war years themselves, many nonfiction filmmakers fully embraced the persuasive power of the big screen and produced films to propose and promote a political agenda.

- Filmmakers in the direct cinema movement that took shape in the United States in the early 1960s used techniques that implied objectivity to present a "direct," unmediated event.

- Many contemporary documentary filmmakers use a subjective, or first-person, style to comment on, react to, and even prompt or stage the events on screen. These filmmakers make no claim to objectivity in taking on contemporary issues.

8-2 ANIMATION

Learning Outcome: *Recognize and appreciate the diversity of animation styles and the blend of artistic imagination and technological innovation that have characterized the development of this film category.*

- Cine-animation began with hand-crafted, pen-and-ink drawings, then moved on to illustrations on transparent cels produced by studio teams and then photographed by a camera designed to produce a single image from multiple layers, to stop-motion figure manipulation, and most recently to computer modeling and imaging captured in 3-D.

- The history of animation is at once a matter of technological development and creative enterprise; it is tied as much to evolving techniques and industrial innovation as it is to creative impulse and imagination.

- Many of the same critical concepts we use to read live-action films come into play when we read animated features: there is a narrative, often organized into three acts, structured around complex characters (or at least characters with complex emotions); and there is discernible visual and sound design.

8-3 EXPERIMENTAL FILM

Learning Outcome: *Develop an awareness and understanding of films that deliberately attempt to shock, provoke, and challenge audiences by breaking the rules of conventional filmmaking and society.*

- Experimental and avant-garde filmmakers dramatically push at the boundaries of cinematic expression and in doing so challenge widely held notions of what movies can or should be.

- Experimental films may be entirely nonnarrative, focusing on images or sounds in and of themselves. The goal is not to represent reality through narrative but instead to evoke the personal, the psychological, and the intimate through filmic images and sounds.

- Surrealists created and juxtaposed images and utterances devoid of reason, control, order, and moral preoccupation. While mainstream cinema tells stories that have a cause-and-effect logic, surrealist cinema is by design and intent more random and absurd.

- The New American Cinema Group founded a new cinematic realism by slowing down the pace of scenes, allowing for scripted and unscripted dialogue and actions. The camera work had an improvisational feel as well, and the mise-en-scène appeared found rather than built and dressed.

- Many of the women making experimental films have explored women's issues from a feminist point of view.

Barbet Schroeder's 1974 documentary *General Idi Amin Dada* focused on the neurotic, ruthless Ugandan despot (His Excellency President for Life, Field Marshal Alhaji Dr. Idi Amin Dada, VC, DSO, MC, CBE) at the height of his power. When the film was edited and readied for release, Amin demanded three cuts and held a number of French nationals captive in Uganda's capital until Schroeder made the changes. The director complied and Amin gave the film his endorsement. Schroeder initially released the film with Amin credited as the director and himself as an assistant. When Amin fell from power in 1979, Schroeder restored the edited footage and current prints credit him as director.

The image below shows Amin preparing for a swimming race. He is a lousy swimmer, but he will win. Indeed, his opponent is smart enough to stop mid-way across the pool. Absent commentary and captured live (the race is filmed from preparation through completion in one shot), the scene nonetheless tells us a lot about Amin and his subjects.

The framing of the image highlights scale (Amin is huge; his opponent is shorter and far skinnier). The scene is a document of a true event, but the full-figure long shot adds a comic touch.

The camera captures both men looking to the left. The camera subsequently zooms out to show the other participants in the race (who are lined up to their left). Much as in a fiction film, the gaze of the characters cues a change in framing.

The long shot also allows us to see the depth of the pool where Amin has chosen to swim. It's a clever hint at what's to come: the dictator is a comically poor swimmer. Mise-en-scène may well be a matter of chance or luck here, but it does guide our reading of the scene.

Sound: Though there is a lot of voice-over narration in the film, this scene includes only diegetic dialogue (Amin taunting his opponents) and sound effects (splashing and swimming). There is no need for commentary; the scene speaks for itself.

Rabbit of Seville is a Bugs Bunny/Elmer Fudd short directed by Chuck Jones for Warner Bros. in 1950. The film begins with Bugs running from Fudd. Bugs takes refuge on stage during a performance of Gioachino Rossini's opera "The Barber of Seville," which Bugs quickly takes over, much to Fudd's bad fortune. Set to sped-up performances of the opera's overture and arias, Bugs drives his nemesis crazy. The cartoon climaxes with the image below as Fudd lands upside-down in a cake wondering what happened and why it had to happen to him.

This cartoon is structured around a series of knockabout stunts or gags. The biggest gag, Fudd's fall into the wedding cake, gives closure to the narrative.

As with most Warner Bros. cartoons, the emphasis is on the speedy, anarchic flow of images and sounds, true to the genre's roots in silent, live-action comedy.

The animation technique used by Chuck Jones features drawn and painted work on cels that are then photographed by the multiplane camera. Note the simulation of depth with cast shadows and objects in the foreground, middle ground, and background.

Sound: Throughout we hear (often sped-up) excerpts from the opera. True to the Warner Bros. formula, many of the gags are accompanied by classical music. The scene also features radio-style sound effects and the expert voice-work of Mel Blanc.

A big part of the Warner Bros. style was the use of vibrant color.

In *Meshes of the Afternoon* (1943), Maya Deren and Alexander Hammid use the purely physical world of cinema (live characters, real settings, props) to evince the interior experiences of an individual. The absence of a coherent narrative and the emphasis on odd juxtapositions, manipulations of mise-en-scène and camera focus, and the repetition and transformation of objects evoke the illogic of the subconscious as opposed to a linear, structured plot. As with many experimental films, we focus on strategies of mise-en-scène, camera work, editing, and sound in order to analyze how the film's experiments with form relate to its purpose, its effect, and, ultimately, its meaning.

The high-angle, subjective camera position shows the key and the woman's hand on the stairs from the character's point of view.

The most important prop in the film is a key, which we see at several points. In these scenes we see the key tumble down the stairs as the woman scampers behind it, and we see the key magically appear from between her lips. We never discover what the key opens or more simply how it got into her mouth.

This close-up neatly juxtaposes the woman with her mirror image. This doubling is a characteristic of the film, in which actions and images are repeated, often in slight variation.

Editing: At one point we dissolve from a shot of the key to a shot of a bread knife. This implies an analogy, but one tied solely to the illogic of the woman's subconscious. No narrative connection between these objects is made clear, though such an editing strategy suggests there might or should be.

Sound: The film has no synchronous sound—no dialogue or voice-over track and no sound effects to match the images we see. Instead there is a mostly discordant music track that for the most part does not relate directly to the images on screen. For example, when the key falls down the stairs, we hear the tapping of a bongo drum. The music roughly simulates the sound of the key tumbling down the stairs, but the drumbeats do not correspond directly to each time the key touches the concrete. The bongo music can be heard elsewhere in the film, even when nothing on-screen makes a similar noise. The other motif on the music track is a prolonged discordant horn note. It sounds ominous but how it relates to the images on screen is never direct or clear.

ANALYZE DOCUMENTARY, ANIMATED, AND EXPERIMENTAL FILMS

Choose a film or range of films from each category, and use the questions below to begin thinking critically about it.

8-1 DOCUMENTARY

- What is the subject and purpose of the film?
- Does the film aim to be objective or does it relate the filmmaker's personal story and/or point of view?
- How is the film structured? Does it lead you to a particular conclusion about or interpretation of the film's subject?
- Does the film present evidence for an argument or truth claim using any of these devices: suggestive graphics, voice-of-God narration, talking-head segments, and the sampling or compiling of film clips from other documentary sources? Does the evidence support the claims? Are there any flaws in the argument?

8-2 ANIMATION

- What animation method was used to create the film?
- Why might this story have been conceived as an animated rather than live-action film? What does animation allow the filmmakers to do or express?
- Describe the overall look of the characters and sets and the qualities of the voices, music, and sound effects. What kind of mood and tone do they create?
- Who is the primary audience for this film? Do the filmmakers attempt to appeal to both adults and children, and, if so, how?

8-3 EXPERIMENTAL FILM

- What makes this film experimental or avant-garde? What conventions of filmmaking or society does it challenge?
- Is the film narrative or nonnarrative? If nonnarrative, what seems to be the organizing idea?
- How does the film experiment with basic visual elements like camera focus, makeup, and props?
- Is the film ironic, camp, or in particularly bad taste? If so, how?
- Does the film make you think about women's lives or the experiences of a subculture in a new and different way? If so, how?

9 FILM HISTORY

The director Akira Kurosawa on the set of *Kagemusha* (1980)

Films exist and can be read and analyzed in the context of culture and history. They can tell us a lot about a place and time. A film made during the Great Depression, for example, is situated in that turbulent time, and it is worth wondering what the film meant to audiences of the day.

Films can also be read and analyzed with regard to the mode of their production (mainstream or independent, for example). And they can be read in the context of a national tradition or film movement. As critical viewers, we are often asked to choose or establish a balance between textual analysis (a focus on the formal elements of cinema, which we have examined in chapters 2 through 6) and the cultural/historical perspective (discussed below).

We begin with a look at American modes of production—commercial mainstream and independent—from the advent of Hollywood through the current conglomerate studio system. The goal here is contextualize films with regard to the industry that produces them and the audience that likely consumes them.

A second important goal of this chapter is to introduce the history of various international cinemas, first Europe and then the range of films produced outside the so-called Western tradition in Japan, Hong Kong, and India. This is by no means an exhaustive survey of world cinema. Filmmakers elsewhere in the world have for over a century created meaningful and influential work. The goal here instead is to offer a starting point for exploring what is after all a global medium.

LEARNING OUTCOMES

After reading this chapter, you should be able to do the following:

9-1 Identify the eras in Hollywood filmmaking from 1896 to the present day, and recognize the major filmmakers of each era.

9-2 Discuss key moments in indie film history.

9-3 Analyze the relationships among history, culture, and film form in four key European film movements: German expressionism, Soviet formalism, Italian neorealism, and the French New Wave.

9-4 Appreciate the contributions of filmmakers working outside the Americas and Europe, and discuss the key aspects of postwar cinemas in Japan, Hong Kong, and India.

▶ **PLAY VIDEO ICON:** This icon signals that a corresponding video clip is available in the eBook. The eBook can be accessed at cengagebrain.com.

Movies in America began in the late nineteenth century on the East Coast of the United States. New York was the medium's first center of business and creative operation. But as audiences grew and demanded a steady stream of new films, the New York–based companies moved their production interests to a better location for year-round outdoor filming—Los Angeles, with its 320 days of sunshine per year and its wealth of possible locations: beaches, prairie, mountains, and an emerging urban center.

The first film studio in the Hollywood district of Los Angeles was founded in 1909 by the Selig Polyscope Company, which rented the back lot of a Chinese laundry on Olive Street. Selig did not stay in business long, but by the time it closed its doors, the first modern studios had established themselves on the West Coast, including Universal (fig. **9.1**), Paramount, and Warner Bros.

Today movie studios and business offices, soundstages, editing facilities, special effects houses and labs are dispersed throughout the L.A. area, but we continue to refer to the site of American filmmaking as Hollywood. Geography may well be beside the point here because Hollywood is not just or not really a place. We tend to use the term less to refer to a specific site than to a tradition of popular moviemaking in America.

The history of Hollywood can be organized into stages or periods that reflect large-scale changes in the film business. Many historians refer to the medium's nascent period from the 1890s through 1914—beginning with the first public presentations by Edison and ending with the advent of the feature-length film—as "early cinema." The silent era follows and runs from the introduction of features in 1914 through the industrywide adoption of sound in 1928.

Some American film historians date the next stage in film history, known as the classical era, from as early as the 1910s through as late as 1968, from the very beginning of a studio system in Hollywood through the industrywide adoption of the Voluntary Motion Picture Rating System. For the purposes of this historical survey, however, the classical era begins in 1928, as the

THE KOBAL COLLECTION

9.1 An aerial view of the Universal studio lot in the 1920s.

Hollywood Eras

1895–1914 Early Cinema

1914–1928 Silent Era

1928–1947 Classical Hollywood

studios transform their product lines to accommodate sound and successfully establish monopoly control over production, distribution, and exhibition, and it ends around 1947, with the eventual decline of the so-called contract era, the implementation of the Hollywood blacklist, and the studios' reactions to the Paramount Decision (discussed later in this chapter).

What to make of the period between the classical era and the more modern industry we have today is challenging. In many ways Hollywood was set adrift after World War II as the studios struggled to establish a new business model and audiences captivated by free television and a new leisure culture in the suburbs got out of the habit of going to the movies. Some American film historians label this era quite simply (but nonetheless accurately) a "transition." We will share that notion here.

The adoption of a new movie rating system in 1968 jump-started an era during which Hollywood executives invested in the auteur theory, the notion that films are authored by directors and the secret to commercially and artistically successful filmmaking lay in trusting talented directors to transform moribund genres. This auteur renaissance got filmgoers back in the habit of going to the movies but it proved short-lived as the industry dramatically shifted gears in the early 1980s, investing in bigger, more anonymous blockbusters favored by a more conglomerated, corporate, new Hollywood which continues to thrive today.

9-1a Early Cinema

The emergence of cinema as a modern American industry and pop-culture pastime accompanied and punctuated the nation's transformation into a mature industrial society. Indeed, cinema was just one in a series of modern industrial inventions; we can certainly view Edison's first projected and screened moving pictures (1896) in context with Alexander Graham Bell's telephone (1876), Edison's phonograph (1877), and Henry Ford's first "horseless carriage" (1896).

Movies rather quickly made the transition from invention to industry, and here again we can see its early development in the context of the times. The early twentieth century saw an increasing consolidation of power and wealth among a handful of American companies. The first move towards a consolidated, modernized, and standardized movie industry came in 1908 when Edison formed the **Motion Pictures Patents Company (MPPC) trust**, a collusive movie industry cartel (fig. **9.2**). The MPPC monopolized the production and distribution of American movies and successfully made cinema production and distribution fit the principles of standardization and efficiency introduced by Henry Ford.

Though the MPPC assured efficiency and productivity, the studio owners never fully understood and appreciated the medium's audience, which was largely composed of lower- and working-class urbanites. Competition quickly emerged from a second cartel, this one headed by a group of first-generation immigrants, men quite like the audience they served. These self-proclaimed

> **Motion Pictures Patents Company (MPPC) trust** The first film industry cartel to monopolize the production and distribution of American movies.

1948–1968 Hollywood in Transition 1968–1980 Auteur Period 1980–present New Hollywood

THE KOBAL COLLECTION

9.2 The Motion Picture Patents Company trust linked the interests of Edison and nine of his competitors: Biograph, Vitagraph, Essanay, Kalem, Selig Polyscope, Lubin, Star Film, Pathé Frères, and Kleine Optical. Seated, front and center, the trust's founder and foremost member: Thomas Edison.

9.3 Edwin S. Porter's *The Great Train Robbery* (1903). Porter's film, made for the Edison Manufacturing Company (one of the MPPC trust companies), was an early example of the narrative short. The MPPC companies did not believe that film audiences, composed of so many immigrants and working-class patrons, were capable of sitting through anything longer than four reels (16–20 minutes).

independents (headed by Carl Laemmle, William Fox, and Adolph Zukor; more on them later in this chapter) ventured west and "invented" Hollywood.

The three most significant filmmakers to emerge in this **early cinema era** were Edwin S. Porter, D. W. Griffith, and Mack Sennett. Porter introduced story films for the Edison Manufacturing Company (fig. **9.3**). Griffith (working for American Biograph, a member of the cartel as well) mined the dramatic potential of the Victorian melodrama and became American cinema's first director-auteur. The former vaudevillian Mack Sennett introduced the knockabout comedy: crude, physically demanding, short films that wrung comic effect out of hair-raising stunts and the exploitation of physical and geographic stereotypes. Sennett made films for Keystone Studios, one of the first West Coast production units.

The precise reasons why movies became as important as they became and why they caught on with the American public as fast as they did are difficult to pin down. Among the possible explanations is that these early films engaged aspects of the rapidly changing

9.4 D. W. Griffith's gangster melodrama *The Musketeers of Pig Alley* (1912). The film focused on the perils of modernity and urbanization, typical of the cautionary melodrama so popular in the early cinema era.

economic and political culture in a medium that most people could appreciate and understand. We find in these early films a penchant for cautionary melodrama—films about the evils of alcohol, for example; films about the perils of modernity and urbanization (fig. **9.4**). Movie westerns also focused on the changing economy and political culture. The Wild West itself still existed—there were still cowboys and Indians—but these films seemed already nostalgic (for simpler times, for a less

independents A label first applied to filmmakers outside the MPPC and later used to refer to those working outside the Hollywood studios.

early cinema era Begins with the advent of cinema (circa 1895) and ends with the introduction of feature-length films (1914).

9.5 A 1921 publicity photograph of the All-American movie star Wallace Reid. He was promoted as a "man's man": the hunting dog and rifle, the shirt unbuttoned to reveal an athletic physique, the sleeves rolled up in a casual manner. His death from a drug overdose was one of several star scandals that rocked the nascent movie colony.

9.6 Comedy film star Charlie Chaplin in *The Bank* (Chaplin, 1915). Here we see the little tramp character, played by Chaplin, pining for a society woman he knows he can never have. He later dreams that he thwarts a bank robbery and earns her love, but when he wakes up he and we realize that the dream is quite clearly an impossible fantasy.

modern America). Finally, the slapstick comedies that were so popular early on revealed an impatience with the puritanical morality of nineteenth-century America; propriety and pretension in these films were almost always upset. At the same time, slapsticks also subtly lampooned modern industrial culture; audiences took pleasure in the sight of all those machines (cars, tractors, etc.) crashing or blowing up.

9-1b Silent Cinema

The movies came of age in America with the advent of features, a growing expertise and sophistication in production, and the introduction of a wide range of genres and styles. Accompanying postwar optimism and an economic boom characterized by conspicuous consumption—the so-called Jazz Age or Roaring Twenties—was the sudden popularity of the Hollywood movie star. Some of these **silent era** stars, Rudolph Valentino and Theda Bara for example, embodied a dangerous sexuality in an era characterized by urbanization, immigration, and a

loosening of nineteenth-century moral codes. Others—Douglas Fairbanks, Wallace Reid (fig. **9.5**), and Mary Pickford—represented an all-American ideal: healthy, handsome, and prosperous. Movie stars became a primary attraction to filmgoers, so much so that Carl Laemmle, the founder of Universal Pictures, dubbed the movie star "the fundamental thing" in the movie business.

By the early 1920s, studio managers like Laemmle (Universal), William Fox (Fox), Adolph Zukor (Paramount), Marcus Loew (MGM), and Sam, Harry, Jack, and Albert Warner (Warner Bros.), Eastern European Jewish immigrants who first found success in the East Coast exhibition business, operated much as the MPPC had ten years earlier: as an industry cartel that limited competition and standardized policies, procedures, and product lines. None of the studio moguls were artists; none of them were filmmakers. They were instead hard-nosed businessmen with unbridled confidence in the commercial value of the product their companies produced and a keen understanding of the audience they served.

Hugely influential in this era were the directors D. W. Griffith, Cecil B. DeMille, Erich von Stroheim, and F. W. Murnau, all of whom specialized in melodramas; the producer Thomas Ince, who made mostly westerns; and the film comedy pioneers Charlie Chaplin (fig. **9.6**), Buster Keaton, and Harold Lloyd. The films made by

silent era Begins with the introduction of features (1914) and ends with the advent of sound (1928).

these directors laid bare the contradictions of the age—between the American ideal of equality and the reality of class difference, between the greater freedoms and pleasures promised by modern city life and the loss of traditional values associated with rural communities—in ways the American moviegoing audience could appreciate and understand.

The silent era provided a number of opportunities for women writers and directors. Among the most influential of the women writing scenarios and scripts in this era were June Mathis (who penned the Rudolph Valentino melodrama *The Four Horsemen of the Apocalypse*, directed by Rex Ingram in 1921), Jeanie Macpherson (who wrote DeMille's seminal melodrama *The Cheat*, 1915), and Frances Marion (whose career spanned the silent and early sound eras; she won Oscars two years in a row for *The Big House*, directed by George W. Hill in 1930, and King Vidor's *The Champ* in 1931). Female directors in this era included Alice Guy (known as Alice Guy Blaché after her marriage to Herbert Blaché, with *The Making of an American Citizen*, 1912, and *The Vampire*, 1915), Lois Weber (*The Merchant of Venice*, 1914), and in a career spanning the silents and talkies, Dorothy Arzner (*The Wild Party*, 1929). The considerable contributions of these women behind the scenes of movie production are only part of the story. Guy Blaché, for example, made the transition from behind the camera to the executive suite, eventually becoming the CEO of the independent film company Solax, and Mathis parlayed her success as the writer of Valentino's films into executive positions at Goldwyn, MGM, and First National.

9-1c Classical Hollywood

The era of **classical Hollywood** begins with the advent of sound (see chapter 6), which allowed for the creation of dialogue-intensive scripts, the introduction of musicals as a film genre, and the establishment of a very successful system for organizing and managing the production, distribution, and exhibition of motion pictures. Classical Hollywood spans twenty years of American cultural history, running from the stock market crash of 1929 through World War II and the beginning of the Cold War.

At its height in the final years before the United States entered World War II, studio dominance over the movie industry was breathtaking. In 1940 the "big

classical Hollywood The so-called "studio era" roughly from the advent of sound through World War II. Distinguished by an approach to filmmaking that strove for an "invisible style" that allowed viewers to become absorbed by the world of the film.

eight"—Columbia, MGM, Paramount, RKO, Twentieth Century Fox, United Artists, Universal, and Warner Bros.—produced 75 percent of the films made in the United States and generated 90 percent of the movie industry's gross revenue. The top three studios (MGM, Paramount, and Fox) boasted annual revenues in excess of $100 million. Seven of the "big eight" studios averaged a release slate of more than forty-five films per year, a simply astonishing output of nearly one feature film per week. Vertical and horizontal integration—profit stakes in the development, production, postproduction, and exhibition of motion pictures; control over a contract workforce; and ownership of interior and exterior sites of production—gave the studios monopoly control over the motion picture industrial process and revenue stream.

The studio system was based on contracts; rather than hire the creative and technical talent required to make each film on a project-by-project basis, the studios established exclusive relationships with labor. From movie stars to hairdressers, from writers and directors to carpenters and soundmen, everyone was contracted to work exclusively for one studio. This contract system proved to be an efficient means of production and fueled the creation of "studio styles." Warner Bros., for example, became known for gritty, urban melodramas, in part because their contracted stars included the un-pretty urban tough guys Humphrey Bogart, Edward G. Robinson, and James Cagney (fig. **9.7**). MGM became well known for musicals, primarily

9.7 The Warner Bros. house style was on display in the gritty, urban detective film *The Maltese Falcon* (John Huston, 1941). The film starred the studio contract players Sydney Greenstreet (seated, center), Peter Lorre (in the bow tie), and Humphrey Bogart (standing screen right, hands on hips), all of whom would appear together again in the Warner Bros. hit *Casablanca* (Michael Curtiz), released the following year.

because they had the movie star Judy Garland and the choreographer-director Busby Berkeley under contract.

To fully understand American movies of this era, one must at least consider the industrial apparatus, the studio system that completely controlled the medium. The house styles formed the foundation for "the classical American cinema," an approach to filmmaking that strove for an "invisible style," a seamless look that emphasized narrative continuity over cinematic experimentation. The classical era witnessed the blossoming of American film genres: the western, the gangster film, the horror film, and the romantic comedy. Genres deftly reflected the social and economic realities of the times, staging cultural concerns (crime, war, gender identity, and sexual relations) in otherwise familiar and formulaic form.

Key titles emerging out of the studio system as often as not came from directors whose names are no longer so familiar today, studio directors who went from project to project, including Victor Fleming, who made *Gone with the Wind* and *The Wizard of Oz* (both 1939); and Michael Curtiz, who, while under contract at Warner Bros., directed *The Adventures of Robin Hood* (1938) and *Casablanca* (1942). A handful of important filmmakers from this era whose names are more familiar today include Ernst Lubitsch, John Ford, Howard Hawks, Frank Capra, and Orson Welles. Lubitsch worked mostly for one studio, Paramount, for which he was perhaps the most interesting but nonetheless one of many directors specializing in the studio's signature brand of romantic comedy. Lubitsch became well known for a light touch as a cine-stylist and a deft ability with risqué material, but he thrived in part because he made the sorts of films that fit the Paramount house style and best used the Paramount stable of stars (fig. **9.8**).

John Ford directed a number of important westerns (*Stagecoach* is his best known from this era), many of them with the same iconic movie star, John Wayne. But like most great studio directors, he was adept at a variety of dramatic films including political melodramas like *The Informer* (1935) and *The Grapes of Wrath* (1940). This sort of versatility was the hallmark of Hawks's career as well. He was the ideal studio-era director because he so expertly made a variety of films in a variety of genres: the gangster film *Scarface* (1932), the romantic comedy *Bringing up Baby* (1938), the hard-boiled detective film *The Big Sleep* (1946), and the classic western *Red River* (1948). Directors during the classical era had to be expert at working within "the system." Without ever calling attention to their own contributions, these directors maintained an artistic integrity with regard to the final product.

9.8 *Trouble in Paradise,* a 1932 romantic comedy directed by Ernst Lubitsch for Paramount, the classical-era studio best known for romantic comedies. The term *the Lubitsch touch* was coined to describe the director's stylization of risqué themes, but his success owed a lot to the studio's commitment to comedy films and the talented comedy actors under contract there.

9.9 Frank Capra's *Meet John Doe* (1941), a timely political melodrama infused with Capra's signature libertarian Americanism. Capra was an unusual studio director during the classical era because he successfully imposed his peculiar politics on every film he made.

Capra and Welles offer useful exceptions to the model of the self-effacing studio director. Like Ford and Hawks, Capra directed a range of films: comedies like *It Happened One Night* (1934), political melodramas like *Mr. Smith Goes to Washington* (1939) and *Meet John Doe* (fig. **9.9**), and the Christmastime classic *It's a Wonderful Life* (1946). But each of these very different films evinces Capra's peculiar American libertarianism. Though the films no doubt satisfied the studio's style and priority on narrative continuity, "Capra-esque"

became a descriptor that really meant something to American filmgoers during the classical era—something approximating a political point of view, a depiction of America and Americana specific to the director.

Welles belongs in a category all his own, and not only because his 1941 debut film, *Citizen Kane*, proved revolutionary with regard to its complex narrative form, deep-focus style, and complex sound mix. Unlike the classical-era directors who made their names working within the system, Welles made his by bucking the studios—by, frankly, not working well with others. It was not a productive strategy, and his contributions to American cinema after 1941 are as a consequence difficult to assess. His second film, *The Magnificent Ambersons* (1942), for example, was the first but not last time he balked at studio procedure, refusing to reshoot and recut the film, even though preview audiences found the picture overlong and depressing. RKO cut 50 minutes from the film's running time and shot a new (happy) ending. What movie audiences saw in 1942 was thus a very different film from the one Welles had made. The same basic pattern prevailed on later films, including his 1958 border mystery *Touch of Evil*, which was edited again without his cooperation or approval. (An authentic version of the film—one that was restored in 1998 by Walter Murch following a 58-page memo Welles sent to the studio—is now available and is a vast improvement upon what audiences saw in 1958.) Most of the rest of his output remains tragically compromised by studio interference, serial problems raising money (interrupting or compromising production), and Welles's own arrogance and intransigence.

The classical era required of its directors an ability to work within a system designed to optimize production (to be fiscally efficient and commercially successful). It also required of them the ability to work within a strict regime of censorship. Following a series of star scandals in the 1920s involving suicide, rape, murder, homosexuality, and drug addiction, conservative "reformers" pressured the Motion Picture Producers and Distributors Association (MPPDA) to monitor the Hollywood colony and censor the content of American movies. The studios endorsed a strict **Production Code** in 1930, and then in 1934 empowered the Production Code Administration to enforce this strict regime of censorship industrywide. (See box "The Production Code: A Summary.")

Production Code A regime of censorship introduced in 1930. This code strictly regulated on-screen images and narratives from 1930 through 1968.

The Production Code: A Summary

The 1930 Production Code elaborated twelve areas of concern:

1. *Crimes:* Included were subsections on the methods used by criminals to commit murder, arson, and robbery (prohibiting anything that could be used as instructions for fear of copycats in the audience); drug trafficking; and alcohol production, distribution, and consumption (illegal under the Volstead Act).
2. *Sex:* Included were subsections on adultery (never justified), scenes of passion (with a specific prohibition on "excessive and lustful kissing"), seduction or rape (seen as more or less the same thing—a specific sub-subsection prohibits use of such scenes in comedy films), sex perversion (not defined or specified), white slavery, miscegenation, venereal disease, scenes of actual childbirth and children's sex organs (the on-screen depiction of which was strictly prohibited).
3. *Vulgarity:* Good taste must prevail.
4. *Obscenity:* Not defined and something of a catch-all.
5. *Profanity:* Rough language (expletives, blasphemy) was strictly censored. The list of forbidden words included: "alley cat" (applied to a woman), "cripes," "fanny," "whore," "damn," "pansy," and "nuts" (except when meaning "crazy").
6. *Costume:* "Complete nudity" was strictly forbidden. Diaphanous, overly revealing clothing could not be worn. Scenes showing characters getting undressed "should be avoided."
7. *Dances:* No sexually suggestive movement or gesture was allowed.
8. *Religion:* All faiths and denominations must be respected. "Ministers of religion...should not be used as comic characters or villains."
9. *Locations:* "The treatment of bedrooms must be governed by good taste and delicacy."
10. *National feelings:* Reverence for the flag and country; respect for other nations and nationalities.
11. *Titles:* "Salacious, indecent, or obscene titles shall not be used."
12. *Repellent subjects:* Prohibitions against depictions of executions, third-degree methods (used by police), brutality, "branding of people or animals," "cruelty to children or animals," white slavery, and surgical operations.

9.10 Transition-era movie star Marlon Brando in Elia Kazan's social-realist melodrama *On the Waterfront* (1953).

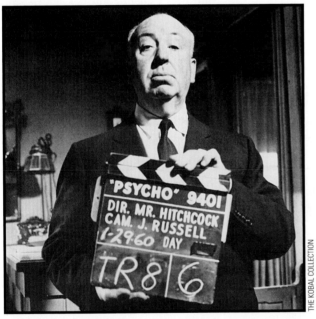

9.11 Director Alfred Hitchcock mugs for the camera on the set of *Psycho* (1960). Hitchcock was one of the few directors during the transitional era who became as well-known as his films.

9-1d Hollywood in Transition

The period between the end of World War II (1946) and the industrywide adoption of the MPAA Voluntary Movie Rating System (1968) resists an easy label. The contract system unraveled with the advent of the postwar economy, and the signature studio styles that had characterized classical Hollywood became less meaningful or distinct. All at once the industry was beset by a government-prompted and industry-enforced blacklist (of alleged Communists in the movie business; see chapter 2) and a Supreme Court antitrust case (the Paramount

Decision of 1948) that forced the studios to sell off their movie theaters and in doing so complicated their decades-old model of financing movies. Urban audiences that had flocked to movie palaces shrunk as the middle class began moving to the suburbs, and the advent of free television and further competition from the (rock-and-roll) recording industry contributed to a troubling box-office decline. American film historians tend to view this era as simply and aptly "Hollywood in transition" ... in transition from old to new, from classical Hollywood to a more modern, conglomerate, global movie business.

While it was anything but business as usual in Hollywood, the industry continued to bank on movie stars such as Marlon Brando (fig. **9.10**), Marilyn Monroe, James Dean, Grace Kelly, John Wayne, and Doris Day. In most cases the stars did not "belong" to any one studio; as a consequence, studio styles were no longer shaped around a charismatic actor or actress. A handful of directors, including Billy Wilder, Alfred Hitchcock (fig. **9.11**), and Elia Kazan, followed Welles's lead and asserted their artistic signatures on their films; they became what the French critics would soon call **auteurs**, or authors, a concept that would have been unthinkable during the classical era.

The studios struggled to find a new business model for financing and exhibiting their films after the Paramount Decision forced divestiture (the selling off of studio-owned theaters), but they nonetheless produced a number of important genre films: westerns like *The Searchers* (John Ford, 1956) and *Rio Bravo* (fig. **9.12**), musicals like *Sound of Music* (Robert Wise, 1965) and *West Side Story* (Wise, 1961), social-realist melodramas like *On the Waterfront* and *Rebel without a Cause* (Nicholas Ray, 1955), comedies like *The Seven Year Itch* (Billy Wilder, 1959) and *Some Like It Hot* (Wilder, 1959), and in the first decade after the war, films noir, despairing crime films like *Out of the Past* (Jacques Tourneur, 1947) and *The Big Heat* (Fritz Lang, 1953).

Many American film historians date the end of this transitional era with the introduction of the Voluntary Movie Rating System in 1968. Indeed, the transitional era was characterized by films that challenged the PCA and its Production Code, which continued to make it difficult for the studios to distinguish their films from the similarly censored shows on television. Adaptations of more adult-oriented material in established stage plays like *The Moon Is Blue* (Otto Preminger, 1953), *Tea and*

auteur French film critics in the 1950s argued that while films are the product of a collaborative process they nonetheless have a single author or auteur: the director.

9.12 Movie star John Wayne in Howard Hawks's transition-era western *Rio Bravo* (1959).

Sympathy (Vincente Minnelli, 1956), and *Who's Afraid of Virginia Woolf* (Mike Nichols, 1966) challenged the code and still did well at the box office. More films with more adult themes—frank language, realistic depictions of crime and punishment, sexual situations, and erotic themes (*The Graduate* [Mike Nichols, 1967], *Bonnie and Clyde* [Arthur Penn, 1967], and *Rosemary's Baby* [Roman Polanski, 1968])—followed and by the mid-1960s the studios faced the fact that they would need to modernize the content of their films or get out of the business of making movies.

9-1e The Auteur Renaissance

1968 proved to be a pivotal year in American film history. The new Voluntary Movie Rating System introduced that year changed the look and sound of American cinema, making possible more adult-themed films that explored formerly regulated subjects like sexuality and criminality. It also ushered in a new era of box-office prosperity.

1968 was also a pivotal year in American social and political history. The year saw two political assassinations (of civil rights leader Martin Luther King, Jr., and presidential candidate Robert F. Kennedy) and a dramatic turn for the worse for U.S. forces in the

Vietnam War as the Tet Offensive (a surprise attack by the North Vietnamese mounted during the New Year celebration) made clear to many Americans that the war could not be won. The year climaxed with riots outside the Democratic National Convention in Chicago and ended with the election of Richard Nixon as president. Many of the films released during this era focused directly or metaphorically on the growing political divide between old and young (the "generation gap") and widespread disillusionment in government in general (thanks to an apparent cover-up in the investigation into the 1963 assassination of President John F. Kennedy and the corruption scandal resulting from the break-in at the Watergate Hotel that led to President Nixon's resignation in 1973).

9.13 and 9.14 Two auteur-era films that profoundly reflected a widespread political disillusionment: Robert Altman's *Nashville* (1975) and Martin Scorsese's *Taxi Driver* (1976). Both films depict young men whose alienation leads them to contemplate an assassination.

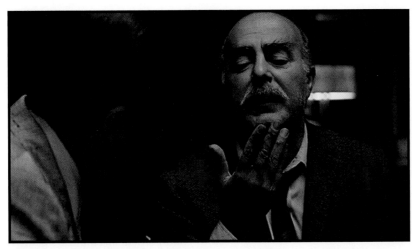

9.15 Francis Ford Coppola's signature visual style: theatrical blocking, chiaroscuro lighting. *The Godfather: Part II*, 1974.

9.16 Robert Altman's signature widescreen mise-en-scène and camera work and complex sound mix can be seen in his 1971 western *McCabe and Mrs. Miller*.

To produce a new American cinema that might reflect or capture this tumultuous era and in doing so attract younger (more politically cynical) filmgoers to finally put an end to the generation-long, box-office slide, the studios turned to a coterie of young directors later dubbed the "movie brats." Many of these young cineastes had honed their skills at the nation's top film schools, where they were exposed to not only the best training in production techniques but also to film history and theory. Popular at the time in critical circles was the auteur theory that posited that every film had an "author" (its director). The three most prominent auteurs in the 1970s were Francis Ford Coppola, Robert Altman, and Martin Scorsese. All three of these auteurs became celebrities whose names alone, like movie stars of years past, could "open" (could be used to successfully promote) a film.

These auteurs endeavored to place their marks, their artistic signatures, on what were otherwise commercial,

Hollywood genre films. What distinguished, for example, Coppola's two 1970s gangster films, *The Godfather* (1972) and *The Godfather: Part II* (fig. **9.15**), was the director's signature style: an affection for theatrical mise-en-scène: stagey set-pieces captured in long takes and a penchant for chiaroscuro lighting; a narrative focus on the family melodrama as opposed to the practical execution of crimes. Coppola reinvigorated the genre and at the same time made the gangster saga his own. In his later work, he brought his signature style to other genres: a war film (*Apocalypse Now*, 1979), a teen-picture (*Rumble Fish*, 1983), and a horror film (*Bram Stoker's Dracula*, 1992).

Altman established a distinct artistic signature adhering around a complex, realistic sound mix, moving camera, and evocative use of widescreen mise-en-scène and camera work. And this style is apparent in a variety of genre projects: a western (*McCabe and Mrs. Miller*, fig. **9.16**), a crime film (*Thieves Like Us*, 1974), and a live-action adaptation of a popular cartoon character (*Popeye*, 1980).

Scorsese imbued many of his films with a recognizable, personal visual style. His films showcase signature stylistic tendencies or habits: an incessant moving camera, complex use of voice-over, and popular music. The narratives often focus on moral, spiritual questions. These signature elements and thematic preoccupations can be found whether we are watching a gangster film (*Mean Streets*, 1973) or a faithful adaptation of Edith Wharton's novel *The Age of Innocence* (1993), a melodrama chronicling the lives and loves of New York City's upper crust in the 1870s.

Many American film historians view the 1970s as a golden age when the artists finally, albeit briefly, took over Hollywood. This era was, alas, short-lived. Studio executives needed a way out of the box-office slide that persisted after World War II; they needed to get young people back into the habit of going to the movies. With the blockbuster success of *The Godfather*, the solution seemed clear: studio executives would need to trust talented filmmakers to update moribund film genres. But such an indulgence of creative talent was by design temporary; executives

9.17 Steven Spielberg's *ET: The Extra-Terrestrial* (1982), the model new Hollywood blockbuster.

9.18 Everything old is new again in the new Hollywood: J. J. Abrams's reimagined and rebooted *Star Trek* (2009), the eleventh installment in the venerable franchise adapted from the classic network television series.

reduced spending on federal social programs and cut taxes. Reagan's insistence on deregulation enabled big businesses across the American economy to get even bigger. In the film industry, this meant a gradual move for the studios back into exhibition and greater diversification and monopolization within the growingly interconnected entertainment industries of movies, TV, and music. Lax enforcement by the FCC (Federal Communications Commission) and FTC (Federal Trade Commission)—hallmarks of the deregulated capitalism of Reaganomics—in many ways made the new conglomerate, synergistic Hollywood possible.

With increased conglomeration came an abandonment of the auteur theory and an increasing emphasis on formulaic blockbusters—thrill-ride movies that delivered on a simple promise to entertain. During this era, action-adventure became the genre of choice and movies were increasingly targeted at adolescent and post-adolescent boys. If any vestige of auteurism survived, it was, on the mainstream screen at least, a box-office auteurism dominated by two producer-directors, Steven Spielberg (fig. **9.17**) and George Lucas. For these two men, whose work and artistic signatures would intersect throughout the eighties and nineties, authorship was less a matter of a personal signature style than of box-office clout.

Much like the classical era, films as opposed to filmmakers took the fore and more and more film franchises—sequelized film properties (fig. **9.18**) celebrating action super-heroes or reinterpreting classic television shows—became so-called tent poles on which the studios could "hang" the rest of their films—blockbusters that earn so much money they support other projects at the studio.

Making fewer films and taking fewer risks than in any previous era, twenty-first-century Hollywood studio revenues have soared. In 2010 the studios earned $10 billion at the domestic box office and many billions more in foreign theatrical screenings as well as ancillary home box office markets both at home and overseas.

were neither anxious nor willing to abdicate control to auteurs for long. Despite the continued success of certain auteur films (Coppola's *Apocalypse Now*, for example, grossed over $100 million in 1979), by the end of the 1970s the studios abandoned the auteur formula in favor of the more predictable and anonymous blockbuster (discussed below).

9-1f The New Hollywood

In a landslide election in 1980, the former Screen Actors Guild President and California Governor Ronald Reagan took the presidency, winning all but four states. Promising to free the federal government from "special interests" and in doing so free the American people from the burden of big government, Reagan supported a "supply-side" ("trickle-down") economic policy that

Independence is in many ways the holy grail in the American film business: something most everyone who makes movies strives for but can never quite attain. To be independent in the film business denotes a freedom from something or someone—the studios, the vicissitudes of the commercial market, and the matrix of companies that dominate the production and distribution of motion pictures in America.

The first self-proclaimed "independents" were those film producers left out of the MPPC but still interested in making and distributing films. Led by the Jewish entrepreneurs Carl Laemmle (fig. **9.19**), William Fox, and Adolph Zukor, these outsiders formed the Motion Picture Distributing and Sales Company. By 1911, the Sales Company had forged a 30 percent market share. A few years later, the independents introduced an alternative product: feature-length films.

9.20 The legendary actor and activist Paul Robeson in his screen debut in Oscar Micheaux's silent melodrama *Body and Soul* (1925). All told, Micheaux directed over forty films, all of them so-called "race films."

In a landmark 1912 court case, *The Motion Picture Patents Company v. IMP* (Laemmle's Independent Motion Picture Company), a U.S. Circuit Court gave the independents access to formerly restricted equipment. The victory in court put the independents on a level playing field with the MPPC. And they seized the day. By 1914 the MPPC was no longer viable and Laemmle, Fox, and Zukor together established a new studio system, headed by their companies: Universal, Twentieth Century Fox, and Paramount, respectively. Ironically, in the years to follow, what independent cinema would be independent of and from would be the very film companies that first fashioned themselves as independents.

9-2a Race Films

When the former independents Laemmle, Fox, and Zukor became the ruling cartel in the film business, independent cinema became the province of small outfits making movies for specific target audiences. In 1915, for example, Noble Johnson's Lincoln Film Company began producing films made by and for African Americans. These **race films** focused on issues of

THE KOBAL COLLECTION

9.19 Carl Laemmle (right) with the French filmmaker Georges Melies. Laemmle led the first wave of independent producers and directors and later founded Universal.

> **race films** Films made by and for certain underserved ethnic groups, e.g., African American and Yiddish-language films in the 1920s and 1930s.

interest to contemporary African Americans in dramas involving social and economic assimilation, including light-skinned African Americans "passing" as white. The best-known director of race films was the entrepreneurial auteur Oscar Micheaux, who went door to door to raise money to make his movies (fig. **9.20**). Micheaux's films played in select urban theaters and on the "chitlin' circuit"—venues in the Southeast where daily life featured a strict racial segregation.

Another genre of race films were the Yiddish-language pictures made by and for European Jewish immigrants living at the time in the Northeast. Set either in Eastern European *shtetls* (villages) or in the Lower East Side of Manhattan, where many Eastern European Jews settled after immigrating to the United States, these films focused on the culture, history, and contemporary struggles of Jews in the first few decades of the twentieth century. Prominent directors included Sidney M. Goldin and Edgar Ulmer (who later directed the classic film noir *Detour* in 1945 and then became a "Poverty Row" executive).

9-2b Poverty Row

All low-budget, independent cinema was and is not created equal; indeed indie cinema ranges from the sublime (art films) to the ridiculous (exploitation films). Even among the so-called niche films—films targeted at underserved audiences (e.g., the race films)—there is a range of products from the artful to the exploitative. Independent films are always independent of or from something, Hollywood usually, but different is not always better.

Movie palaces in the 1930s through the 1950s routinely offered audiences a full afternoon or evening's worth of entertainment: two features (a "double bill"), along with a newsreel, a live-action short (a comedy perhaps), and/or a cartoon. The double bill was headlined by the studio's A attraction. The **B film**, a lower-budget, genre film (a western, gangster picture, etc.), was a bonus for filmgoers who likely went to the theater to see the A feature. The studios initially made their own B films, but over time they ceded the business to a handful of small film companies headquartered in Gower Gulch, a neighborhood in Hollywood. These **Poverty Row** independent film companies, so named because they shared a neighborhood and a business

> **B film** Mostly low-budget genre films made by smaller, independent film companies to round out a double bill.
>
> **Poverty Row** A handful of small film companies specializing in B films headquartered in Gower Gulch, a neighborhood in Hollywood.

9.21 Republic Pictures' singing cowboy Gene Autry.

plan, included Republic, Monogram, Grand National, Mascot, Tiffany, Peerless, Producers Releasing Corporation (PRC), Reliable, Syndicate, Big-Four, and Superior.

The Poverty Row companies made inexpensive, formulaic genre pictures. Though far less ambitious than the bigger studios, the Poverty Row houses made films faster than their better financed counterparts. Speed proved a distinct advantage when responding to fads, like the singing cowboy craze in the mid-1930s. Republic produced a series of films featuring Gene Autry (e.g., *Tumbleweeds*, Joseph Kane, 1935; fig. **9.21**), and Grand National banked on their singing cowpoke Tex Ritter in *Sing, Cowboy, Sing* (Robert Bradbury, 1937). The B western in general was extremely popular in the 1930s—the genre's nostalgic appeal never fully waned—and a number of nonsinging B-movie cowboy stars emerged: Johnny Mack, Harry Carey, Hoot Gibson, Tom Mix, and the soon to be A-list movie star, John Wayne.

Many B action-adventure films exploited the popularity of a previous major studio film or popular radio show. For example, Republic made a quickie-adventure film set in India titled *Storm over Bengal* (Sidney Salkow, 1938) after *Lives of a Bengal Lancer* (Henry Hathaway, 1935) and *The Charge of the Light Brigade* (Michael Curtiz, 1936) were successful for the major studios. B movies were unpretentious and often unambitious, but

they were nonetheless essential to the larger movie show. Going to the movies was a good deal in those days; an afternoon's or evening's entertainment could be had for as little as twenty-five cents in 1940, fifty cents in 1950.

9-2c Exploitation

While the B-movie studios made films to fill out programs headlined by studio A pictures in exchange for a quick, modest payoff, **exploitation filmmakers** like Kroger Babb, a savvy huckster, made films that openly defied the strictures of the MPPDA Production Code and thus could not be screened on the same bill as a "legitimate" studio picture. Kroger is best known today for his 1945 sex-hygiene film *Mom and Dad*, a film chronicling the disastrous consequences of a young single girl's ill-advised sexual liaison.

THE KOBAL COLLECTION

9.22 A drug fiend clutching a marijuana cigarette at a jazz party in *Reefer Madness* (aka *Tell Your Children*, Louis Gasnier, 1936). Exploitation films offered lurid tales in the guise of education.

Because *Mom and Dad* could not be shown as part of a larger, legitimate film program, Babb traveled with his film in his car and rented out (four-walled) theaters for a day. (See the discussion of four-walling in chapter 7.) Babb would advertise his show with lurid posters (which themselves would have been forbidden by the mainstream industry's Production Code) promising just what the studios could not at the time deliver: "Everything shown. Everything explained." For many of the screenings of *Mom and Dad*, Babb hired an actor to play the part of a fictional sexologist named Dr. Elliot Forbes, who, after the screening answered questions from the crowd. It proved a popular if transparently ridiculous stunt. Babb and many of his fellow exploitation filmmakers made a lot of money by never overestimating the intelligence and taste of his audience.

Exploitation films often exploited filmgoers' fascination with sinful behavior in no small part because the studios had to be so careful about controversial issues. Popular topics for exploiters in the United States and abroad included lurid tales of drug-addled and/or sex-crazed youth (fig. **9.22**). These films so exaggerated the social problem they documented and the script and acting were so bad that audiences often found them comical, even camp.

Ridiculous as many of these films were, they were also somewhat ahead of their times. At the very least they tackled taboo topics the studios largely ignored. Some historians argue that exploitation cinema was "necessary" because of the Code and largely disappeared after 1968 when the Code was replaced with the Voluntary Movie Rating System. For example, exploitation films featured on-screen nudity well before mainstream cinema did. Indeed, a popular exploitation genre in the 1950s was the nudist colony film. *Garden of Eden* (Max Nosseck, 1955), for example, showed ample on-screen nudity, which was forbidden by the Production Code. Following a landmark New York court case, in 1959 the independent filmmaker Russ Meyer made *The Immoral Mr. Teas*, a film about a man who gets conked on the head and develops the ability to see through women's clothing. We share that gift with Mr. Teas as we watch the film through his eyes, which linger on a number of attractive women he secretly undresses.

The Immoral Mr. Teas spawned a brief new wave of independent, exploitation pictures. These more visually explicit films included a variety of colorfully termed new genres: nudie cuties (suggestive, often light comedies with nudity but no touching), roughies (depicting antisocial behavior as well as nudity), kinkies (including a series of concentration camp–set soft-core sex films), and ghoulies (merging kink with gruesome horror). The common element among all these independent exploiters was on-screen nudity.

exploitation films Low-budget, independent films that appealed to filmgoers' fascination with sinful behavior or interest in pop culture fads. These films often defied the strictures of the Production Code.

9.23 *Muscle Beach Party* (William Asher, 1964) was just one of several successful beach party films produced by Sam Arkoff for American International Pictures. Here comedian Don Rickles as Jack Fanny takes over the surfers' beach with his crew of bodybuilders, setting the ludicrous plot in motion.

Striking a less salacious note, another group of independent filmmakers in the 1950s and 1960s took aim at the burgeoning youth culture and found a ready and willing audience. Turned off by mainstream Hollywood fare, these teenagers had their own music, their own style. Chief among the purveyors of youth-oriented exploitation cinema were Samuel Z. Arkoff and Roger Corman, who together and then separately released films under the American International Pictures (AIP) and New World banners. Notable among Arkoff's productions are the *Beach Party* films (1963–1966; fig. **9.23**). Made fast and on the cheap, these films exploited the popularity with young American moviegoers of Southern California beach culture: surfing, young women in bikinis, the Beach Boys' pop music, and so on. These films were often screened at drive-ins, a popular destination for teenagers nationwide. That the films tended to trivialize youth culture did not seem to matter much; after all, patrons of drive-ins were not necessarily all that interested in the movie being screened there.

In his over forty years in the indie film business, Roger Corman produced well over 300 pictures. He is best known for producing cheap horror movies for the drive-in market, films with titles like *Attack of the Crab Monsters* (fig. **9.24**), *Attack of the Giant Leeches* (1959), and *Creature from the Haunted Sea* (1961). Corman also produced and directed a handful of titles that transcended their puny budgets and slapdash production methods, films that are classics of a sort: *A Bucket of Blood* (1959), *Little Shop of Horrors* (1960), and *The Trip* (1967).

9-2d Marginalized Filmmakers

The vast majority of commercial studio films are produced, written, directed, advertised, and promoted by white men. For women, people of color, and proponents or participants in non-traditional subcultures, there is little opportunity in Hollywood to make a big-budget movie. As a consequence, lower-budget, non-studio filmmaking—filmmaking independent of and from the Hollywood mainstream, filmmaking less dependent upon reaching a mass audience—has become the site for stories told by and about people that Hollywood movies tend to vilify, stereotype, or simply ignore.

We can count today the number of African American filmmakers making big commercial films on one hand. But African American auteurs have found financing and a modicum of success on the indie circuit. Many of the films present a distinct, alternative point of view: for example, Leslie Harris's *Just Another Girl on the I.R.T.*, which tells the story of a promising African American high school student who gets pregnant and loses her chance to get out of the projects (fig. **9.25**). The film features long sequences of direct address (as the young woman tells her story—a rare instance of getting the first-person perspective of an African American woman), real urban locations, and a hip-hop score. What distinguishes it from a mainstream melodrama is

THE KOBAL COLLECTION

9.24 Cheap thrills: *Attack of the Crab Monsters* (1957), one of the hundreds of low-budget exploitation horror films produced by Roger Corman.

9.25 *Just Another Girl on the I.R.T.* (1992), directed by Leslie Harris. Chantel Mitchell, the main character, speaks directly to the audience in a break from the form and content of mainstream filmmaking. She talks about going to college and getting out of the projects, but Harris's film evinces no simple uplifting fantasy; Chantal talks a big game, but in the end she fulfills the promise of the film's title.

its sensibility, and its identity politics: it is a film by a young African American woman about a young African American woman.

Authenticity is a key to these new race movies. Many of them tell stories similar to those found in mainstream commercial films but focus on race in their approach to a social problem: Charles Burnett's cop film *The Glass Shield* (1995), for example, or Vondie Curtis-Hall's drug-rehab melodrama, *Gridlock'd* (1997), both of which focus on the causes of crime as opposed to simply exploiting its effects. Others focus on everyday lives of people of color, as in, for example, the working-class Chinese Americans in *Chan Is Missing* (Wayne Wang, 1982).

Indie cinema is also a haven for women filmmakers, most of whom continue to find it difficult to break into the mainstream commercial industry. It is a sobering fact that the percentage of women in executive positions and the percentage of women in the director's chair in the early 2000s are smaller than they were in the early 1900s. Like the race films by African–American and Chinese American filmmakers mentioned above, indie pictures directed by and about women provide an alternative to the typecasting and stereotyping characteristic of mainstream commercial pictures. Dating back to Claudia Weill's *Girlfriends* (1978) on through Nicole Holofcener's *Lovely and Amazing* (2001) and *Please Give* (fig. **9.26**), we find in these indie films by female directors character studies of adult women, women depicted as neither sex objects nor sidekicks.

The lives and loves of gay men and women are also handled differently in indie cinema; indeed, the humanized gay men in the indie film *Parting Glances* (Bill Sherwood, 1986) and the gay women in Lisa Cholodenko's low-budget *High Art* (fig. **9.27**) seem remarkable because they are not stereotyped or simplified. Such sensitive material successfully covered first in indie films often finds a second, bigger budget and wider audience life in boutique independents (see below). *Parting Glances* no doubt influenced the bigger-budget *Brokeback Mountain* (discussed below) and *High Art* helped set the stage for *The Kids Are Alright* (also directed by Cholodenko in 2010).

9-2e Boutique Independents

In the 1990s and early 2000s many of the independent film companies that began as alternative movie upstarts were swallowed up by the major studios. Disney, for example, bought out Miramax; Time Warner added New Line and Fine Line, and Universal picked up Focus Features. Other studios diversified in-house. Sony, for example, established its own indie subsidiary, Sony Pictures Classics, and Fox created Fox Searchlight.

The studios' move into so-called independent production and distribution has done little to unsettle the basic function of this alternative cinema; we are still talking about movies that emphasize talk over action, movies

9.26 Nicole Holofcener's indie character study *Please Give* (2010) depicts adult women as something other than attractive sidekicks or sex objects.

directed by women and people of color, movies showcased primarily at festivals and in art houses. And this is by design. These **boutique independents** have added much-needed prestige to studio release slates otherwise dominated by empty action pictures. And when boutique releases win prizes at festivals like Sundance, Cannes, Venice, Berlin, and Toronto or awards at the Golden Globes or Oscars, they boost the studio's reputation and credibility. Though the bottom-line success of studio boutique films may not impress, especially when compared to the box-office take of a studio blockbuster, the bigger picture of studio success, which includes exposure during awards season, has come to depend on boutique label "independent" films.

For example, *Brokeback Mountain* (Ang Lee, 2005; fig. **9.28**), released by Focus Features, earned eight Oscar nominations, winning three including Best Director. That year it also won Best Feature and Best Director at the Independent Spirit Awards. In 2005 Focus Features was widely seen as an indie outfit, but it was in fact a wholly owned subsidiary of NBC/Universal, a boutique division of a major studio. Independence was in this case more a matter of spirit than fact.

In contemporary Hollywood, *independence* is a term often used more casually to refer to films directed by independent-minded auteurs. Quentin Tarantino and the Coen brothers, for example, make films that reach wide audiences (especially among the coveted youth demographic), and most of what they make is distributed by major studios into multiplexes, not art houses (fig. **9.29**). Independence in this context

9.27 Lisa Cholodenko's 1998 lesbian-themed indie niche film *High Art*. Indie films often more sensitively focus on behaviors mainstream films vilify, oversimplify, or simply ignore.

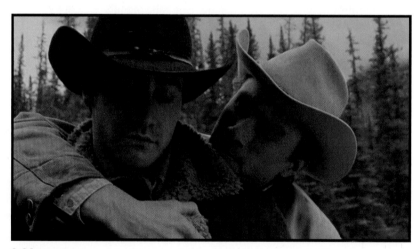

9.28 Focus Feature's *Brokeback Mountain* (Ang Lee, 2005), a boutique indie that focuses frankly on a marginalized subculture.

9.29 Quentin Tarantino's *Kill Bill, Volume 1* (2003) was independent in spirit perhaps but not in fact. It was released by Miramax, at the time owned by Disney, which invested over $50 million dollars in its production and another $25 million in its promotion and release . . . roughly ten times the financial investment involved in a typical indie production.

boutique independents So-called independent films made by subsidiaries of the major studios. Boutique independent companies include Miramax, Focus Features, and Fox Searchlight.

is more a state of mind, an attitude, a vibe, a matter for the studios to finesse and use to their collective advantage. Independent filmmaking in contemporary American cinema need not have all that much to do with real independence; it is instead a genre, a type of film the studios make and market in a specific way.

Cinema is a global medium and traditions in movie-making have emerged in almost every country on almost every continent on earth. Hollywood may well be the primary brand, but American movies share the stage, so to speak, with indigenous products, films that are often formally and technically quite different from the Hollywood product. These national cinemas evince the particular and peculiar histories and cultures of their given places and times; from them we can learn a bit about how other cultures think, how they frame and tell stories, their notions of design and composition, and the importance of conversation and music in their art and in their lives.

Though we risk a superficial sort of cultural tourism if we watch movies made elsewhere and draw conclusions from them about the places and events depicted on-screen, when we view foreign-made films we nonetheless gain a certain access to a culture we might otherwise never know. In this era in which the fluid transfer of money, information, and pop culture across national borders is commonplace, a broader notion of a global cinema is a necessity for the able global citizen. If we open ourselves up to foreign-made films, we can come to better understand and appreciate cultural differences while sharing a common affection for the medium.

We begin our study of filmmaking beyond the United States with European cinema, specifically the following national film movements: German expressionism, Soviet formalism, Italian neorealism, and the new waves in France, England, and Eastern Europe. These movements are notable because of their experiments with film form and themes and because they emerged at particularly interesting historical moments. While it is not possible to offer a complete survey in such a limited space, this brief introduction can serve as a starting point for exploring the rich offerings of European cinema.

9-3a German Expressionism

The **German expressionist** film movement thrived between the two world wars during what historians term the Weimar Republic. Its starting point is inexact; some historians begin with Henrik Galeen and Paul Wegener's *Der Golem* (1915), a film in which Jewish mystics create a monster out of clay. Other historians begin with a film released four years later, the psychological drama *The Cabinet of Dr. Caligari* (Robert Wiene), the story of a somnambulist hypnotized to commit murder (fig. **9.30**). The end point of the movement is easier to fix: 1933, the year Adolph Hitler became chancellor of Germany and nationalized the film industry under his Ministry of Propaganda. Hitler's government effectively put an end to the creative filmmaking that characterized the movement.

9.30 *The Cabinet of Dr. Caligari* (1919), Robert Weine's film about a sleepwalking killer, is an early example of German expressionism.

> **German expressionism** A cinematic style that emerged in Germany between the two world wars. Expressionism is visually characterized by chiaroscuro lighting and highly stylized sets. The best-known expressionist filmmakers are Fritz Lang, F. W. Murnau, and G. W. Pabst.

9.31 The vampire in *Nosferatu* (F. W. Murnau, 1922) is illuminated by a single key light that, in the absence of fill and back lights, presents an ominous figure floating in a void. The blue tint is unique to this print and was created by submerging it into a transparent dye.

9.32 Nosferatu ascends the staircase en route to Ellen Hutter's bedroom, where she will preside over his demise, keeping him "occupied" until dawn. To express visually the vampire's evil, his enormous shadow (his dark side, so to speak) precedes him up the stairs.

Expressionism celebrated the primacy of the shot (as opposed to the cut) and as such emphasized mise-en-scène over editing. *The Cabinet of Dr. Caligari*, for example, features hand-painted sets with dramatically distorted proportions for the architecture and furnishings. Expressionist lighting was notably ominous with visible shadows and dramatic fields of darkness in the frame. The low-key/high-contrast style depicted figures that seemed to float in a dark void, as in F. W. Murnau's *Nosferatu*, loosely adapted from Bram Stoker's 1897 novel *Dracula* (figs. **9.31** and **9.32**).

What makes expressionism especially interesting are the ways in which the films seem to embody a sense of foreboding in Germany between the wars. Some historians have claimed that if we watch closely we can, figuratively speaking, see Hitler coming. We can observe a collective desire among Germans for someone or something to save the nation from peril both supernatural (monsters, killers, maniacs) and commonplace (poverty, inflation).

Several key titles, most notably G. W. Pabst's *Pandora's Box* (1929) and Fritz Lang's *M* (fig. **9.33**), offer deft ruminations on the then-current debate regarding psychoanalysis. Sigmund Freud's work was widely discussed in Germany at the time. The focus in these films on the characters' inner torment, on the symbolism of their dreams, on the power of hypnosis, and the psychology of evil all seem grounded in that nation's intellectual engagement with Freud's new ideas.

9.33 The introduction of the child molester/murderer in Fritz Lang's *M* (1931). The film dared to ask viewers to understand the killer. Note the expressionist visual style as the ominous shadow reveals the character's dark side.

Hitler liked but seems to have misread many of the expressionist films discussed here. Legend has it that he greatly admired the filmmaker Fritz Lang's work and endeavored to appoint him to head the new Nazi film industry. When Lang, a progressive with Jewish ancestry, discovered Hitler's plans for him, he got on a train to Paris. Lang's exit signified and explained the end of expressionism.

9.34–9.39 To simulate the hustle and bustle of the modern Soviet city in his film *Man with a Movie Camera* (1929), Dziga Vertov intercut quickly between static images (the eye) and off-angle shots of things moving in the frame (the trolley, the pedestrians). The effect is kaleidoscopic, but the meaning was nonetheless apparent to the early Soviet filmgoer; it was an exciting time to be a Soviet citizen, to be on the bustling streets, to be a witness (an *eye*witness) to history in the making.

9-3b Soviet Formalism

The Russian revolution of 1917, in which the tsar was ousted and the Bolsheviks established a communist government, ushered in a new era that encompassed politics, society, and art. Vladimir Lenin, who headed the new Soviet government, considered cinema the most influential of the arts and a valuable tool of propaganda for the vast new nation.

Postrevolution Soviet filmmakers believed in the primacy of the cut (as opposed to the shot). Following the editing experiments performed by the film school teacher Lev Kuleshov (see chapter 5), filmmakers like Dziga Vertov (*Man with a Movie Camera*, 1929), Sergei Eisenstein (*Potemkin*, 1925), V. I. Pudovkin (*Mother*, 1926), and Alexander Dovzhenko (*Earth*, 1930)—the directors who epitomized the **Soviet formalist** movement—all believed that the key to a revolutionary film language was editing. Indeed, the two principal Soviet theories of editing—Pudovkin's idea that editing was a matter of "linkage," that shots interconnected like links on a chain, and Eisenstein's theory of montage that theorized the "collision" between shots—were at bottom dialectic formulas. This is relevant here because dialectic reasoning lay at the heart of Marxist thought: thesis / antithesis = synthesis.

Dziga Vertov's newsreels and his experimental "day in the life of a new nation" feature *Man with a Movie Camera* used editing to create an energetic celebration of the emerging, modernizing Soviet state (figs. **9.34–9.39**). Alternating shots from different camera distances and angles with reminders that what we are watching has been photographed by a camera (we see Vertov himself behind the camera in the film) and that these images are meant to be witnessed in wide-eyed awe (the many images of spectating; the close-ups on eyes), Vertov ably showcased the Soviet formalist film style.

Vertov may well have been the most significant filmmaker for the fledgling nation—he headed the newsreel division of the new national Soviet cinema called Kino-Pravda ("a cinema of truth"). But Eisenstein acquired the biggest international reputation. Indeed, his 1925 film *Potemkin* about a failed mutiny aboard a Russian battleship in 1905 simultaneously celebrated the inevitable revolution of the working class and elaborated a new style of filmmaking that influenced filmmakers across the globe. The notion that meaning in cinema hinged upon the collision of shots, the critical juxtaposition of each shot to the shots that preceded and followed it, was ably demonstrated throughout the film. The legendary Odessa Steps sequence, for example, chronicles (actually it stages a fictionalized account of) a massacre of civilians by Cossacks (armed police) through shots of alternating distance and angle (see figs. **5.80–5.83**). The effect is at once frenetic, as such an event would be, and disorienting; in other words, the editing simulates the real experience of what is depicted on-screen. The mutiny itself (figs. **9.40–9.43**) is staged through a sequence of shots of Vakulinchuk, who leads the rebellion, and the sailors who follow him. Again Eisenstein alternates camera distance and angle, at once creating interest in the jubilation felt at unseating authority and the anxiety inherent in the risky task ahead.

The end point of the formalist movement came gradually with the advent of sound and Joseph Stalin's consolidation of power after 1927. Stalin was suspicious of artists in general and of the formalist filmmakers in particular because their free thinking ran counter to a blind faith in the government. Stalin presided over a systematic dismantling of the formalist movement and then carefully restricted filmmaking in the Soviet Union to work that blandly supported state programs and objectives.

In 1929 Eisenstein immigrated to the United States to make movies in Hollywood. It marked a final real and symbolic end to the movement but alas did not mark the beginning of something new for the director. Eisenstein's stay in Hollywood was disappointing; studio executives were at the time used to having their say in the editing of "their" movies. Eisenstein believed that editing was the key to creating meaning in cinema. The notion that a studio executive might alter his editing scheme or choice and sequence of shots was fundamentally unacceptable. Following his disappointing and brief Hollywood stint, Eisenstein returned to the Soviet Union in 1938 but found a movie industry stripped of its vitality, stripped of its centrality to the political and intellectual mission of the Bolshevik revolutionaries who introduced formalism in the 1910s.

9-3c Italian Neorealism

Neorealism took shape in post–World War II Italy and focused on the daunting task of rebuilding a nation in ruin. Adhering around a manifesto of sorts—expressed most eloquently in screenwriter Cesare Zavattini's 1953

Soviet formalism A film movement in the Soviet Union that took shape during the Bolshevik Revolution (1917) and unraveled in the early years of Joseph Stalin's repressive regime (1929). Soviet formalist filmmakers—including Sergei Eisenstein, V. I. Pudovkin, and Dziga Vertov—believed that the essential unit of meaning in cinema is the cut.

Italian neorealism A post–World War II film movement in Italy in which directors adapted the conventions of documentary realism in their fiction films. The best-known neorealist filmmakers are Roberto Rossellini, Luchino Visconti, and Vittorio De Sica.

9.40–9.43 Vakulinchuk calls for action and the sailors put their lives on the line for the cause of social justice in Sergei Eisenstein *Potemkin* (1925).

essay "Some Ideas on the Cinema"—the neorealist film-makers adopted the aesthetic conventions of documentary in the production of their fiction films. They used real locations, cast real people (unprofessional actors) even in leading roles, and shot in natural light. Their goal was to produce a seemingly unmediated reality that, as Zavattini proposed, gave individuals a sense of their historical importance as citizens of a formerly imperialist and intolerant fascist regime and as the hope of a new nation finally free of such tyranny.

The first important neorealist film was Roberto Rossellini's *Rome, Open City* (1945), shot and set in the tumultuous time between the German occupation of Italy and the Allied liberation that followed. The film celebrates the courage of the Italian partisans and their clandestine fight against the Nazis. It depicts the German occupiers as debauched villains who resort to torture and murder because their cause is corrupt and because the war has by then turned against them. In the film's disturbing climax, one of the heroes, Don Pietro (a soccer-playing priest who helps the Partisan underground) is executed in a schoolyard in full view of the children in his parish (figs. **9.44** and **9.45**). In a Catholic country like Italy, Don Pietro's martyrdom served as a frank reminder to filmgoers of the nation's brief surrender to the temptations of imperialism and fascism and their obligation to build a better future for Italy's next generation.

Neorealist films often focused on poverty, unemployment, and life amidst the ruins of what were once great cities. In *Bicycle Thieves* (released in the United States in 1948 as *The Bicycle Thief*), for example, a family's welfare hinges tenuously on the possession of a bicycle (fig. **9.46**). The bicycle is stolen by a street kid with epilepsy who lives in a whorehouse and is protected by the local Mafia. When the father fails to recover the bicycle, he is forlorn; he knows that without it he will lose his job crisscrossing the city putting up posters for Hollywood movies. So, in desperation, on the streets outside

▶ **9.44 and 9.45** The partisan priest Don Pietro is executed in a schoolyard as the neighborhood children look on in Roberto Rossellini's neorealist film *Rome, Open City* (*Roma, città aperta*, 1945).

a soccer stadium, he decides to steal a bicycle. He gets caught and is humiliated in front of his son. In the film's final moments, the owner of the bicycle decides against turning the father over to police, and as father and son exit into the dusk, the boy takes his father's hand, granting forgiveness. The tears on the father's face tell us how important this gesture is to him, but true to the neorealist commitment to a cinematic truth, the father still does not have a bicycle and still does not have a job. Such are the bitter facts of life in postwar Italy.

French New Wave A group of post–World War II French directors including François Truffaut, Jean-Luc Godard, Jacques Rivette, Claude Chabrol, Eric Rohmer, Alain Resnais, and Agnes Varda, all of whom strove to create a more spontaneous and personal style of filmmaking. Many of these directors began as film critics for the magazine *Cahiers du Cinéma.*

9.46 The father (whom we see here cut off at the chest) in Vittorio De Sica's *Bicycle Thieves* (*Ladri di biciclette*, 1948) finds a sort of grace at the end of the film (thanks to the love of his son), but like many Italians after the war, he will soon be out of work.

Other significant neorealist filmmakers include Luchino Visconti (*La Terra Trema*, 1947) and Giuseppe De Santis (*Bitter Rice* [*Riso amaro*], 1949), who, like Rossellini and De Sica, focused on the real conditions of life in Italy after the war. The movement eventually lost steam at the end of the 1950s, and most historians mark the beginning of a new, postneorealist Italian cinema with two films released in 1960: Federico Fellini's *La Dolce Vita* and Michelangelo Antonioni's *L'Avventura*, both of which chronicled a postwar generation lost amidst conspicuous consumption. These films reveal rather cynically that the political commitment at the heart of the neorealist project gave way to a pervasive sense of disengagement.

9-3d New Waves in France, Britain, and Eastern Europe

La nouvelle vague (the **French New Wave**), like the Italian neorealist movement, marked a seeming rebirth of a national cinema unsettled by the war and an embarrassing complicity with the Nazis. Neorealism commenced as the war was winding down. The seeming rebirth of the French film industry took more time—nearly fifteen years after the war's end—in large part because of the sins of collaboration under Vichy (the French collaborationist government under Nazi occupation) and the bloody aftermath of France's liberation. In France the industry had to wait for a new generation of filmmakers untainted by the war to come of age.

9.47 Alain Resnais's 1955 documentary *Night and Fog* affirmed the horrors of the Holocaust using footage shot by the Nazis themselves. Many historians view this film as the necessary first step towards a new, postwar French cinema.

9.48 Francois Truffaut's New Wave film *The 400 Blows* (1959) told the story of a boy, Antoine, who, much like the director when he was that age, found joy in just one place: the movie theater. Here we see Antoine and a friend exiting a movie theater while playing hooky from school.

▶ **9.49** Truffaut's stand-in Antoine is frozen in the film's last image. His future, for the moment, is uncertain. Truffaut would return to Antoine (played throughout the series by the same actor, Jean-Pierre Léaud) in five more films culminating with the 1979 feature *Love on the Run*.

Alain Resnais's 1955 documentary *Night and Fog* is often cited by historians as the film that made the New Wave possible. The film focused unflinchingly on the horrors of the Holocaust and inferred French culpability in the deportation and extermination of its own citizens (fig. **9.47**). Historians contend that this was a necessary step for French cineastes to "move on"—that some very public "mea culpa," some very dramatic display of collective responsibility for collaborating with the Nazis was necessary before a new generation of filmmakers might introduce a new French national cinema.

Many of the filmmakers who participated in the New Wave had at one time worked for the French film magazine the *Cahiers du Cinéma* and were devoted attendees of screenings at the Cinémathèque Française, the French film archive. The *Cahiers* was edited at the time by André Bazin, a groundbreaking film critic who introduced the auteur theory: the notion that like other visual and narrative arts, films have an author or auteur (the director). The young writers working for him included François Truffaut, Jean-Luc Godard, Jacques Rivette, Claude Chabrol, and Eric Rohmer. Legend has it that the neorealist filmmaker Roberto Rossellini dared these young men to stop writing about movies and start making them. They took him up on the challenge and set in motion the French New Wave.

The film that introduced this new wave of French filmmakers to the global audience was the 1959 film *The 400 Blows*, a semi-autobiographical film by Truffaut that chronicled a child's unhappy youth (fractured family, abusive teachers, reform school). The boy's only escape was to go to the cinema (fig. **9.48**). *The 400 Blows*, which won the Grand Prize at the Cannes Film Festival, used a documentary style to further the impression of autobiography. In keeping with its astonishing realism, the film resists any neat narrative closure, ending with a freeze frame on Truffaut's stand-in, Antoine (fig. **9.49**). His future is, at film's end, anything but certain.

Truffaut's fellow *Cahiers* staffer and later auteur-rival Jean-Luc Godard hit the scene the following year with

9.50 An absurdist image that offers a clever commentary on capitalist escape: Juliette dons a Pan Am bag to please a customer in *2 or 3 Things I Know About Her* (Jean-Luc Godard, 1967).

9.51 and 9.52 In *2 or 3 Things I Know About Her* (1967) Godard toys with the verisimilitude of film space with pictorial graphics and intertitles. The intertitle (**9.52**) translates to "the psychology of form."

Breathless, which introduced a radical new film style built upon documentary-style camera work and the attention-grabbing jump cut (see chapter 5). Many of Godard's early films are genre pastiches, reconsiderations of popular American film types like the crime picture (*Breathless*) and futurist science fiction (*Alphaville*, 1965). Godard's films grew increasingly "political" in the 1960s,

culminating in two features released in 1967: *2 or 3 Things I Know about Her* and *Week End*, both ruminations on the banality of bourgeois existence.

The heroine of *2 or 3 Things I Know About Her* is a bored suburban housewife who moonlights as a prostitute. The escape proves unsatisfying; she discovers that every encounter is based on an exchange of cash (fig. **9.50**). Throughout *2 or 3 Things I Know about Her* Godard interrupts the narrative with expressive pictorial graphics that suggest American comic book or magazine advertisements (fig. **9.51**) and intertitles that tell us how to read the film (fig. **9.52**). In *Week End* Godard lampoons the family melodrama in order to critique bourgeois social institutions, especially marriage. As in *2 or 3 Things I Know About Her*, sex in *Week End* is subsumed by commerce, in this case a crazy plan to acquire an inheritance.

An end date for the movement is difficult to pin down. Some historians argue that the cinematic new wave ceased to be after May 1968, when a student protest and nationwide strike brought France to the verge of some very significant changes. Godard, for one, had invested a lot in the politics underpinning the strike, and when it failed—when the De Gaulle regime reasserted its control by declaring a state of emergency—he seemed to lose hope. He gave up on feature filmmaking and turned to documentary and TV production—a career shift that lasted for more than a decade.

As other European national cinemas were (re)born after the war, the term *new wave* became an appropriate descriptor for simultaneous or subsequent challenges to moribund or formerly censored and/or corrupt filmmaking traditions elsewhere in Europe. For example, a British new wave emerged in the late 1950s and 1960s in concert with new literary works of social realism. John Osborne's play *Look Back in Anger*, for example, was adapted for the screen by Tony Richardson in 1959, and Allan Sillitoe's novel

9.53 Youth in (violent) revolt in Lindsay Anderson's British New Wave feature *If* (1969).

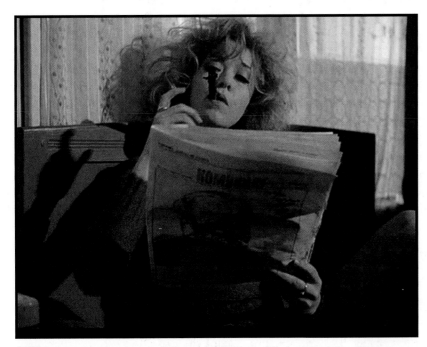

9.54 Dusan Makavejev's wildly original *W. R. Mysteries of the Organism* (1971). The magazine she is reading is "The Communist" and the headline at the bottom of the tabloid reads: "How Karl Marx Fell in Love." With a single image, Makavejev's pokes fun at Communist propaganda and Western tabloid journalism.

Saturday Night and Sunday Morning was adapted by Karel Reisz in 1960.

Historians have since labeled the social-realist films in Great Britain after the war "kitchen sink cinema" because the design in these films was dressed down to match the reality of the working-class characters. These films were shot in a realist style quite like the neorealist films in Italy a decade earlier and Truffaut's films in France; indeed, many of the filmmakers began in the Free Cinema Group that specialized in personal documentaries. But much as these films came to characterize one aspect of postwar adjustment for the disillusioned working class, a far more buoyant, anarchic alternative emerged in the youth-oriented films celebrating the burgeoning pop culture in swinging London in the early 1960s. The youth-oriented films—*If* (fig. **9.53**) and *Hard Day's Night* (see figs. **5.94–5.98**)—deftly adapted TV techniques of three-camera, live coverage and commercial-style, fast-paced editing to capture the fleeting and unpredictable lives of postwar teenagers. Here as in the other new wave movements, the focus was on the transition from past to future, a transition made difficult for those depicted in the kitchen sink films and made easy for the rollicking youth living in the moment of pop culture bliss.

Several of the former Soviet bloc countries also enjoyed brief cinematic new waves after the war. Less directly focused on the war and its aftermath, these films examined life under Soviet influence. In Poland, for example, a new wave emerged featuring directors like Andrzej Wajda (*Ashes and Diamonds*, 1958) and Roman Polanski (*Knife in the Water*, 1962). Many historians argue that the cinematic new wave in Poland offered a prologue to the Solidarity movement in the 1980s. Similarly, the so-called Prague spring of Czech cultural "liberation" from the Soviet Union in 1968 was foreshadowed on-screen in the work of Czech new wave directors like Milos Forman (*The Loves of a Blonde*, 1965) and Jiri Menzel (*Closely Watched Trains*, 1966). And in the former Yugoslavia, Dusan Makavejev made wildly original films that featured graphic sex scenes and sampled documentary images intercut to contrast the joys of the flesh with the less satisfying seductions of popular political and intellectual schools of thought (fig. **9.54**).

Moreso even than European cinema, the vast body of so-called non-Western film—movies made in Asia and Africa—cannot be properly addressed in these brief pages, and a much narrower focus is needed. What follows is a selective look at three modern non-Western film traditions in Japan, Hong Kong, and India, three highly creative national cinemas that have proven popular and influential on the world stage. The few pages here are not intended to fully account for a century-long film history in these countries, but instead they are meant to introduce the important films and filmmakers of a specific place and time with an eye on the relationship between (film) form and culture.

9-4a **Modern Japanese Cinema**

Movies in Japan date to 1896 when the Edison Kineto-graph was first introduced. The first Japanese-made films borrowed heavily from the tradition of Kabuki theater, which is to say that from the very start they looked little like the Hollywood films of the time. As we focus here on modern, post–World War II Japanese cinema—yet another postwar new wave (roughly, 1950–1980)—dramatic formal differences between non-Western and Western cinema can still be observed.

9.55 The sixteenth-century, honor-bound warrior, the samurai, became a symbol of Japan's lost history and culture in its head-long rush into postwar society. *Seven Samurai* (*Shichinin no samurai,* Akira Kurosawa, 1954).

Japanese films are even on first glance different from what most American filmgoers are used to. They tend to concentrate more on character than action and focus more microscopically on details within the mise-en-scène. We can see in this distinct formal system a fundamental cultural difference—a reflection of a society more attuned to detail and more comfortable in small spaces, a society that is, in a word, different from ours.

The director most responsible for establishing an international reputation for postwar Japanese film is Akira Kurosawa, whose 1950 study of a crime and its various retellings, *Rashomon*, won the Golden Lion (grand prize) at the Venice Film Festival, this after its distributor was reluctant to submit it, fearing that the Western judges would not understand the film. Four years later Kurosawa directed *Seven Samurai*, an action film patterned after the Hollywood western but with a distinct Japanese historical context: the cowboys from the American version are in Kurosawa's film sixteenth-century, honor-bound warriors, samurai. A historical figure from a glorious (and glorified) past, the honorable samurai stood in stark contrast to the average postwar Japanese citizen's routine humiliations under American occupation after the war and his or her concessions to a growing Westernization in modern Japanese culture (fig. **9.55**).

Kurosawa went on to shoot a number of samurai films, including *Yojimbo* (1961), *Kagemusha* (1980), and *Ran* (1990). Though the stark black-and-white mise-en-scène of *Seven Samurai* and *Yojimbo* gave way to glorious widescreen color in *Kagemusha* (figs. **9.56** and **9.57**) and *Ran*, a basic compositional scheme held sway in all the films: the juxtaposition of interior and exterior space (of closed to open space; of cramped to expansive space) and the formality of every image, from the bare and meticulously composed interiors to the outdoors where the director emphasizes the formal pageantry of warfare.

The struggle with modernity to which Kurosawa's samurai films allude was recast in a more contemporary context in Nagisa Oshima's *In the Realm of the Senses (Ai no korîda)*, an erotic melodrama produced in 1976. The annihilating love affair between a married man and a geisha pits tradition against an increasingly impersonal and Westernized modern Japan. The film's graphic

▶ **9.56** The sparse and meticulously composed interiors in Akira Kurosawa's *Kagemusha* (1980).

▶ **9.57** The pageantry of warfare captured in an extreme long shot reminiscent of the American western.

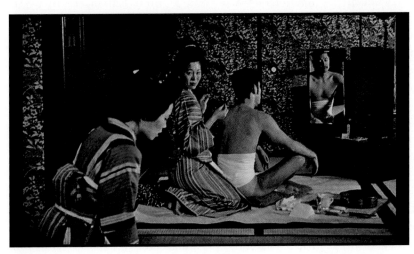

9.58 The importance of composition in Nagisa Oshima's erotic melodrama *In the Realm of the Senses* (1976).

sexuality and its astounding climax, in which the geisha mutilates her lover, may well have overshadowed for many filmgoers the film's trenchant critique of an increasingly amoral modern society. The meticulous design of the film's interior set-pieces (fig. **9.58**), including the graphic sex scenes, were shot, like a lot of Japanese films, with a camera placed as if seated on the floor, level to the action.

For American audiences the best-known Japanese film of this era is the post-nuclear horror picture *Godzilla* (*Gojira*, Inoshiro Honda, 1954). It too focused on the challenges of postwar Japanese society. The monster who lays waste to Tokyo has been awakened and rendered radioactive by bomb tests in the Pacific—a scenario all too close to reality given the events in Hiroshima and Nagasaki less than a decade earlier. The military is powerless to stop the monster (again, a World War II context is apparent), and it is the clever new generation of Japanese scholars and scientists who seize the day. In *Godzilla*, as in so many postwar Japanese films, we see writ large the political, social, and historical anxieties of a nation in transition.

Other important modern Japanese filmmakers include Kenji Mizoguchi (*Ugestu*, 1953), Yasujiro Ozu (*Tokyo Story* [*Tôkyô monogatari*], 1953), Hiroshi Teshigahara (*Woman in the Dunes* [*Suna no onna*], 1964), Kon Ichikawa (*The Makioka Sisters* [*Sasame-yuki*], 1983), and Shohei Imamura (whose film *Vengeance Is Mine* [*Fukushû suru wa ware ni ari*] is discussed in chapter 1). Absent time or space here to do justice to their considerable contributions to global cinema, it is important to assert here, by way of conclusion, that the process of close reading for these films is no different from the methods we bring to bear on more familiar and accessible American films. We are able to focus on narrative, mise-en-scène, camera work, editing, and sound, and how they shape our understanding of a film's meaning.

9.59 The American poster for the Bruce Lee martial-arts feature *Fists of Fury*, directed by Lo Wei for the Hong Kong action studio Golden Harvest in 1971. Lee was born in San Francisco, became an action film star in Hong Kong, and seemed poised to become a global star before his "death by misadventure" in 1973.

9-4b Contemporary Hong Kong Action Films

Modern Hong Kong cinema begins with the Shaw Brothers Studio, a vertically integrated conglomerate that in the 1960s specialized in **wuxia pan**, Mandarin-dialect swordplay action films, as celebrated in Ang Lee's later international hit *Crouching Tiger, Hidden Dragon* (2000). The Shaw brothers' films enjoyed box-office success in the burgeoning film markets of Hong Kong, Taiwan, Singapore, Malaysia, and Thailand.

In 1970 Raymond Chow, an advertising executive with the Shaw Brothers Studio, left the company to form (with Leonard Ho) Golden Harvest. The new studio attained even wider international success than the Shaw Brothers with a series of kung-fu films starring the American-born martial arts expert Bruce Lee, including *Fists of Fury* (fig. **9.59**). Lee's popularity in Asia prompted a coproduction deal with Chow and Warner Bros., which had hoped to establish Lee as a fully international action star. The film the two studios made together, *Enter the Dragon* (Raymond Clouse, 1973), was as hoped an

wuxia pan Mandarin-dialect swordplay action films.

international sensation—the highest-grossing film in Asia to that date.

Lee's successor at Golden Harvest was Jackie Chan, a graduate of the Peking Opera School (a martial arts and acrobatics academy), who in stunt-based action-comedies gained the sort of international popularity Lee had seemed destined to achieve before his untimely death in 1973. Chan is equal parts Bruce Lee and Buster Keaton, an adept fighter but otherwise bumbling every-man astonished at his own ability to escape danger and subdue his adversaries. Like Keaton (and unlike Lee), Chan is an affable presence, but he makes sure (often in bloopers intercut into the closing credits) that there is no mistaking his martial arts and acrobatic talent or the risks he takes in such a stunt-based genre (figs. **9.60** and **9.61**). His early films for Golden Harvest include *Drunken Master* (*Jui kuen*, Yuen Woo-Ping, 1978), *The Young Master* (*Shi di chu ma*, Chan, 1980), and *Armour of God* (*Long xiong hu di*, Chan, 1986).

Chan is a natural "ham," and his goofy, sweet, and amazingly athletic screen persona made for an easy transition to American action comedies. Here we can see the global cinema at work; the accommodation of action stars from non-Western films in mainstream Hollywood blockbusters. He is best known to American audiences for his roles in two popular franchises, *Rush Hour 1, 2,* and *3* (Brett Ratner, 1998, 2001, and 2007) and *Shanghai Noon* (Tom Dey, 2000) and *Shanghai Nights* (aka *Shanghai Noon 2*, David Dobkin, 2003), action-buddy-comedies for which Chan's funny mangling of English and acrobatic, choreographed fight sequences seemed a perfect fit.

The next big star at Golden Harvest was the mainland-China–born martial arts champion Jet Li, whose stoic demeanor seems almost a cliché version of Western stereotypes regarding the inscrutable Asian hero. Li's career took off when he appeared in the producer-director Tsui Hark's epic *Once Upon a Time in China* (*Wong Fei Hung*), released in three parts: 1991 (fig. **9.62**), 1992, and 1993. The Vietnam-born Hark was educated in the United States before establishing himself at Golden Harvest, first making action films and then the popular comedy *Peking Opera Blues* (*Do ma daan*, 1986), which was a surprise hit on the U.S.

9.60 Part Bruce Lee, part Buster Keaton: Jackie Chan, the star of the Golden Harvest kung-fu film *The Young Master* (Chan, 1980). Note how the stunt is shot in full figure, much as a choreographed dance move might be photographed in a musical comedy.

9.61 Chan routinely includes bloopers in the closing credit sequence to show just how dangerous his brand of comedy really is. Here he is holding his back after landing badly from an aerial stunt in *Rush Hour* (Brett Ratner, 1998).

9.62 Jet Li in the first installment of Tsui Hark's action trilogy for Golden Harvest, *Once Upon a Time in China* (1991). Hark's expert use of widescreen gives a panoramic view of the full-figure, martial-arts action.

art house circuit. His teaming up with Li made for an action trilogy that could be taken seriously internationally just as many of Chan's early, cheaply, and poorly produced and dubbed features made at the same studio could not.

Like Chan, Li made an easy transition to American features, including the popular *Romeo Must Die* (fig. **9.63**) and its sequel *Cradle 2 the Grave* (Andrzej Bartkowiak, 2002). These films mark the extent to which action cinema has become globalized. *Romeo Must Die* stars a Chinese-born, martial-arts national champion (Li) and a Bahamian-born pop singer (Aaliyah); it is directed by a Polish-born former cinematographer (Bartkowiak) for an American studio (Warner Bros.) and is loosely based on *Romeo and Juliet*, written in the sixteenth century by the British playwright William Shakespeare.

There is a significant difference between the way American and Hong Kong action sequences are shot. American action sequences are assembled from combining master shots of continuous action with separately shot close-ups. Hong Kong action sequences are usually shot in short bursts with each move choreographed not only between the actors but between the actors and the camera. Editing in the Hong Kong action films is fairly linear, a matter of linking the consecutive sequences that compose the entire set-piece. American action in contrast is more fragmentary, the product of alternating full-figure shots and close-ups.

The contemporary Hong Kong action film is a fascinating mix of stylistic elements from the *wuxia pan* and martial-arts films popular in the 1960s and 1970s, both of which featured elaborate, often aerial, stunt work and the narrative formulas from the 1980s Hollywood action film, which had by that time gained worldwide popularity. Some contemporary Hong Kong films are composed almost entirely of acrobatic action set-pieces often highlighted by stop-motion and slow motion—a choreographed, stylized version of the Asian action set-piece and American gangster narrative that has proved to be popular with audiences worldwide.

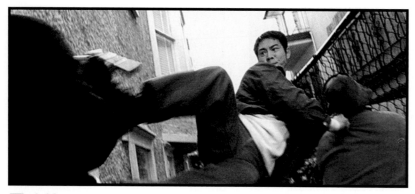

9.63 One of Jet Li's many martial-arts stunts in *Romeo Must Die* (Andrzej Bartkowiak, 2000).

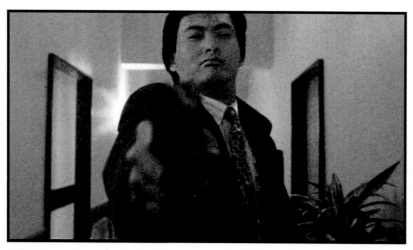

9.64 Chow Yun-Fat in a familiar pose, gun drawn in John Woo's *A Better Tomorrow* (1986).

9.65 In *The Matrix* (1999) Andy and Larry (now Lana) Wachowski signal their indebtedness to Hong Kong action and *wuxia pan* films. Here Neo battles his adversaries with two guns blazing in an action sequence that alludes to the films of John Woo.

The best-known Hong Kong studio director of these more Westernized action features is the Chinese-born John Woo, who with the tough-guy, action star Chow Yun-Fat, made ultra-violent crime films that featured elaborate stop- and slow-motion action set-pieces. The films often focus on a character at a moral crossroads—an ex-gangster reconciling with his policeman brother in *A Better Tomorrow* (*Ying hung boon sik*) (fig. **9.64**), a hired gun who accepts one last job to pay for an operation that will restore the sight of an unintended victim in *The Killer* (*Dip huet seung hung*, 1989)—but the premise is inevitably overwhelmed by the choreographed action. Legend has it that when an American studio executive reluctantly affirmed, "I guess Woo *can* direct action scenes," the American film director Quentin Tarantino added, "Sure, and Michelangelo can paint ceilings."

Like Chan and Li, Woo eventually landed in Hollywood, where his distinctively Hong Kong action style has enlivened and emboldened otherwise formulaic Hollywood action films. Woo's American *oeuvre* includes *Face/Off* (1997) and *Mission Impossible 2* (2000). His success and the popularity of Hong Kong martial-arts films and film stars among younger moviegoers in the United States has fueled a new more global "American" action style. The *Matrix* films directed by Andy and Larry (now Lana) Wachowski, for example, combine fight scenes from kung-fu and *wuxia pan* films and action set-pieces from contemporary Hong Kong action-packed crime films with state-of-the-art American studio special-effects work (fig. **9.65**). It is interesting that the action film, as epitomized by the popular *Matrix* series, is the one genre that has become so fully globalized, seamlessly merging film traditions from the east and west.

9.66 Bollywood movie star Aamir Khan in *Lagaan: Once upon a Time in India* (directed by Ashutosh Gowariker for Khan's production company in 2001). Here he sings his way into his co-star Gracie Singh's heart.

9.67 A rag-tag group of Indian villagers take on the nattily dressed cricketers from the colonial power Great Britain.

9.68 A reminder of just how out of place the British cricketers (and British colonialists in general) are in India; two British players chase a wayward ball to the feet of a colorfully decorated elephant . . . not exactly a scene you'd find back in England.

9-4c Bollywood

Moviemaking in India in the postwar period has featured a range of film styles and types, including the critically acclaimed art cinema of Satyajit Ray and Aparna Sen and the contemporary transnational filmmaking of Mira Nair and Shekar Kapur. Much like the American film industry, which produces a wide range of movies but is often characterized by its action blockbusters, Indian cinema is routinely associated with its most visible product line: **Bollywood**. Produced by the Hindi film industry at the extraordinary rate of 1,500 movies a year, Bollywood features are extremely popular in South Asia, Africa, and the United Kingdom (where in 2008 they out-grossed English-language films). They are known for their epic length and elaborate musical production numbers, which are worked into a wide variety of genres. They mix without apology (or for Western audiences what might pass for adequate narrative preparation or explanation) the present and past of Indian history and society, as well as the natural and supernatural (in the form of Hindu gods and goddesses). For Western audiences, the formal challenges posed by these films can be significant, but cultural and language differences are mollified if not transcended by the films' infectious spirit of fun.

Though often promoted as divertissements and escapist fun, some Bollywood films focus on

Bollywood Films produced by the Hindi film industry that feature elaborate production numbers that are worked into a wide variety of genres.

9.69 *Slumdog Millionaire* (2008) concludes in a manner consistent with the Bollywood formula: Jamal wins a million dollars, escapes poverty, and gets the girl. To mark the happy ending, the train station erupts into a musical-dance number.

serious and important social issues. For example, *Lagaan: Once upon a Time in India*, which received an Oscar nomination for Best Foreign Language Film in 2002, features the usual Bollywood musical production numbers but also presents a thoughtful postcolonial history lesson (figs. **9.66–9.68**). The film focuses on a game of cricket between Indian villagers and experienced British cricketers. The game is meant to resolve a local dispute over taxation (*lagaan* is Hindi for tax), but as the film makes clear, the contest comes to signify a growing resistance in the village (and by extension other Indian villages at the time) to British colonial rule. The match foreshadows the coming Indian struggle for independence and not incidentally the nation's future dominance in the sport. Though the film is almost entirely in Hindi, and with its freewheeling mix of historical drama and elaborate musical numbers it runs nearly 4 hours, Sony Pictures Classics picked up *Lagaan* for a U.S. release and platformed the film in a successful thirty-four-screen, art-house run.

Indian cinema in general and Bollywood in particular achieved worldwide notice thanks to *Slumdog Millionaire* (fig. **9.69**), which won the 2009 Best Picture Oscar and grossed nearly $150 million in the United States alone. The film is not really a Bollywood film, but it is a model twenty-first-century global product and as such introduced elements of Bollywood film into a more Western package. *Slumdog Millionaire* was produced by a British production company (Celador), which was purchased a few months before the film's release by a Japanese conglomerate (Sony, which also owns the American distributors Columbia Pictures, Tri-Star, and Sony Pictures Entertainment). Danny Boyle, the film's director, is British, as is the film's scriptwriter, Simon Beaufoy. The screenplay is based on a novel (*Q&A*) written by former Indian diplomat Vikas Swarup and stars a young man of Indian descent born and educated in England (Dev Patel), who appears with veteran Indian and Bollywood industry actors.

CHAPTER SUMMARY

The history of film in the United States can be viewed as the evolution of Hollywood as a mode of production and distribution and of independents as a separate but parallel development. International cinemas have their own histories, which have influenced and been influenced by Hollywood.

9-1 HOLLYWOOD

Learning Outcome: *Identify the eras in Hollywood filmmaking from 1896 to the present day, and recognize the major filmmakers of each era.*

- The history of Hollywood can be organized into stages or periods that reflect large-scale changes in the film business: early cinema (1895–1914), silent cinema (1914–1928), the classical era (1928–1947), Hollywood in transition (1948–1968), the auteur renaissance (1968–1980), and the new Hollywood (1980–present).

- The films in each era were shaped by such factors as the power of the studios, censorship of adult content, competition from other entertainment industries, the political and social climate, and the creativity and appeal of individual directors and performers.

9-2 AMERICAN INDEPENDENTS

Learning Outcome: *Discuss key moments in indie film history.*

- "Race films" are an early example of independent cinema. These films focused on issues of interest to African Americans, whose lives were mostly ignored in mainstream films.

- B movies were created to offer a double-feature to filmgoers in the 1930s through the 1950s.

- Another early type of fast and cheap independent film-making was the exploitation film, which appealed to filmgoers' fascination with sinful behavior or interest in pop culture fads.

- While the independent film market offers a showcase for women and people of color, the tight production budgets and limited playoff in theaters restricts their access to a small audience.

- In contemporary Hollywood, *independence* is a term often used more casually to refer to films directed by independent-minded auteurs.

9-3 EUROPEAN FILM

Learning Outcome: *Analyze the relationships among history, culture, and film form in four key European film movements: German expressionism, Soviet formalism, Italian neorealism, and the French New Wave.*

- Expressionist films embodied a sense of foreboding in Germany between the wars, with ominous lighting and dramatic fields of darkness within the frame. Their characters and themes suggest a collective desire for someone to save the nation from peril both super-natural (monsters, killers, maniacs) and commonplace (poverty, inflation).

- Formalism emerged in the Soviet Union just after the Russian Revolution. Two Soviet theories of editing were introduced: Pudovkin's idea that editing was a matter of "linkage," that shots interconnected like links on a chain, and Eisenstein's theory of montage that theorized the "collision" between shots.

- Neorealism took shape in post–World War II Italy. Neo-realist filmmakers made films about ordinary life during and after the war that used real locations, cast non-professional actors, and shot in natural light. Their goal was to give Italian audiences a sense that they were participating in an important historical moment.

- The French New Wave marked the rebirth of cinema in a nation haunted by its complicity with the Nazis. New waves emerged in other European countries as well and were also characterized by filmmakers' attempts to rework conventional formulas.

9-4 NON-WESTERN FILM

Learning Outcome: *Appreciate the contributions of filmmakers working outside the Americas and Europe, and discuss the key aspects of postwar cinemas in Japan, Hong Kong, and India.*

- In many postwar Japanese films we see the anxieties of a nation in transition from war-era Japan, through the American Occupation, on to its emergence as a world commercial and industrial power.

- Contemporary Hong Kong cinema has attracted global audiences to its unique mix of stylized Asian action set-pieces and American gangster narrative.

- The enormous output of the Indian film industry known as Bollywood is characterized by epic-length, elaborate, musical production numbers and stories that bring in elements from Indian mythology and history, contemporary life, and Western influences.

Vittorio De Sica's *Bicycle Thieves* (1948) was a landmark film in the Italian neorealist movement. It refers to a specifically Italian predicament at a moment in history when that country was in physical ruin and spiritual crisis. We can see in the film's narrative content, mode of production, and visual style a commitment to the movement—a discernible difference from the American films from that era.

The film's main couple struggle with basic human comforts and as a result they argue a lot. But we know they love each other from this scene. It begins with Antonio talking about his new job as Maria carries both buckets. When she stumbles going downhill, he realizes he's been talking about his problems and not paying attention to her. He grabs one of the buckets, a sweet gesture that reveals in the midst of all the despair and chaos his love for her. Note how a single image from the film reveals many of the key aspects of this movement.

Two distinct generations literally cross paths: the older generation who lived through the Mussolini regime and World War II moving towards the camera and the new generation of children moving in the opposite direction. This was a key theme in many neorealist films: a cold, hard look at the present and a nervous look to the future.

The lead actor, Lamberto Maggiorani, had never been in a film before. The director wanted a real person to embody (and not impersonate) the Italian everyman in the film.

Consistent with neorealist tenets, the scene is sunlit (no artificial light) and is captured on the fly by a moving camera, like a documentary.

Antonio and Maria live in a major Italian city but they need to fetch water from a community well. In 1948 this image revealed to an international audience the astonishing fact that in a major city in a former European world power, many citizens do not have running water.

ANALYZE THE HISTORICAL CONTEXT

Use the following questions to consider the significance of the historical and cultural context of the film you are analyzing. You will need to do additional research to answer many of these questions. For each of the films, answer these general questions as well:

- In what country and during which year was the film produced? What were the major historical events and social trends of that place and time? Which of these events and issues are addressed, either directly or indirectly, in the film?

9-1 HOLLYWOOD	• During which era of Hollywood filmmaking was the film made? • Does the treatment of sex, violence, and/or drugs reveal a censorship code? • Does the film reflect a particular studio's or director's style? • Who is the star in the movie? What was the star's image or public persona, and how does that image affect the part he or she plays?
9-2 AMERICAN INDEPENDENTS	• Who produced this film, and what makes this producer an "independent"? • Where was this film originally screened? What kinds of audiences did it attract? • How do the style and/or story differ from that of Hollywood films of the same period?
9-3 AND 9-4 EUROPEAN FILM AND NON-WESTERN FILM	• Is the film part of a larger film movement? How do its style and/or story reflect that movement? • What can you learn from this film about the culture that produced it—its values and stylistic preferences? • How do these films evince different styles and narrative strategies from American films of the same period?

Barton Fink (Joel Coen, 1991)

FILM

Writing a successful paper for a film studies class involves balancing what you know or feel instinctively about a film—impressions formed after years of going to the movies—with observations and insights grounded in class discussion and readings. Most writing assignments offer the opportunity to think deeply about how a film works. Such deep and close analysis forms the foundation for a critical interpretation or reading of a film that is built upon its formal content and/or its cultural, industrial, or historical contexts. The process of exploring ideas, developing an interpretation, and supporting it with specific details is both challenging and rewarding.

This chapter endeavors to guide you through the stages of writing an academic film essay. It can be consulted at any time in the course and covers a sampled range of assignments.

For many students, an essay assignment can be a daunting task. And though it may be a cliché, that movie image of a writer sitting at a keyboard staring at a blank page or screen "works" because it is grounded in a familiar experience. The following practical suggestions will guide you through writing an essay for a film class, from understanding the assignment to proofreading the final draft.

10-1a Understand the Assignment

At the risk of stating the obvious, the first step in writing a college essay is to read the assignment carefully and make sure that you understand what is being asked of you, including the purpose of the assignment and type of essay it calls for, the scope of the proposed paper, and the audience for whom you are writing. When thinking about the purpose of the assignment, ask what skills are being tested or challenged by the paper and what aspects of the coursework does the assignment regard? Are you being asked to focus on matters of film form and style—narrative, mise-en-scène, camera work, editing, and sound? Or are you being asked to discuss the film in the context of an established genre or with regard to the commercial, social, or historical context in which it was produced? For such contextual essays, you will need to look "outside the frame" and do additional reading.

Some assignments explicitly ask for your opinion about or personal response to a film. There is no right or wrong when it comes to taste, of course, so the professor is likely looking to see if and how you can support your reactions or develop an argument regarding what you have found attractive or unattractive about the material in question. Such impressionistic assignments are often preliminary; your initial responses can be the starting point for an analysis that is objective rather than subjective—an analysis that puts aside opinions and personal preferences in order to construct an interpretation of the film's meaning or meanings and significance. Indeed, most academic film classes endeavor to develop analytical and critical skills, and most writing assignments ask for what composition professors call "interpretive analysis," the close study of some aspect of a work with a goal of figuring out what it might mean or how this one aspect might contribute to the work as a whole. It is important to be clear from the start whether personal opinions and assessments are appropriate to the assignment.

The scope of the assignment will also drive your plan for the writing process. Are you being asked to focus closely on a single scene or a whole film? In either case, you will need to view the film multiple times. Are you being asked to consider how other academics have thought about the film in question? Given such an assignment, you will need to do some library and/or Internet research. If the scope of the paper is broad—involving several films and/or larger trends—you will need to narrow the topic down significantly. For example, if your topic is the history of the woman's film and your essay is to be five or fewer pages, you will need to hone in on a single aspect common to these films, for example, a character type, a narrative tendency, the use of close-ups, the use of lush orchestral underscoring.

A final aspect of the assignment concerns your audience. Knowing for whom you are writing informs both content and style. If you will be writing a film review for a general audience, then you would likely provide an extensive plot summary, avoid "spoilers," and adopt an informal tone. When writing an academic essay for your professor and possibly other students, you should employ the vocabulary of film analysis, adopt a more serious tone, and use plot summary only when needed to establish a framework for your points.

The following advice is primarily designed for assignments that ask for a close analysis of a scene or full film. Help with research essays that require appropriate documentation is provided in section 10-2.

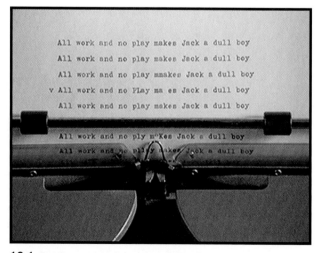

10.1 Getting started can be difficult, as Jack Torrance discovers in *The Shining* (Stanley Kubrick, 1980).

10-1b Close Reading and Taking Notes

The process of writing about a film begins with your first encounter with the "primary text"—the film itself. It is helpful to come to a screening with some questions in mind, prepared to take notes. (Screening questions are offered at the end of each chapter; see if they fit your assignment or devise your own.) While you don't want note taking to detract from your enjoyment of the film, quickly record your observations either during or immediately following the screening, while your impressions are still vivid. Don't worry about how the entries might fit together into an argument or thesis. If something strikes you, write it down.

Even though taking notes can be difficult in a public setting and in the dark, many film professors still prefer their students to watch a projected film. The experience of watching a movie with other people on a big screen with a proper sound system can significantly enhance one's appreciation and understanding of a film. Comedy and horror films, for example, depend greatly on their effect on audiences. So while it may not be relevant to comment upon other people's reactions, it is useful on first viewing to get a sense of how such films affect the people around you. Laughing aloud or gasping at a sudden jolt of violence are involuntary responses and are markers of important moments in the film. Watching a film straight through without interruption gives you a better sense of narrative (real and screen) time. Suspense, for example, is about things suspended in time both in the story world and in the theater.

Whether you are watching a film for the first time with other students or alone, the key is to recognize important, unusual, and transitional moments: a major event in the narrative, a (perhaps corresponding) shift in visual style or sound, an exemplary scene that stands out, a sound, a line of dialogue, or an image that is repeated in subtle variations in the film. These observations will help you decide which scenes to focus on for your close analysis.

Subsequent viewings on DVD or online will allow you to take fuller notes and pause the action while you write. You will be able to take notes more quickly by using abbreviations for terms connected to camera work, editing, and sound (see the feature Common Film Abbreviations).

The following example of note-taking focuses on a single key scene in the 1947 film noir *Out of the Past*. The scene in question occurs at the 36-minute mark and roughly at the end of the film's first act, the act that gives the backstory ("the past" of the title) for the events to

Common Film Abbreviations

CU: close-up

XCU: extreme close-up

MCU: medium close-up

MS: medium shot

LS: long shot

XLS: extreme long shot

MLS: medium long shot

HA: high angle

LA: low angle

SL: screen left

SR: screen right

CM: camera movement

TS: tracking shot

HH: handheld

CR: crane

Z: zoom

LT: long take

S/RS: shot/reverse shot

DISS: dissolve

FI: fade-in

FO: fade-out

DS: diegetic sound

NDS: nondiegetic sound

VO: voice-over

OS: off-screen

follow. The scene begins with Jeff and Kathie, hiding out from the gangster Whit Sterling, from whom Jeff has stolen Kathie and from whom Kathie has allegedly stolen $40,000. Jeff (and the audience) believes at this point in the narrative that she is innocent of that crime. Their life on the lam is interrupted when they are discovered by Jeff's former partner, the detective Jack Fisher, who asks for money to keep their location from Whit. A fistfight between the two men ensues—a predictable enough scene. But the fight is punctuated by the film's first big surprise, Jack's murder by Kathie. It is hard to miss that this is a key scene; after all, there is a murder and the scene ends with Kathie abandoning Jeff, leaving behind a dead body and a bankbook affirming her theft from Whit.

10.2 Jeff and Kathie framed in the doorway in Jacques Tourneur's *Out of the Past* (1947).

10.3 Jeff's former partner Jack calmly approaches the house.

Beginning of scene, Jeff (Robert Mitchum) and Kathie (Jane Greer) at a cabin in the woods at night, looking outside (fig. **10.2**).

- Framing: Off-center two-shot; it's an unsettling image—they have been caught, they are trapped. The doorway is a frame within the frame.
- Camera angle and placement: LA/MS (low-angle medium shot; see the feature Common Film Abbreviations); we see them from the point of view of someone outside, someone they see looking at them.
- Acting: He appears mildly surprised. She looks angry.
- Costumes: He is in his detective's trench coat, and she is dressed in a snug and stylish suit jacket. His city clothes look out of place in the country setting. She is the film's femme fatale, and she looks the part.
- Editing: An eyeline match reveals Jack Fisher walking up the driveway.
- Sound: We hear Jeff's voice-over setting the scene. This explains why Jack's arrival is initially viewed as bad news, and Jack is initially identified as the scene's villain (and not—not yet at least—its victim). The scene is otherwise relatively quiet, with only natural, diegetic sound effects and no music.

Jack Fisher (Steve Brodie) approaches the cabin (fig. **10.3**).

- Camera angle and placement: HA/MLS. We see Jack's arrival from Jeff and Kathie's point of view.
- Acting: The actor appears carefree, nonchalant. The character Jack Fisher thinks he has the upper hand.
- Costume: Jack is dressed in black; he is, from our perspective at this point, the villain in this scene.

10.4 Kathie shows her ruthless side: "Why don't you break his head?"

10.5 Another oddly framed and angled shot.

Once they are all inside, the focus turns to Kathie (fig. **10.4**).

- Camera placement: MS
- Lighting: A characteristic noir shadow is behind her (a dark doubling suggests that she's up to no good).
- Sets and props: The cabin is decorated with country touches like the ceramic figures in the background at right. These characters look out of place in this setting. The curtain rod and curtains along with the window frame Kathie. The angle of the window frame is leading her out the door.
- Dialogue: "Why don't you break his head?" A shocking line. Maybe Kathie really isn't so innocent after all? Effects remain incidental and diegetic. No music.
- Editing: The line of dialogue surprises both men and cues the next shot.

The two men turn and look at her (fig. **10.5**).

- Framing: Canted and unsettled. Things in the filmed world are suddenly "off."
- Camera angle and placement: LA/MCU. The scale of the human figures is off: Jack fills screen right; Jeff seems smaller, especially with all the negative space above his head. They are looking at Kathie, who is off-screen. Why?
- Lighting: Jeff's face is half-lit, half-dark. Jack's face is dark. This speaks to their characters: half-good/half-bad; all bad.

The two men slug it out until we hear a gunshot. Then, three quick cuts: from a two-shot of the men fighting (fig. **10.6**), to LA/MCU of Jeff looking surprised (fig. **10.7**), to a complexly framed shot of Kathie holding the gun at her waist (fig. **10.8**).

- Camera angle and position: The LA/MS on Jeff (fig. **10.7**) is ironic; he looms large in the frame but wins the fight only because Kathie shoots Jack.
- Lighting: Jeff's looming shadow coupled with the scale of the shot (fig. **10.8**) is further ironic: he looms large but she's got the gun.
- Acting: Jane Greer as Kathie is cold and emotionless when she explains why she shot Fisher.
- Editing: The eyeline cut promised by the shot of Jeff looking is not realized. We get a two-shot of Kathie and Jeff instead (fig. **10.8**).
- Combined camera work, lighting, acting, and editing: These highlight the notion that things are suddenly not what they seem.
- Sound: A gunshot is heard (fig. **10.6**). Underscoring is introduced: orchestral music rising quickly to a crescendo, then to sustained notes in a lower register and in a minor key. Interesting how there is no music at all in the rest of the scene. And as a result its introduction here makes clear that this is a climactic moment. The gunshot is OS/DS (off-screen and diegetic).

10.6–10.8 Kathie finishes the fight for Jeff. She is clearly not who we thought she was.

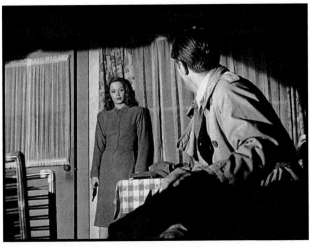

10.9 An ominous shadow hangs over the scene.

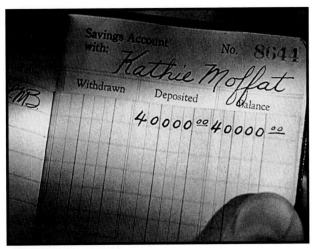

10.10 Kathie's bankbook.

We then see Jeff kneeling over Jack's body, checking that he is dead (fig. **10.9**).

- Camera work and blocking: Scale again; Jeff is large in the foreground, Kathie is small in the background. This is odd given what's just happened. He is seen from the waist up, she in full figure. The door is in the frame—why? (We soon discover why: Jeff looks away from Kathie for a moment and she swiftly exits through the door.)
- Lighting: An ominous shadow hangs atop the frame.
- Props: It's hard to miss the gun. In the previous shot it is at her waist and pointing straight ahead. In this shot it just hangs at her side. She isn't threatening Jeff, but she remains armed and in control.
- Dialogue: Kathie explains why she shot Fisher: "You wouldn't have killed him. You would have beat him up and thrown him out." (She finishes the job he can't or won't.)
- Music: Orchestral underscoring—long sustained notes—highlighting the suspense.

Jeff pauses over the body, and the camera holds on him as he lights yet another cigarette (a motif throughout the film). In the meantime we hear sounds from off-screen culminating with a car ignition firing and tires moving along a gravel road. We see the open door. Subsequent shots are of Kathie driving away and Jeff looking at Kathie's bankbook (fig. **10.10**). This shot proves that Kathie really did steal from Whit.

- Camera position and angle: CU on bankbook page suggests Jeff's point of view.
- Lighting: Maintains noir shadows, but the name and deposit amount in the bankbook are lit and readable.
- Music: Orchestral underscoring mark Jeff's (and our) realization that Kathie is a criminal, not a victim.

Your notes will provide the specific details that you'll need to support your interpretation of the film. They can also help you see significant patterns in the scene that can be the starting point for an interpretive claim or thesis. In this scene, for example, the doorframe is noted in connection with entrapment and escape, which may lead you to look for how doors and gates are used elsewhere in the film and then discuss what the significance of this aspect of mise-en-scène might be. The notes above include observations about gender role reversal that could lead to an examination of gender and power as it plays out in the narrative, including an analysis of Kathie as a femme fatale or of Jeff as a man's man nonetheless losing control over the narrative (this despite the extensive use of voice-over that might otherwise signify his mastery, his control over what he sees and does). You might consider the larger significance of such unusual elements as the canted framing, the odd shadows, and the way that these characters look out of place in the country setting. Engaging the scene in a dialogue—a Q and A session of sorts in which you ponder how aspects of narrative form and style function in the film—can also help you to generate ideas that will lead to an interpretive claim, a basis upon which you can build the argument proposed by your paper.

10-1c Organizing and Writing

While no single formula applies to every writer, it is generally a good idea to organize your notes before you begin writing. For many writers, making an outline helps. An outline can be a simple list of ideas or a selection of important shots and scenes to highlight. Adding details or examples (from your notes) under these basic headings helps you move from generalities to specifics.

For the sample scene analysis essay reprinted at the end of this chapter (see Focus on Writing a Scene Analysis Paper: *Now, Voyager* on page 290), the writer's notes followed the chronology of the scene, but the outline then reordered the observations into an alternative scheme, putting into separate categories aspects of narrative, theatrical blocking, lighting, costume, makeup and hair, sets and setting, camera work, editing, and sound. For the sample film analysis essay also reprinted at the end of the chapter (see Focus on Writing a Film Analysis Paper: *The Big Sleep* on page 292), the working outline was initially organized into five key moments in the film that clearly illustrated the writer's interpretive idea. The writer then filled in details taken from the viewing notes that supported the interpretation.

The essay follows the basic chronology of the selected scenes and the headings in the writer's outline.

When you are ready to start writing, it is time to develop your interpretive idea into a thesis and then to express that idea in a concise and precise form: a thesis statement. The thesis statement is crucial in focusing your argument, making clear to your reader what you plan to do, what you plan to examine, and (as many professors like to put it) "what's at stake" in your paper. The thesis statement goes beyond mere description (a neutral account of what you observe in the film) to offer a complex intellectual argument.

A compelling thesis moves past what would be obvious to anyone seeing the film. Many professors encourage students to begin with "a working thesis," a rough version of the argument, which might change as you think through your ideas in writing. By the time you have a final draft of the paper, the thesis should be precise and assertive.

Each paragraph works to develop the thesis. In the sample scene analysis paper, each paragraph focuses on a single element and how it communicates an idea about the character's transformation. In the sample film analysis paper, the paragraphs build an argument about class conflict by moving chronologically through the film, devoting a paragraph or more to explicating each of the key scenes. Every paragraph should have a unifying idea, usually announced in a topic sentence at the beginning of the paragraph, a sentence that indicates how the paragraph will develop the thesis. All of the details in the paragraph should focus on the "promise" made in the topic sentence.

There is no set length for paragraphs. But if a paragraph is just a couple of sentences, it may mean that you are not spending enough time elaborating your argument, that you do not have a sufficient number of examples or are not spending enough time describing these examples and making clear how they support your argument. If a paragraph fills an entire page, there is probably more than one topic in play, and breaking it into two paragraphs will be a good idea.

Writing the final, or concluding, paragraph can be challenging. One approach is to restate the opening thesis in a slightly altered fashion and then to segue into some version of "As I have shown, . . ." or "This paper has shown" This satisfies a narrative continuity: the introductory paragraph has established what will be discussed, the body of the paper carries out that promise, and the concluding paragraph states in general terms how the rest of the paper has delivered on the promise made in its introduction. But this style can be quite dull;

if the reader has read the paper closely, why do they need to be reminded about what they have already read? Also, this formal strategy invites oversimplification and generalization, the very things you have endeavored to avoid in the body of your paper. You have after all written several paragraphs to make your argument; how then can you summarize all this work without cheapening it?

A better strategy for the concluding paragraph is to use summary and recapitulation, both necessary to an extent in a conclusion, to make or highlight a final point. The concluding paragraph in the scene analysis paper offers a useful model (see Focus on Writing a Scene Analysis Paper: *Now, Voyager* on page 290). It accomplishes two goals: it focuses on sound (especially underscoring) and it takes us to the final shot of the film (and back to the title of the essay, which is taken from the film's exit line). In doing so, this concluding paragraph uses the brief discussion of sound and music to reemphasize the larger argument about Charlotte's transformation, as promised in the introductory paragraph. The concluding paragraph in the film analysis paper focuses on how the film's ending glosses over the central conflict developed in the essay in order to supply the film's "Hollywood ending." In doing so, it follows the chronological account of the film presented in the body of the paper but also offers a mild surprise or twist on the thesis (see Focus on Writing a Film Analysis Paper: *The Big Sleep* on page 292).

10-1d Revising and Proofreading

Writing is a process: notes, outline, first draft. Completing a first draft is an accomplishment. But expecting this first stab at your paper to be ready to hand in is unrealistic. Indeed, a final and crucial stage remains: revision, which includes rereading, rethinking, rewriting, and proofreading. Successful writers—critics, historians, novelists, poets—routinely go through multiple drafts before they submit their work.

The following checklist should help you revise your paper successfully.

1. If possible, take a day off between completing your first draft and starting the second draft. You want to bring "fresh eyes" to the work.
2. As you reread the essay, ask, does the paper have a clear (and clearly stated) thesis? Will the reader understand what you set out to prove?
3. Does the opening paragraph establish which film(s) or scenes you will be discussing and provide sufficient context for your reader?
4. Does each paragraph have a clear topic or function that connects to and helps you explore your thesis? Do the examples follow and support a stated topic, idea, or goal? Are the examples relevant and persuasive?
5. Do the paragraphs follow logically in the exposition of your argument?
6. Does the body of the paper fulfill the promise made in the opening paragraph?
7. Does the paper have a clear, concise, and interesting concluding paragraph?
8. Reread the paper again, aloud. As you read through the essay, *listen* to the prose. Is the diction (the word choice) natural and persuasive, controlled and clear? Listen for awkward phrases and sentences that don't seem to follow logically. If you have to slow down or stumble as you read aloud, that's a clue that something might need to be rewritten.
9. If possible take another day off. Fresh eyes, again.
10. Proofread. Your word-processing program will do some of the work for you, but it is not infallible, and the program does not know what you're trying to say in your paper. Here again, reading aloud helps, if only because it slows down your rereading, which will help call attention to instances of clunky grammar and awkward phrasing. Proofreading shows the reader you cared enough about what you've written to make sure it looks and sounds right.
11. Finally, if you've done outside research, check to make sure the quotations and the citations are accurate.

10-2 RESEARCH AND CITATION

Academic writing is often viewed as a conversation among scholars in which ideas are shared and debated. Reading other critics' interpretations of a film not only gives you new insights but may also help you develop your own observations. You must, however, credit their work. This section offers tips for finding and documenting sources.

10-2a Conducting Research

Research is a broad term and can include everything from gathering information on the cast and crew to learning more about the movie business, historical and social contexts, and seeing what other scholars have said about the film and filmmakers you are discussing. It is important to remember that research is not simply the accumulation of information to decorate or fill out a paper. The key to successful research is discerning what information supports your argument or thesis. Thinking about and answering a few key questions can help you begin a research project:

- What am I looking for? (This need not involve a certain conclusion. You may not know in advance what you will find out. But a basic research question helps narrow things down. Remember: a research paper begins with an implied promise, a critical or analytical question.)
- What does my audience expect to learn or gain from this project? (Take a long, hard look at the assignment.)
- In what sort of texts (monographs or books, academic journals, trade journals, popular magazines, newspapers, or websites) will I likely find useful information?

With regard to the third question above, it is also smart to use a balance of different sources. You don't want your paper to depend on just one key source. If it does, you risk simply recasting someone else's argument as your own. And you don't want your paper to depend on just one type of source. For this latter concern, it is important to distinguish between the two types of research material: primary and secondary sources. Primary sources—the film, a script, a production budget, an autobiography, relevant legal documents, and artifacts—provide first-hand testimony or direct evidence. You will always use at least one primary source, of course—the film or films you are studying. If, for example, you were writing about *The Godfather* as an example of a Hollywood studio-produced auteur film that reversed the box-office decline after the second world war (see 9-1e), primary sources such as the original production budget, the contentious memos exchanged between producer Robert Evans and director Francis Coppola, and data on the film's box-office performance will be valuable. If your focus is instead on the film as an adaptation, you would need Mario Puzo's novel as a key primary source.

Secondary sources offer description and interpretation of primary sources; critical essays and biographies are examples. Secondary sources are valuable for most critical analysis papers as they offer a broader context for arguments culled from primary sources.

The best place to start a research project is your college library, where a research librarian can help direct your search. A quick catalogue search and even a walk through the stacks in the relevant subject area can produce excellent results. Also quite useful are electronic databases like Lexis/Nexis and Project Muse and published periodical guides like the *Reader's Guide to Periodical Literature* and the *MLA Bibliography*. Encyclopedias are useful for fact checking and basic background information but they seldom include analysis that you can productively use.

The Internet offers access to a wealth of film journals, blogs, databases, and wiki-sites. Focus your attention on sites that are vetted—where publication is selective and based on rigorous editorial criteria. The work found on these sites will be properly edited, fact-checked, and proofread. For example, *Film Comment* (http://filmlinc.com/film-comment), a print journal published by the Film Society of Lincoln Center, offers much of its material free online, and the venerable film, media, and society journal *JumpCut* (http://www.ejumpcut.org/home.html) is available in its entirety and free online. Other reliable Internet sources include the official sites of the American Film Institute (www.afi.com) and the Library of Congress Motion Picture and Television Reading Room (http://www.loc.gov/rr/mopic/). For business context and production details, the industry trade journal *Variety* (http://www.variety.com/Home/) is very helpful.

Some rules of the road: be wary of glitzy gossip-oriented sites and opinion-based blogs. Be judicious

10.11 Depending on your focus, a research essay on *The Godfather* (Francis Ford Coppola, 1972) could draw from primary sources such as the script, the novel, and interviews, or secondary sources such as film reviews, essays, and books about the film, director, era, and genre.

when using Wikipedia and the Internet Movie Database (IMDb); laudable as these projects are, many of the entries are "under construction" or "under review" and accuracy is a goal not yet met. The Internet has put a wealth of information at our fingertips. But a lot of what we find on the web is subjective. And a lot of it is inaccurate. Determining the reliability of a site is essential and difficult. Many professors prefer library research to Internet surfing. Others require students to use a combination of print and electronic sources.

From first-hand experience I can attest that research can be a lot of fun, and it can lead in some unexpected directions. In my own research, for example, I have begun looking into one thing and ended up learning a lot about another. Doing research is much like piecing together a puzzle, one that changes and moves towards conclusion subtly but distinctly with each new piece of information.

For example, after a screening of *The Blair Witch Project* in my New American Cinema class a student asked, "Well if *The Blair Witch Project* was so successful, why did Artisan Entertainment (its distributor) go out of business so soon after the film's release?" I didn't know the answer, so I decided to do a little research. My research at the library and on the web took me in a number of fascinating directions, some merely interesting but not that relevant to the project (e.g., the film's star, Heather Donahue, quit acting after failing to find a decent follow-up role and took up growing marijuana for a living), and others that helped explain how and why the company failed (its earlier troubled history as Live Entertainment, the company owned by Jose Menendez, who was killed along with his wife by his two sons in one of the most famous murders in recent Hollywood history), its failed ventures into home video (just as that industry fell apart), and its purchase and liquidation by Bain Capital, a venture capital company founded and run by Mitt Romney. What I gleaned from my research into why Artisan went out of business was the story of a company embroiled in scandal (the Menendez murders), a company that invested foolishly (in videotapes and later retail video stores just as the Internet would make such businesses obsolete), a company that fell victim to a well-known venture capitalist and politician who profited from its takeover and liquidation.

10-2b Crediting Sources

Whenever you use research material in the writing of your essay, whether it is a direct quotation or a paraphrase (in which you've put another writer's ideas in your own words), you need to attribute credit where it is due: you need to properly cite the source of the quotation or idea. Failure to do so is plagiarism, a breach of academic honesty and integrity that is not tolerated on any campus anywhere.

The principal exception to this rule is when information that you've encountered in your research is a commonly held opinion or a fact that can be readily obtained: "the 1960s were a politically turbulent decade," for example, or "Brad Pitt is a movie star." You would need to document someone else's original research into a cause of 1960s unrest or their opinion on the reasons for Pitt's stardom. A second exception is specific to film essays: quotations from movie dialogue, even when checked for accuracy in a published screenplay, need not be cited.

In addition to using citations to credit your sources as described in the next section, remember to use quotation marks when you are using a source's exact language. When you paraphrase, avoid phrasing that closely resembles the original.

Among the most common formats for documenting sources in college papers are the MLA (Modern Language Association) style, in which abbreviated citations are made in parentheses in the body of the essay; the APA (American Psychological Association) style, which also uses parentheses; and the *Chicago Manual of Style*, which uses numbered in-text citations. All have specific formats for listing works cited at the end of the paper. No documentation style is inherently superior (so, always use the documentation format assigned by your professor), and all serve the same basic purpose; they give due credit to the author of the quoted passage or borrowed idea or information in a consistent and clearly organized format. An additional function of following a proper citation format is to provide readers with the information necessary to easily find and consult your sources themselves.

10-2c MLA Documentation Style

MLA Style: In-Text Citations

Parenthetical (in-text) citations in your essay give readers some basic information about your sources and also allow them to locate your source in a list entitled *Works Cited* at the end of your paper. Basic information includes the author and page reference. If the author is named in the body of the sentence, then the parenthetical citation does not repeat that name. The parenthetical citation is placed after a quoted or paraphrased idea, within the sentence.

In the novel *Now, Voyager*, the omniscient narration grants us access to Charlotte's thoughts: "But she hadn't smoked the cigarette to assert her own personality. On the contrary she smoked it to conceal her own personality" (Prouty 3).

As the film historian Robin Wood asserts, *Meet John Doe* "at once transcends its director and would be inconceivable without him" (66).

Eric Smoodin's research into the fan mail generated by *Meet John Doe* reveals a startling lack of consensus among American moviegoers in 1941 to the policies of President Franklin Delano Roosevelt's New Deal (158).

If you include *two or more works by the same author* in your paper, then the author's name alone would not be enough for your reader to locate the full source in your works-cited list. Include the title of the work in your sentence, either in parentheses or within the body of the sentence.

When citing a film for the first time, include the director as well as the title. MLA style does not require that you include the year of the film's release; however, it is common to do so in a film paper.

Irving Rapper's 1943 film *Now, Voyager* celebrates the notion of female self-sacrifice for a higher cause.

Now, Voyager (Irving Rapper, 1943) celebrates the notion of female self-sacrifice for a higher cause.

For a quotation of four or more lines, use block quotation style—quotation marks are not used; the passage starts a new line and is indented by one inch. Note that block quotations are the exception to the rule about putting the parenthetical citation within the sentence. The page number in this example is placed outside the end punctuation, the question mark.

In a 1992 essay titled "Slacking Toward Bethlehem," journalist Andrew Kopkind summarized the attitude of Gen-X slackers and Kevin Smith's film characters:

> In a few years, a steady job at a mall outlet or a food chain may be all that's left for college graduates. Life is more and more like a lottery—is a lottery—with nothing but the luck of the draw determining whether you get a recording contract, get your screenplay produced, or get a job with your MBA. Slacking is thus a rational response to casino capitalism, the randomization of success . . . if it is impossible to find a good job, why not slack and enjoy life? (187)

For an in-text citation of an online source, follow the same guidelines as above. If paragraph or screen numbers are provided instead of page numbers, work those into your citation: (author, screen no.) or (author, par. no.). If those are not available, embed a cue into your sentence that will lead the reader to the appropriate citation in your works-cited list. Do not clutter in-text citations with URLs.

MLA Style: The Works-Cited List

The works-cited list provides fuller publication data about your sources so that it would be possible for a reader to locate them in a library or online. The list starts a new page with "Works Cited" as the centered heading, and the list is arranged alphabetically. It is double-spaced, with one-inch margins on all sides, and the page number in the upper right corner (this formatting applies to the entire paper). Entries that are longer than one line should be indented one-half inch on the subsequent lines. The simplest approach is to type the entries flush left, with a new line for each entry, and then apply a one-half-inch hanging indent to the entire list after you are done.

The following guidelines are for the types of sources most commonly found in documented papers written for introductory-level film courses. For more information or guidelines on other types of sources, consult the *MLA Handbook, Seventh Edition* (2009).

A film. Include the name of the film, the director, distribution data, and medium (film, DVD, web). Note how the title of a foreign film is handled.

Breathless [À bout de souffle]. 1960. Wellspring Media, 2004. DVD.

Now, Voyager. Dir. Irving Rapper. Warner Bros., 1942. Film.

A book. Include author or editor's name(s), the book's title, publication data, and medium consulted.

Barnard, Timothy, and Peter Rist, eds. *South American Cinema: A Critical Filmography, 1915–1994*. New York: Garland, 1996. Print.

Coupland, Douglas. *Generation X: Tales for an Accelerated Culture*. New York: St. Martins, 1991. Print.

Smoodin, Eric. *Regarding Frank Capra: Audience, Celebrity, and American Film Studies, 1930–1960*. Durham: Duke UP, 2004. Print.

Note that additional entries for the same author substitute three hyphens for his or her name.

—-. *Animating Culture: Hollywood Cartoons from the Sound Era*. New Brunswick: Rutgers UP, 1993. Print.

A work in an anthology. Include the author and title of the piece you are citing within the anthology as well as information about the anthology. Include the page numbers of the entire piece in the works-cited list and the specific page you are citing in your in-text citation.

> Wood, Robin. "Ideology, Genre, Auteur." *Film Genre Reader II*. Ed. Barry Keith Grant. Austin: UT Press, 1995. 60-74. Print.

An article or essay in a journal, magazine, or newspaper. Include the author, title of the piece, and general publication information (journal title, volume, issue, and year), including inclusive page numbers.

> Klinger, Barbara. "Contraband Cinema: Piracy, Titanic, and Central Asia." *Cinema Journal* 49.2 (2010): 106-24. Print.
>
> Kopkind, Andrew. "Slacking Toward Bethlehem." *Grand Street* 44 (1992): 176-8. Print.
>
> Möller, Olaf. "One Man's Hong Kong: Patrick Lung Kong, Keeper of the Cantonese Cinema Flame." *Film Comment* 46.4 (2010): 14-5. Print.

A web publication. The latest MLA guidelines state that it is not essential to include a URL in your works-cited list. The guidelines also recognize that not all desired information is available for web sources and that the main idea is to be as thorough and consistent as possible when citing them. In addition to supplying the author, title, and date of publication as you would for a print source, include the title and publisher or sponsor of the web site, and date of access.

> Greven, David. "American Medusa: Bette Davis, Beyond the Forest, Femininity and Camp." *Jump Cut* 53 (2011): 1. Web. 6 March 2012.
>
> Prouty, Olive Higgins. *Now, Voyager*. Boston: Houghton Mifflin, 1941. *Google Book Search*. Web. 6 March 2012.

10-2d APA Documentation Style

Like the MLA style, the APA citation format has two parts: in-text citations and a works-cited list at the end of the paper (titled *References* and starting a new page). The key elements of in-text citations in APA style are author, year of publication, and page number if there is a direct quotation. Any of these elements that are not embedded in the sentence should appear in parentheses within the sentence:

> As the film historian Robin Wood asserts, *Meet John Doe* "at once transcends its director and would be inconceivable without him" (1995, p. 66).

> The fan mail generated by *Meet John Doe* reveals a startling lack of consensus among American moviegoers in 1941 to the policies of President Franklin Delano Roosevelt's New Deal (Smoodin, 2004).

The reference list is organized alphabetically, and hanging indents are used after the first line of each entry. The following are sample entries for a film, a book, and a journal article. For more detailed information, consult the *APA Style Manual, Sixth Edition*, or visit www.apastyle.org.

> Rapper, I. (1942). *Now, voyager* [DVD]. Burbank, CA: Warner Home Video.
>
> Smoodin, E. (2004). *Regarding Frank Capra: Audience celebrity and American film studies, 1930–1960*. Durham, NC: Duke University Press.
>
> Klinger, B. (2010). "Contraband cinema: Piracy, Titanic, and Central Asia." *Cinema Journal*, 49(2), 106–124.

10-2e *Chicago Manual* Documentation Style

The Chicago Manual of Style guideline has two required parts: numbered in-text citations and numbered footnotes or endnotes. Often a bibliography of works consulted is also required. (Note also that *Chicago* has an alternative system as well that is similar to MLA and APA styles.) Within the text, a superscript number is placed by the quotation or borrowed material:

> The fan mail generated by *Meet John Doe* reveals a startling lack of consensus among American moviegoers in 1941 to the policies of President Franklin Delano Roosevelt's New Deal.[1]

> As the film historian Robin Wood asserts, *Meet John Doe* "at once transcends its director and would be inconceivable without him."[2]

Either at the foot of the page or in a new page at the end of the paper that is headed *Notes*, give the source information that corresponds to the numbered citation. For details, consult the *Chicago Manual of Style, Sixteenth Edition*, or visit the Chicago Manual of Style's online citation quick guide at www.chicagomanualofstyle.org.

> 1. Eric Smoodin, *Regarding Frank Capra: Audience Celebrity and American Film Studies, 1930–1960* (Durham, N.C.: Duke University Press, 2004), 158.
>
> 2. Robin Wood, "Ideology, Genre, Auteur." In *Film Genre Reader II*, ed. Barry Keith Grant (Austin: University of Texas Press, 1995), 66.

The scene analysis assignment requires a close and focused reading of a key moment in a film. The goal may be a purely descriptive paper, one that ably observes and identifies the elements of narrative, mise-en-scène, camera work, editing, and/or sound in the chosen scene. Often, however, the paper asks for "analysis," an examination of how the elements contribute to an aspect of the film's meaning. The analysis might proceed by analyzing each shot in sequence (see the shot-by-shot analysis of a scene from Truffaut's *The 400 Blows* in chapter 1), or it might be organized topically, with each paragraph devoted to an element of film form or style.

"Don't Let's Ask for the Moon, We Have the Stars": A Scene Analysis

The 1942 Hollywood melodrama *Now, Voyager* (Irving Rapper) ends as Charlotte (Bette Davis) affirms her love for Jerry (Paul Henreid), a married man she met on a cruise, and his daughter Tina, whom she has taken into her care. The scene is significant not only because it brings the narrative to a close but also because this closure is achieved on her terms, not his. All of the cinematic elements in this scene signal the completion of Charlotte's transformation from a miserable spinster, entirely dependent on a repressive mother, to an independent woman in control of her own destiny.

Now, Voyager's final scene begins as a confrontation between Charlotte and Jerry over Tina. Jerry wants to take Tina from Charlotte, arguing that raising her is too much of a sacrifice for Charlotte to make; Charlotte finds his reasoning "conventional, pretentious, and pious" and expresses her dream of sharing a bond with him through their love of this child. Closure begins as Jerry finally accepts Charlotte's proposal, which comes with the requirement (stipulated by Tina's psychiatrist) that they cannot be lovers. Acquiescing, Jerry says, "Shall we have a cigarette on it?" He then lights two cigarettes in his signature gesture, which had previously suggested sexual desire and now signals their agreement to remain chaste. The sequence and the film end as Charlotte delivers a powerful exit line, one that affirms a new sense of her life's

The introduction establishes the name of the film, year of release, and director. The scene to be discussed is put in context of the larger narrative and its significance is explained. The final sentence in the introduction establishes the thesis, the claim to be developed in the remainder of the paper.

This plot summary of the scene provides the reader with background for the analysis to follow, but it also elaborates on the idea of closure being achieved on Charlotte's terms.

potential as a "mother" in an unconventional family. "Will you be happy, Charlotte?" Jerry asks. And she responds, poetically, "Oh Jerry, don't let's ask for the moon, we have the stars."

Charlotte's transformation into a woman in control of her own destiny is enacted in the theatrical blocking of the scene. She is the more physically active of the two characters; the camera finds Jerry standing still in most of the shots, but it follows Charlotte as she moves into the room to see Jerry, then away from him during their argument, and then back toward him at the end. At one point he draws her close to him as if to kiss, but she finds the strength to resist and persuades him to let her go. In the end, they stand side by side, not as a romantic couple but as individuals (and equals) who share a deep affection for Tina.

The three-point lighting on Charlotte also figures into her transformation, giving her that "kind of beauty" she tells Tina about in a previous scene: "a light that shines from inside you because you're a nice person." Her wardrobe, makeup, and hair complete the physical transformation that accompanies her psychological development. At the beginning of the film, she wears a frumpy, old-fashioned dress with ugly shoes. Her drab makeup makes her look pasty and pale and accentuates her thick brows. Her hair is held tight in an unattractive bun. In this last scene, Charlotte's clothes are elegant and look expensive, her hair is stylishly arranged, and her makeup accentuates her expressive eyes (see fig. 1), important here because they tear up to signal her heartbreak.

The setting also communicates that Charlotte is living her life on her own terms. She now owns the house that had once imprisoned her, and it too has been transformed. The room where she meets privately with Jerry has a fire in the fireplace, which has an obvious romantic implication, but it also says something

The topic sentence signals the connection to the main idea announced in the introduction and makes it clear that the paragraph will be about blocking. The details about blocking in the sentences that follow have a clear connection to the topic sentence.

The topic sentence does not always have to be the first sentence in the paragraph; here, the first two sentences establish the connection to the paper's main idea.

If you include illustrations in your paper, assign each one a figure number and include a reference to the figure in the body of your paper. *Jump Cut: A Review of Contemporary Media* describes how to create frame grabs in its "About Us" section under "Creating a Visual Essay."

about Charlotte's rejection of the ways of her tyrannical mother, who forbade fires as a wasteful luxury. Charlotte promises to be a far warmer mother to Tina than her mother was to her. There are flowers in every room as well. Not only do the flowers add to the beauty of the environment that Charlotte has created but they also refer to the flower motif that has run throughout the film paralleling Charlotte's "blossoming." Also prominently placed in the setting is a baby-grand piano, which is in striking contrast to the little ivory boxes that had once been Charlotte's only artistic outlet. In the final scene, Charlotte invites Jerry to visit her in this house, but it is clear that she will remain firmly in charge of it.

All of the details of mise-en-scène are presented in terms of how they connect to the idea of Charlotte's transformation.

▶ Fig. 1. Bette Davis is lit and styled to communicate her inner beauty in the final scene of *Now, Voyager*. A medium-close shot allows us to see the tears in her eyes.

The camera work and classical Hollywood continuity editing scheme serves primarily to let us watch the characters interact and be absorbed by their emotions, especially Charlotte's. The one medium-close shot in the final moments allows us to read her face and acknowledge the tears in her eyes (see fig. 1). The final cut of the film takes us out of the room and into the sky, a reference to the metaphor in Charlotte's final line about their future together (see fig. 2). This final camera gesture takes us out of the world of the film and into a future that may not be all that

Camera work and continuity editing are combined in one paragraph here, but a more detailed analysis of each element would require separate paragraphs.

Charlotte could have ever wanted but that is nonetheless filled with promise and love (for Tina).

Max Steiner's lush romantic music enhances the scene's emotional intensity and underscores Charlotte's sacrifice. When the scene begins, the dialogue is most prominent in the sound mix, as it provides insight into Charlotte's plan—her decision to abandon her romantic relationship with Jerry for the good of "their" child—that is necessary for narrative closure. While there is some incidental music in the background, it is hardly noticeable. But when the characters move close and an embrace seems imminent, the underscored music swells. "It Can't Be Wrong," aka "Charlotte's Theme," is a melody used earlier in the film to signal the intensity of their romance but here marks the end of their romantic relationship. Charlotte's noble sacrifice for the good of Tina completes her transformation into a strong, independent woman and allows the film to close on an upbeat note, despite the teary ending.

▶ **Fig. 2.** The closing shot in *Now, Voyager* is an eyeline match that refers to Charlotte's final line in the film.

Because this is a short paper, the conclusion is a simple statement at the end of the last paragraph. It refers back to the original idea without repeating it, adding new ideas that have been introduced along the way. In a fuller essay (see the next sample paper), the conclusion would be a separate paragraph.

The film analysis assignment takes the scene analysis essay to another level. Rather than focus on just one key moment in the film, the object here is make an interpretive claim that encompasses the whole film and to support that claim with a close reading of several scenes. The following sample includes a few outside sources that offer additional perspectives on the essay's central thesis and that provide an example of MLA documentation style. Note that this is not a model for a research paper, which requires building upon published work from a number of outside sources to formulate and elaborate an argument.

Dramatizing Class in *The Big Sleep* (1946)

Howard Hawks's 1946 film adaptation of Raymond Chandler's 1939 detective novel *The Big Sleep* focuses on dramatic conflicts between upper-class and working-class characters. These conflicts provide the foundation for what is basically a crime drama, and we are asked to view crime as a consequence or manifestation of class-distinct attitudes and values. Also in play are notions of masculinity and social and romantic interaction that are complicated by class differences, especially in the film's surprising denouement.

The fundamental class differences at stake in the story are introduced the moment Marlowe arrives at the Sternwood mansion in the film's opening sequence. It is an imposing place with large, public rooms at the front and a glassed-in greenhouse at the back. Marlowe is met at the door by Norris, a butler, whose neat formal attire and prim manner appear in clear contrast to Marlowe's rumpled suit and wisecracking informality. The butler walks briskly ahead while the detective pauses to take in the sights, including an ornate family crest (a prop surely identifying the Sternwoods as "old money") placed prominently in the entryway (see fig. 1). It is clear from this moment that Marlowe has entered another world in which appearances are at once important and deceptive, another world that will fascinate him for the duration of the film.

The introduction establishes the name of the film, year of release, and director and the pertinent detail that it is an adaptation of a novel. The thesis is stated.

The paper tracks the film chronologically. We begin with the first scene and end with the last scene.

The second paragraph introduces the chronological organization. It also begins with a sentence that sets the scene and then proceeds, through a discussion of relevant aspects of style and form, to present an interpretation of that scene relevant to the thesis stated in the opening paragraph.

Fig. 1. A tracking shot takes Marlowe into the Sternwood mansion. Here he pauses to gawk at the Sternwood family crest, a symbol of the family's upper-class, old-money status.

As Marlowe is left to wait in the mansion's anteroom and Norris exits the scene to inform the General of Marlowe's arrival, Carmen Sternwood descends the stairway. Costumed in what for the time was an outrageously short skirt, sheer nylons, and a tight-fitting blouse, Carmen proceeds to flirt with Marlowe. Just as Norris returns, and no doubt performing for his benefit, Carmen falls into Marlowe's arms. Later Marlowe will tell Carmen's father that "she tried to sit in my lap while I was standing up"—a typical wisecrack for the world-weary, working-class detective. Carmen is attractive and available, but Marlowe knows better than to encourage her. He sees through her performance and recognizes in her behavior symptoms of a careless lifestyle.

Marlowe is also astute enough to recognize that Carmen is "trouble" and that she is also "troubled," that the act she puts on reveals someone quite out of control. Thus, taking Carmen up on her offer would involve taking advantage, and his working-class masculinity—a subject of interest throughout the film—does not allow that. Marlowe will soon discover that men less tied to working-class notions of honor, loyalty, and fair play have behaved carelessly with regard to Carmen; indeed, their exploitation of Carmen's mental illness (as her promiscuous behavior is regarded in the film) is the reason that Marlowe has been called to the mansion in the first place.

Aspects of mise-en-scène are used to develop the significance of this first scene.

The dialogue between Carmen and Marlowe that precedes her fall into his arms does well to establish Marlowe's essential character. She asks flirtatiously if he is a prizefighter, no doubt a comment on his rugged and ragged appearance. The private detective, like the boxer, was a staple of forties-era crime films and this character type consistently embodied a working-class masculinity: hard work, hard knocks, and so on. When she asks his name, he responds, jokingly, with "Doghouse Reilly," a remark that regards the difference in their social class. His play on the idiom "in the doghouse" implies that he exists outside so-called polite and proper society. Filmgoers in 1946 immediately recognized this character type in large part because Marlowe is played by Humphrey Bogart. As the film historian James Naremore notes in his book *More than Night*, Bogart's star persona was fully consistent with the character he plays in *The Big Sleep*: "tough, introspective . . . fond of whiskey and cigarettes" (27). Throughout the film we are asked to read Marlowe and Bogart as consistent, intersecting, working-class, masculine types. Such a reading also involves Bogart's celebrity as a romantic lead—he had appeared in *Casablanca* half a decade earlier—which is especially important to the film's unlikely denouement, as we will see.

After dispensing with Carmen, Marlowe meets the General in the mansion's hothouse. The setting is revealing; it depicts in physical terms the consequences for the General of a life of sin and dissolution, behaviors the General himself describes as consequences of wealth and privilege (see fig. 2). Much of his conversation with Marlowe is steeped in regret; he acknowledges that a careless life has left him as frail as "a baby spider." The setting speaks also to Carmen's character; while Carmen's flirtatiousness has its sinister side (her father describes her as "still a little child who likes to pull wings off of flies"), she is also regarded by her father as a

The paragraph begins with a topic sentence. The body of the paragraph follows up on the promise made in this first sentence, to examine how their dialogue regards class difference.

This relevant use of an outside source (and the inclusion of a verbatim quotation from that source) includes an appropriate setup in the paper ("As the film historian . . .") and citation (here using the MLA style).

This last sentence, along with the final sentence of the first paragraph foreground and foreshadow the essay's conclusion.

This paragraph examines how set design and, more generally, setting can be used to establish key distinctions in the story told by the film.

"hothouse flower." Like one of the General's prize orchids, several of which are conspicuously placed in the hot house set, she has been pampered, overprotected, and as a consequence she is ill-suited to the cold hard life outside the mansion's walls. Indeed, Marlowe has been called to the Sternwood mansion to deal with just the latest situation that Carmen has stumbled into; a blackmailer named Geiger has taken nude photographs of Carmen after she passed out on drugs and alcohol in his company.

Fig. 2. Marlowe and General Sternwood in the hothouse discuss the case.

The essay briefly breaks with chronology to make an important comparative point.

After Marlowe exits the hothouse, Norris offers to pay him. But Marlowe, who clings to a strict work ethic, refuses; he wants to get paid only after he has done the job. His fee structure is certainly working class: "$25 a day plus expenses." This we see in comparison to the General's older daughter Vivian, who later in the film lets $14,000 ride on a single spin of the roulette wheel. Marlowe's work ethic puts a value on money; it is something he earns. Vivian gambles because money has little value to her; if she loses, as she often does, she knows her father will come to the rescue.

Before he leaves the Sternwood mansion, Marlowe is summoned to Vivian's room. The fundamental class difference between Marlowe and Vivian is made clear in this, their first, tense meeting. She is neatly and stylishly dressed; he is still sweat-soaked from his meeting in the hothouse. They step on each other's lines—an acting technique

The opening sentence sets the scene and the rest of the paragraph offers specific observations and poses an interpretive analysis of the scene based on those observations that are relevant to the thesis.

that dramatizes disagreement and incompatibility. She remarks at his lack of deference, that he does not immediately show her the respect she has become accustomed to because of her wealth and privilege. For the working-class detective, respect is something one does not simply get; it is something one earns. At one point in their conversation, Vivian quips, "I don't like your manners." He confesses that he doesn't like them much himself. Marlowe regards manners with suspicion; as a working-class hero, he is decidedly unpretentious. This is not to say that Marlowe is impolite. Indeed, when he meets the general in the overheated greenhouse, despite his discomfort, he waits for the old man to suggest that he take off his coat. Such common courtesy is consistent with his simple working-class, masculine tastes: the general asks how he likes his brandy, and Marlowe replies simply "in a glass."

The contrasts between the upper class and the working class are again apparent after Marlowe leaves the mansion and ventures to two bookstores. He first visits Geiger's Rare Book Store, masquerading as an effeminate book collector. The masquerade is keyed by a brief conversation in the public library in the previous scene where a comely blond librarian says to Marlowe, "You don't look like a man who collects first editions," to which Marlowe wisecracks in response, "I collect blondes in bottles too." To look and act more like someone who *does* collect first editions, Marlowe wears glasses and lisps as he talks, linking styles or degrees of masculinity with class-based stereotypes (see fig. 3). The store has few volumes in sight, and the front desk is attended not by a clerk but by Agnes, a beautiful young woman in a tight-fitting dress who, Marlowe quickly ascertains, knows nothing about books, rare or otherwise. The store is, he discovers, a front for Geiger's criminal enterprise, which includes the publication and distribution of pornography, including pictures of Carmen. Geiger is a white-collar criminal

The topic sentence here accomplishes three things: it sets up what follows in the paragraph (a descriptive and interpretive analysis of the scene in Geiger's bookstore), it provides the larger narrative context (with regard to a subsequent scene in the Acme Book Store), and it takes us from one point to another later in the film.

hiding behind the trappings of an upper-class location—a rare bookstore—and a glamorous woman.

Fig. 3. Marlowe props up his hat, dons glasses, and speaks with a lisp to masquerade as an upper-class book collector. Agnes is less successfully putting on a masquerade. She seems hardly dressed like a "shopgirl."

To learn more about Geiger, Marlowe goes across the street to the aptly named Acme Book Store. There he is met by a young "shopgirl" who is made-up, coiffed, and costumed to fit the part. She wears heavy-framed eyeglasses and far thriftier and more practical threads than Agnes: a doughty polka-dot blouse with an unflattering body-concealing bodice over it. Marlowe asks her the same questions he asked Agnes and quickly discovers that this working-class woman knows a lot about rare books even though she could never afford to buy one.

The scene that follows is similar to the earlier scene in Vivian's bedroom in that it is composed of a series of medium two-shots and features some snappy, sexually suggestive dialogue. But here the dialogue leads somewhere; unlike Vivian, the working-class store clerk is not interested in playing games. The pace of the editing efficiently keys the sexual tension; it quickens as something romantic builds between Marlowe and the shopgirl. We get three shots in rapid succession: of the two of them looking out the window of the shop at the rain, of the shopgirl looking at Marlowe alluringly, and of Marlowe smiling knowingly. Taken together, this sequence signals a mutual desire and it also marks a compatibility and mutual

Again the first sentence sets the scene. And it is followed by specific observations about the mise-en-scène (makeup, costuming, hair, props) to support the argument.

understanding *vis à vis* social class. They are, after all, both "on the job" when they meet. And they go right back to work when they are done. (Pointedly, neither Carmen nor Vivian works.)

In one of the film's most affecting sequences, one again steeped in the politics of class conflict, Marlowe encounters Harry Jones, aka "Jonesy," a slight, little man trying to be like Marlowe. Jonesy has the requisite tough-guy banter ("I'm no kibitzer," he says to prove he has been around), private-eye trench coat, and hat slanted just so. Soon after he and Marlowe first meet, Jonesy is cornered by Lash Canino, a brutal thug working for the upper-class gangster Eddie Mars. Canino wants to know the whereabouts of Agnes, the clerk from Geiger's bookstore (see fig. 4). Shots of the interrogation are intercut with shots of Marlowe watching from just out of Canino's line of sight. (Just a few minutes earlier, in a similarly edited sequence, we see Jonesy watch Marlowe take a beating from some thugs also hired by Mars.) Jonesy, who is in love with Agnes, finally gives up an address and is then murdered. Jonesy's death prompts Marlowe's later remark that Mars "kills by remote control," that as an upper-class criminal he hires others to do his dirty work.

This topic sentence takes us from a discussion of the scene in the Acme Book Store to a much later scene involving the interrogation of Jonesy. It also ties this scene directly to the topic at hand: class difference.

Fig. 4. Marlowe sympathizes with Jonesy, not because he is heroic but because he takes the street position; even under duress Jonesy does not betray Agnes.

Canino leaves and Marlowe enters the room just in time to watch Jonesy fall victim to the poison. Marlowe makes a quick phone call and discovers that Jonesy has

Some plot summary is necessary here to give context to Marlowe's remark.

given Canino the wrong address. Sitting beside the dead body, Marlowe mutters to himself, "You did all right, Jonesy." This is not simply a matter of one man appreciating another's bravery. Instead, it is locked into Marlowe's class-based worldview, where honor and loyalty are prized. Marlowe also appreciates that Jonesy is the real "Doghouse Reilly," no match for the wealthy and nasty criminals who do him in. When Marlowe finally implicates Mars in a number of crimes and orchestrates his death, it is in large part in revenge for the Mars-ordered hit on Jonesy, a parsing out of class-based justice for working-class underdogs everywhere in a world mostly rigged against them.

Well before Marlowe witnesses Jonesy's death, Geiger, the man the General had hired Marlowe to "deal with," has been killed. Yet Marlowe stays on the case, absent a client, absent a financial interest in the story's outcome. When he is asked why he will not "let it all go," Marlowe replies, "Because so many people told me to stop." Persistence is a valuable attribute for the working-class detective, and it is hardly surprising that the upper-class characters find such a quality difficult to understand.

An alternative class-based explanation for Marlowe's persistence is provided by the film scholar Michael Walker in his essay "*The Big Sleep*: Howard Hawks and Film Noir." Walker offers a psychological reading of the narrative that focuses on Marlowe's apparent fascination with the lives of the rich and powerful. Walker contends that Marlowe is obsessed with trying to understand the psychologies of criminality and power which, for him, are both inextricably tied to wealth and privilege (191, 196, 197, 198, 202).

Marlowe's persistence with the case leads him back to Geiger's house where he finally outwits Eddie Mars and tricks Mars's men into killing their boss. Having solved the crimes, he tells the police that Mars was behind the murder of Sean (Rusty) Reagan, a character who preceded Marlowe as the General's working-class confidante.

This paragraph intro-duces the first of two possible answers to a single narrative question: why does Marlowe stay "on the case" long after Geiger is killed? This first interpretation is fully consistent with the paper's thesis.

This second interpre-tation is based on an argument made in an outside source that is nonetheless clearly relevant to (and puts a new spin on) the paper's thesis about class difference and conflict.

Though this second reference to an outside source does not include a verbatim quotation, it nonetheless merits clear contextualization in the paper and appro-priate citation (here again following the MLA style).

This closure reveals a significant compromise on Marlowe's part. Throughout the narrative, he has been on a quest for truth, but here at the end he lies.

Perhaps he does so to protect his clients—the sympathetic General and the damaged Carmen, whom Vivian agrees to send away for treatment. Another possible reading is that Marlowe cannot help but be tainted by the upper-class characters he has worked for and against. No closure to a story plotted by such duplicitous characters is possible without fabrication and compromise.

A final plausible explanation for this denouement can be found in the film's fundamental departure from its source, Raymond Chandler's novel. The book ends with Marlowe ruminating over the darkly comic adventures of the upper class, adventures he has only narrowly escaped alive. The novel is decidedly cynical and misogynist. Mars is not brought to justice. And Marlowe does not "get the girl" but instead Carmen takes a shot at him with a gun loaded with blanks. All of the principal women in the novel—Vivian, Carmen, and Agnes—survive more or less unscathed and unapologetic. Two of the working-class men who come in contact with them—Reagan and Jonesy—have at the end entered "the big sleep" of death.

The film ends quite differently, with Mars dead and Marlowe and Vivian in what appears to be the prelude to a kiss. This very "Hollywood" closure gestures to the market necessities of popular moviemaking. The novel's cynicism and misogyny is eschewed in favor of romance in which two movie stars, Bogart and Lauren Bacall (who plays Vivian), themselves a well-known couple, transcend their class differences in the film and seem suddenly and strangely in love. This ending may well be what the 1940s audience wanted, but it imposes a false class reconciliation to a story that had otherwise insisted upon a world characterized by class differences and struggle.

If a scene is complex and invites more than one reading, it can be a useful strategy to discuss each of the plausible interpretations. This paragraph introduces two readings that build on observations made about elements of form and style in the scenes. The interpretive claims made in both readings are consistent with the larger argument laid out in the paper.

This third possible reading is not built on content but on context: here, the relationship between the film and its source, Chandler's novel.

This last, concluding paragraph further explains the third reading (above) in an additional context, one regarding "the market necessities of popular movie-making." Though this introduces a new and potentially rich subject for further inquiry it is also consistent with the paper's thesis and suitably takes us to the final image of the film, the prelude to a kiss. This fulfills the paper's overarching structure: chronology.

Works Cited

Chandler, Raymond. *The Big Sleep.* New York: Vintage, 1998. Print.

Naremore, James. *More than Night: Film Noir in Its Contexts.* Berkeley: U of California P, 1998. Print.

Walker, Michael. "The Big Sleep: Howard Hawks and Film Noir." *The Movie Book of Film Noir.* Ed. Ian Cameron. London: Studio Vista, 1992. 191-202. Print.

The works-cited list, here shown in MLA style, should start a new page.

GLOSSARY

180 degree rule A principle of continuity editing that requires the camera to stay within a 180-degree area defined by the **axis of action**, so that the spatial relationships across a sequence remain consistent.

A and B stories (also, **kernel and satellite stories**) A narrative formula that prioritizes one of the narratives while simultaneously tracking a second narrative.

actualities Slice-of-life documentaries produced by the Lumière brothers at the end of the nineteenth century.

ancillary revenues Money made on a film in addition to movie theater box office—including licensing, merchandising, network and cable television, and DVD/Blu-Ray sales.

animated film An alternative to live-action film composed of pen-and-ink drawings, illustrations on transparent cels, fabricated models, or computer-designed images.

animated film

anime A style of Japanese animation that includes a range of styles and types including adaptations of Japanese Manga (young-adult magazines).

anthropomorphize To give human qualities to a nonhuman creature or object.

art house A theater, also known as an independent movie theater, that typically screens independent and foreign-language films.

aspect ratio The ratio of frame width to frame height. The **Academy ratio** was the standard during much of the silent and early sound era. **Widescreen** formats include Cinemascope and Panavision.

Academy ratio

auteur French film critics in the 1950s argued that while films are the product of a collaborative process they nonetheless have a single author or auteur: the director.

backstage musical A subgenre of musicals in which the song and dance numbers are not integrated into the story.

backstory The past that characters bring with them into a film.

B film Mostly low-budget genre films made by smaller, independent film companies to round out a double bill.

blocking The choreographed positioning of actors and camera(s).

blocking

Bollywood Films produced by the Hindi film industry that feature elaborate production numbers that are worked into a wide variety of genres.

Bollywood

boutique independents So-called independent films made by subsidiaries of the major studios. Boutique independent companies include Miramax, Focus Features, and Fox Searchlight.

boutique independents

canted shot A shot made by tilting the camera at an angle on the subject.

cel A painting or drawing made on celluloid for use in an animated film.

CGI (computer-generated imagery) Images that are not photographically produced but are created on a computer.

chiaroscuro Dramatic high-contrast lighting that exploits gradations and variations of light and dark in an image.

chiaroscuro

classical Hollywood The so-called "studio era" roughly from the advent of sound through World War II. Distinguished by an approach to filmmaking that strove for an "invisible style" that allowed viewers to become absorbed by the world of the film.

close-up A shot of a person's face, or any shot that offers a detail of the subject. Variations include the **medium close-up** (usually face and chest) and the **extreme close-up**.

close-up

closure The resolution of narrative questions and/or problems.

continuity editing An editing style that minimizes the filmgoer's awareness of shot transitions and in doing so supports a seamless telling of the film's story.

crane shot An aerial or overhead shot executed by a camera operator on the platform of a moving crane.

crane shot

critical flicker fusion A phenomenon in which the light of a film projector flashes so rapidly with each new frame that we do not see it pulse but instead see a continuous beam of light.

cross-cutting The process of cutting back and forth between two or more parallel actions; also known as **parallel editing**.

cross-promotion The use of partnerships with toy, fast-food, and media companies to build the visibility of an event film.

cut The place where one shot ends and another begins; a direct transition from one shot to the next.

deep focus Describes a shot where both the foreground and background planes are in sharp focus.

deep focus

deus ex machina The introduction of a contrived event to solve the problems set in motion in the story.

dialogue Words spoken between two or more characters.

diegetic sound Sound that originates from within the story.

direct address A type of speech in which the character breaks the fourth wall and speaks to the camera or audience.

direct address

direct cinema A documentary movement in the United States in which the camera acts as an objective, disinterested observer, capturing events as they unfold.

dissolve A transitional device in which one shot disappears as another appears.

dissolve

documentary Films that present themselves as works of nonfiction, as factual and trustworthy, and ask us to view them as such.

Dogme 95 A group of mostly Scandinavian filmmakers who signed a manifesto, agreeing to abandon all aspects of Hollywood artifice. They use only hand-held digital video cameras, shoot only in natural light, and add no music.

dubbing The process of rerecording dialogue and synchronizing it with shots; also known as **looping**.

early cinema era Begins with the advent of cinema (circa 1895) and ends with the introduction of feature-length films (1914).

ellipses The omission of significant chunks of story time in the on-screen plot.

elliptical editing Editing that allows an action to consume less screen time by transitioning between shots that suggest the passage of time.

establishing shot, also master shot A shot that orients the audience for the scene that follows.

ethnographic film A film that documents the way of life in a foreign land.

ethnographic film

experimental, or avant-garde, film A type of film that challenges widely held notions of what movies can or should be and that often challenges the status quo.

exploitation films Low-budget, independent films that appealed to filmgoers' fascination with sinful behavior or interest in pop culture fads. These films often defied the strictures of the Production Code.

exposition The presentation of narrative information that provides context for the story and plot, including character development and the establishment of setting and/or location.

eye-level shot A shot made by placing the camera at eye level with the subject.

eye-level shot

eyeline match An editing pattern that cuts between a character looking and the object of his or her gaze.

eyeline match

fade A transitional device in which a shot slowly darkens and disappears (fade-out) or lightens and appears (fade-in).

feminist films Films that challenge gender inequality and/or assert female identity.

feminist films

film genre A category of film based on its narrative pattern and/or emotional effect.

film noir A French term for a style originating with American crime films of the 1940s and 1950s, characterized by deep shadows, night scenes, shady characters, and plots involving elaborate schemes and betrayals.

first-person narration Commentary on the film's action by a character who speaks as "I."

flashback A scene that interrupts the chronological flow of story events by referring to an earlier time.

flash-forward A scene that interrupts the chronological flow of story events by skipping ahead to a later time.

Foley artist A member of the sound design team who creates sounds in a studio using various props.

Foley artist

Fordism A production system modeled on the assembly-line operation popularized by Henry Ford.

form The visual and aural shape of a film. Form embraces all aspects of a film's construction that can be isolated and discussed: the elements of narrative, mise-en-scène (the "look of the scene"), camera work, sound, and editing.

found footage Filmed material that is discovered and used by another filmmaker.

found objects Everyday objects that are repurposed to create art.

fourth wall The imaginary wall or barrier between the audience and the characters that creates the illusion of a separate story world.

four-walling A strategy of renting a theater for a day or so before moving the print to a new town.

frame The smallest compositional unit of a reel of film: a single photographic image; also, the boundaries of the image.

French New Wave A group of post–World War II French directors including François Truffaut, Jean-Luc Godard, Jacques Rivette, Claude Chabrol, Eric Rohmer, Alain Resnais, and Agnes Varda, all of whom strove to create a more spontaneous and personal style of filmmaking. Many of these directors began as film critics for the magazine *Cahiers du Cinéma*.

German expressionism A cinematic style that emerged in Germany between the two world wars. Expressionism is visually characterized by chiaroscuro lighting and highly stylized sets. The best-known expressionist filmmakers are Fritz Lang, F. W. Murnau, and G. W. Pabst.

graphic match, also known as a cut on form A way of connecting two or more shots through repeated shapes or patterns.

handheld shot A shot made with a portable camera that may show signs of not being mounted, such as jitter or off-center framing.

hand-held shot

high-angle shot A shot made by placing the camera above the subject, angled downward.

high-angle shot

high-key lighting A lighting scheme that typically uses fill and backlights to lessen the contrast between the light and dark areas in the frame.

high-key lighting

horror A film genre that is recognized and understood based on the effect the narrative has on us, and how the events and characters create the desired sense of suspense and dread.

idealization A mode of engagement with film content; something in the film resonates with our dreams and aspirations: if only our lives were quite like this!

identification A mode of engagement with film content; something in the film reminds us of our own experience, and we tend to identify with the relevant character and his or her situation.

impressionism An avant-garde style that celebrated the poetry of moving images while resisting narrative forms and formulas.

independent film company A company outside the conglomerate system. These companies make less-mainstream and less-expensive films.

independents A label first applied to filmmakers outside the MPPC and later used to refer to those working outside the Hollywood studios.

internal diegetic sound A character's thoughts and memories, heard but not spoken aloud.

intertitle A piece of text inserted into the film to cue the audience to the passage of time. Intertitles might also provide dialogue (in silent films), prologue, or epilogue copy.

intertitle

One Year Later

iris A transitional device in which the image contracts or expands within a small circle.

iris

Italian neorealism A post–World War II film movement in Italy in which directors adapted the conventions of documentary realism in their fiction films. The best-known neorealist filmmakers are Roberto Rossellini, Luchino Visconti, and Vittorio De Sica.

jump cut A cut that seems to suggest a glitch or skip in the film.

jump cut

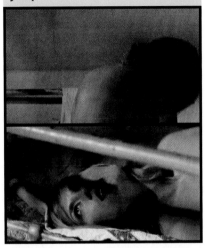

line delivery the way in which an actor says the words from the script; also called **line reading**.

location shooting The filming of a scene in a found location rather than in a constructed set.

long shot A shot that includes the entire person and background or a shot where the subject appears relatively small. Variations include the **extreme long shot** and the **medium long shot**, a shot of a person from the subject's knees up or a shot where the subject is slightly smaller than a medium shot.

extreme long shot

long take A single continuous shot of unusually long duration.

low-angle shot A shot made by placing the camera below the subject, angled upward.

low-angle shot

low-key lighting A lighting scheme that emphasizes key light and diminishes or sometimes eliminates fill and backlights. Low-key lighting creates greater contrast between the light and dark areas in the frame.

marketability A film's potential as a commercial property independent of its quality.

medium shot A shot of a person from the waist up, or a shot where the scale of the subject is of moderate size.

medium shot

metonymy A type of metaphor in which a thing is represented through one of its attributes. Most often this rhetorical form uses a part to signify the whole, e.g., "the crown" to signify royalty.

mise-en-scène Roughly translated from the French, "putting into the scene." Mise-en-scène is composed of the set and props, the look of the characters (costumes, makeup, and hair), dramatic staging (the blocking of characters as they move about the set), and the lighting (including the position, intensity, and balance of the lights).

monologue A lengthy speech by one character.

montage sequence A series of brief shots that summarizes a section of the story.

motif Repeated images, lines of dialogue, or musical themes that are significant to a film's meaning.

Motion Picture Production Code The strict set of censorship guidelines adopted by the Hollywood studios in the 1930s and enforced through the 1960s.

Motion Pictures Patents Company (MPPC) trust The first film industry cartel to monopolize the production and distribution of American movies.

movie editing The cutting and joining of shots to assemble a film; also known as **montage**.

movie palace An opulent standalone theater that brought glamor to the moviegoing experience. In the 1910s movie palaces had seating capacities approaching 1,000. By the 1940s, some movie palaces could seat over 5,000.

movie set Most often refers to a set constructed on a studio lot or soundstage. Also used more generally to refer to any location, real or constructed, where filming takes place.

multiplex A single venue with multiple screens. A venue with 16 screens or more is known as a **megaplex**.

musical comedy A subgenre of musicals in which characters break into song to express their feelings.

musical motif A brief and recurring pattern of notes.

narrator A person who sets up the story and comments on the action.

natural light The use of natural sunlight (or occasionally moonlight) in exterior or interior scenes.

New American Cinema Group A group of avant-garde filmmakers whose anti-Hollywood manifesto was responsible for initiating the New York film underground of the 1960s.

nickelodeon A storefront theater that showed films during the early cinema era. A series or group of short films were available for viewing for a nickel.

nondiegetic A term used to denote material within a film that comes from outside the world of the story.

nondiegetic insert An image inserted into a scene that comes from outside the world of the story.

nondiegetic sound Music, words, or effects from outside the story world that shape our experience of the film but do not originate within scenes.

nonnarrative Structured by a focus on something other than story.

non-simultaneous sound Sound from the past or the future within the story world.

off-screen sound Sound that originates from a source that we cannot see but assume nonetheless to be part of the story world.

off-screen space The space in a scene that the audience cannot see but knows to contain someone or something of importance to the story.

overexposure A technique that creates a washed-out image by bathing the film in excessive light.

overexposure

overlapping editing The repeated presentation of a plot event, expanding its on-screen duration and underscoring its significance.

pan A lateral camera movement along an imaginary horizontal axis.

period piece A film set in the past, often characterized by lavish set design and costuming.

persistence of vision The tendency for one image to persist or linger on our retina as the next image enters our perception, contributing to the illusion of motion pictures.

phi phenomenon The optical illusion that accounts for the impression of movement when one image follows another at the proper speed.

pitch The frequency of sound vibrations, described on a scale from high to low (or treble to bass).

playability A film's creative quality independent of its commercial potential.

plot Story events presented on screen.

plot duration The time span encompassing only those story events that are selected for the plot.

plot order The sequence of events adopted in the telling of a story.

positioning A marketing term that refers to the work of generating and managing the discourse surrounding a film.

Poverty Row A handful of small film companies specializing in B films headquartered in Gower Gulch, a neighborhood in Hollywood.

principal photography The phase of film production in which the scenes are shot.

print The developed film (or positive print) sent by the distributor to the exhibitor and meant to be screened on a motion picture projector.

Production Code A regime of censorship introduced in 1930. This code strictly regulated on-screen images and narratives from 1930 through 1968.

prop Short for *property*, an object placed in the set. Props may play a significant part in the action.

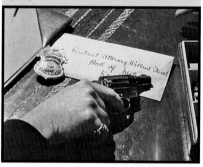

prop

propaganda film A film that promotes a political agenda.

protagonist The film's hero.

race films Films made by and for certain underserved ethnic groups, e.g., African American and Yiddish-language films in the 1920s and 1930s.

racking focus Describes a shot where the focus shifts among foreground, middle ground, and/or background planes.

reaction shot A shot that shows how one character is responding to what another is saying or doing.

saturation distribution strategy A strategy that aims for a big payoff on a film's opening weekend.

score A nondiegetic musical accompaniment written specifically for a film.

screen direction The directional relationships in a scene determined by the position of characters and objects, by the direction of their movements, and by eyeline matches.

screen duration The running time of the film.

selective focus Describes a shot where part of the image has been deliberately blurred while another is in sharp focus.

selective focus

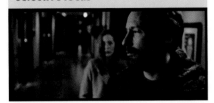

shot A continuously exposed, uninterrupted, or unedited piece of film of any length; a basic unit of film structure with discernible start and end points.

shot/reverse shot An editing pattern that cuts between two characters in conversation.

showcase distribution strategy A strategy that involves the slow build-up from limited showings to a full nationwide release.

silent era Begins with the introduction of features (1914) and ends with the advent of sound (1928).

silent era

slice-of-life documentaries Short films produced for the Edison Manufacturing Company that captured everyday events.

sound bridge A sound that connects two scenes. It could be a sound that carries over from one scene to the next or a sound from the second scene that is heard before the first scene ends.

sound cue A musical theme or sound effect that signals the arrival of a character or the performance of an action.

sound editing The process by which the components of the voice, music, and effects tracks are chosen and synched to the images on-screen.

sound mixing The process by which separate tracks are combined into a single soundscape.

sound perspective The use of volume, pitch, and timbre to imply distance or location.

soundstage Looking much like an airplane hangar, a soundstage is a windowless, soundproofed shooting environment.

Soviet formalism A film movement in the Soviet Union that took shape during the Bolshevik Revolution (1917) and unraveled in the early years of Joseph Stalin's repressive regime (1929). Soviet formalist filmmakers—including Sergei Eisenstein, V. I. Pudovkin, and Dziga Vertov—believed that the essential unit of meaning in cinema is the cut.

speed of motion A camera-based special effect that makes the action on screen move at unrealistic speeds (fast, slow, or briefly paused, or stopped). Speed-of-motion effects are created by filming action at faster or slower speeds and then projecting the images at standard speed.

speed of motion

stock music Preexisting music that is repurposed for a score.

stop-motion A method of animation in which three-dimensional objects are moved and photographed for each frame.

story duration The time span encompassing all of the story events.

story order The chronological sequence of narrative events.

structural or minimalist cinema Films characterized by static framing and long takes, that employ anti-illusionist filmmaking techniques.

style The particular or characteristic use of formal elements.

subjective point-of-view shot A shot that simulates what a character sees.

surrealism An avant-garde movement of the early twentieth century that explored the workings of the unconscious.

synergies Strategic relationships between media and information companies.

tagline A line used in marketing that communicates the message of the film for audiences.

telephoto lens A lens with greater magnification power that can make objects seem closer to the camera and that can decrease the illusion of depth within the shot.

test screening A prerelease film screening to gather reactions from sample audiences.

third-person narration Commentary on the film's action by someone who is not a character in the story and who refers to all of the characters as *he*, *she*, or *they*.

three-point lighting A balanced lighting scheme that employs three points of illumination: a bright light that directs our eyes to the subject (**key light**), a balancing (less intense) **fill light** that softens the shadows created by the key light, and a **backlight** behind the subject to add highlights.

three-point lighting

tilt An upward camera movement along an imaginary vertical axis.

timbre The "color," quality, or feeling of a sound.

top lighting A lighting scheme in which the key or source light is placed above the subject.

top lighting

tracking shot A shot produced with a camera that moves smoothly alongside, behind, or ahead of the action.

travelogue A film that presents a tour of a foreign land.

two-shot A shot with two people.

under lighting A lighting scheme in which the key or source light is placed below the subject.

vertical integration A strategy in conglomerate capitalism in which several subsidiary companies under a single corporate umbrella perform inter-related tasks with regard to a single product. The film business today operates as a vertically integrated entertainment marketplace with the large corporations that own the film studios controlling the filmed product from development through exhibition.

voice-over narration Lines spoken by a narrator that are nondiegetic.

volume The degree of loudness and softness.

Voluntary Movie Rating System The system of assigning a rating that is meant to provide information about the appropriateness of a film for audiences 17 and under. Managed by CARA (the Classification and Rating Administration) for the MPAA (the Motion Picture Association of America).

western A film genre that is recognized and understood based on its narrative elements: the characters (cowboys, American Indians, gunslingers, and outlaws), the setting (the wide-open spaces, the saloon), and certain narrative events (the inevitable gunplay).

wide-angle lens A lens that allows for a wider angle of view and that can increase the illusion of depth within the shot.

wipe A transitional device where one image appears to be pushed aside by the next.

wipe

wuxia pan Mandarin-dialect swordplay action films.

zoom lens A lens with a variable focal length that can lengthen (zoom out) or diminish (zoom in) the apparent distance between the camera and its subject.

INDEX

Meyer, Russ, 259
MGM, 249, 250
Micheaux, Oscar, *257, 258*
Microphone, 155, *156*
Milieu, defined, *59–60*
Miller, Frank, 111
"Mimi," 165, 166, *166*
Minimalist cinema, 237
Ministry of Propaganda, 213
Minnelli, Vincente, 254
Miramax, 185, 261, 262
Mise-en-scène
 Altman and, *255*
 in animated films, 222, *224*
 blocking and (*See* Blocking)
 budget and, 186
 camera work and, 85, 90, 94, 106, 112
 Coppola and, *255*
 costumes and (*See* Costumes)
 defined, 55
 documentary films and, 209
 in experimental films, 229, 230,
 233, 242
 in film essay, 284, 296
 hair and (*See* Hair)
 in Japanese cinema, 273
 lights/lighting and (*See* Lights/lighting)
 makeup and (*See* Makeup)
 in *Nanook of the North*, 211
 performance and, 69–75
 production design and, 56
 Psycho and, 82
 sets as (*See* Sets)
Mitchum, Robert, 286
Mix, Tom, 258
Miyazake, Hayao, *228,* 229
Mizoguchi, Kenji, 273
MLA Bibliography, 292
MLA documentation style. *See* Modern
 Language Association (MLA)
 documentation style
MLA Handbook, Seventh Edition, 294
Mobile framing, 103
Modern Language Association (MLA)
 documentation style, 293–295, 300
Modes of production, 186–187
Monaural sound, 202
Money
 modes of production and, 186–187
 movies and, 184–187, 190
Mono signal sound, 202
Mono sound, 202
Monogram, 258
Monologues, 158
Monophonic sound, 202
Monopoly, 250
Monroe, Marilyn, 40, *40,* 41, 253
Montage
 in *American Gigolo, 128*
 defined, 121, 127
 Eisenstein and, 266
 in *Rocky,* 128, *128*
 sound and, 173
Montage sequence, 126–128
Montage theory, 121
Mood
 lighting and, 75
 sound and, 153
Moore, Michael, 217, *217,* 218, *218,* 219
Moreno, Rita, 167
Morganifield, McKinley. *See* Muddy Waters
Movie brats, 255

Motif, 14
Motion Picture Association of America
 (MPAA), 193, 219, 253
Motion Picture Distributing and Sales
 Company, 257
Motion Picture Patents Company v. IMP, 257
Motion Picture Producers and Distributors
 Association (MPPDA), 252, 259
Motion Picture Production Code, 196
Motion Picture Rating System, 232
Motion Pictures Patents Company (MPPC),
 188, *248,* 249, 257
Motion Pictures Patents Company (MPPC)
 trust, 247, *248*
Motion toys, 4, *5*
Motivations, 34–35, 74
Movement, camera work and, 86
Movie editing, defined, 119
Movie making, 189
Movie palaces, 198, *199*
Movie sets, defined, 57
Movie stars, screen characters and, 40–41
Moviegoing, modern, 5
Movies. *See also* Films
 analyzing, 3–16, 18
 as art, 6–12
 development of, 189
 as entertainment, 6–12
 home, 211, *211*
 magic of, 4–6
 making, 189
 mass production of, 187–190
 money and, 184–187
 moving image in, 4–5
 positioning of, 191, 192, 193, 194
 postproduction of, 189
 production of, 189
 reactions to, 3
 silent, 5, *5,* 36
Moving camera, 95–97, 99, 103
Moving images, 4–5
Mozzhukhin, Ivan, 121
MPAA. *See* Motion Picture Association of
 America (MPAA)
MPPC. *See* Motion Pictures Patents
 Company (MPPC)
MPPC trust. *See* Motion Pictures Patents
 Company (MPPC) trust
MPPDA. *See* Motion Picture Producers and
 Distributors Association (MPPDA)
MTV, 185
Muddy Waters, 164, *164*
Muffled sound effects, 172
Multichannel sound, 170
Multiplex, 197–199, *199,* 200
Mundwiller, Joseph-Louis, 211, *211*
Murch, Walter, 252
Murnau, F. W., *45, 113, 131,* 249, 264, *264*
Music
 Altman on, 179
 in animated films, 222
 background, 161–163
 diegetic pop, 163
 musicals as, 165–167
 nondiegetic background, 161
 nondiegetic pop, 163, 164, *164, 165*
 pop music soundtrack as, 163–165
 as sound, 149–155
 sound editing and, 173
 sound mixing and, 175, 176
 source, 150
 stock, 161–162

Music editing, 150
Music editor, 150
Music track, 150
Musical comedies, *165*
Musical motif, 162
Musicals
 backstage, 165
 broadway, 167
 Hollywood and, 250, 253
 long shots and, 91
 sound and, 165–167
Musker, John, 167
"My Old Kentucky Home," 161
Myrick, Daniel, *45, 101*

N

Nair, Mira, 277
Narration
 of characters, 37–40
 first-person, 40
 voice-of-God, 214
 voice-over, 159–161, *160*
Narrative
 blocking and, 70–71
 budget and, 186
 characters in (*See* Characters)
 defined, 21
 Double Indemnity and, 51–52
 in film essay, 284, 285, 290, 296
 in Japanese cinema, 273
 sound effects and, 169–171
Narrative fiction film, 208
Narrative formulas, 209, 235
Narrative structure
 A and B stories in, 28–29
 hero's journey in, 27–28
 narrative time in, 30–33
 parallel stories in, 29–30
 plot in, 23–24
 story order in, 23–24
 three-act structure in, 24–26
Narrative time, 30–33
Narrator, defined, 40
Natural light, 79–80
Natural Vision, 201
Naturalism, 69
NBC, 185, 262
Needham, Terry, *189*
Needle drop, 150
Negative space, 94
Neorealism, *80,* 266–268
Neorealist films, 80, 280
Netflix, 197
Netscape, *185*
Neveldine, Mark, 192
New American Cinema, 232, 233, 293
New Journalism style, 217
New Line Cinema, *185,* 261
New Line marketers, 193
New wave movements, 268–271
New York Herald, 220
New York underground, 232–235
News Corporation, 185
Niccol, Andrew, *201*
Niche films, 195, 258
Nichols, Mike, 254
Nickelodeon, 185, 197, *198*
Nishiguchi, Akira, 9
Nixon, Richard, 254